Shrouds of the Night

 # hrouds of the N ight

Masks of the Milky Way
and Our Awesome New View of Galaxies

by

David L. Block

and

Kenneth C. Freeman, FRS

 Springer

Prof. Dr. David L. Block
Director: Anglo American Cosmic Dust Laboratory
School of Computational & Applied Mathematics
University of the Witwatersrand, Johannesburg
1 Jan Smuts Avenue
Johannesburg
2001 South Africa

Professor Dr. Kenneth Freeman
Research School of Astronomy and Astrophysics
The Australian National University
Mount Stromlo Observatory
Cotter Road
Weston Creek PO
ACT 2611
Australia

Cover Photo: [Figure 202] secured with the Hubble Space Telescope, courtesy NASA, ESA, Natan Smith at the University of California, Berkeley, and his collaborators, together with the Hubble Heritage Team at the space Telescope Science Institute, Baltimore.

ISBN: 978-0-387-78974-3 e-ISBN: 978-0-387-78975-0
DOI: 10.1007/978-0-387-78975-0

Library of Congress Control Number: 2008931168

Printed on acid-free paper

9 8 7 6 5 4 3 2 1

springer.com

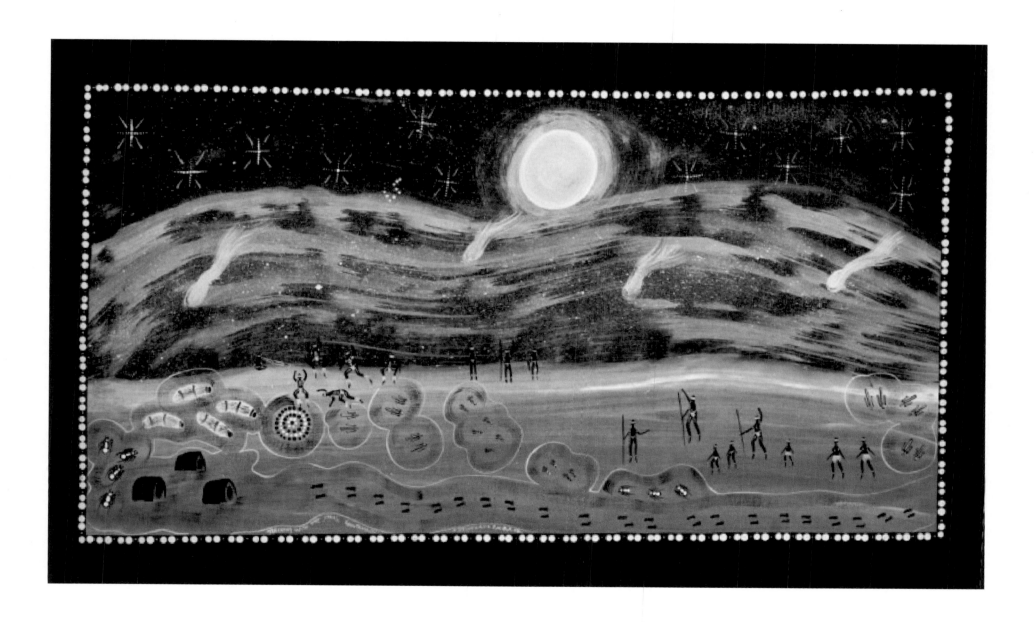

reamble

Grains of carbon based cosmic dust – the stuff of which every reader is made – were recognized in the early photographs of nebulae and galaxies. How pervasive were these dusty Shrouds of the Night in galaxies external to our Milky Way? It was only in 1994 that the dilemma facing astronomers, as to the existence and amounts of cold and very cold dust grains in galaxies other than our Milky Way, was definitely solved by author David Block and his collaborators. The temperatures of these grains may be minus 253 degrees Centigrade – and even colder. There is one story of the enigmatic masks themselves, and another of the awesome New View of spiral galaxies behind their masks. The duality in the structure of spiral galaxies was featured on the cover of the British journal *Nature* in 1991.

Then there is the mysterious "dark matter" enveloping galaxies. Matter which is there, but which emits no light whatsoever. In 1970, a research paper on galaxies by Ken Freeman pointed out that "…there must be in these galaxies additional matter which is undetected … Its mass must be as least as large as the mass of the detected galaxy …" John Bahcall, astrophysicist at the Institute of Advanced Study in Princeton, wrote to Freeman that this 1970 paper "is the earliest explicit recognition of the [dark matter] problem that I know about from rotation curves."

In the following pages, join our authors David Block and Kenneth Freeman, as they explore enigmatic Shrouds of the Night. The thoughts contained in this book have occupied their minds and the minds of their collaborators for a total of more than 60 years. They will

introduce many of the modern ideas about galaxies and explain how these concepts were discovered. Although this book is not a historical treatise, you will meet some of the older ideas and also many of the key players in galactic astronomy over the past few centuries, and learn how they made the discoveries which gradually led to our present level of understanding. Some of these pioneers were very influential in their time but their names have now been almost forgotten, like the British amateur astronomer John Reynolds to whom Edwin Hubble wrote for assistance in the classification of spiral galaxies. Some surprises lie in store, such as the person who took the First Photograph (ca. 1826) well before the public announcement of photography in 1839, and the remarkable equipment used at Birr Castle to draw objects of our night skies in the dark.

Preface:

 Vera Rubin

Over many millennia, civilizations have been curious about the Universe in which they find themselves, so stories about origins were devised: how the Milky Way formed, why there are seasons, what causes the rising and the setting of the Sun and the stars. These stories were handed down throughout generations, and became an important part of science history. As tools and understanding progressed, questions were answered but new discoveries and new questions arose to take their places.

In recent times, the pace of science and technology has increased enormously. Before 1950 we lived in a Universe that we detected almost entirely with our eyes, or with substitute eyes, such as telescopes or cameras. These instruments were generally sensitive only to the wavelength region seen by the eye. But in the last fifty years or so, the pace of new astronomical discoveries has been enormous. Every decade or so, a new discovery has forced scientists to revise their understanding of the history and evolution of the Universe. Some of these phenomena were surprises, enabled by new technologies. Some advances came from using known technology, some from using new ideas, some from both.

Consider this increase in our knowledge of astronomy in only 50 years:

1950s: New detectors sensitive in the radio region of the spectrum returned images of stars and galaxies as seen by their emission of radio waves. Astronomers discovered radio galaxies, galaxies that emit more of their radiation at radio wavelengths than at optical wavelengths. Within a few decades or so, astronomers could detect and study galaxies also by their ultraviolet, infrared, x-ray, and gamma ray radiation.

1960s: Quasars were discovered, now understood as energetic cores of galaxies, many enormously distant from our Galaxy. They are also called quasistellar objects, due to their point-like nature.

1970s: Studies of rotation velocities for stars and gas in galaxies, some acquired from optical, some from radio observations, indicate that most of the matter in the Universe is dark. Now called dark matter, radiation is not one of its attributes. Most of the dark matter cannot be composed of conventional matter.

1980s: Distant galaxies appear to be expanding at velocities faster than predicted from simple cosmological models. Dark energy, an unknown energy, is invoked to explain the high velocities.

1990s: Astronomers increase the dust mass in spiral galaxies by ninety percent. The first extrasolar planets are also detected, planets orbiting nearby stars. The number of known extrasolar planets now numbers almost 250.

What discoveries will the next 50 years bring astronomers and the interested public? We can only guess how our view of the Universe will be altered. Earlier science history suggests an accelerating rate of discoveries. The work of David Block and Kenneth Freeman already forms an important part of this accelerating knowledge. As they describe in this book, their discovery that cold cosmic dust pervades space makes it necessary for astronomers to redesign their classification scheme for galaxies. They suggest that symmetry should be at the heart of a new classification scheme in the near-infrared. One look at the stunning images produced by astrophotographer David Malin in Chapter 11 is sufficient to convince any skeptic.

Along the way, this book takes the reader on a whirlwind tour of astronomical photographic history beginning with the world's first heliographs (one of these newly unveiled by David Block) to the present day difficulties of classifying galaxies. But the described route is not linear. Instead, the reader is exposed to nights at a telescope, travels to talk and to learn, biographies of early and recent scientists who have contributed to the path David and Ken follow. Their story is part of the history as they describe their work as

astronomers. And they write about their discoveries in a manner that makes it fun to read. David and Ken's book is unconventional. It mixes history, geography, physics, geometry, biography, art, poetry, plants and religion, with ground based and space photographs of galaxies. Some readers may question the discussion of religious beliefs, but this is their story.

Even to an astronomer who studies galaxies, the comparison of the early and even recent images with the newly processed ones can only be described as breathtaking. The authors correctly call these "the new view of galaxies." But some of the knowledge is old, only uncovered by the authors. The book contains extended quotes from the scientists themselves. Many of Sir John Herschel's drawings from the Cape of Good Hope concern the Magellanic Clouds observed by eye, and their details are unforgettable.

I congratulate the authors. As a tribute to them, I add a quote from Marcel Proust:

> *The real voyage of discovery consists not in seeking new landscapes but in having new eyes.*

Vera C. Rubin is an observational astronomer who has studied the motions of gas and stars in galaxies and motions of galaxies in the Universe for seventy-five percent of her life. Her work was influential in discovering that most of the matter in the Universe is dark. She is a graduate of Vassar College, Cornell University, and Georgetown University; George Gamow (George Washington University) was her thesis professor. A staff member at the Department of Terrestrial Magnetism, Carnegie Institution of Washington since 1965, she is now a Senior Fellow. She is a member of the U.S. National Academy of Sciences and Pontifical Academy of Sciences. President Clinton awarded her the National Medal of Science in 1993. She received the Gold Medal of the Royal Astronomical Society (London) in 1996. The previous woman to receive this medal was Caroline Herschel in 1828. She has numerous honorary degrees, including Harvard, Princeton, Yale and Smith College. In 1994 she delivered the *Henry Norris Russell* Lectureship; previous recipients of this esteemed Lectureship have included Nobel laureates Enrico Fermi and Charles Townes. Vera is active in

encouraging and supporting women in science. Her husband (deceased January 2008) and their four children are Ph.D. scientists in physical chemistry, geophysics, astronomy, and mathematics.

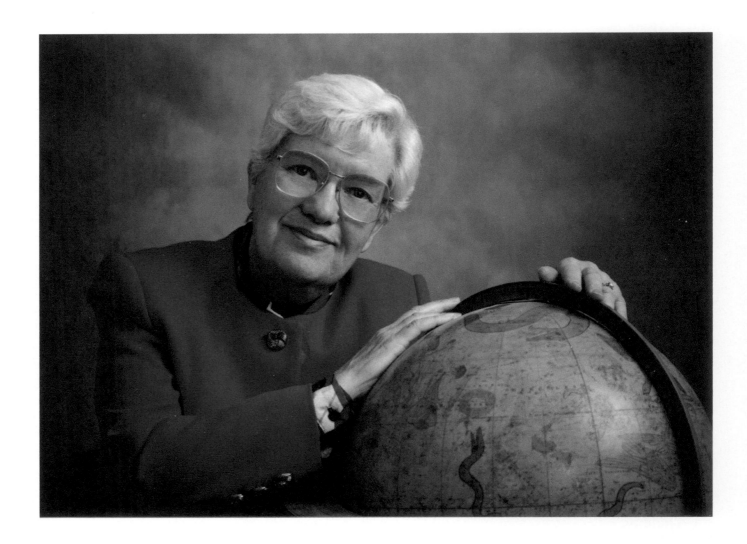

Photograph by Philip Birmingham

Acknowledgements

It is a joy for us to thank our respective wives Liz and Margaret for their patience and forbearance while we were writing this book at Mount Stromlo Observatory in Canberra. They made it possible for *Shrouds of the Night* to see the light of day. We dedicate our book to Liz and Margaret.

We are deeply grateful to Dr Vera Rubin and to Dr Bruce Elmegreen for writing the preface and epilogue to our book, respectively. Vera Rubin and Bruce Elmegreen are both pioneers of modern extragalactic astronomy and they continue to blaze their trails with passion and insight.

The home institute of Dr Vera Rubin is the Carnegie Institution of Washington – it was this Institute which published some of the most remarkable photographs of our Milky Way – an atlas by the American astronomer E.E. Barnard. A selection of Barnard's exquisite photographs appear in our book.

We owe an enormous gratitude to the Trustees of the Anglo American Chairman's Fund for financing the research of our Cosmic Dust Laboratory at the University of the Witwatersrand, Johannesburg. The Anglo American Chairman's Fund also financed three international conferences on cosmic dust, held on South African soil – many of the ideas contained in this book were birthed at these conferences. David also warmly thanks the Vice Chancellor of the University of the Witwatersrand, Johannesburg for the Vice Chancellor's Research Award in 2006; this award facilitated a long term stay at Mount Stromlo.

It is also a great pleasure for David to warmly thank his former student, friend and sponsor Mr Fani Titi. Without his continued encouragement and support, this book may never have seen the light of day.

We extend our heartfelt thanks to Madindwa Mashinini of the TISO Foundation for his personal encouragement, as well as to First National Bank, Kunene Brothers Holdings, SASOL and Saab, for their sponsorship.

We are very grateful to Mr Andy Stephens in the United Kingdom, for introducing us to the current Lord and Lady Rosse. What a detective trail it was for Lady Rosse to seek out the equipment used by earlier astronomers at Birr Castle to *draw objects in the dark without any illumination from the Moon*, but the search was successful – we are so appreciative in all their efforts, given the most demanding schedules of Lord and Lady Rosse.

A special vote of thanks is extended to Antoinette Beiser, Librarian at the Lowell Observatory in Flagstaff, Arizona. Antoinette gave us unlimited access to the Lowell Observatory archives, containing so much of the correspondence discussed in certain chapters of this book. It is also a great pleasure to thank Peter Hingley, Librarian at the Royal Astronomical Society in London, for his hospitality and use of their archival material. We are most indebted to John Grula, Librarian at the Carnegie Observatories in Pasadena for permission to reproduce photographs from Edward Barnard's *A Photographic Atlas of Selected Regions of the Milky Way*. Expressions of deep appreciation are also due to Shereen Davis, Librarian at the South African Astronomical Observatory in Cape Town and to Peter Duncan, Assistant Librarian of Early collections at the William Cullen Library, University of the Witwatersrand. We record our special thanks to Africana Librarian Margaret Northey as well as to Diana Wall and Kathy Brookes at Museum Africa.

David Malin was hugely generous in sending us his images – thank you David. It would not have been possible to include several priceless photographs from the library at the Boyden Observatory in Bloemfontein, were it not for our special friends there, Dawie van Jaarsveldt (Education Officer at the Boyden Observatory) and Dr. Matie Hoffman (Manager of the Boyden Observatory). Dawie and Matie, your generosity and hospitality during our visits to Boyden are forever etched in our memories. A deep note of appreciation, too, is expressed to Gert Rautenbach.

It is a pleasure to thank Professor Owen Gingerich at Harvard University. His friendship to David extends over twenty years, when Owen wrote the Preface to David's first book *Starwatch*. What an enriching experience it has been to personally hold "De revolutionibus

orbium caelestium" – and many other treasures – in our hands. Owen's prompt replies to our emails were also extremely helpful.

We express our deep appreciation to our three research assistants Robert Groess, Michael Hewson and Michael Dabrowski. Weeks upon weeks in proof reading the entire manuscript, in scanning the woodcut initials and in the initial layout were invested by Dr Robert Groess; it is appropriate to record our gratitude to this dedicated and gifted young astronomer.

We also thank Professor Alvin Plantinga and Dr M. Crowe at the University of Notre Dame for their input.

We warmly thank each person, Institute or Observatory whose name is credited in our figure captions.

We are deeply grateful to all our present and past collaborators on matters pertaining to cosmic dust and galaxy structure, including J. Mayo Greenberg and Joss Bland-Hawthorn. Many images secured by the Spitzer Space Telescope were placed at our disposal by Dr Giovanni Fazio at Harvard University. Words are inadequate to describe the legacy of this extraordinary pioneer in the design of the Infrared Array Camera. The hospitality of Giovanni and his wife Suzanne will always be treasured with the fondest of memories.

It has been a singular honor working with Dr Harry (J.J.) Blom, Senior Astronomy Editor at Springer, on the production of three of our Conference Volumes and now, with the present work, *Shrouds of the Night*. We also extend out deep gratitude and appreciation to our Senior Production Editor at Springer, Ms. Lesley Poliner, for her meticulous attention to detail, and to Joseph Piliero, for his skillful and creative design. We furthermore thank Associate Editor, Christopher Coughlin, for his valuable input. We are most grateful to Amina Ravi for her highly impressive degree of professionalism.

Dr William Sheehan's masterful biography entitled *The Immortal Fire Within: The Life and Work of Edward Emerson Barnard* was a great inspiration to the authors. We also acknowledge Dr Sheehan's innovative detective work on the provenance of the "Hubble" tuning fork diagram, which can be traced to the astronomer and great lover of music, Sir James

Jeans, and thank Dr Sheehan for his special written words of encouragement to David on his 50th birthday celebration in South Africa.

We wish to record the great inspiration of pioneering papers published by Dr Allan Sandage in many areas of astrophysics. Dr Sandage's contributions to the history of our Galaxy, the Milky Way, blazed the trail for future research. Sandage's studies of our Galaxy and the ages of globular clusters are no less important than his contributions to galaxy morphology and cosmology. It was Sandage, in collaboration with Martin Schwarzschild, who painted the time progression of a star such as our Sun into its bloated and cooler "red-giant" epoch. For this seminal paper, published in 1952, Sandage and Schwarzschild were awarded the Eddington Medal of the Royal Astronomical Society. In 1960, Sandage (with Matthews, Bolton, Greenstein and Munch) discovered a star-like object (known as 3C 48) in the position of a source which emitted radio waves. This discovery, together with the fundamental discovery by Maarten Schmidt – that such semi-stellar sources were not inside our Galaxy but located at vast distances from us – ushered in the era of quasars. In 1962, Eggen, Lynden-Bell and Sandage proposed that our Galaxy had formed rapidly, about 10 billion years ago, from the collapse of primordial gas clouds. This paper was enormously influential and opened up the modern era of galaxy formation studies.

In the context of this book, we wish to acknowledge that it was Sandage who made galaxy morphology accessible to the general astronomical community, by authoring the masterful photographic *Hubble Atlas of Galaxies*, published in 1961. Sandage also contributed to our understanding of the dusty Shrouds of the Night in our Milky Way Galaxy, through his discovery of the reflecting dust clouds lying high above the plane of the Galaxy.

Over the years, we have spent many days carefully studying Sandage's fundamental papers. Dr Sandage continues to be a great inspiration. The warm hospitality extended by Allan Sandage to both of us in Pasadena can never be forgotten. He is a friend and colleague to us and we do thank him most sincerely.

David L. Block and Kenneth C. Freeman
Mt. Stromlo, Canberra
December 2007

ontents

ur Choice of Woodcut Initials

In the design of this book, the publisher and authors have selected the woodcut initials of Jean Petit. Jean Petit was at the center of a very talented group of printers, booksellers and scholars based in Paris, and using his position and business skills, ensured the printing of some of the most beautiful books printed in France between 1490 and 1530. Although not an active printer himself, he commissioned work from other distinguished Parisian printers – often supplying the finance to make such commissions possible. For example, Jean Petit recognized the typographical talents of J. Bade, and created a printing shop on his behalf. Petit's woodcuts are extraordinary. The foliated and floriated initials come from a volume printed by Jean Petit in 1527. The woodcut initials are over 470 years old.

The Grand Stage Before Us: "The Sidereal Messenger"

 memorable year: July 1609.
The setting: Venice.
The astronomer: Galileo Galilei.
The challenge: Viewing distant objects as if nearby; the design of the very first telescopes.

Galileo Galilei was born in 1564 at Pisa (Figure 1). Galileo began his studies in medicine at the University of Pisa, but soon left those studies, preferring mathematics with Ostilio Ricci. In 1592 he secured the chair of mathematics at Padua.

Telescopes, in the form of low-magnification spyglasses, were being made since the autumn of 1608. In 1609, Galileo was in Venice, when he heard of an invention that allowed distant objects to be seen as distinctly as if they were nearby.

It was in October 1608 that a spectacle-maker by name of Hans Lipperhey, born in Germany, but who spent most of his life in Zeeland (the Netherlands) had already applied for a patent (which was actually refused). When Galileo heard of this new instrument he set about designing and making improved versions, with higher magnifications.

The *Sidereus Nuncius* (or, "The Sidereal Messenger") represents Galileo Galilei's first publication regarding the Grand Stage Before Us, through the eyes of his recently designed telescopes ... Some of the richness and grandeur which the night sky revealed through Galileo's telescopes, including telescopic views of the Moon, multitudes of stars undetected by the naked eye as well as the discovery of four bright moons ("wandering stars") orbiting the planet Jupiter, are poignantly described in his *Sidereus Nuncius*.

From the pen of Galileo Galilei:

In this short treatise I propose great things for inspection and contemplation by every explorer of Nature. Great, I say, because of the excellence of the things themselves, because of their newness, unheard of through the ages, and also because of the instrument with the benefit of which they make themselves manifest to our sight.

Certainly it is a great thing to add to the countless multitude of fixed stars visible hitherto by natural means and expose to our eyes innumerable others never seen before, which exceed tenfold the number of old and known ones.

It is most beautiful and pleasing to the eye to look upon the lunar body, distant from us about sixty terrestrial diameters, from so near as if it were distant by only two of these measures, so that the diameter of the same Moon appears as if it were thirty times, the surface nine-hundred times, and the solid body about twenty seven thousand times larger than when observed only with the naked eye. Anyone will then understand with the certainty of the senses that the Moon is by no means endowed with a smooth and polished surface, but is rough and uneven and, just as the face of the Earth itself, crowded everywhere with vast prominences, deep chasms, and convolutions.

Moreover, it seems of no small importance to have put an end to the debate about the Galaxy or Milky Way and to have made manifest its essence to the senses as well as the intellect; and it will be pleasing and most glorious to demonstrate clearly that the substance of those stars called nebulous up to now by all astronomers is very different from what has hitherto been thought.

But what greatly exceeds all admiration, and what especially impelled us to give notice to all astronomers and philosophers, is this, that we have discovered four wandering stars, known or observed by no one before us. These, like Venus and Mercury around the Sun, have their periods around a certain star notable among the number of known ones, and now precede, now follow, him, never

Shrouds of the Night
2

digressing from him beyond certain limits. All these things were discovered and observed a few days ago by means of a glass contrived by me after I had been inspired by divine grace.

Perhaps more excellent things will be discovered in time, either by me or by others, with the help of a similar instrument, the form and construction of which, and the occasion of whose invention, I shall first mention briefly, and then I shall review the history of the observations made by me.

About 10 months ago a rumor came to our ears that a spyglass had been made by a certain Dutchman by means of which visible objects, although far removed from the eye of the observer, were distinctly perceived as though nearby. About this truly wonderful effect some accounts were spread abroad, to which some gave credence while others denied them. The rumor was confirmed to me a few days later by a letter from Paris from the noble Frenchman Jacques Badovere. This finally caused me to apply myself totally to investigating the principles and figuring out the means by which I might arrive at the invention of a similar instrument, which I achieved shortly afterward on the basis of the science of refraction. And first I prepared a lead tube in whose ends I fitted two glasses, both plane on one side while the other side of one was spherically convex and of the other concave. Then, applying my eye to the concave glass, I saw objects satisfactorily large and close. Indeed, they appeared three times closer and nine times larger than when observed with natural vision only. Afterward I made another more perfect one for myself that showed objects more than sixty times larger. Finally, sparing no labor or expense, I progressed so far that I constructed for myself an instrument so excellent that things seen through it appear about a thousand times larger and more than thirty times closer than when observed with the natural faculty only. It would be entirely superfluous to enumerate how many and how great the advantages of this instrument are on land and at sea. But having dismissed earthly things, I applied myself to explorations of the heavens. And first I looked at the Moon from so close that it was scarcely two terrestrial diameters distant. Next, with incredible delight I frequently observed the stars, fixed as well as wandering, and as I saw their huge number I began to think of, and at

And so, it was in the early 1600s that the science of observational astronomy by means of a telescope was born. Impinged on the brain of people on Earth could be photons of starlight unseen by the naked eye – photons of light which may have traversed hundreds of years or more, before finally journeying down the telescope tube to the Eye of the Observer. Starry messengers indeed. The years 1608 and 1609 were small steps for Man, but giant leaps for Mankind, to paraphrase the words of astronaut Neil Armstrong. That era marked the dawning of a new age wherein not only could the Moon be observed by Galileo at closer quarters, but the fiery stars of the night, as well.

Figure 1 [405] Note: The captions to the figures in this book are located on the page indicated in the brackets next to the figure number.

Cosmic Masks: Shrouds of the Night

ow beautiful is the rising of the full moon upon the Continent of Africa. Sounds in the bush by day are so vastly different to those at night. Ancient hunters have depended on the eerie light cast by the full moon, in guiding them to their prey.

Enter cosmic masks, or cosmic shrouds. The full moon itself is a mask, for it masks (or hides) myriads of fainter stars in our heavens above. In its brilliant light by which lions stalk their prey, only the very brightest of stars are seen.

In Roget's Thesaurus, we encounter the following definition of a mask: [noun] screen, cloak, shroud [verb] to camouflage, to make opaque, to disguise.

How vastly different do the skies appear in the absence of the full moon. When our mask of blazing reflected sunlight is no longer present, the skies show a breathtaking splendour of countless myriads of suns.

As with masks covering a human face (Figures 2–4), our perception of the night sky is inextricably intertwined by the presence of masks, or shrouds. Remove the mask – penetrate the veil or shroud – and behold wondrous, hitherto unimaginable, insights!

Our thoughts go back to hunters and gatherers in epochs past. What a breathtaking sight it must have been, in the absence of light pollution, for men and women of old to actually *see* the Milky Way Galaxy in all its grandeur and splendour.

In a book entitled *Bushman Folklore* by the late W. Bleek and L. Lloyd, there is a moving account of "The Girl of the Early Race, who made the Stars." We share a section of that story here:

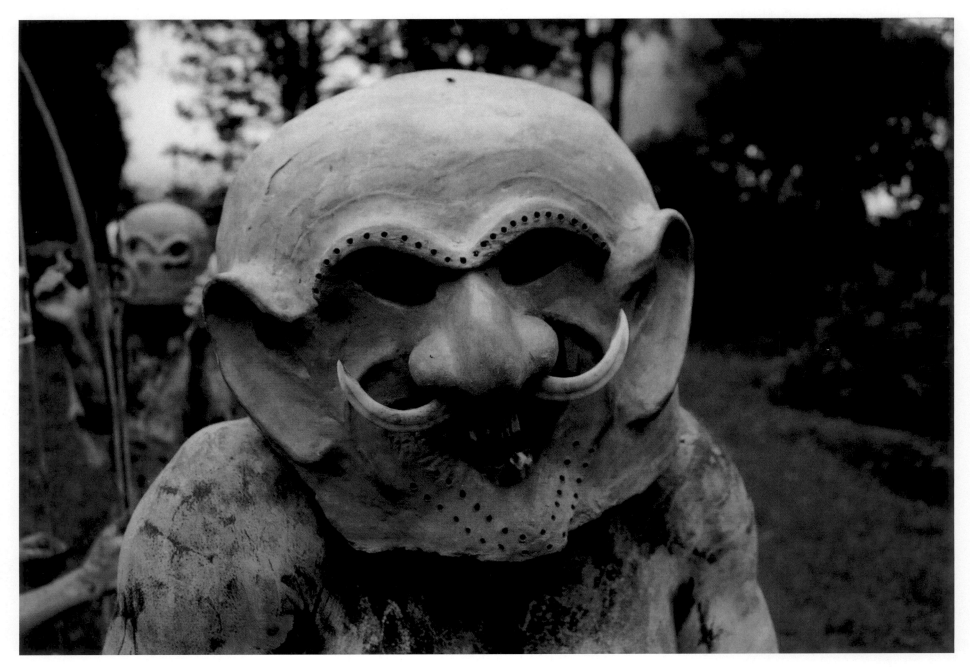

Figure 2 [405]

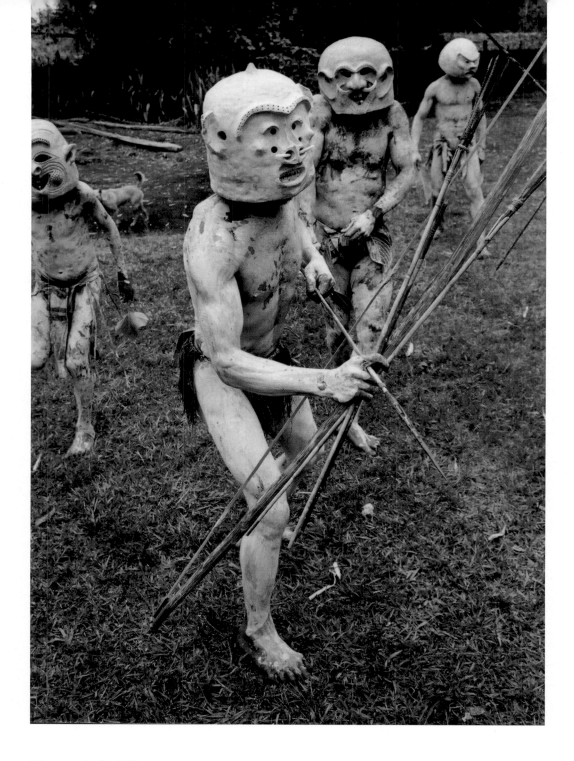

Figure 3 [405]

Figure 4 [405]

"My mother was the one who told me that the girl arose; she put her hands into the wood ashes; she threw up the wood ashes into the sky. She said to the wood ashes: 'The wood ashes which are here, they must altogether become the Milky Way ...' Then, the people go by night; while they feel that the ground is made light. While they feel that the Stars shine a little. Darkness is upon the ground. The Milky Way gently glows; while it feels that it is wood ashes. Therefore, it gently glows. While it feels that the girl was the one who said that the Milky Way should give a little light for the people, that they may return home by night, in the middle of the night. For, the Earth would not have been a little light, had not the Milky Way been there. It and the Stars."

"The girl thought that she would throw up (into the air) roots of the !hiun, in order that the !hiun roots should become Stars ... She first gently threw up wood ashes into the sky, that she might presently throw up !hiun roots ..." Bleek and Lyold elaborate: *"She threw up a scented root (eaten by some Bushmen) called !hiun, which became stars; the red (or old) !hiun making red stars, the white (or young) !hiun making white stars. This root is ... eaten by baboons and also by the porcupine."*

One's mind reflects back to the Middle Ages. What a foreboding sight the dancing Northern Lights, the Aurora Borealis (Figures 5 and 6), must have been, in an era when no scientific explanation was known. In Middle-Age Europe, the Northern Lights were thought to be reflections of heavenly warriors. As a sort of posthumous reward, the soldiers who gave their lives for their king and country were allowed to battle on the skies forever. The aurorae were believed by some to be the breath of these brave soldiers as they resumed their fight in the skies. The Old Norse word for the aurora borealis is *norðrljós*, "northern lights." The first occurrence of the term *norðrljós* is in the book *Konungs Skuggsjá* (*The King's Mirror*, known in Latin as *Speculum Regale*), written in 1250 AD, after the end of the Viking Age (the Viking Age dates ca. 800–1100 AD). In *The King's Mirror*, the narration (as translated by L.M. Larson in 1917) between a Father and Son concerning the Northern Lights as seen by settlers in Greenland reads as follows:

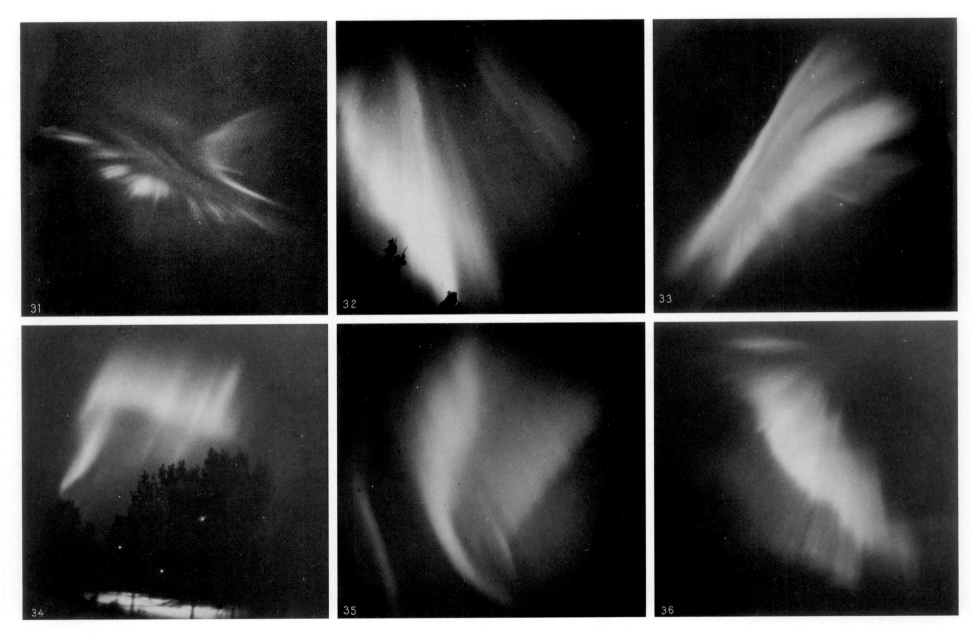

Figure 5 [405]

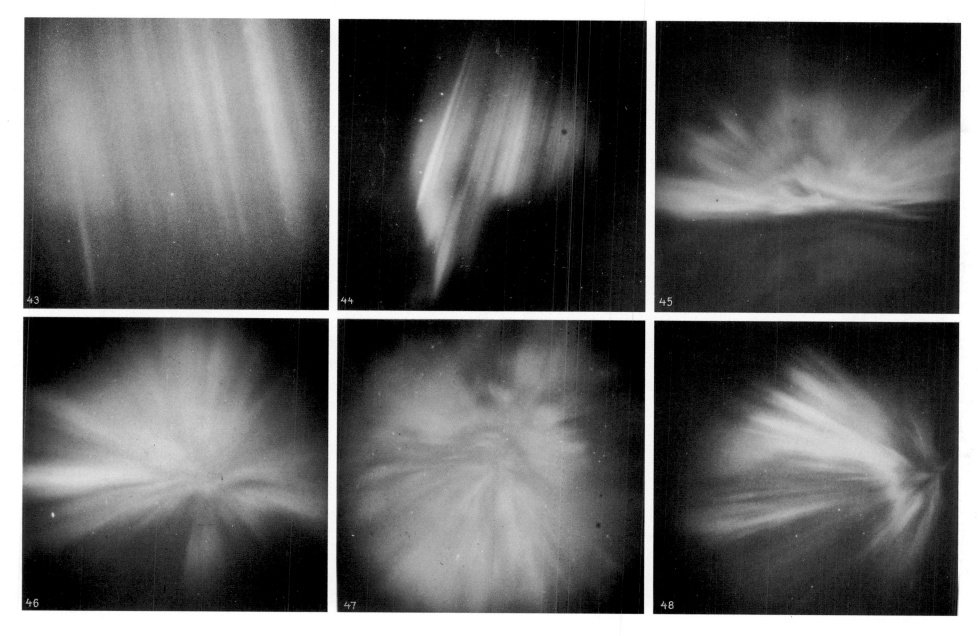

Figure 6 [405]

Cosmic Masks
11

Father. *But as to that matter which you have often inquired about, what those lights can be which the Greenlanders call the northern lights, I have no clear knowledge. I have often met men who have spent a long time in Greenland, but they do not seem to know definitely what those lights are. However, it is true of that subject as of many others of which we have no sure knowledge, that thoughtful men will form opinions and conjectures about it and will make such guesses as seem reasonable and likely to be true. But these northern lights have this peculiar nature, that the darker the night is, the brighter they seem; and they always appear at night but never by day, most frequently in the densest darkness and rarely by moonlight. In appearance they resemble a vast flame of fire viewed from a great distance. It also looks as if sharp points were shot from this flame up into the sky; these are of uneven height and in constant motion, now one, now another darting highest; and the light appears to blaze like a living flame. While these rays are at their highest and brightest, they give forth so much light that people out of doors can easily find their way about and can even go hunting, if need be. Where people sit in houses that have windows, it is so light inside that all within the room can see each other's faces. The light is very changeable. Sometimes it appears to grow dim, as if a black smoke or a dark fog were blown up among the rays; and then it looks very much as if the light were overcome by this smoke and about to be quenched. But as soon as the smoke begins to grow thinner, the light begins to brighten again; and it happens at times that people think they see large sparks shooting out of it as from glowing iron which has just been taken from the forge. But as night declines and day approaches, the light begins to fade; and when daylight appears, it seems to vanish entirely.*

The men who have thought about and discussed these lights have guessed three sources, one of which, it seems, ought to be the true one. Some hold that fire circles about the ocean and all the bodies of water that stream about on the outer sides of the globe; and since Greenland lies on the outermost edge of the earth to the north, they think it possible that these lights shine forth from the fires that encircle the outer ocean.

Others have suggested that during the hours of night, when the Sun's course is beneath the earth, an occasional gleam of its light may shoot up into the sky; for

they insist that Greenland lies so far out on the earth's edge that the curved surface which shuts out the sunlight must be less prominent there. But there are still others who believe (and it seems to me not unlikely) that the frost and the glaciers have become so powerful there that they are able to radiate forth these flames. I know nothing further that has been conjectured on this subject, only these three theories that I have presented; as to their correctness I do not decide, though the last mentioned looks quite plausible to me. I know of no other facts about Greenland that seem worth discussing or mentioning, only those that we have talked about and what we have noted as the opinions of well-informed men.

Son. *Everything that you have told here seems wonderful to me, though also very instructive, and this fact most of all, that men, as you have pointed out, are able to leave the earth, as it were, and view for themselves the boundaries which God has drawn amid such great perils. Your last remark, however, suggests that there is yet a little matter to inquire about along this same line. In speaking of those three conjectures you said that you think it most likely that these lights have their origin in frost and ice; but just before in describing their appearance, you added that now and then fog and dark mist resembling smoke would mount up among these lights. But even if the cold should be so prevalent there as to give rise to these lights with their fire-like rays, I cannot help wondering whence that smoke can come which sometimes appears to shade and becloud the light till it seems almost quenched; for to me it seems more likely that the smoke is due to heat than to frost. There is one more thing that looks strange to me which you mentioned earlier in your speech, namely that you consider Greenland as having a good climate, even though it is full of ice and glaciers. It is hard for me to understand how such a land can have a good climate.*

Father. *When you say, in asking about the smoke that sometimes appears to accompany the northern lights, that you think it more likely that the smoke comes from heat than from cold, I agree with you. But you must also know that wherever the earth is thawed under the ice, it always retains some heat down in the depths. In the same way the ocean under the ice retains some warmth in its depths. But if the earth were wholly without warmth or heat, it would be*

one mass of ice from the surface down to its lowest foundations. Likewise, if the ocean were without any heat, it would be solid ice from the surface to the bottom. Now large rifts may appear in the ice that covers the land as well as openings in the ice upon the sea. But wherever the earth thaws out and lies bare, whether in places where there is no ice or under the yawning rifts in the glacier, and wherever the sea lies bare in the openings that have formed in the ice, there steam is emitted from the lower depths; and it may be that this vapor collects and appears like smoke or dark fog; and that, whenever it looks as if the lights are about to be quenched by smoke or fog, it is this vapor that collects before them.

We now have fully scientific explanations for the aurorae; they are generated as streams of high energy particles from our closest star, the Sun, enter the ionosphere of the Earth. The magnetic field of the Earth steers these particles toward the poles; hence the dancing cascades of lights in regions close to the poles, such as Greenland and Iceland. The brilliance of an aurora may be greatly enhanced when the Sun undergoes periods of increased sunspot activity. In earlier centuries, myths abounded as these foreboding aurorae displayed ever changing curtains of light and of glowing color.

So much in our heavens captures the imagination. From the aurorae dancing above the tundra, to our Galaxy – and to multitudes of galaxies beyond. Early drawings of the Night Sky show the arching Milky Way, with numerous cosmic veils or shrouds. While these were once believed to be vacant holes in the very fabric of space, we now understand that these veils contain matter, and are indeed enigmatic Shrouds of the Night.

Renowned Aboriginal artist Collette Archer (of the tribe Djunban in Far Northern Queensland, Australia) shares her thoughts:

Our people (Aboriginals) always use the stars to find their way on walkabouts during the nights. At the same time, this is also when all the bushtucker come out, Witchetty Grubs (high in protein), and honey ants (very sugary). Tracking of animals also best looked for on a night like this. Our people celebrate the full moon and dance with happiness. They always admire the stars as do myself.

From within the hearts of royalty (*The King's Mirror*) and shepherd alike, the canopy of the Milky Way has aroused the deepest of emotions.

One of South Africa's most celebrated veteran poets, Winifred Dashwood, vividly describes righteous souls triumphantly marching across the starry vaults of the *Via Lactea*.

Dashwood aptly utilizes the imagery of the Archer drawing his Bow amidst the rich star fields of Sagittarius, where stars appear as innumerable as the sand and where Shrouds of the Night abound.

Her poem is entitled "My Universe, My Home!" and reads as follows:

Let no memory remain
Of the loved and lately lost.
Bury hope and joy and pain
In the grave where roses, tossed
From a tired and nerveless hand,
Bruise their petals on the clods.
Sullen clay or fickle sand
Hides the victim from the gods.

This is execution's stay.
Here must retribution end.
Prisoners freed on judgement day
Need no advocate nor friend.
Past the swinging stars they go,
Out of sight and out of mind
Past the Archer's blazing bow,
Leaving Betelgeuse behind.

Traipsing up the Milky Way
Swaying on oblivion's brink,
Dazzled by the rainbow day
Where new planets dance and sink.

Gliding down through fields of force,
Latticed by sidereal light,
Drink at Resurrection's source!
Burst the carapace of night!
— (WINIFRED DASHWOOD PRESENTED THIS POEM TO COAUTHOR DAVID, ABOUT ONE
YEAR BEFORE HER DEATH, AT AGE 84. THIS IS THE FIRST TIME THAT DASHWOOD'S
POEM "MY UNIVERSE, MY HOME!" APPEARS IN A BOOK ON ASTRONOMY.)

Collette Archer's exquisite work on canvas, showing the setting Milky Way, with fiery meteors entering the Earth's atmosphere above, and the tracks of small creatures in the sand below, is seen in Figure 7. Let us now focus our attention on those smoky, black, dusty labyrinths permeating the space between those glowing heavenly jewels, the stars.

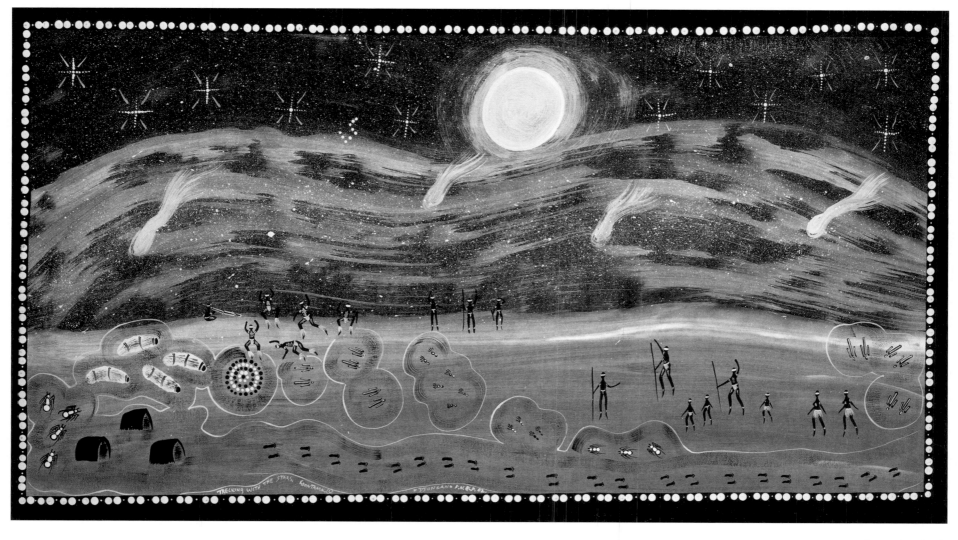

Figure 7 [405]

Detectives in Chile

"The learned say that your lights will one day be no more," said the firefly to the stars.
The stars made no answer.

(R. TAGORE)

Sweep on through glittering star fields and long for endless night! More nebulae, more stars. Here a bright and beautiful star overpowering in its brilliancy, and there close to it a tiny point of light seen with the greatest difficulty, a large star and its companion. How plentiful the stars now appear. Each sweep increases their number. The field is sprinkled with them, and now we suddenly sweep into myriads and swarms of glittering, sparkling points of brilliancy – we have entered the Milky Way. We are in the midst of millions and millions of suns – we are in the jewel house of the Maker, and our soul mounts up, up to that wonderful Creator, and we adore the hand that scattered the jewels of heaven so lavishly in this one vast region. No pen can describe the wonderful scene that the swinging tube reveals as it sweeps among that vast array of suns.

EDWARD EMERSON BARNARD IN THE NASHVILLE *ARTISAN* (1883).
THE QUOTATION IS EXTRACTED FROM *THE IMMORTAL FIRE WITHIN* BY W. SHEEHAN
(CAMBRIDGE UNIVERSITY PRESS).

ir Isaac Newton and Sir William Herschel believed in the transparency of interstellar space. In the period spanning 1840 and 1930, astronomers who believed otherwise (such as Angelo Secchi, Friedrich Struve, Hugo Seeliger, Max Wolf and Heber Curtis) were in the minority, despite the grand photographic efforts of Edward Barnard. Virginia Trimble recalls: "Only with Trumpler's 1930 publication of the relationship between angular diameter

and apparent brightness of star clusters did the community accept that all of interstellar space was capable of swallowing starlight … not until 1952, at the Rome International Astronomical Union, did most astronomers catch on."

Light obeys an inverse square law: observe the headlight of a car from a fixed distance and then let the car travel four times that distance: the intensity of the headlight's beam will have dropped by a factor of sixteen (the square of four is sixteen). If one assumes that open clusters of stars may be categorized into certain subclasses with fixed diameters (in light years, for example), Trumpler showed that the distances to the further clusters were systematically too large. The reason is this: foreground dust between a cluster of stars and the observer fools the astronomer in thinking that the cluster is dimmer (and therefore, further) than it actually is. Distances derived from the inverse square law for clusters obscured by foreground clouds of dust are too large. A ship sailing in thick fog may actually be relatively nearby, but it may *appear* to be much farther away on account of the dimness of the lights on deck as seen through the fog!

Once astronomers had accepted a dusty Milky Way, the question beckoned as to the amounts of dust in spiral galaxies external to the Milky Way. Prior to 1994, the prevailing opinion amongst astronomers was that our Milky Way was particularly rich in cosmic dust – in technical terms, its ratio of "dust-to-gas" mass was believed to be ten times higher than that for other spiral galaxies. We shall see the *raison d'etre* behind this argument, presently.

How prevalent is cosmic dust in our Universe? It was time for detectives to seek for clues. We shall never forget those nights spent on a mountain in Chile's Atacama Desert in the early 1990s. It is one of the supremely dry places on Earth, and there are said to be patches where the rain falls but once in a century. If ever a place deserves to be called "dry as dust," it is here.

The Atacama desert is an ideal place from which to study dust – of the cosmic, rather than terrestrial, variety (Figures 8–16). At La Silla (*the Saddle*), the European Southern Observatory (whose headquarters are in Garching, Germany) has stationed some of its most

sophisticated instruments, due to the clearness and dryness of the atmosphere. Our team had set our hearts and minds on testing new methods we had devised for unveiling cold (minus 210 degrees Centigrade) and very cold (minus 250 degrees Centigrade) cosmic dust grains in galaxies beyond the Milky Way!

Before we started our work, we stepped out of the observatory control-room into the crisp, clear evening air, climbed onto the catwalk circling the great dome, and gazed upon the Milky Way, stretching majestically across the sky. We were indeed "in the midst of millions and millions of suns" to quote Edward Barnard.

Viewing the blazing Milky Way above our heads, spawning countless myriads of stars, we returned to the telescope control room with a renewed determination and enthusiasm to penetrate Cosmic Shrouds of the Night in spiral galaxies beyond our Galaxy (Figure 17), and to determine their masses.

On the face of it, ours might have seemed like a totally impossible mission. After all, how could one hope to "see" anything within these distant cosmic mists? How could one actually "view" or "penetrate" these cold cosmic dust shrouds, where some grains may have temperatures only a few degrees above absolute zero – and, in galaxies millions of light years away? And why should we even bother?

At La Silla, the dusty Milky Way, the starry river of the night, appeared to curve, like a majestic archway, from one horizon to the other. Against it were multitudes of cosmic shrouds – dark, mysterious patches –which astronomers have once believed to be devoid of stars. In a paper published in 1946 authored by Jan Oort and Henk van de Hulst, the title was particularly lucid: "Gas and smoke in interstellar space." Lindblad, Oort, van de Hulst, Schalen and other astronomers believed that the apparent vacuities in our Milky Way were clouds of cosmic "smoke" – a smoke whose properties are very effective at blotting out stars lurking behind masks of cosmic dust.

From La Silla, how would our team seek to penetrate these Shrouds of the Night in other galaxies; Shrouds which may span diameters of one hundred thousand light years – sometimes more – and yet appear so small on account of distance?

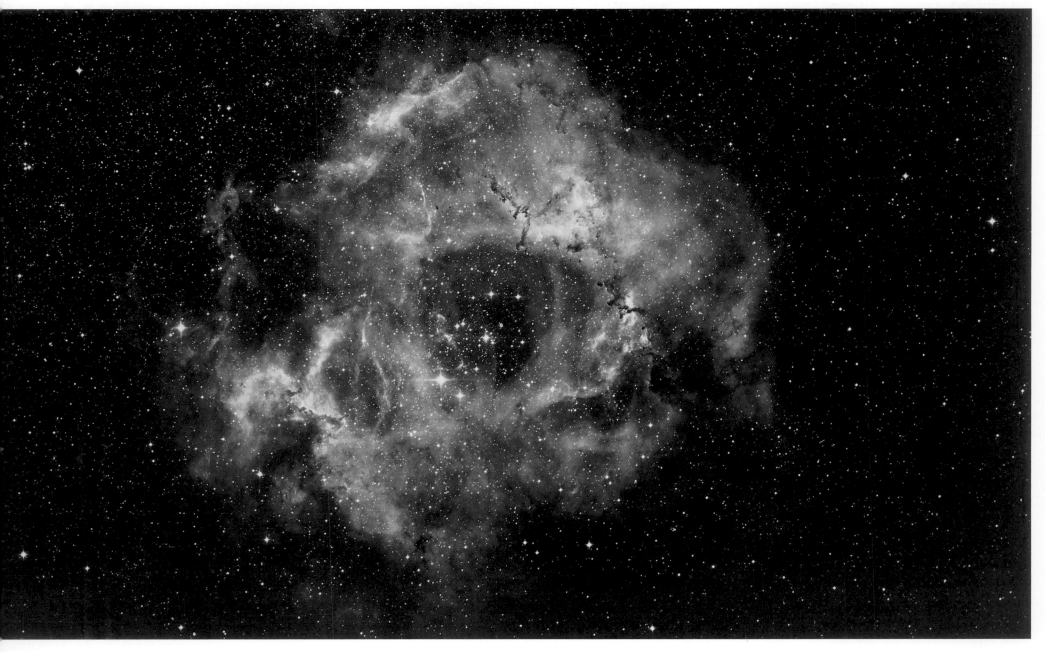

Figure 8 [405]

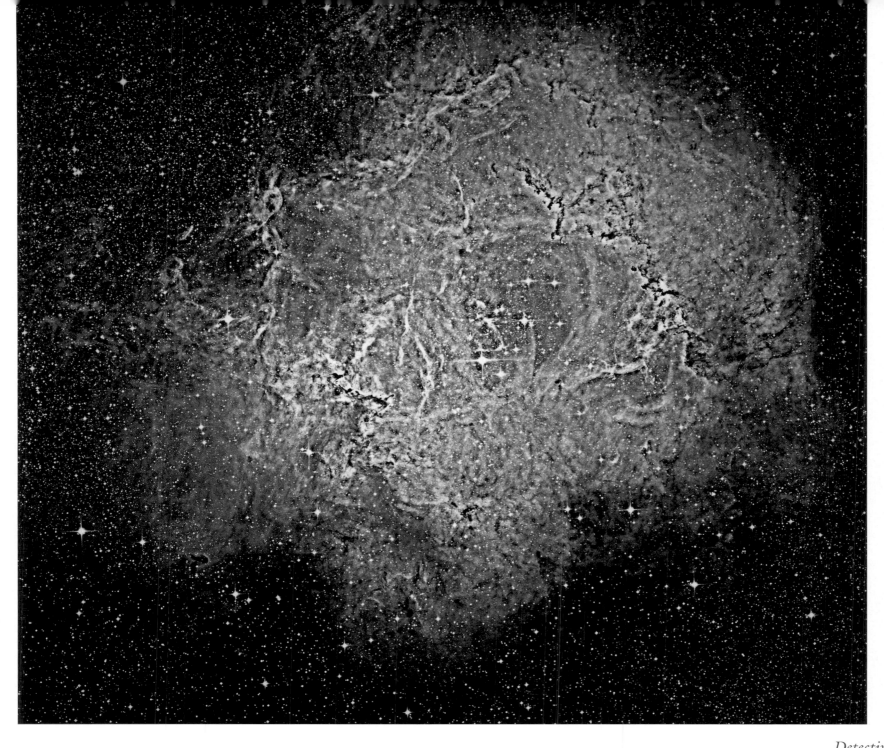

Figure 9 [405]

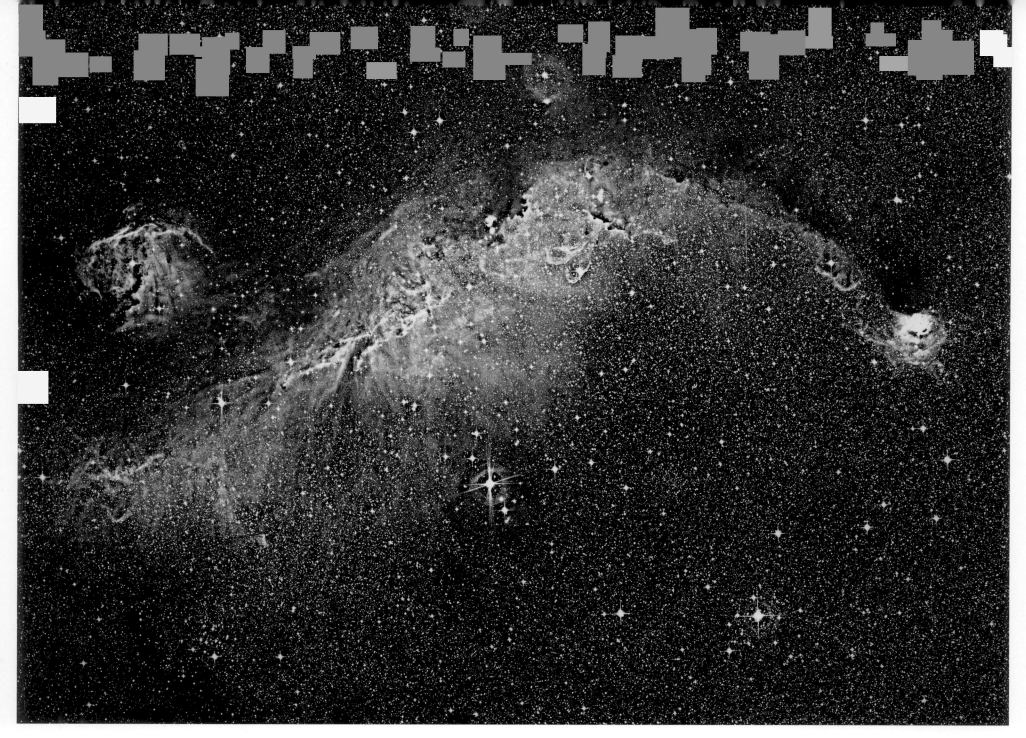

Figure 10 [406]

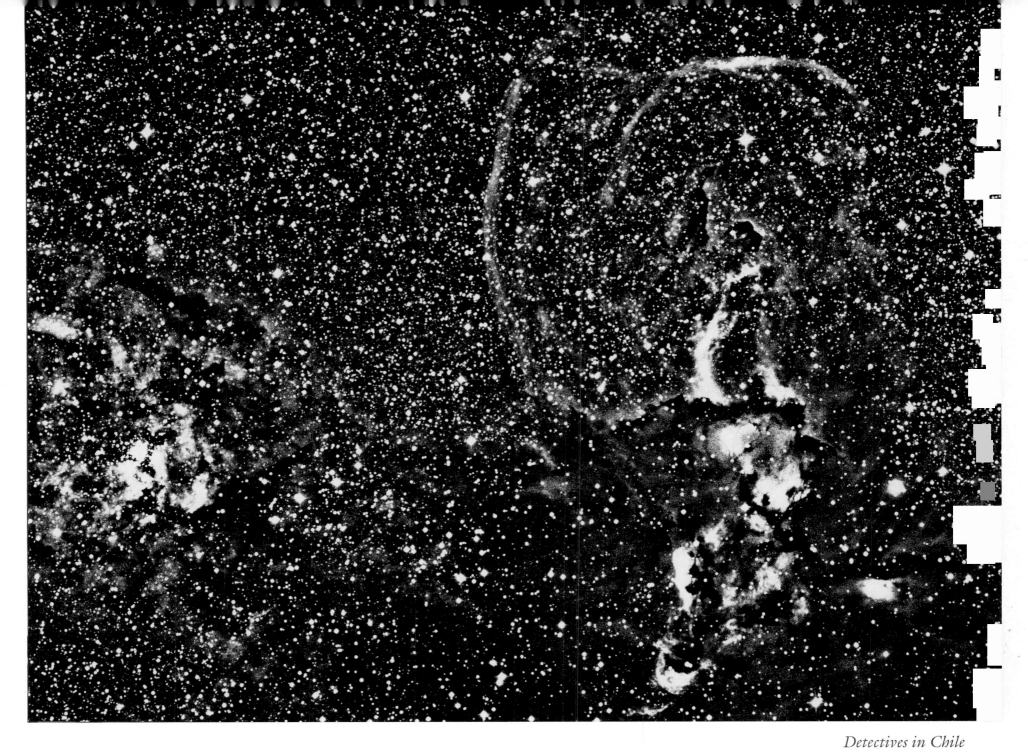

Figure 11 [406]

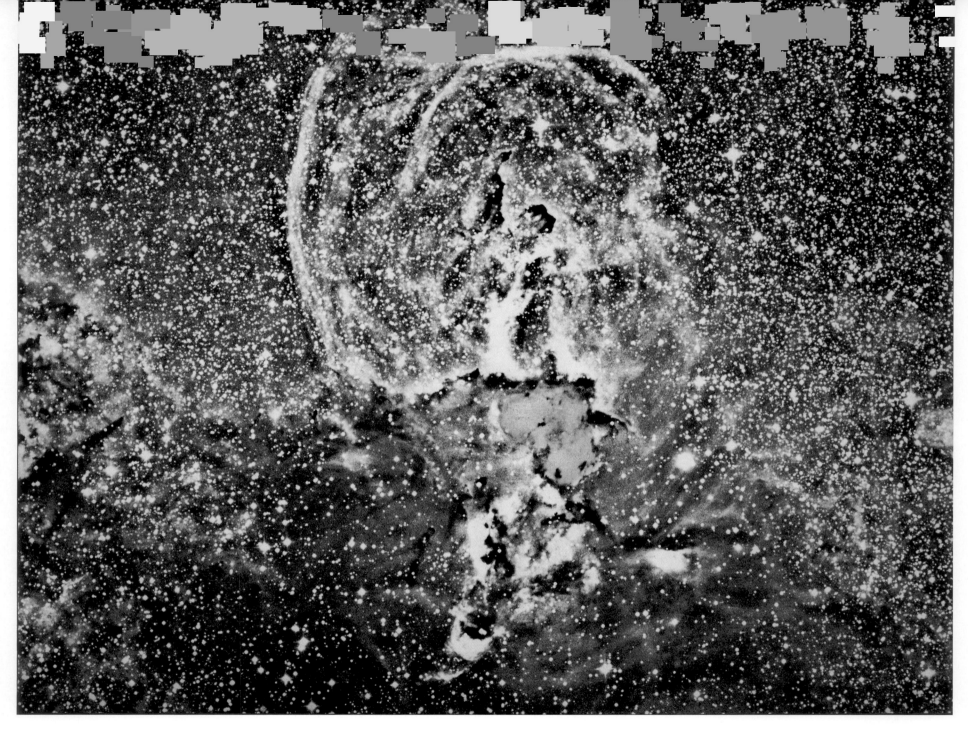

Figure 12 [406]

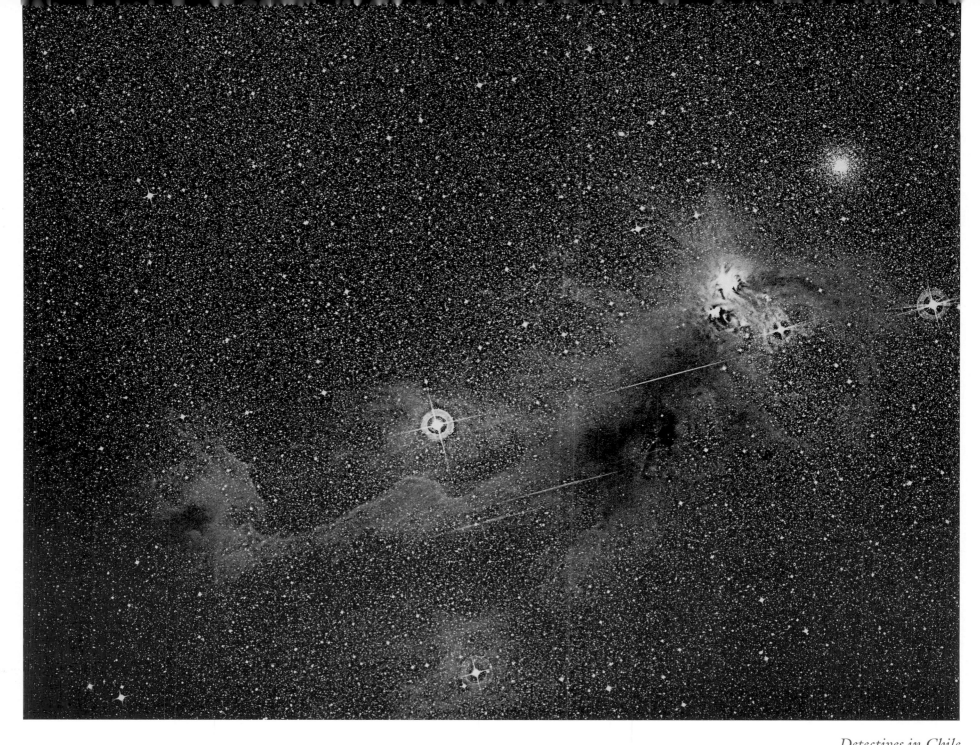

Figure 13 [406]

Detectives in Chile

27

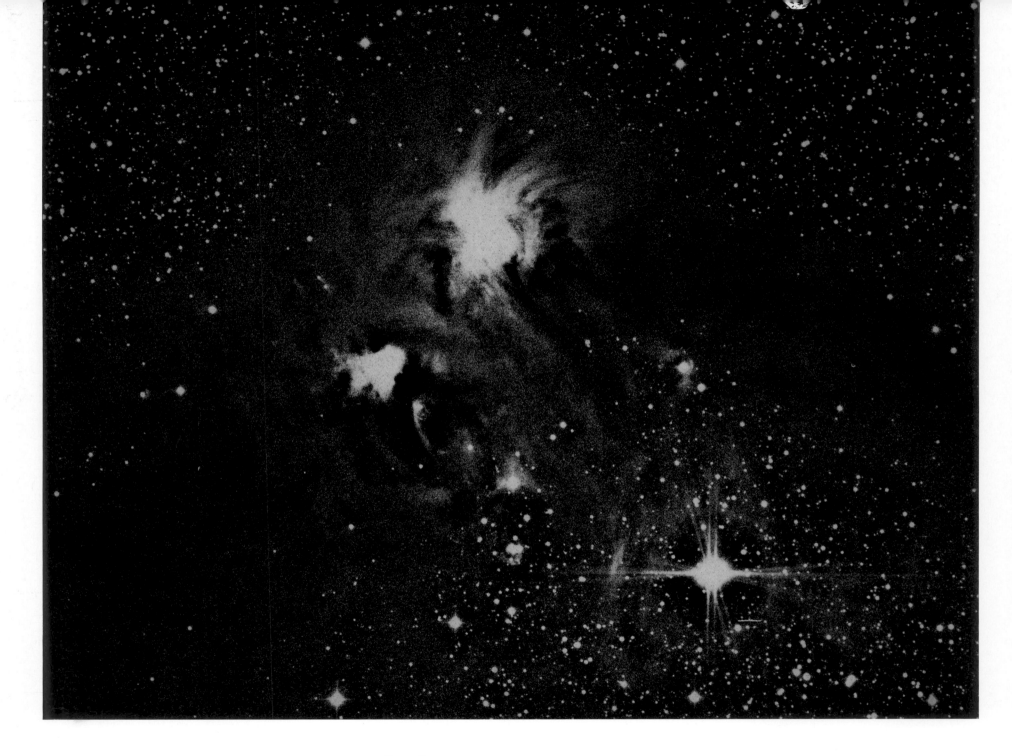

Figure 14 [406]

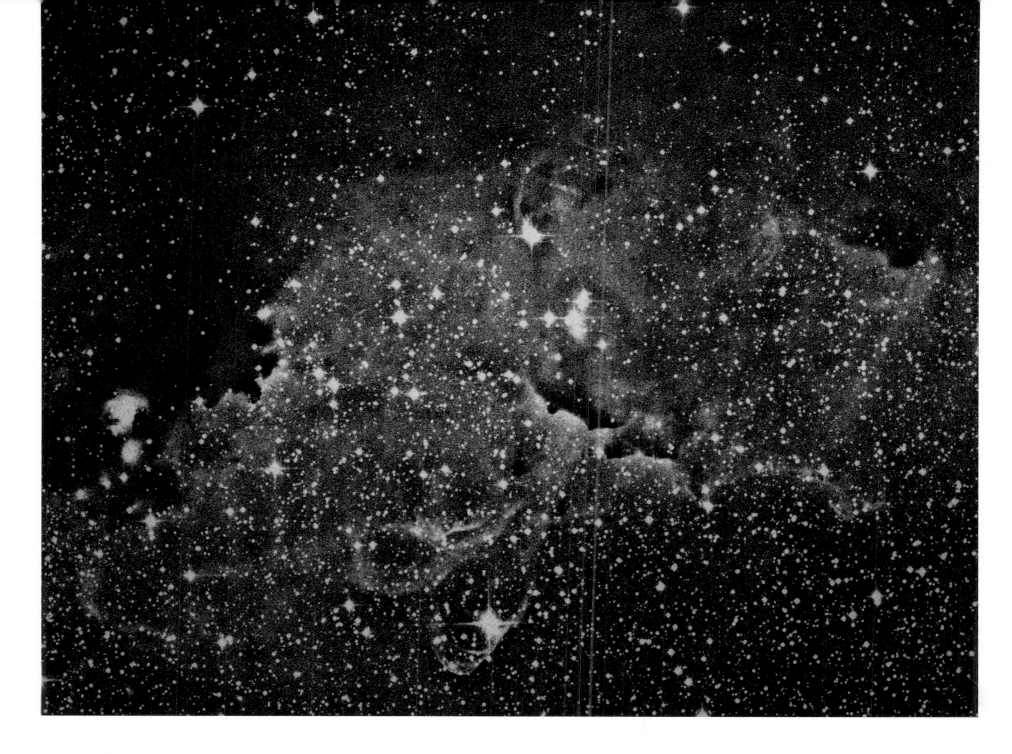

Figure 15 [406]

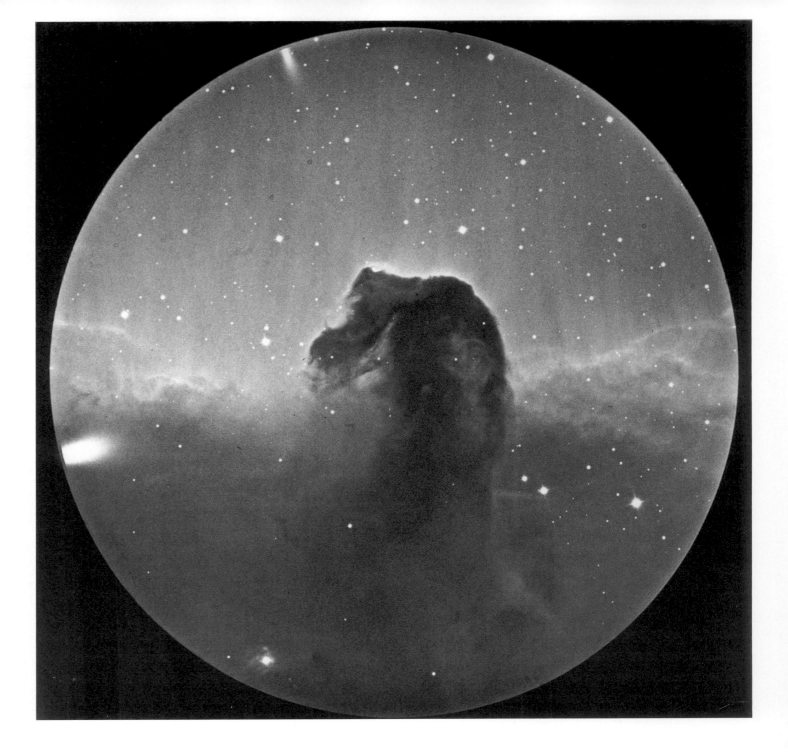

Figure 16 [406]

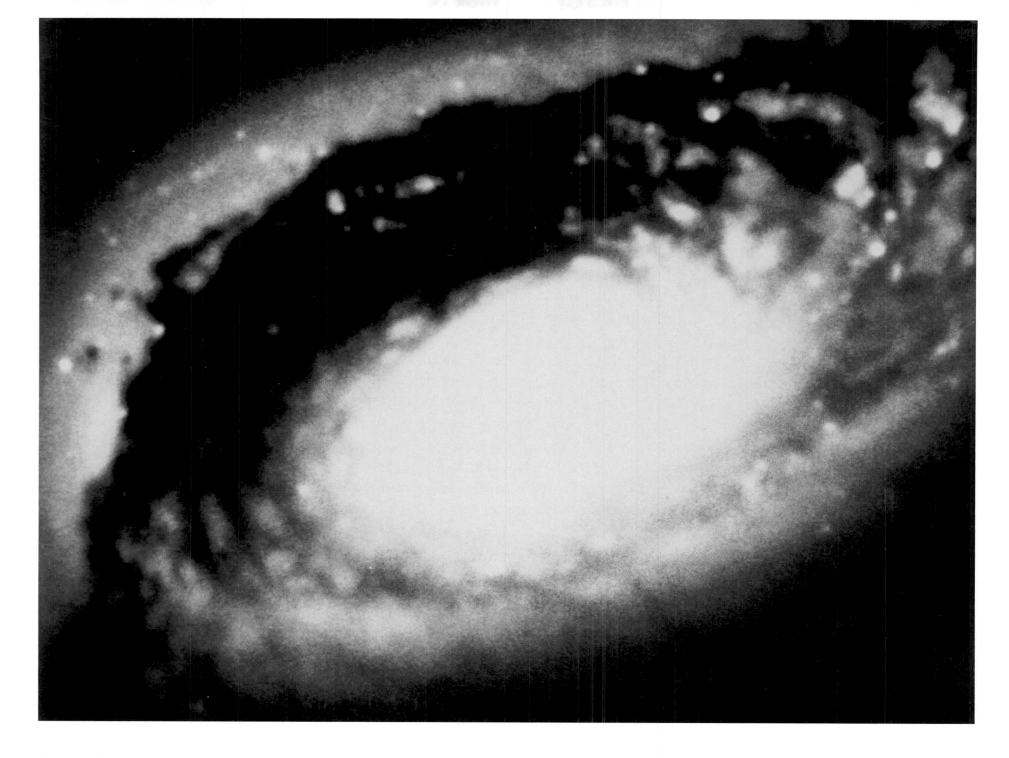

Figure 17 [406]

Very fortunately, we had access to special "near-infrared" eyes. If an airport is encased in a fog, it does not imply that the airport is not there: it merely implies that one requires a special set of eyes – infrared eyes – to penetrate the fog! Likewise, the presence of homes in a valley cannot be ascertained if the valley is enshrouded in mist (Figure 18). Herein lies a fundamental question:

What does the unmasked view of our cosmos reveal?

What structures of stars lie behind these dust masks of the night?

"Have you ever, looking up, seen a cloud like to a Centaur, a Part, or a Wolf, or a Bull?" asked the Greek poet and satirist Aristophanes (c. 448–380 BC).

Grains of cosmic dust may be studied in two completely different ways: The one way is by means of the feeble radiation which these tiny grains emit. Special telescopes have been erected which are sensitive to such radiation, called submillimeter telescopes. Submillimeter astronomy is that branch of astronomy based on radiation from space whose wavelengths range from a few hundred microns to a millimeter (one micron is one thousandth of a millimeter). The giant James Clerk Maxwell Telescope on the Big Island of Hawaii, with its impressive 15 meter diameter antenna composed of 276 individually adjustable panels, is a submillimeter telescope (the photons which its receiver detects belong to the submillimeter region of our electromagnetic spectrum). It began observing the skies in 1987.

Dust pervasive as smoke (Figure 19), a fog or an aerosol ... why could such telescopes not have provided definitive answers prior to our investigative work in 1994?

Studies with telescopes such as the James Clerk Maxwell Telescope and the California Institute of Technology (Caltech) Submillimeter Observatory, with its 10.4 meter radio dish, had brought the issue of cold dust in other galaxies to the fore, but with diametrically opposed possibilities. Some research papers published between 1989 and 1993 claimed that very cold dust in galaxies may simply not be present. The reasons for this controversy are manifold, but a principal factor is that it is possible to find *markedly different* distributions of the temperatures of dust grains from an identical set of submillimeter observations. A key unknown

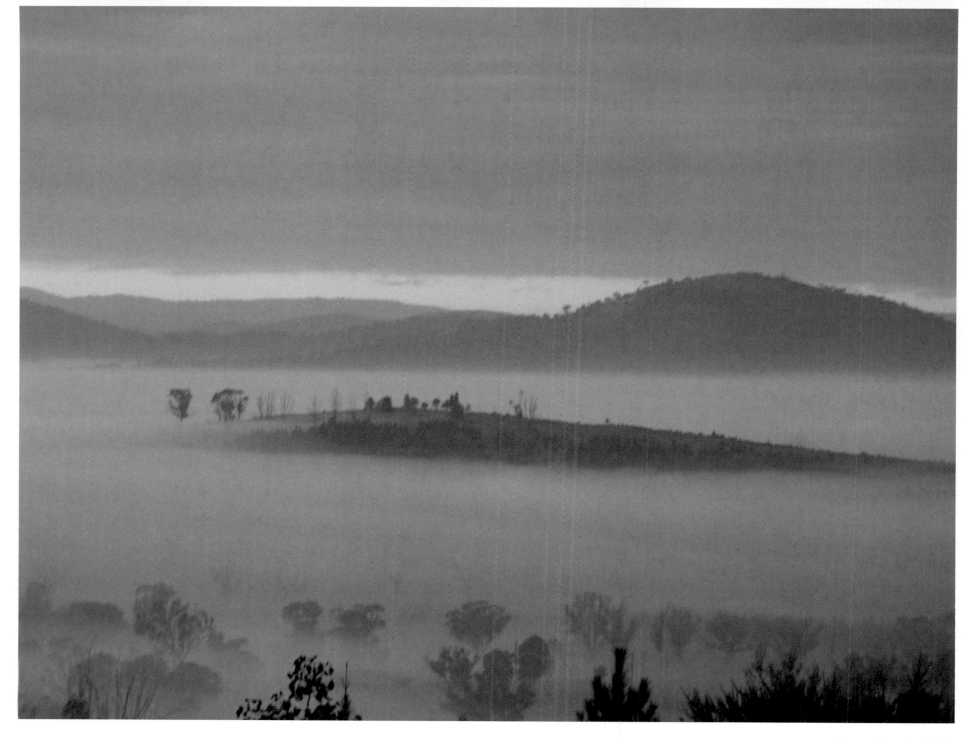

Figure 18 [406]

Figure 19 [406]

is the efficiency with which dust grains emit radiation at these long wavelengths. Also, dust grains as cold as minus 260 degrees Centigrade simply remain undetected at submillimeter wavelengths.

Large scale, diffuse "cirrus clouds" had been strikingly detected in our Milky Way Galaxy by the space-borne Infrared Astronomical Satellite, launched in January 1983. This satellite was a joint project of the United States, the United Kingdom and the Netherlands. It was equipped with a special 0.57 meter infrared telescope, and during its ten month mission produced a survey spanning the entire sky, at wavelengths of 12, 25, 60 and 100 microns. The satellite was sensitive to the emission from dust grains whose temperatures ranged from about minus 240 degrees Centigrade to 30 degrees Centigrade (the Infrared Astronomical Satellite beautifully observed the zodiacal light between minus 25 degrees and 30 degrees Centigrade; the zodiacal light results from sunlight scattered by dust in the plane of the planets, and is shown in a drawing in Chapter 5 – see Figure 28).

Sky maps of the Milky Way by the Infrared Astronomy Satellite at 100 microns magnificently revealed the presence of dust grains in both "cirrus clouds" and in giant clouds of molecules, in our Galaxy. These cirrus clouds in our Galaxy bear a striking resemblance to terrestrial cirrus clouds; hence their name. However, the Infrared Astronomy Satellite was only sensitive to radiation from *hot* grains as well as warm grains – *not* the cold grains of dust which lurk in molecular clouds in which stars are born – grains whose temperatures may be a mere 20 degrees above absolute zero (in other words, minus 253 degrees Centigrade).

Such grains only add only small contributions to the low-frequency end of the emission spectrum (even though these cold grains may constitute by far the bulk of the proportion of the dust mass). When astronomers secured infrared images of galaxies outside of our Milky Way with the Infrared Astronomy Satellite, the emission was masked or dominated by the higher temperature (technically "brighter") dust grains. One may think of a lighthouse analogy; as a ship approaches a coastal city at night, the view from the deck would be dominated not by the distant city lights, but by the emission of blazing rays of light from a lighthouse.

The Infrared Astronomy Satellite therefore did not detect cold cosmic dust grains in spiral galaxies external to our Milky Way – with one notable exception: the Milky Way itself.

We live in this Galaxy, and therefore we can secure high spatial resolution images of it! With the four bands of Infrared Astronomy Satellite, we can successfully separate high and low temperature regions in such maps of the Milky Way. The Milky Way is so close that we can demarcate areas where the feeble emission from low temperature dust grains is not *swamped* or masked by regions containing higher temperature cosmic dust grains. On the other hand, for more distant spiral galaxies, astronomers can measure only the total brightness in the four Infrared Astronomy Satellite bands, and therefore the radiation from cold dust is completely swamped by the warm dust.

The prevalent viewpoint in the 1980s was that although cosmic dust certainly was seen in the photographs of Keeler, Curtis and others, the ratio in mass of dust to gas in spiral galaxies (as determined from observations with the Infrared Astronomy Satellite) was about ten times smaller than that determined for our Milky Way Galaxy. Was our Milky Way simply very unusual in having copious amounts of cosmic dust? Or could it be that the Infrared Astronomy Satellite had actually missed *ninety percent* of the dust content in spiral galaxies external to our Milky Way, as a result of masking by the hotter dust grains?

Let us for a moment think of a soldering iron. The iron will not only warmly glow in the infrared, but it will also block out optical light. Herein lies the second method of detecting cosmic dust – a dust grain will block out background starlight, independent of its temperature. This is the method we invoked at La Silla.

One of the galaxies we observed is known as NGC 2997. An optical image (Figure 20) shows a plethora of bright young stars and a magnificent set of dust lanes. In the infrared (Figure 21), the obscuring effects of dust are enormously reduced. If one subtracts a "dust-free" near-infrared image of a spiral galaxy from an optical image, the result is a map of the distribution of dust in the galaxy without any starlight (see Figure 22). Such maps reveal the presence of dust grains *of all temperatures*, including the very cold ones which we could not detect directly from their emission. Moreover, it is possible to actually quantify the masses of our Shrouds of the Night and herein lay the crucial clues … clues which would definitively unravel whether it was only our Milky Way which contained large amounts of cosmic dust.

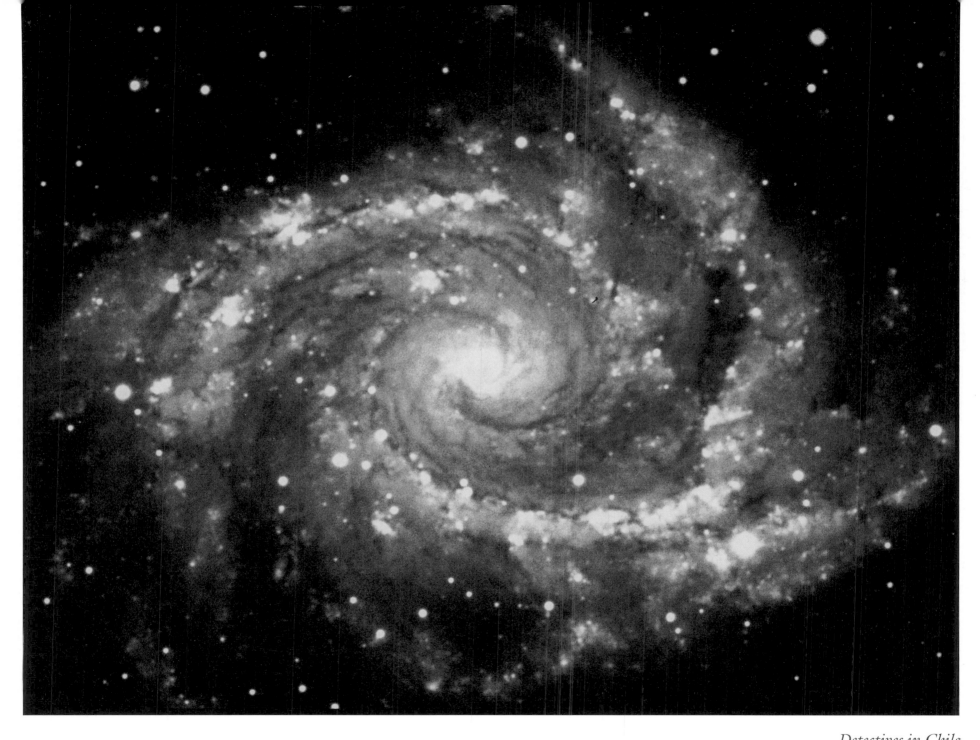

Figure 20 [406]

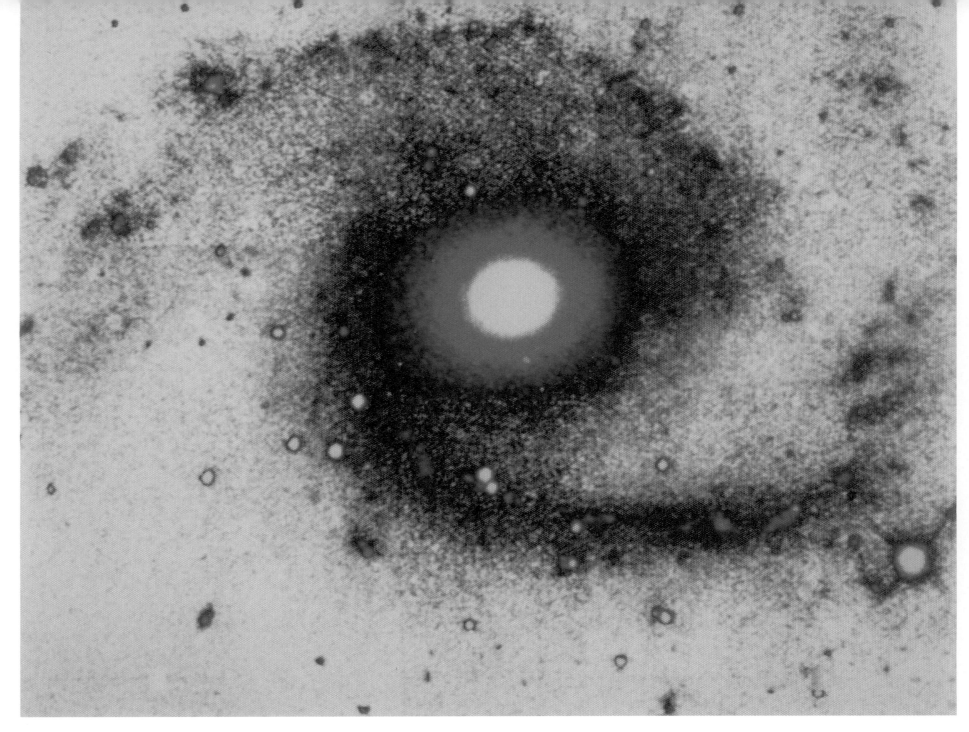

Figure 21 [407]

To our astonishment, we found that *ninety percent of the dust mass in spiral galaxies external to the Milky Way had been missed by the Infrared Astronomy Satellite*: astronomers had vastly underestimated how thick the galactic fog was through which they had been observing the Universe. At this juncture, we owe an enormous debt to our collaborators from Germany, Italy, Spain, the Netherlands, the United Kingdom and the United States of America, who worked so closely with us prior to our infrared and cold dust publications in 1994.

What we had discovered in Chile was that dust grains do not simply lie along spiral arms of galaxies themselves; rather, vast curtains of dust also lie *between* spiral arms (technically known as "inter-arm" dust). Shrouds of the Night betray a breathtaking structure of their own (Figure 22). True, there certainly *were* clearly defined dust lanes along the spiral arms, but these dust lanes alone do not fully describe the complexity of a cosmic dust shroud. We are reminded of the words of the English novelist Ellen Thorneycroft Fowler (1860–1929):

> *Though outwardly a gloomy shroud,*
> *The inner half of every cloud*
> *Is bright and shining:*
> *I therefore turn my clouds about*
> *And always wear them inside out*
> *To show the lining.*

<div align="right">ELLEN FOWLER IN <i>WISDOM OF FOLLY</i></div>

Our discoveries on the prevalence of dusty Shrouds of the Night in spiral galaxies beyond our Milky Way were published during the historic year 1994 – the year that saw the emergence of the New South Africa under Nelson Mandela. Mayo Greenberg, one of the world's foremost laboratory astrophysicists who we will meet in the next chapter, stood up at a meeting at Cardiff (Wales) and exclaimed his excitement at our team's observational confirmation of his 23-year-old prediction that cold cosmic dust was a reality, and that it constituted *most of the dust mass* in spiral galaxies.

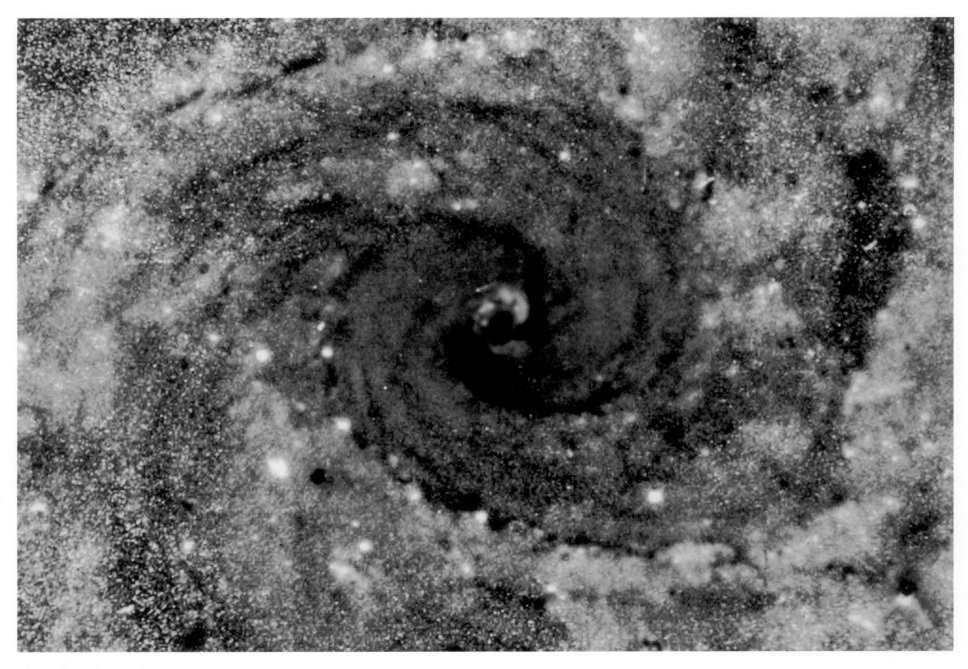

Figure 22 [407]

I've waited 23 years to "see" cold dust. You did it. Thanks!

he told our team at the Cardiff meeting.

––––––––––––––––

Nobel-laureate Indian poet Rabindranath Tagore writes in his book entitled *Stray Birds*:

The dust receives insult and in return offers her flowers.

Without dust, no flowers: do not planets themselves come from the material produced in stars? Planets, icy comets, and life itself: at the kernel, stardust. "Remember, man, that thou art dust. And into dust thou shalt return" writes the author of *Genesis*.

Chemical Factories Smaller than a Snowflake

 osmic dust grains in our Shrouds of the Night (Figure 23) – how large are they? Do such dust grains need to be comparatively large to effectively obscure distant starlight? The answer is decidedly: no! How highly effective is fog in obscuring homes in a valley, yet its particle sizes are truly minuscule.

In the warmer dust clouds (whose temperature is about 60 degrees above absolute zero, or minus 213 degrees Centigrade), the silicate grains are on the order of 1/100th of a micron in size (recall that one micron is a thousandth of a millimeter), whereas in very cold dust clouds (20 degrees above absolute zero, or minus 253 degrees Centigrade), the sizes are typically 1/10th of one micron, so they are minute indeed. A comparison may be helpful.

An ordinary snowflake – one of billions which may gently drift downward during winter – is 25 000 times larger – snowflakes are typically of the order of 2500 microns across. A snow-flake is a veritable immensity compared to one grain of cold cosmic dust. Furthermore, the nucleus at the center of a snowflake measures one micron; the aerosols in the atmosphere around which a snowflake crystallizes measures 1/10th of a micron. Cold grains in dusty Shrouds of the Night, 1/10th of a micron in size, are truly like aerosols – the mists of a fog.

Cosmic dust pioneer Mayo Greenberg devoted his entire life to the study of these minute laboratories in space. The legendary Greenberg never developed theories to explain existing observations; rather, he developed theoretical models and predicted scores of observations. One may think of other great scientists who followed similar patterns; the deflection of starlight around our Sun was *predicted* by Einstein before it was observed. Greenberg was a mentor to one of us, David, for many years, extending the warmest of hospitality at his home in Leiden. Greenberg *predicted* that cold cosmic dust would pervade space, at a time when

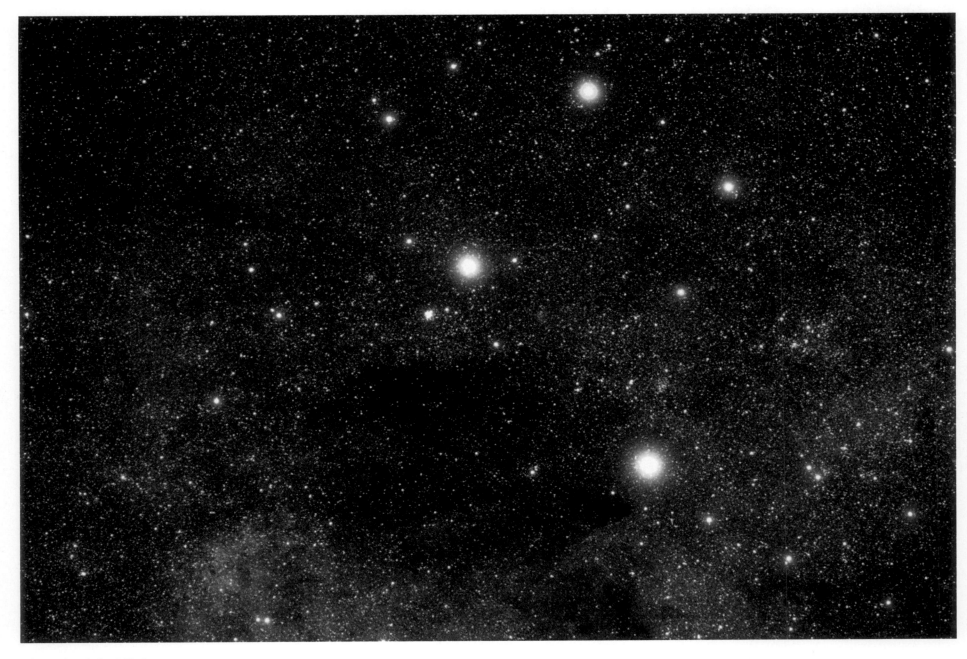

Figure 23 [407]

his contemporaries regarded dust as a "nuisance;" a topic of small relevance, to be avoided. The giant Greenberg thought otherwise.

Greenberg always likened minute dust particles to those of smoke particles; Leiden astronomers Jan Oort and Henk van de Hulst also referred to cosmic smoke, and for good reason. The cold dust particles are approximately the same size as smoke particles exhaled by a cigarette smoker.

Stand in a room and look at a light-bulb. Next, fill the room with smoke. The dimming of the light-bulb is immediately apparent. The dimming of light in a smoke-filled room is caused by exactly the same phenomenon as the dimming of the light of distant stars. Each particle of smoke, whether in a home on Earth or lurking in interstellar space, diverts the light which hits it. It does so either by scattering it off in other directions, or by absorbing it, or by a combination of both. Our sky is blue because of the scattering of short-wavelength blue photons from sunlight by particles of gas in our atmosphere.

The starting point for the production of interstellar dust grains is in the atmospheres of cool, older stars. Minute rock-like particles called silicates, are blown from the atmospheres of these stars into surrounding space. These "submicron" particles (smaller than one micron) are blown away from their parent stars, and there, drop down in the coldness of space to temperatures as low as minus 253 degrees Centigrade – sometimes colder!

Herein lies the marvel of the story. These grains are so cold that any ion, molecule or atom from surrounding gases will simply stick to them. Cold dust grains have mantles of ice around them; this was not merely a theoretical postulate but proven to exist by Greenberg, who carefully conducted experiments in his laboratories in the United States and in the Netherlands.

The chemical changes which may occur on the surfaces of these ice mantles are profound. Just as water vapor forms frost on the inside of windows on a cold winter's day, these tiny silicate grains first accrete mantles of frozen water, methane, ammonia, carbon monoxide and many other molecules. When the ice mantles on grains of cosmic dust are exposed to the ultraviolet radiation from neighboring stars, simple molecules gradually convert into more complex ones.

Eventually, many pre-biotic molecules (such as amino acids) are produced. Chemical factories much smaller than a snowflake? Of such are our Shrouds of the Night made.

Common molecules include carbon monoxide and ammonia. These dusty regions have an average density of one hundred to one thousand particles per cubic centimeter of space, whereas the average number of such particles in the vicinity of our Sun is only about one per cubic centimeter. In the dense cores of molecular clouds, the number of particles may be in excess of ten thousand to one million particles per cubic centimeter. The masses of giant molecular clouds range from ten thousand to a few million times the mass of our Sun; these clouds are enormous indeed.

Greenberg was renowned for his famous "yellow stuff" – the complex organic materials produced in the ice mantles of cosmic dust grains. He would produce ice mixtures in laboratories on Earth, and then study the changes in chemistry which occur as these substances are exposed to ultraviolet photons. Ultraviolet lamps were used instead of hot stars! During the lifetime of an interstellar grain of dust, the grain mantles containing organic material are actually subjected to substantial ultraviolet light, leading to chemical and physical modifications of these "first generation" organics as simulated in the laboratory.

The ERA (Exobiology Radiation Assembly) platform on the *EURECA* satellite offered the opportunity to expose Greenberg's laboratory samples to long-term radiation from the Sun. (The Sun may not be a typical representation of the radiation fields encountered by grains in space, but it provides a significant advantage over any laboratory experiments – not only in long-term exposure, but also in that such an experiment permits simultaneous bombardment of many different samples.)

Greenberg and colleagues prepared this "yellow stuff" by subjecting samples of ice (water, carbon monoxide, ammonia, methane, methyl alcohol and acetylene) to radiation from ultraviolet lamps for periods of between twenty-two and sixty-eight hours. The samples were next deposited onto small blocks of aluminum at a temperature of ten degrees above absolute zero and mounted in the ERA sample carrier. The sealed sample carrier was taken into space on the ERA platform of the *EURECA* satellite, which remained at an altitude of 500 km; all of the samples were subjected to illumination by the full solar spectrum for a total of four

months. Finally, the sample carrier was sealed in space and returned back to Earth – and finally, the University of Leiden. The solar radiation had indeed changed the organic "yellow stuff" to organic "brown stuff," and Greenberg and colleagues could examine the chemical changes using an instrument known as a spectrometer.

Nearby giant molecular complexes may cover considerable portions of a constellation, such as the Orion Molecular Cloud, or the Taurus Molecular Cloud. These local giant molecular clouds are arrayed in a ring. This ring includes many bright stars, and is known to astronomers as Gould's Belt (named after Benjamin Gould, who noted this "circle" in the heavens). Writing from Argentina in 1874, Gould penned these words:

> *I desire to mention a fact which early attracted and repeatedly compelled my*
> *attention during my residence in South America ... [A] great circle or zone*
> *of bright stars seems to gird the sky, intersecting with the Milky Way at the*
> *Southern Cross, and manifest at all seasons.*

Actually, Sir John Herschel had already traced the southern section of Gould's Belt working from the Cape in South Africa. In his observations published in 1847, Herschel described:

> *the zone of large stars which is marked out by the brilliant constellation of*
> *Orion, the bright stars of Canis Major, and almost all the more conspicuous*
> *stars of Argo [modern Puppis, Vela, and Carina] – the Cross – the Centaur,*
> *Lupus, and Scorpio.*

It was Gould who had discerned the belt around the entire sky, and the enigmatic structure bears his name. Early studies of this extensive belt, inclined at some 10–20 degrees to the plane of our Milky Way, were conducted by astronomers Charlier (1916), Seares (1928) and Bok (1931). We recently again *gazed* upon this extraordinary structure by eye from outside our offices at Mt Stromlo; the air was crisp, the atmosphere steady, and the sight: it was breathtaking to view the Scorpio–Centaurus aggregates of bright stars. We could rekindle the excitement which must have been experienced as photons from this belt reached the eyes of Herschel, Gould and others.

The Gould Belt contains many fiery hot blue stars in the neighborhood of the Sun, such as the Cassiopeia–Taurus associations which include the Pleiades star cluster. It is believed to be part of the local spiral arm of our Galaxy to which the Sun belongs; in other words, our Sun is presently crossing the Gould Belt in its orbit about the center of our Milky Way. The age of the Gould Belt is estimated to lie between forty-five and ninety million years. Molecular cloud complexes such as those in Aquila, Cepheus, Cassiopeia, Perseus and Vela all appear to be part of the Gould Belt.

In giant molecular clouds, dust grains may coagulate ("stick together"): the largest dust grains will lurk in the interiors of the more massive and colder dust clouds, where shielding from the rays of nearby stars is highly effective. The temperatures of dust grains in these environs may be *very* cold indeed – possibly only a few degrees above absolute zero.

Carbon based star dust is not at all far removed from our everyday existence, for it is from these very dusty shrouds that the starry hosts are born – and it is indeed the stuff of which every reader is made.

Professor Owen Gingerich at Harvard University wonderfully links his thoughts to a story of the three little bears: "Clearly we live in a Universe with a history, a very long history, and things are being worked out over unimaginably long ages. We live in an incredibly vast cosmos, something that goes hand-in-hand with a long history. Stars and galaxies have formed, and elements are coming forth from the great stellar cauldrons. Like the little bear's porridge, the elements are just right, the environment is fit for life, and slowly life forms have populated the earth."

Galaxies look supremely different once their masks of cosmic dust are penetrated ... it is the *New View of Galaxies* ...

From Seeds to Stars: The Art and Science of Classification

ioneering thoughts from Allan Sandage in *Galaxies and the Universe*.

The first step in the development of most sciences is a classification of the objects under study. Its purpose is to look for patterns from which hypotheses that connect things and events can be formulated by a method produced and used by Bacon (1620). The power of any mature classification system is in its systematic arrangements of like objects into connective patterns that themselves suggest explanations external to the classification itself. However, the danger in devising a classification from scratch is that, if the classifier has preconceived notions of what those explanations might be, then the classification becomes circular if it is later used to provide the explanations. A good classification can drive the physics, but the physics must not be used to drive the classification. Otherwise the process becomes circular.

The seeds for classification lie in the works of the British naturalist John Ray (1628–1705). Commencing in 1660 with his *Catalogue of Cambridge Plants,* and ending with the posthumous publication of *Synopsis Methodica Avium et Piscium* in 1713, John Ray published systematic works on plants, birds, mammals, fish and insects. In these works, Ray brought order to the chaotic mass of names in use by the naturalists of his time. Like Linnaeus, Ray searched for the "natural system," a classification of organisms that would reflect the Divine Order of creation. Unlike Linnaeus, whose plant classification was based entirely on floral reproductive organs, Ray classified plants by overall morphology: the classification in his 1682 book *Methodus Plantarum Nova* draws on flowers, seeds, fruits, and roots. Ray's plant classification system was the first to divide flowering plants into monocots and dicots. This method produced more "natural" results than "artificial" systems based on one feature alone; it expressed the similarities between species

more fully. Ray's system greatly influenced later botanists such as Jussieu and de Candolle, and systems based on total morphology came to replace systems based on only one feature or organ. Ray cautioned against blind acceptance of authorities: in *The Wisdom of God*, he wrote:

> *Let it not suffice to be book-learned, to read what others have written and to take upon trust more falsehood than truth, but let us ourselves examine things as we have opportunity, and converse with Nature as well as with books.*
>
> <div align="right">(ITALICS, OURS)</div>

Each seashell is unique, but there are similarities in form. However, within each family there are subtle differences: for example, in the Modiola family, the mussel *Modiola Modiolus* is not rayed, but *Modiola Radiata* shows a striking family of rays in the seashell. *Modiola Barbata* shows "barbs of epidermis serrated" according to G.B. Sowerby, whereas *Modiola Cuprea* is "rhomboidal, smooth" and not serrated. Yet all of these seashells belong to the family (genus) *Modiola*.

And so, too, it is with galaxies. Each is truly unique in its own right; no less than each snowflake or every seashell; although each has a unique form, it is the challenge of the morphologist to group these into *form families*.

Never forget the wonder of a Little Snowflake:

> *... looking at herself as she tumbled over and over, fragile and airy as the wind that blew her, Snowflake knew that she was beautiful.*
> *She was all stars and arrows, squares and triangles of ice and light, like a church window; she was like a flower with many shining petals; she was like lace and she was like a diamond. But best of all, she was herself and unlike any of her kind. For while there were millions of flakes, each born of the same storm, yet each was different from the other.*
>
> <div align="right">(FROM THE NOVEL OF PAUL GALLICO – SNOWFLAKE.)</div>

Prior to the dawning of the photographic era, astute and careful observers produced some of the most exquisite drawings of objects in our night sky, by eye and by hand. One of our favorite drawings of the Milky Way Galaxy comes from the work of the French born artist and amateur astronomer Etienne Leopold Trouvelot (1827–1895), who emigrated from France to the United States in 1855. In 1882, Trouvelot clearly stated his intentions in a volume entitled *The Trouvelot Astronomical Drawing Manual*:

> *My intent is ... to represent the celestial phenomena as they appear to the trained eye and to an experienced draughtsman through the great modern telescopes provided with the most delicate appliances ... my aim is to combine ... accuracy in details ... with the natural elegance and delicate outlines peculiar to the objects depicted ... A well-trained eye alone is capable of seizing the delicate details of structure ... which are liable to be affected, and even rendered invisible, by the slightest changes in our atmosphere.*

He was captivated by the grandeur of the Milky Way (Figure 24), and wrote:

> *During clear nights when the Moon is below the horizon, the starry vault is greatly adorned by an immense belt of soft white light, spanning the heavens from one point of the horizon to the opposite point, and girdling the celestial sphere in its delicate folds.*

Trouvelot's drawing of the Milky Way was based on naked-eye studies spanning not one month, or four months, but the years 1874–1876. Discernable are stars belonging to the constellations of Scorpio, Sagittarius, Aquila, Lyra, Cygnus and Cassiopeia ... also magnificently captured, with his astute eye, are the "starry vaults" in our Galaxy. The Milky Way truly spawns multitudes of Shrouds of the Night in Trouvelot's exquisite drawing.

What an extraordinary challenge it must have been to produce drawings of the night sky – by hand: one obviously would require *some* faint light source (such as a candle) to carefully guide the hand on paper in the drawing process, but the pupil of the eye immediately contracts upon looking at candlelight, and more time is then needed to get the eyes "dark-adapted"

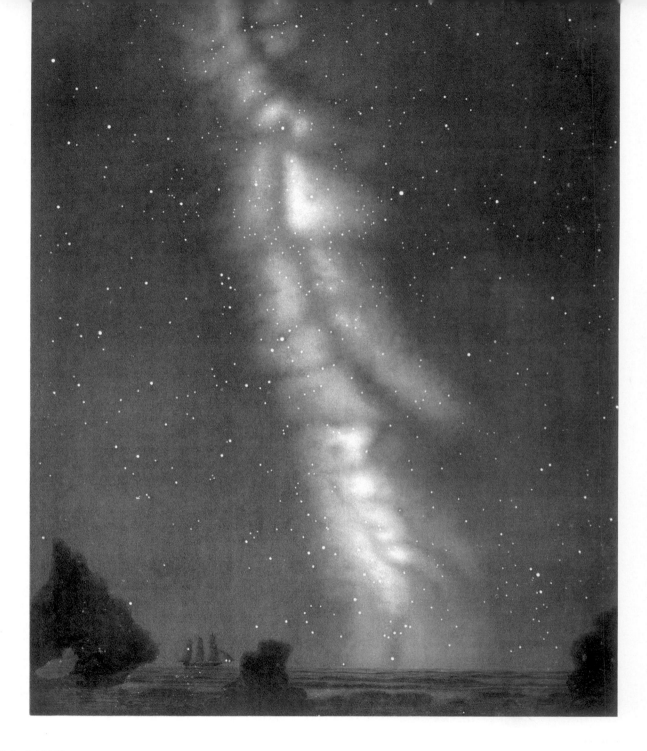

Figure 24 [407]

again, before undertaking further drawings of the night sky. Positional accuracy was essential. Furthermore, darkness (the absence of a bright Moon) is crucial to visually appraising the grandeur of the Milky Way, as Trouvelot himself pointed out.

Trouvelot produced approximately *seven thousand* astronomical drawings (examples appear in Figures 25–29), including the planet Saturn (Figure 25), a star cluster in the constellation of Hercules (Figure 26), the Great Nebula in Orion (Figure 27, based on telescopic observations in 1875 and 1876), a total eclipse of the Sun (July 29, 1878), exquisite lunar landscapes, the Aurora Borealis (March 1, 1872), the Great Comet of 1881 (Comet Tebbutt) and the splendor of the zodiacal light (Figure 28). The glowing zodiacal light is due to sunlight scattered off particles of cosmic dust which are present in our solar system. This interplanetary dust is distributed in a volume of space centered on the Sun and extending beyond the orbit of our Earth. Also drawn by this assiduous observer were "The November Meteors" (see Figure 29). Trouvelot vividly recalls the extraordinary celestial display on November 13, 1868:

> *My observations were begun a little after midnight, and continued without interruption till sun-rise. Over three thousand meteors were observed during this interval of time …*
>
> <div align="right">(ITALICS, OURS)</div>

It is a fitting tribute to this exceptionally gifted artist that at coordinates 49 degrees north and 6 degrees east on the Moon, lies the Trouvelot crater, named in his honor.

A key discovery regarding the structure of galaxies outside of our Milky Way came from Ireland. A giant mirror, measuring 72 inches across, was successfully cast on April 13, 1842 and formed the heart of the famous "Leviathan of Parsonstown," a telescope which saw "first light" (a term used by astronomers to denote that moment when a fully assembled telescope receives its "first set" of celestial photons) on February 15, 1845. The "Leviathan of Parsonstown" is still in place today at Birr Castle in Ireland. At the time, it was the largest reflecting telescope on the planet. William Parsons, who became the 3rd Earl of Rosse in 1841, visually identified spiral structure in the Whirlpool Galaxy Messier 51, in 1845.

Figure 25 [407]

Figure 26 [407]

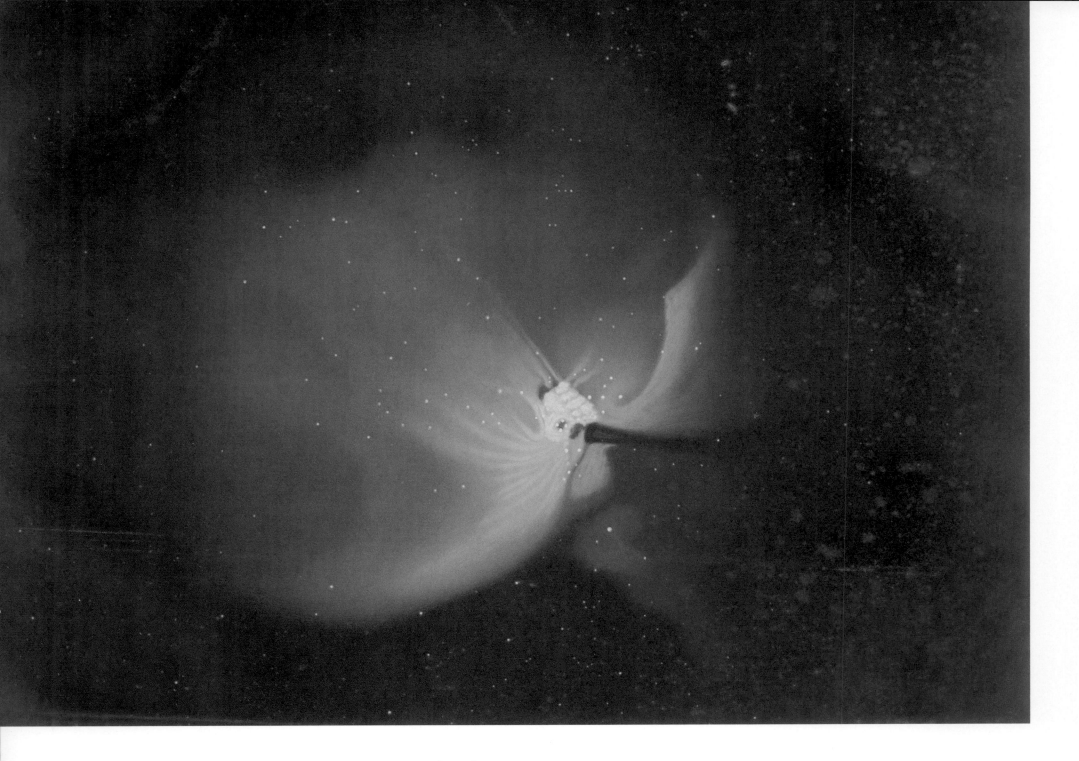

Figure 27 [407]

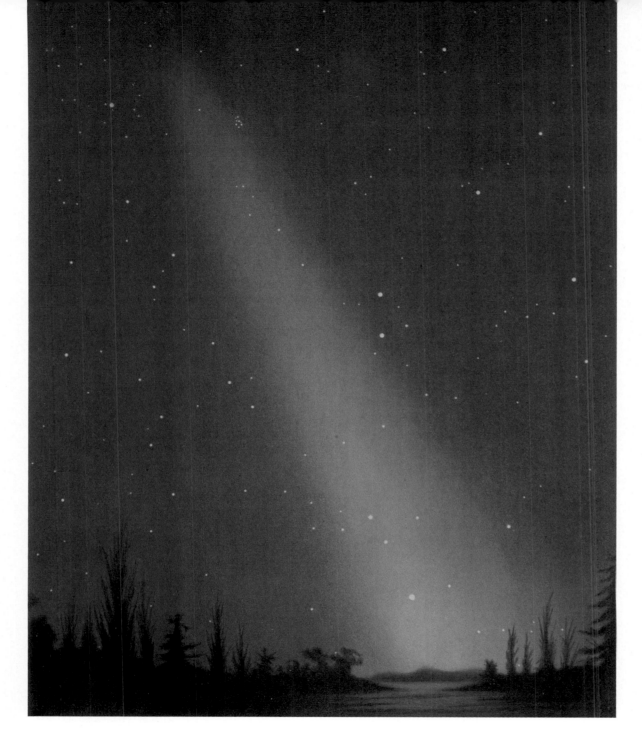

Figure 28 [407]

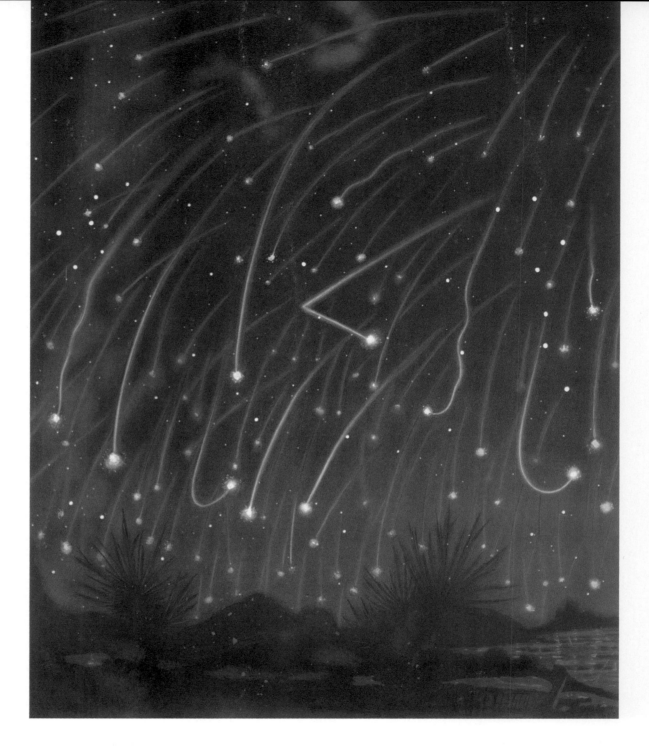

Figure 29 [408]

Lord Rosse subsequently identified spiral structure in approximately 20 additional galaxies. Exquisite drawings were made at the telescope; among the galaxies drawn were Messier 101 (Figure 30) and Messier 33 (Figure 31), as well as the Dumbbell Nebula within our Galaxy (Figure 32).

Astronomers at Birr Castle included R.S. Ball (who worked there in the period 1865–1867) as well as J.L.E. Dreyer (1874–1878), who became world famous for his "New General Catalogue" (N.G.C.) of celestial objects.

The telescope was dismantled in 1908 but was restored in the period 1994–1999; tourists to Ireland should not miss a visit to see this historic telescope through which the spiral pinwheels in the Whirlpool Galaxy were first detected. An exquisite drawing of the Milky Way was produced at Birr Castle by the German astronomer Otto Boeddicker (1853–1937), who became the astronomical assistant to Lawrence Parsons, the 4th Earl of Rosse. Boeddicker's breathtaking drawings of the Milky Way (Figures 33 and 34) were made over a period of *six years*, and published in 1892.

Boeddicker wrote:

> *The drawing of the Milky Way referred to was begun by me on October 24, 1884, and has occupied the greater part of my time and energy ever since. It was undertaken in the belief than an accurate representation of the Galaxy, such as it appears to the naked eye, was an astronomical desideratum, and would be of some value for a variety of special investigations ... As much as possible I drew the different sections only when they were near the meridian, in order to obtain the conditions most favourable for atmospheric transparency. This involved for the greater part of the Milky Way the necessity of my lying flat on my back (or nearly so) in the open air for hours together – a position which, especially on frosty nights, proved somewhat trying, for no amount of clothing was found sufficient to counteract the radiation of heat from the body ...*

His drawings received the highest of praise. In the November 30 1889 edition of the *Saturday Review*, we read:

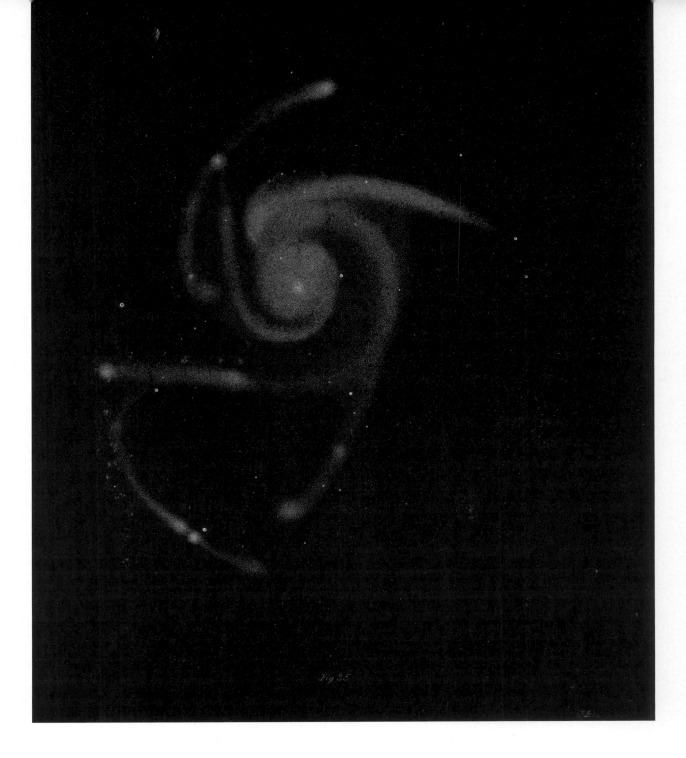

Figure 30 [408]

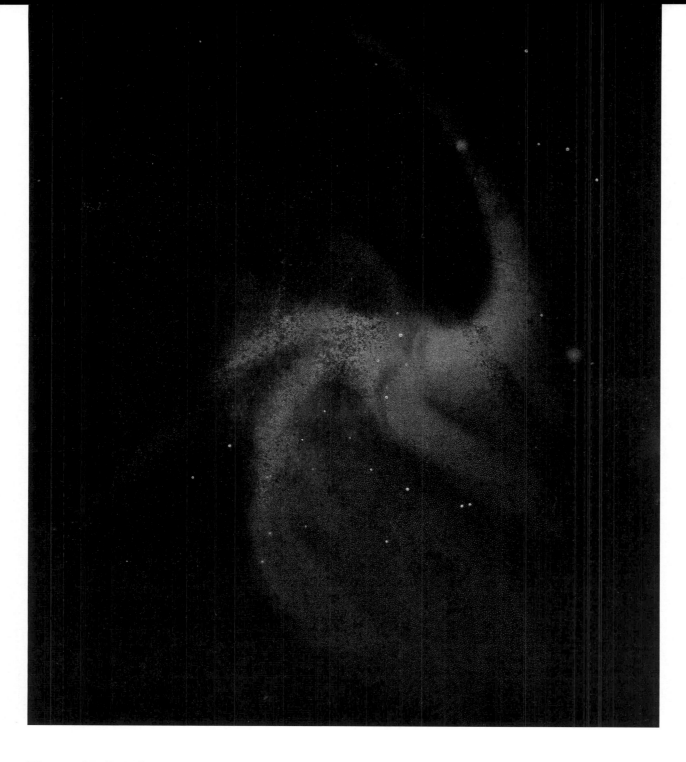

Figure 31 [408]

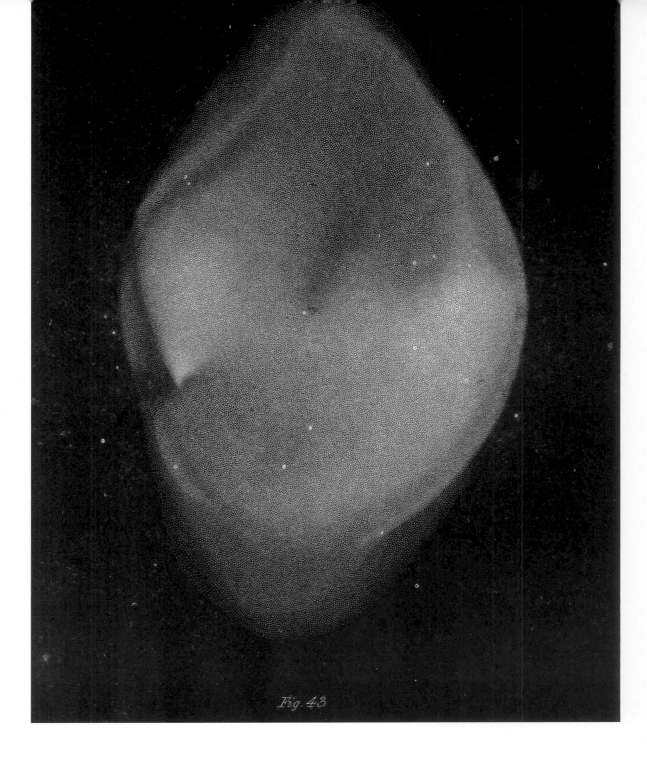

Fig. 43

Figure 32 [408]

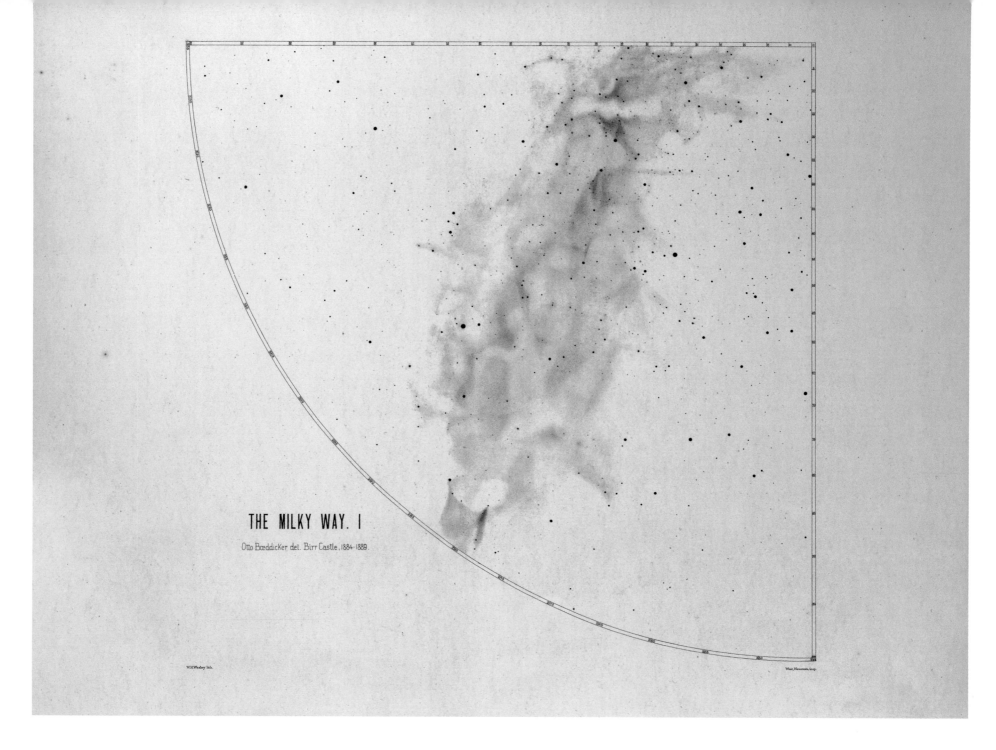

THE MILKY WAY. I

Otto Bœddicker del. Birr Castle, 1884-1889.

W.H.Wesley lith.

West, Newman, imp.

Figure 33 [408]

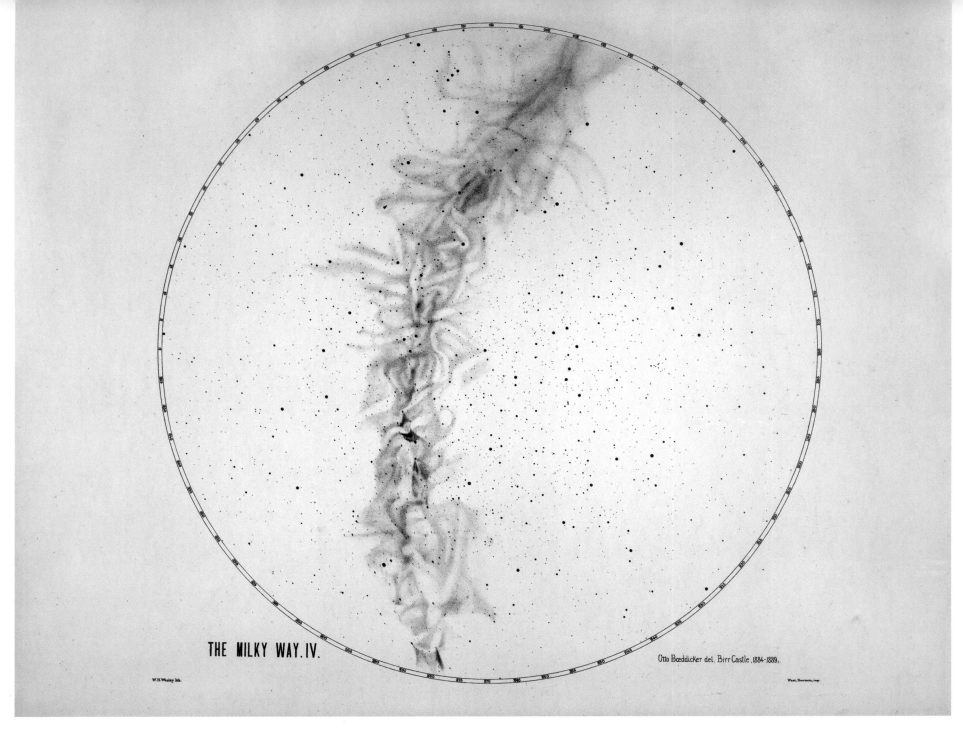

THE MILKY WAY. IV.

Otto Bœddicker del. Birr Castle, 1884-1889.

W.H. Wesley lith.

West, Newman, imp.

Shrouds of the Night

Figure 34 [408]

To appreciate the labour of depicting, in all its delicate details, the majestic arch of accumulated suns by which our situation in space is surrounded, one should examine Dr Boeddicker's splendid drawings of it ... They are in many respects a completely new disclosure. Features barely suspected before come out in them as evident and persistent: every previous representation appears by comparison structureless. There is something of organic regularity in the manner of divergence of innumerable branches from a knotted and knarled [sic] trunk; nor can the protusion [sic] of cloudy feelers toward outlying nebulae and clusters be regarded as purposeless; while the fidelity with which the milky effulgence coils and sweeps along the lines laid down by the stars emblazoned upon it is perplexing, if it be not significant. It is simply amazing that such a work should have been executed in such a climate as that of Parsonstown.

In the *English Mechanic* of January 3, 1890, praise for Boeddicker's meticulous drawings of our Galaxy follows thus:

Commencing in 1884, and working on every occasion since then, Dr. Boeddicker, Lord Rosse's assistant astronomer, has produced a series of drawings of the whole of the Milky Way visible in these latitudes, which is as unsurpassed as it is probably unsurpassable in the elaborate character of its minute detail. It is verily a marvel of the most minute and patient accuracy ...

Drawing in the dark at Birr Castle

Exactly what sort of illumination did Lord Rosse use, to make his exquisite drawings of the "nebulae?"

The crucial point is that, in order to see a galaxy through the eyepiece of Lord Rosse's giant telescope (whose speculum mirror weighed over 3 tons), the eye of the observer first has to be "dark adapted." In simple terms, the retina contains two types of receptors: rods and cones.

There are approximately 120 million rods compared with 6–7 million cones. Our daylight vision (cone vision) readily adapts to changing light levels in a few seconds, as occurs when walking indoors out of sunlight. The rods, far more numerous, are highly efficient receptors to photons of light – more than 1000 times as sensitive as the cones – but the rod adaptation process is much slower. It is the rods of the retina which facilitate our dark-adapted or scotopic vision, enabling an observer to see intricate but faint details at the eyepiece. After a optimum period of about 30 minutes, the eye becomes adapted to the dark.

Now comes the dilemma. Lord Rosse produced some of the most striking drawings of the Whirlpool Galaxy and of nebulae. How did Lord Rosse actually "draw in the dark" and retain his dark adapted vision? Were he to use any bright (white) source of illumination on his drawing paper, such illumination would almost immediately have destroyed his dark adapted vision.

"Drawing in the dark" could never have relied on light from the Moon, since it is only in the *absence* of a bright Moon that faint features could be visually discerned through the eyepieces of Lord Rosse.

Dark adapted eyes are best preserved in the presence of only a certain kind of light: photons of long wavelength (red light). Rods respond little to red light. Sir John Herschel knew this well. It is most intriguing to have learnt from world renowned historian Professor Owen Gingerich at Harvard University, that the great astronomer Johannes Kepler himself, in his *Astronomia Nova*, mentions how he had to use a glowing coal to read the scales on his sextant because it was too windy to use a candle. Glowing coals would best preserve dark adapted eyes!

In the translation of the *Astronomia Nova* by Donahue, Kepler writes:

> *I think we are 10 minutes too high. For the wind was blowing so hard that it was only by a glowing coal that we could cast light upon the scale so as to read it.*

Professor Gingerich further shared his thoughts with us:

> *I think if you look at the magnificent drawing of Eta Argus in Herschel's Cape Observations, or the details in Lord Rosse's drawing of M51, there is no way they*

could remember such intricate detail to recreate it later. Therefore it is entirely plausible that they used very dim lanterns, because when dark adapted not much light would be required, and they probably polished up the rough but detailed sketch the following morning.

Some further clues were kindly provided to us by Richard Handy in the United States. He drew our attention to *Reminiscences and Letters of Sir Robert Ball*, edited by W. Valentine Ball in 1915. Those reminiscences describe the period when Sir Robert Ball actually worked at Birr Castle, Parsonstown, in the period 1865–67. Sir Robert Ball had two principal duties: to tutor the three younger sons of Lord Rosse and to serve as an astronomer there.

Sir Robert Ball describes tutoring the three younger Rosse sons, as follows:

> *When I went to Parsonstown, in 1865, Lord Rosse was advanced in years. He no longer took an active part in the work of observation, but he evinced a lively interest in all. Lord Oxmantown, Lord Rosse's eldest son, was not one of my pupils. They were his three younger brothers, who are now the Hon. and Rev. Randal Parsons, the Hon. R. C. Parsons – a well-known engineer – while the youngest is the Hon. Sir C. A. Parsons. It has always been a great satisfaction to me to remember that I had the great honour of instilling the elements of algebra and Euclid into the mind of the famous man who has revolutionized the use of steam by his invention of the steam turbine. It would seem that he inherited his father's brilliant mechanical genius, with an enormous increase in its effect on the world.*

Robert Ball poignantly describes his observing at Birr Castle, thus:

> *Let me describe the scenes and conditions amongst which my life for the next two interesting years was to be passed. The residence of the Earl of Rosse is at Birr Castle, in King's County, about eighty miles from Dublin. Birr Castle is situated at the little town, which was then officially known as "Parsonstown," but to the inhabitants as "Birr." Quite recently I believe the*

official designation has been abandoned, and the Post Office only recognizes "Birr." Birr Castle is a noble building of modern erection, surrounded by a moat. It is situated in a beautiful park, through which two pretty rivers flow, and these unite in a single stream before they leave. The park has also a large artificial lake, ingeniously constructed by Lord Rosse himself, which is the perennial home of innumerable wild duck. Several instances of Lord Rosse's consummate mechanical skill are to be found about the grounds. Visitors used to stand gazing in wonder on a water-wheel which, being turned by the waters from the lake, raised water from a drainage system connected with low-lying lands around. A suspension bridge was thrown across the river close to the castle. The outstanding feature of Birr Castle, by which it will be forever famous in the annals of science, is the mighty telescope. Between the lake and the castle are two great walls, which are now somewhat overgrown with ivy. I have been told that Visitors entering the gates of the park for the first time have driven up to these walls in the belief that they were approaching the castle itself, which is not visible from the park gates. Between these two walls there swings a tube sixty feet long and six feet in diameter – a tube large enough to be the funnel of a good size steamship. At the lower end of this tube is the mighty mirror or speculum. Lord Rosse's telescope is what is known as a "reflecting telescope" – a reflecting telescope of the Newtonian type. The instrument is raised by means of a winch, which is place towards the north, and the observers who are to use the telescope have to make their way to the galleries. It is characteristic of this type of telescope that the eye-piece is at the top of the tube, not, as in the refracting instruments; at the bottom four men had to be summoned to assist the observer. One stood at the winch to raise or lower, another at the lower end of the instrument to give it an eastward or westward motion as directed by the astronomer, while the third had to be ready to move the gallery in and out, in order to keep the observer conveniently placed with regard to the eye-piece. It was the duty of the fourth to look after the lamps and attend to minor matters.

Lamps indeed!

Sir Robert Ball continues:

On fine evenings I would go to the observatory as soon as it was dark. The observatory proper was a little building containing two small instruments, close under the shadow of the two great instruments outside. One of these was the great reflector already mentioned. The other was the "three-foot instrument" that is to say, an instrument having a mirror three feet in diameter, the tube of the telescope being ten times as long as the width of the mirror. The great six-foot instrument was, however the one which we employed for important observations. I shall suppose that we are ready to commence a night's work. The assistants above referred to are already at their posts. Up we climb to the lofty gallery, taking with us a chronometer, our observing book, various eye-pieces, and a lamp. The "working list" as it is called, contains a list of the nebulae, which we want to observe. A glance at the book and at the chronometer shows which of these is coming into the best position at the time. The necessary instructions are immediately given to the attendants. The observer, standing at the eye-piece, awaits the appointed moment, and the object comes before him. He carefully scrutinizes it to see whether the great telescope can reveal anything which was not discovered by instruments of inferior capacity. A hasty sketch is made in order to record the distinctive features as accurately as possible.

It was clear that the "lofty gallery" could accommodate heavy items of equipment. We read in the following section (also from Sir Robert Ball) that …

Lord Oxmantown was also an assiduous observer. Many a night did we spend together at the great telescope. Astronomy was just then beginning to quicken with new life under the great impulse that had been given to it by recent spectroscopic discoveries. A spectroscope (then regarded as of colossal dimensions, for it weighed about seventy pounds, though that itself would be nothing in comparison with the spectroscopes now used at the Yerkes Observatory) had been built from Lord Rosse's design. By means of it we saw that superb spectacle, certain lines in the spectrum which announced the gaseous character of the Nebula in Orion.

With infinite patience Lord Rosse devoted years to making a drawing of the Great Nebula.

We wanted to know more about the kind of lantern that the Birr Castle observers used to preserve their dark vision. Their patience was astounding; the drawing of the Orion Nebula (Figure 35) was based on almost twenty years of observation. We were on a detective trail to actually locate such a lantern, with absolutely no leads as to the details of such lamps or lanterns, until David contacted Andrew Stephens in the United Kingdom. Andrew Stephens has a great interest in the history of astronomy, and has a large collection of antiquarian books, including drawings by Charles Messier. Moreover, Mr Stephens has close ties with the present Lord and Lady Rosse at Birr Castle – and herein comes a most extraordinary discovery.

Could it be true that the lamps used by Lord Rosse actually had a brownish-yellow glass in front of them, so as to allow intricate details seen in the eyepiece to be transcribed to paper by Lord Rosse and his assistants?

By a lucky coincidence, the present Lord and Lady Rosse had recently cleared the attic space above a workshop tower used for scientific experiments, and the photographic dark room. Among the objects discovered here was a mysterious lantern …

The answer: Item found!

Lady Rosse communicated to Andrew Stephens that she had located a lantern (Figure 36), with a yellow brown glass! She writes: "John Weafer found it when we started to get into the attic area at the top of the tower."

What is most extraordinary about the discovery is that the lamp or lantern does not have transparent glass in front of it, but rather a brown-yellowish glass. A lantern with a filter, to preserve dark adapted eyes, while at the same time allowing some of the finest astronomical drawings ever made, to emerge from Birr Castle!

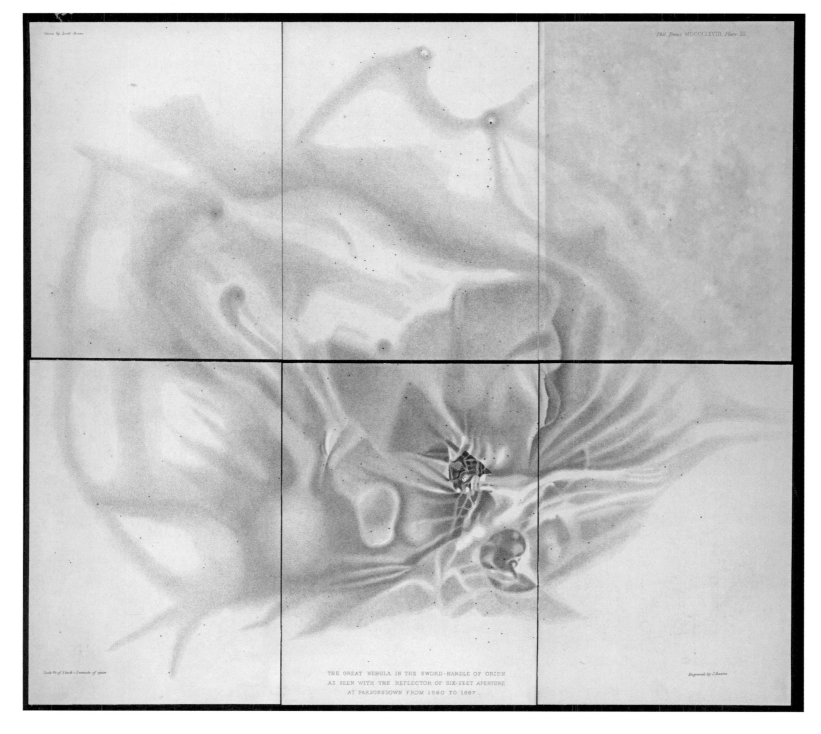

THE GREAT NEBULA IN THE SWORD-HANDLE OF ORION
AS SEEN WITH THE REFLECTOR OF SIX-FEET APERTURE
AT PARSONSTOWN FROM 1860 TO 1867.

Scale 9/4 of 1 inch = 1 minute of space

Engraved by J.Basire

Figure 35 [408]

Andrew Stephens writes:

Figure 36 [409]

Looking at the lamp we can deduce it sat over an oil burner which would have fitted in the bottom, this being a vessel containing an oil, probably whale oil, and a small wick casting a low intensity, reddish light, sufficient to illuminate a page of drawing paper, but not so bright as to destroy the sensitivity of a dark adapted eye to any great extent … we can also guess there would have been some sort of "funnel" fitting over the metal rim visible at the top. We might guess this would have been made of glass or metal and when in place would have ensured the wick burned evenly and without flickering too much even in a light wind.

The most extensive all-sky surveys before the photographic era were conducted by father and son Sir William Herschel and Sir John Herschel, from about 1780 to 1860. The detector was the eye. South Africa features prominently in the story, for it was from there that the monumental survey of the southern skies was undertaken.

Sir John Herschel departed from Portsmouth on board a wooden (teak) sailing ship, the Mount Stewart Elphinstone – belonging to the Dutch East India Company – on 13 November 1833, arriving safely at the Cape of Good Hope, South Africa on 15 January 1834.

The explorer William John Burchell (1781–1863) in his *Travels in the Interior of Southern Africa* poignantly describes the view of land from sea, as one nears the Cape of Good Hope. He writes:

> *At five in the afternoon, (13th November, 1810) the sailors on deck, who had for some time been anxiously looking out, called to us that land was in sight. At this pleasing intelligence we hastened up from the cabin, and although nothing could be seen but a small cloud, which seemed fixed on the horizon, and was at first not very easily to be distinguished, the captain, who was well acquainted with the singular appearance of the cloud which rests on the Table Mountain during a south-east gale, declared that the land which we had now before us was that of the Cape of Good Hope.*

> *It appeared gradually and slowly rising out of the ocean, while our sails, well fitted with the gentle gale, bore the gliding vessel of the deep … Every other thought was banished, and our whole attention was now turned towards the distant cloud … every mile we advanced added some agreeable idea to the animating anticipation of my feelings on first setting foot on the land of Africa … Table Mountain and Lion's Head were very easy to be recognized by the peculiarity of their form … the remarkable cloud which covered the top of Table Mountain, resting upon it with all the appearance of a ponderous substance … Its thin misty skirts no sooner rolled over the edge of the precipice, than they rarefied into air and vanished … The western part of Table Mountain, with its rocky precipitous side cleft in deep ravines, rose majestically out of the ocean …*

> *As we advanced nearer the shore, the mountains displayed an imposing grandeur, which mocked the littleness of human works: buildings were but white specks; too small to add a feature to the scene; too insignificant either to adorn or to disturb the magnificence of nature.*

Table Mountain was well known to early explorers (Figure 37) and astronomers (Figure 38). A photograph secured in ca. 1880s of the grand Table Mountain is reproduced in Figure 39.

From naturalists and botanists such as William Burchell (after whom Burchell's rhinoceros – the famous white rhino – and Burchell's zebra *equus burchelli* are both named) to astronomers such as Sir John Herschel, the Cape was to open up multitudes of treasures, from the Earth spawning its flora and fauna below, to the starry skies above.

Writes N.S. Dodge of Sir John Herschel's anticipation to explore the southern skies, whilst on board the Mount Stewart Elphinstone:

> *No one knew so well as the great astronomer of whom we write, even before, while recumbent on the deck of the vessel that was bearing him through the tropic zone, he watched for hours together the shifting panorama of the star-fretted vault, how the moon appeared brighter, fairer, and better defined through a more transparent atmosphere; how the planets seemed to be other orbs; how the stars, long watched in a northern sky, drooped toward the horizon, and were at length looked for in vain; how orbs, which, to his former vision, had modestly moved along the southern outskirts of visible creation, now marched majestically overhead, each "Walking the heavens like a thing of life," while new and strange bodies ascended high and higher, until the old earth had passed away and a new heaven was aloft; nor how the Via Lactea, in the neighborhood of the Centaur and the Cross, coupled with profuse collections of nebulae and asteroids, stars and constellations, makes the southern sky the most magnificent star-view from any part of earth. Like the sources of the Nile to the untraveled geographer, or the ice-cliffs of Greenland to the student of arctic voyages, he knew well what a personal inspection would place before him, and though the civilized world rang with applause at his sacrifice of home and its comforts, and country and its honors, for the sake of science, yet true philosophers knew that the compensation, present and future, far outweighed the loss.*

Pl. II.

VUE DU CAP PRISE ÉTANT SUR L'ISLE ROBIN.

MONTAGNES DU CAP VUE EN MER DU COTE DE L'OUEST.

VUE DU CAP DE BONNE ESPERANCE PRISE EN RADE.

A. Montagne du Diable. B. Montagne de la Table. C. Tête du Lion. D. Croupe du Lion. E. Pointe des Pendus.

Amelie F.e Coiny Sculp.

Figure 37 [409]

Shrouds of the Night
76

Figure 38 [409]

Figure 39 [409]

In his own words, Sir John Herschel describes his aim in traveling to South Africa:

> *I resolved to attempt the completion of a survey of the whole surface of the heavens, and for this purpose to transport into the other hemisphere the same instrument which had been employed in this, so as to give a unity to the results of both portions of the survey, and to render them comparable with each other ... Having disembarked the instruments [a reflecting telescope of 18¼ inches clear aperture and 20-feet focal length and a telescope of five inches aperture and seven feet focal length, used for the measurement of double stars] ... my next care was to look out for a comfortable residence in a locality suitable for their erection. This I was fortunate enough speedily to find at the mansion of a Dutch proprietor, W.A. Schonnberg, Esq., bearing the name of Feldhuysen, or Feldhausen, about six miles from Cape Town, in the direction of Wynberg, a spot charmingly situated on the last gentle slope at the base of Table Mountain ...*

Sir John Herschel writes of Feldhausen:

> *... well sheltered from dust, and, as far as possible from wind, by an exuberant growth of oak and fir timber; far enough removed from the [Table] mountain to be, for the most part, out of reach of annoyance from the clouds which form so copiously over and around its summit, yet not so far as to lose the advantage of the reaction of its mural precipices against the south-east winds which prevail with great violence during the finer and clearer months, but which seldom blow home to the rock on this side ...*

Accompanying John Herschel and his family to the Cape, was his assistant John Stone.

In England, Sir John Herschel had

> *engaged the services of an attendant for the purpose of working the sweeping, and other mechanical movements, of the Reflector during the observations, and executing any necessary repairs. John Stone, the person so engaged, to the useful, and, indeed, indispensable qualifications of a ready mechanic, whether in wood*

or iron work, joined that of experience in this particular employment, having performed that office for me during a considerable portion of my review of the northern heavens, with undeviating steadiness and regularity, as he continued to do during the whole of that of the southern, without once absenting himself from his duty.

<div align="right">(ITALICS, OURS)</div>

John Herschel would scan the skies, searching for new objects, by "sweeping" of the sky with his reflecting telescope. He would move the telescope (Figure 40) in zones of 3 degrees breadth (the equivalent of six full moons). These observations were executed "...in the absence of the moon, on all occasions when weather permitted, and the definition of the stars was such as to render it worth while to do so."

John Herschel had brought with him three metal mirrors for use in his reflector telescope:

> *... one made by my Father, and used by him in his 20-feet sweeps, and other observations; one made by myself, under his inspection and instructions; and one which I ground and figured subsequently, but which was cast at the same time, and from the same metal as that last mentioned. They are each 18¼ inches of clear diameter of polished surface, and all, so far as I am able to judge, equally reflective when freshly polished, and in every respect similar in their performance.*

(In Herschel's day, the mirrors in reflecting telescopes were made of metal, usually speculum metal, an alloy of copper and tin. Small quantities of other metallic elements such as arsenic would make the metal whiter and more reflective. Modern telescope mirrors usually consist of glass, Pyrex, quartz or low expansion ceramics upon which coatings of silver or aluminum are deposited in vacuum conditions.)

Sir John Herschel describes the famous dark "Coalsack" in the southern sky, as follows:

> *... that singular vacuity on the south following side of the [southern] cross, called the "Coal-sack," a pear-shaped oval, whose greatest length is about 8 degrees,*

Museum Africa, Johannesburg: H113

and breadth 5 degrees, the longer axis being nearly parallel to the line joining α and β Crucis ... As this is always regarded by voyagers and travelers as one of the most conspicuous features of the southern sky, it may not be irrelevant to state a few particulars as to its telescopic constitution. It is by no means entirely devoid of stars ... Its striking blackness is, therefore, by no means owing to an absolute want of telescopic stars, but rather to its contrast with the very rich portion of the Milky Way adjacent ...

Sir John Herschel's observations of the Magellanic Clouds opened to astronomers the detailed structure or morphology of these objects for the first time.

Of the Nubecula Major and the Nubecula Minor (the Large and Small Magellanic Clouds), Sir John Herschel comments:

The general appearance of these objects to the naked eye in a clear night and in the absence of the moon (whose light completely effaces the lesser and almost also the larger of them), is that of pretty conspicuous nebulous patches of about the same intensity with some of the brighter portions of the milky way.

When examined through powerful telescopes, the constitution of the Nubeculae, and especially of the Nubecula Major, is found to be of astonishing complexity.

Herschel compiled a preliminary catalogue of 1163 stars, nebulae and clusters of stars in the Magellanic Clouds.

He sketched the Magellanic Clouds with extraordinary perceptiveness, using a lamp-light and the naked eye.

I consider, therefore, that it will not be irrelevant to lay before the reader such representations as I have been able to make of them, entirely without telescopic aid, when seated at a table in the open air, in the absence of the moon, and with no more light than absolutely necessary for executing a drawing at all.

Herschel identified *spiral structure* in the Large Magellanic Cloud as well as a *central bar*, which we shall further explore in Chapter 11. Sir John Herschel uses rich imagery ("an axis of light") to describe the bar which he visually discerned in that object.

We are most grateful to astronomer David Malin for drawing our attention to the following quote by Sir John Herschel:

> *To the naked eye ... the greater nubecula [the Large Magellanic Cloud] exhibits the appearance of an axis of light (very ill-defined indeed, and by no means strongly distinguished from the general mass) which seems to open out at its extremities into somewhat oval sweeps ...*

The monumental survey of the southern starry vaults by Sir John Herschel was published in 1847, in a volume entitled: "Results of Astronomical Observations made during the years 1834, 5, 6, 7, 8, at the Cape of Good Hope; being the completion of a telescopic survey of the whole surface of the visible heavens, commenced in 1825."

The survey lists 1708 nebulae and clusters and 1202 double stars. Herschel had swept the entire southern sky in only four years (1834–38). The sheer amount of work in the catalogues alone which are contained in the above volume, leaves the reader almost gasping for breath. Then, there were his outstanding astronomical drawings (Figures 41–43). Herschel would prepare grids for his drawings, carefully positioning stars on these grids, before sketching the object itself – such as the Orion Nebula – on these "working skeletons." Herschel mentions using a lamp-light at the telescope to produce his masterful drawing of the Orion Nebula (Figure 42). Extraordinary patience, indeed: from January 1835 to December 1837 the grid for the drawing of the Orion Nebula was painstakingly laid out and carefully corrected.

In addition to the above, John Herschel used the method of "star gauging" to establish the distribution of stars in our Milky Way. "Star gauging" consists of counting the number of stars in selected circular fields of the telescope and then adding their sums to obtain an average (or mean) count. These gauges revealed striking differences in the density of stars in various parts of the sky. Herschel gauged or counted 68 948 stars in 2299 different telescopic

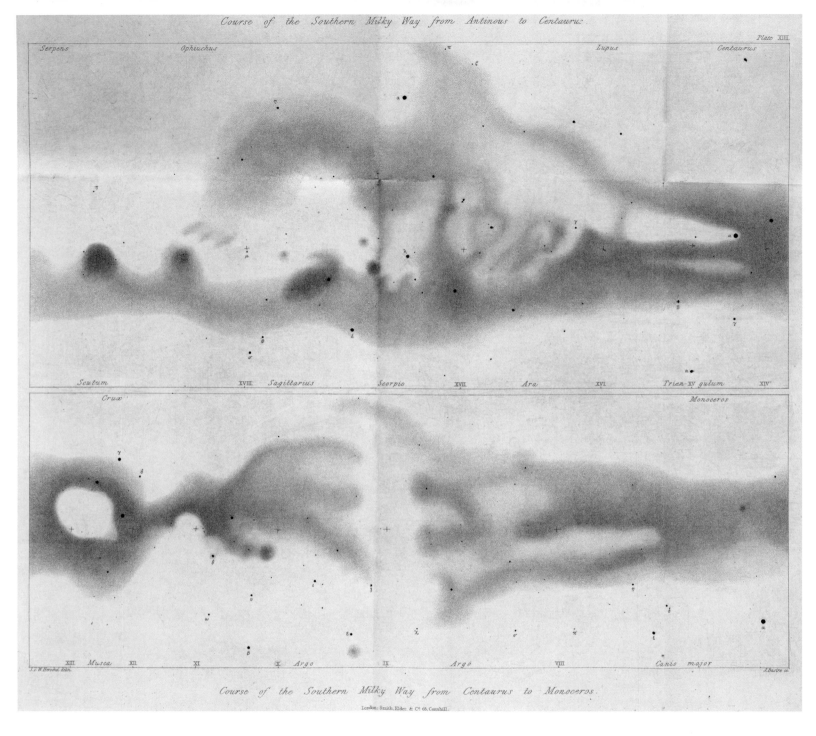

Figure 41 [409]

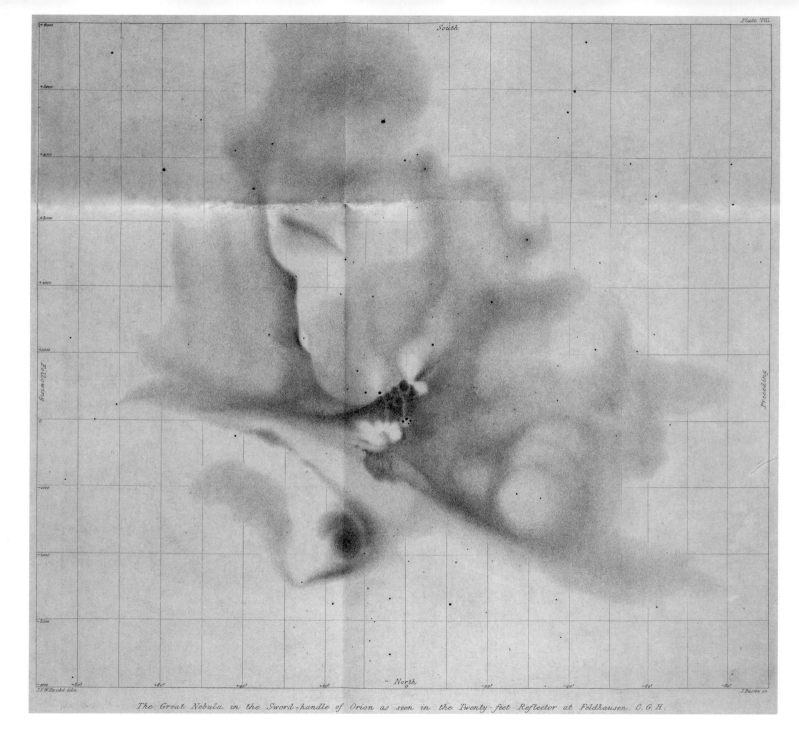

The Great Nebula in the Sword-handle of Orion as seen in the Twenty-feet Reflector at Feldhausen, C.G.H.

Figure 42 [409]

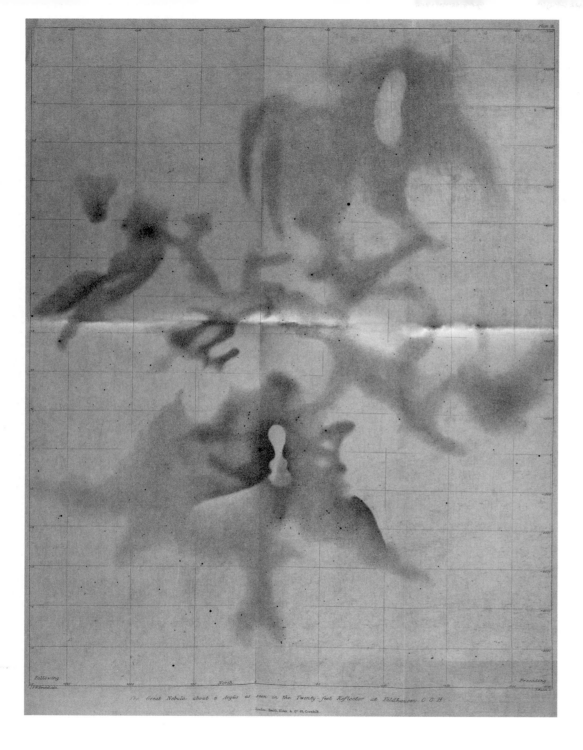

The Great Nebula about η Argūs as seen in the Twenty-feet Reflector at Feldhausen C.G.H.

London: Smith, Elder & Co. 65, Cornhill

Figure 43 [410]

fields and noted that his star counts increased toward the plane of our Galaxy. "Nothing can be more striking," Sir John wrote, "than the gradual, but rapid increase of density on either side of the Milky Way as we approach its course."

Below follows a few of his descriptions of the districts of the southern Milky Way:

> *Here the Milky Way is composed of separate, or slightly, or strongly, connected clouds of semi-nebulous light; and, as the telescope moves, the appearance is that of clouds passing in a scud as the sailors call it … The Milky Way is like sand, not strewed evenly as with a sieve, but as if flung down by handfuls (and both hands at once), leaving dark intervals, and all consisting of stars … down to nebulosity, in a most astonishing manner.*

> *After an interval of comparative poverty, the same phenomenon, and even more remarkable. I cannot say it is nebulous. It is all resolved, but the stars are inconceivably numerous and minute. There must be millions on millions, and all most unequally together …*

> *…we see, foreshortened, a vast and illimitable area scattered over with discontinuous masses and aggregates of stars in the manner of the cumuli of a mackerel sky, rather than of a stratum of regular thickness …*

In his 1847 volume, John Herschel pays much attention to the *classification* of the nebulae.

Eneas Sweetland Dallas (1828–1879) is believed to be the author of a book entitled *Three Essays*, a copy of which was owned by Sir John Herschel. In the *Three Essays*, published in 1863, we read these words:

> *Every principle of classification is a conception to be applied to the plan of nature for verification. The mode in which a classification is verified, or found truly to represent the plan of nature, is in finding the characteristics chosen as distinctive of the classes, orders, and genera, predominant in the same degree in nature as*

in the classification – so predominant that when we speak of the qualities which distinguish the classes we find we speak of truths of wider generality than when we speak of the qualities which distinguish the orders, and so forth ... a true system of classification, such as shall be verified in nature, reduces the mass of facts from a confusion which none can follow to an order which none can mistake.

In the same chapter, the author of *Three Essays* quotes Sir John Herschel as follows:

"Classification in such a case," says Sir J. Herschel, "is only another word for the announcement of general laws, the result of inductive observation – results, that is to say, of a more elevated order than those which depend on a mere remarking of general resemblance, or even on the specifications of particular arbitrary selected points on which logical proof of such resemblance can be rested."

Before we can enter into any thing which deserves to be called a general and systematic view of nature, it is necessary that we should possess an enumeration, if not complete, at least of considerable extent, of her materials and combinations; and that those which appear in any degree important should be distinguished by names which may not only tend to fix them in our recollection, but may constitute, as it were, nuclei or centers, about which information may collect into masses. The imposition of a name on any subject of contemplation, be it a material object, a phenomenon of nature, or a group of facts and relations, looked upon in a peculiar point of view, is an epoch in its history of great importance.

<div align="center">

WROTE JOHN HERSCHEL IN HIS BOOK *A PRELIMINARY DISCOURSE ON THE STUDY OF NATURAL PHILOSOPHY* FIRST PUBLISHED IN 1830.

</div>

Embarking upon unexplored scientific territories, Sir John Herschel expresses his thoughts thus:

The character of the true philosopher is to hope all things not impossible, and to believe all things not unreasonable. When once embarked on any physical research, it is impossible for anyone to predict where it will ultimately lead him.

The true answer of science is that which again is at once the parallel and the illustration of the language of the apostle, "The mysteries of knowledge, which in other ages were not made known unto the sons of men, are now revealed, and will be still more revealed to those whom God has chosen." Or still again, "The students of science are as messengers from Heaven to earth to make such stupendous announcements, that they may claim to be listened to when they repeat in every variety of urgent instance, that these are not the last announcements they have to communicate; that there are yet behind, to search out and to declare, not only secrets of nature which shall increase the wealth and power of men, but truths which shall ennoble the age and country in which they are divulged and, by dilating the intellect, react upon the moral character of man-kind."

While at the Cape, Sir John Herschel produced a most impressive set of drawings using a camera lucida:

The camera lucida superimposes by means of a prism a virtual image of any view on the plane of a drawing board so that it can be traced by an artist. There is no projected image, but only a virtual one. In other words, by looking into the prism of the camera lucida at just the correct angle, two images enter the eye; one, of the landscape or object to be sketched, the other of the pencil and paper with which the artist intends to draw with. The resulting effect is that, with the camera lucida, the eye perceives the scene to actually lie superimposed on the drawing paper – while in reality it does not. The superposition of scene and drawing paper affords the artist the opportunity to trace nature in perspective, using a pencil. Only the artist sees the superposition of both scene and paper; an on-looker would not see any virtual image on the drawing paper at all. What added to its great use by artists was that the camera lucida was a highly portable device.

Writes N.S. Dodge: "Like a child, he went to Nature's school to learn what she had to teach."

Sir John Herschel was a most extraordinary *observer*. His interests spanned cosmic horizons in the broadest of senses, making contributions to ornithology, geology, botany, mathematics and chemistry – apart from his chief passion, astronomy. His camera lucida sketches (some of which are reproduced in Figures 44–46) show a meticulous attention to detail.

Figure 44 [410]

Figure 45 [410]

Figure 46 [410]

He was keenly aware of the interface between observation and theory:

> *"First let, me mention," Sir John Herschel writes "that if we should hope to make any progress in investigations of a delicate nature, we ought to avoid two opposite extremes, of which I can hardly say which is the most dangerous. If we indulge a fanciful imagination and build worlds of our own, we must not wonder at our going wide from the path of truth and nature; but these will vanish like the Cartesian vortices that soon gave way when better theories were offered. On the other hand, if we add observation to observation, without attempting to draw, not only certain conclusions, but also conjectural views from them, we offend against the very end for which only observations ought to be made."*

In the 1847 volume, Herschel concludes:

> *The record of its site [where the Reflector stood] is preserved on the spot by a granite column erected after our departure by the kindness of friends, to whom, as to the locality itself and to the colony, every member of my family had become, and will remain, attached by a thousand pleasing and grateful recollections of years spent in an agreeable society, cheerful occupation, and unalloyed happiness.*

In the space of only four years at the Cape, John Herschel had accomplished more than some may hope to achieve in a lifetime. The Herschels began their sea voyage back to England on 11th March 1838.

In her book entitled *The Herschels and Modern Astronomy*, Agnes M. Clerke sums up John Herschel's "southern sojourn" thus:

> *… enchanting scenery, translucent skies, blossoming glens and hillsides worthy of Maeldune's Isle of Flowers, contributed to render his southern sojourn a radiant episode. He wrote of it … as "the sunny spot in my whole life, where my memory will always love to bask." But "the dream," he added, "was too sweet not to be dashed by the dread of awakening." That spell was broken when in the middle of March, 1838, he sailed in the Windsor Castle for England.*

Star clusters, galactic nebulae and galaxies were catalogued by the Herschels, and descriptions were provided. Nebulae were classified according to "magnitude" (great, large, middle, small, minute), "resolvability" (discrete, resolvable, granulated, mottled and milky) as well as "brightness," "roundness" and "condensation" (see Figure 47). One nebula might be "middle-sized, bright, round, stellate, resolvable" while another might be "small-sized, dim, elongated, discoid, milky." Sir John Herschel also applied the term "falcated" to certain nebulae in the form of a sickle (falcated is derived from the Latin *falcatus*, sickle).

What a tremendous source of joy it is to personally hold and to examine many of the Herschel drawings of the nebulae in one's hand, at the library of the Royal Astronomical Society of London. An astonishing 4630 objects were actually discovered by William and John Herschel.

The morphologist needs to see, to examine, important structural features of galaxies (such as resolving stars in the spiral arms of myriads of "nebulae") – this awaited the dawn of the photographic era. The classification of galaxies – grouping them into different families of form or morphology – is both a science and an art. We can say that it is a science, because the appearance or form of galaxies is determined by the scientific processes that took place as each galaxy formed and developed with time. Although classification surely has a scientific

Figure 47 [410]

basis, one cannot place too much emphasis on classification as a science, because we still do not really understand all of the processes which determine the appearance of any particular galaxy. Even now, in the classification scheme of Hubble, the openness of the spiral arms is a primary classification criterion. But we do not fully understand why some galaxies have open spiral arms and others are much more tightly wound.

Galaxy classification began before astronomers knew that galaxies were huge systems lying outside the Milky Way. The early classifiers, like Reynolds (whom we will meet later in Chapter 7), based their classifications on what they *saw*, not what they *understood*. In that sense, their classifications had an element of subjective judgement, with the classifier at liberty to decide what is important. That is the art, working out what is significant even when the science is not understood.

It takes the most astute of eyes to identify features which are important for defining morphological families – especially when astronomers do not know all the physics which lie behind these features. But that is how it should be. As Allan Sandage has stressed, the physics must not be used to drive the classification of galaxies. There is no place for preconceived notions about the science that underlies galaxy classification. Marjorie Nicholson, in writing about the influence of the microscope and telescope – the worlds of the microcosm (Figure 48) and macrocosm – writes about the Divine Artist thus: "…the Divine Artist, who draws in little as exquisitely as in large … God alone may rejoice in an Art which is as perfect as Nature; for … 'Nature is the Art of God.'"

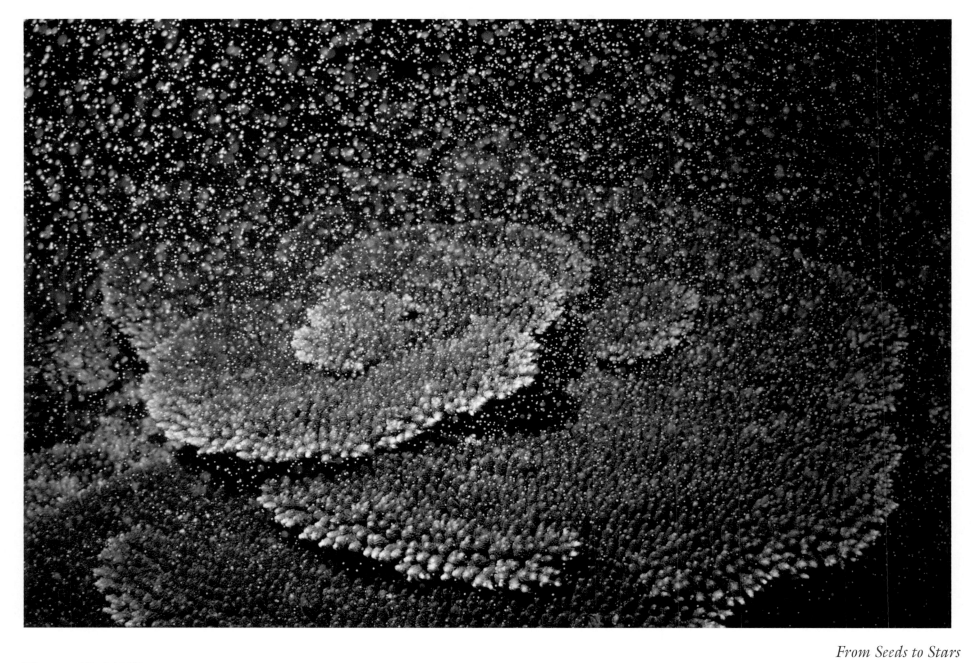

Figure 48 [410]

The Dawning of the Photographic Era

uch has been written about the fathers of photography. The first recognizable image formed by a camera obscura (an optical device used in drawing, described further below) was secured by Joseph Nicéphore Niépce (1765–1833) in ca. 1826. This extraordinary image shows the view through a window at his country house near Chalon-sur-Saône. The exposure time was some eight to ten hours. He termed his process "héliographie" or "heliography" ("sun-writing" or "sun-drawing"). Niépce had placed within his camera obscura a polished pewter plate coated with bitumen of Judea (an asphalt derivative of petroleum), and found that the view through the window had been "drawn" on the plate by means of exposure to sunlight. Eleven years later, in 1837, Louis Jacques Mandé Daguerre (1789–1851) made his first Daguerreotype. Daguerre used a thin film of polished silver on a copper base, sensitized with vaporized iodine and developed with the fumes of mercury. In other words, in a Daguerreotype, the image formed on a sheet of copper, plated with a thin coat of silver – there was no "negative."

Meanwhile, the dream to permanently record images was also birthed in the mind of William Henry Fox Talbot (1800–1877). In October of 1933, Talbot visited Lake Como in Italy, making sketches of the breathtaking scenery using a camera obscura. The camera obscura (from the Latin for "dark chamber" or "dark room") used by Talbot, "resembles a modern reflex camera. A lens at one end of the box throws an image to a mirror at the other end placed at forty-five degrees. The mirror in turn reflects the image onto a ground glass screen which forms the top of the box" writes Beaumont Newhall. Talbot could then place a translucent paper over the ground glass and sketch the scenery visually by hand, using a pencil.

In a poem by William Cowper entitled "The Task" we read:

To arrest the fleeting images that fill
The mirror of the mind, and hold them fast,
And force them sit, till he has pencilled off
A faithful likeness of the form he views.

To "arrest" the "fleeting images" ... Talbot has himself noted that ... "...the practice [is] somewhat difficult to manage, because the pressure of the hand and pencil upon the paper tends to shake and displace the instrument (insecurely fixed, in all probability, while taking a hasty sketch by a roadside, or out of an inn window) ..."

Talbot reflected: "on the immutable beauty of the pictures of nature's painting which the glass lens of the camera throws on the paper in its focus ... fairy pictures, creations of a moment and destined as rapidly to fade away ... It was during these thoughts that the idea occurred to me – how charming it would be if it were possible to cause these natural images to imprint themselves durably and remain fixed upon the paper." (W.H. Talbot, in *The Pencil of Nature*.) In 1834, Talbot experimented with his famous *photogenic drawings,* by placing a leaf, or fern, or a section of lace, on the surface of sensitized paper, exposing it to the Sun and then "fixing" it – a term used to prevent further action of light upon the sensitized paper. (Sir John Herschel had discovered the fixing process of using sodium thiosulfate – also called sodium hyposulfite, or more commonly, "hypo" – in 1819.) Photogenic drawings did not require a negative. A year later, in 1835, Talbot made the earliest known surviving photographic negative on paper. Talbot sensitized paper by giving it repeated and alternate washes in salt and silver solutions. Using the paper in a moist state, Talbot could secure an image with the camera obscura in exposure times of about ten minutes.

Talbot's findings were read to a meeting of the Royal Society on 31 January 1839. His paper was entitled: "An Account of the Art of Photogenic Drawing or the process by which natural objects may be made to delineate themselves without the aid of the artist's pencil." In that same year, on March 14, 1839, Sir John Herschel (Figures 49 and 50) presented to the Royal Society, a paper entitled "Note on the art of Photography, or The Application of the Chemical Rays of Light to the Purpose of Pictorial Representation." It is to Sir John

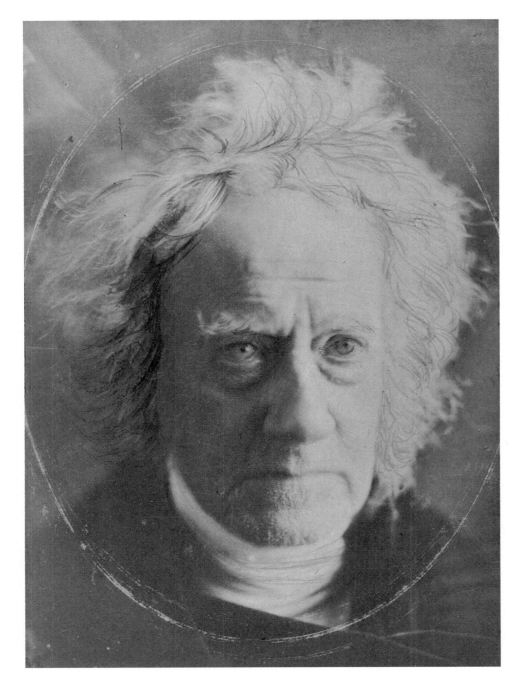

Figure 49 [410]

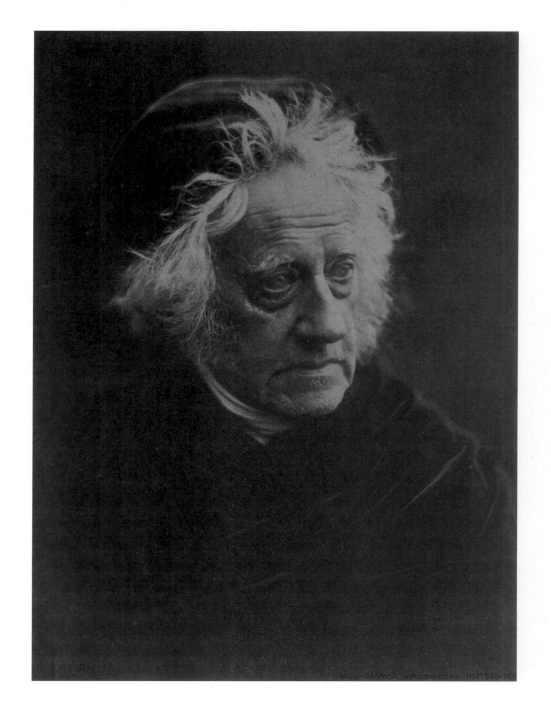

Figure 50 [411]

Herschel whom we owe the word *photography*, taken from the Greek *photos* (light) and *graphien* (to draw). Not only was Sir John Herschel an astronomer amongst astronomers, but his knowledge of chemistry leaves the reader spellbound. On February 20, 1840 he presented a paper to the Royal Society, entitled: "On the Chemical Action of the Rays of the Solar Spectrum on Preparations of Silver and other Substances, both metallic and non-metallic, and on some Photographic Processes" in which he writes:

> *We could hardly have predicted, a priori, for example, that, acting on one description of paper, the chemical spectrum ... should include within its limits the whole luminous spectrum, extending much beyond the extremest visible red rays on the one hand, and on the other to a surprising distance beyond the violet; while, if another paper is used, all action should appear definitively cut off at the orange; if another, at the commencement of the green; and if another, at that of the blue rays ...*

Herschel did not only restrict himself to the use of silver in the preparation of photographic papers, but he also experimented as follows:

> *Light has long been known to reduce the salts of gold as well as silver, and I have shown that platina in some of its combinations is also very powerfully affected by the same agent.*

Platina ... platinum. The most exquisite black and white photographic printing process today is produced using the noble metals of platinum and palladium. In the case of platinum, three elements comprise the metallic salt: these are potassium, platinum and chloride (the compound is known chemically as potassium chloroplatinite). The palladium salt contains sodium in place of potassium and is known as sodium tetrachloropalladate. Also required is a sensitizer salt containing iron, known as ferric oxalate. A piece of suitably chosen paper (such as the hundred percent cotton rag paper Arches Platine) is coated with the metallic salts of platinum and palladium in conjunction with the sensitizer salts of iron and the coated paper is then dried. A negative is next placed in direct contact with the paper so prepared, and carefully put in an ultraviolet light chamber, wherein energetic ultraviolet photons begin the process of reducing the platinum and palladium salts to their metal states. There is no

enlarger involved. The size of the platinum–palladium print is that of the original negative. Its tonal range is breathtaking (Figure 51).

What is so intriguing about the process is that the noble metals of platinum and palladium become embedded within the actual fibres of the matte paper – there is no coating of gelatin, as in the commonly used silver gelatin photographic process. Although the patenting of the platinum process only occurred in 1873 by William Willis (who found that platinum salts could be reduced to metallic platinum by using a developer of potassium oxalate), we should always remember those first steps by the pioneers Ferdinand Gehlen, Johann Dobereiner, Robert Hunt and … Sir John Herschel, in his experimentation of mixing salts of platinum with hydrochloric and nitric acids and calcium hydroxide and then exposing those papers to the rays of our closest star, the Sun.

As noted earlier, it was also Sir John Herschel who had paved the way for the "fixing" of photographic prints using "liquid hyposulphites for fixing the photographic impression, in virtue of the property they possess … of readily dissolving the chloride and other combinations of silver insoluble in the generality of menstrua."

Figure 52 is an image secured by Sir John Herschel, working with salted paper, showing the 4-foot telescope of his father, Sir William Herschel. A letter written by Sir John Herschel containing his comments on a method of treating daguerreotypes with a solution of gold to contribute to their permanence, is reproduced in Figure 53.

―――――――――――

Many experiments with photochemistry had taken place as early as 1725, by J. Schulze. The first published experiment, by T. Wedgwood and H. Davy, was in 1802. Talbot cites these experiments in *The Pencil of Nature*:

> *… I met with an account of some researches on the action of Light, by Wedgwood and Sir H. Davy, which, until then, I had never heard of … They succeeded, indeed, in obtaining impressions from solar light of flat objects laid upon a sheet of prepared paper, but they say they found it impossible to fix or preserve*

Figure 51 [411]

The Dawning
103

Figure 52 [411]

Figure 53 [411]

The Dawning
105

those pictures: all their numerous attempts to do so having failed ... And with
respect to the principal branch of the Art, viz. the taking of distant objects with
a Camera Obscura, they attempted to do so, but obtained no result at all ...

In the mind of the British botanist Francis Bauer, F.R.S., who befriended Joseph Nicéphore Niépce in his visit to Britain, it was Niépce – working at his Saint-Loup-de-Varennes country house, Le Gras – who should be credited with the invention of photography.

In September 1827, Nicéphore Niépce came to England to visit his brother Claude, who was seriously ill at Kew. It was in Kew that he met Francis Bauer. Nicéphore Niépce prepared a memoir to the Royal Society – having being urged to do so by Bauer – but he did not reveal the secret of his process, only speaking of it in general terms. (The memoir and specimens were never formally communicated to the Royal Society.) Nicéphore Niépce returned to France in January 1828; he obviously was disappointed by the lack of interest shown in Britain to his heliography.

Nicéphore Niépce died of a stroke in 1833. His name: unknown to the world at large. Silence prevailed for a few years. Then came the great news from France: the invention of photography, in January of 1839. The sensation: the daguerreotype by Daguerre. Francis Bauer was greatly displeased at the injustice done to Nicéphore Niépce, and contacted the Editor of the *Literary Gazette of London.*

Bauer's letter to the Editor, written from Eglantine Cottage, Kew Green, is dated February 27, 1839 and reads in part:

> *... my attention was attracted by the Literary Gazette, which reported an*
> *article from the Gazette de France, dated Paris January 6, 1839 and signed*
> *by H. Gaucherant, in which I find to my great surprise that M. Daguerre,*
> *well known for his Diorama, claims not only having been the first to discover*
> *this interesting and important art, but wants to imprint on it also his proper*
> *name!*

Bauer then refers to the famous verbal announcement made by the French mathematician, physicist, astronomer and politician François Jean Dominique Arago (1786–1853) to the Académie des Sciences in France, on January 7, 1839 regarding the discovery of Daguerre, and notes that:

> ... *the name of M. Niépce was not mentioned in this report, which, I insist, is incomprehensible ... the merit of the invention belongs no less to my estimable friend Nicéphore Niépce.*

Historical documents bear complete harmony to the claim by Francis Bauer F.R.S., that the First Photograph was taken by Nicéphore Niépce and that the rightful inventor was [the then deceased] Nicéphore Niépce.

Here follows the story, after Nicéphore Niépce returned to France from Britain in 1828. He did enter into a formal partnership with Daguerre on 14th December, 1829.

The commercial name of the company, as stated in the agreement, was to be Niépce–Daguerre. It is important to note the ordering of the names.

The company was to be devoted to "the purpose of cooperating in perfecting the said discovery *invented* by M. [Monsieur] Niépce and perfected by M. [Monsieur] Daguerre." (From Article 1 of the 1829 agreement signed by Niépce and Daguerre; italics ours. Source: "*La vérité sur l'invention de la photographie*" by V. Fouque, 1867; translated into English by E. Epstean in 1935.)

Article 3 of the 1829 Agreement reads: "As soon as the present agreement is signed, M. Niépce must confide to M. Daguerre ... the principle upon which his discovery rests ..." (from the book authored by V. Fouque, 1867).

In his book entitled *The Origins of Photography*, photo historian Helmut Gernsheim comments:

The partnership was somewhat unequal from the start. Niépce had to supply Daguerre with complete details of his process, while Daguerre's contribution consisted merely in "a new combination of camera obscura, his talents, and his industry". Evidently Daguerre had made no progress whatever with his photographic experiments so far, and he had nothing to show or to contribute.

Article 14 of the aforesaid 1829 agreement reinforces Niépce as inventor:

The profits of the partners ... will be distributed equally between M. Niépce in his capacity of inventor, and M. Daguerre for his improvements.

(SOURCE: V. FOUQUE. ITALICS, OURS)

Nicéphore Niépce died on 5th July 1833, at the age of 69 years. Now the drama unfolds: An "Additional Contract" of 9th May 1835, almost two years after the death of Nicéphore Niépce, is drawn up between Daguerre and Isidore Niépce, son of the late Nicéphore Niépce. The Niépce–Daguerre listing no longer appears in the original order as agreed to by the two living parties in 1829.

As elucidated by V. Fouque, Article 1 of the "Additional Contract" refers to the "firm name *Daguerre et Isidore Niépce* for the exploitation of the discovery invented by M. Daguerre and the late Nicéphore Niépce."

Daguerre is now first in the listing; the late Nicéphore Niépce is second, but he cannot defend himself. According to Article 1 of the additional (1835) contract, Daguerre is now the principal inventor of the process. What stark contrast to Article 3 of the 1829 agreement!

A "Final Contract" between Daguerre and Isidore Niépce – prepared in advance by Daguerre – insists that "the new process of which he [Daguerre] is the inventor and which he has perfected ... will carry the name *only of Daguerre.*" The Final Contract was signed on 13th June 1837.

One can rightly understand the sense of indignation of Francis Bauer in his letter of 27th February 1839, when the name and work of Nicéphore Niépce lay Shrouded in the Night.

Nicéphore Niépce had given his First Photograph to Francis Bauer before returning to France in 1828. When the world celebrated the public announcements of the invention of photography in 1839, Francis Bauer moved quickly to unveil the true inventor, Nicéphore Niépce.

Bauer had in his possession the First Photograph secured ca. 1826. Daguerre himself had affirmed Nicéphore Niépce as the inventor of fixing an image from nature, in the signed document of 14th December, 1829.

Francis Bauer died at Kew in 1840. The ownership of the Niépce materials moved to botanist Dr Robert Brown, F.R.S. in 1841 and were subsequently purchased by Robert Brown's assistant, John J. Bennett, in 1858. Following the death of Bennett, his estate was auctioned off in 1884. The original Niépce manuscript on heliography and his First Photograph were purchased by the Pritchard family. These items were shown in 1885, at the Photography Section of the International Inventions Exhibition in London. Thirteen years later, in 1898, the artefacts were once again borrowed from the Pritchard family and displayed at the Historical Section of the Royal Photographic Society's International Exhibition at Sydenham. It was after that Exhibition in 1898 that the whereabouts of the world's earliest photograph from nature were unknown – "lost." The priceless treasure was later "rediscovered" in England by the Gernsheim family, in 1952. It is now on display in Austin, Texas.

"What course photography would have taken had Niépce's invention been made public at this period [during his visit to England in late 1827 and early 1828] forms a fascinating speculation ... Niépce would certainly have not entered into partnership with Daguerre ..." reflects Helmut Gernsheim. "However," writes Gernsheim, "such speculations are idle ... [they] were clearly not interested in Niépce's invention."

On the paper backing of the original frame which held the photograph of the "View from the Window at Le Gras", Francis Bauer wrote by hand:

L'Heliographie.
Les premiers résultats
obtenus Spontanément
par l'action de la lumiere.

Par Monsieur Niepce
De Chalon sur Saone.
1827.

Monsieur Niépce's first successful
experiment of fixing permanently
the Image from Nature.

(The year 1827 is the year Bauer received the gift; the photograph is generally accepted to have been taken in France one year earlier. Two renditions of the First Photograph appear at the end of our book, as a famous gelatin silver print with watercolor, dated 1952 – and in a much more faithful and recent digital color reproduction. These are shown in Figures 191 and 192 respectively.)

From Niépce's view (c. 1826) from the window at Le Gras, to the public announcements in 1839 from research emanating from the Niépce–Daguerre partnership in France and Talbot in England, the photographic era was ushered in. The Pencilling of Nature had triumphantly moved from sketches on paper to images where photons of light were stored upon light-sensitized materials and recorded by photochemical means in realistic amounts of exposure times. We have a facsimile copy of *The Pencil of Nature* in our offices. In that extraordinary work, Talbot, a lover of classics, has the motto:

Juvat ire jugis qua nulla priorum Castaliam molli devertitur orbita clivo.

The lines are from Virgil, and freely translated read as follows: "Joyous it is to cross mountain ridges where there are no wheels ruts of earlier comers, and follow the gentle slope to Castalia."

Niépce–Daguerre and Talbot had indeed walked along roads where no wheels before had gone, using entirely different methods. To Talbot belongs the distinction of being the first person to publish a workable photographic system which could be adopted worldwide.

One of Talbot's early photographs is reproduced in Figure 54. Figure 55 shows an exquisite engraving by Talbot of lace – it reveals the most extraordinary detail. Talbot had patented a method of etching steel plates from which prints could be made with permanent ink, in 1852. The engraving seen in Figure 55 is dated 1853.

In his book entitled *The History of Photography*, author Beaumont Newhall describes the process: "[Talbot] first coated the plates with gelatine to which had been added potassium bichromate. On these sensitized plates he put an object – a blade of grass or a stalk of wheat [or a piece of lace] – and exposed it to light. All the areas except those shaded by the object where made insoluble by light action. Talbot then washed the plate, and the image was revealed in the bare metal, which he then etched." Talbot improved his technique in 1858 – this process, known as *photoglyphic engraving*, became the basic principle employed in the graphic arts process of *photogravure*.

In the early days of photography, exposure times were extremely long: Niépce's famous image ca. 1826, near Chalon-sur-Saône, was secured over a period spanning several hours. In 1839, the average exposure time for a Daguerreotype in bright weather could range between fifteen and thirty minutes. In 1841, portraits would typically require an exposure of between one to two minutes; a person being photographed would have to remain *very* still; in the early epochs of portraiture, children could easily appear out of focus.

In 1851, studio portraits using wet glass negatives required exposures ranging from forty seconds to two minutes. According to photo-historians Helmut and Alison Gernsheim, it was only in 1900 that exposure times of $1/250^{th}$ of a second became possible using gelatine emulsions. Tell-tale signs of long exposures are evident upon careful inspection of some images, such as in Figure 56.

Many of the early astrophotographic prints were made from negatives using the albumen printing technique. These included albumen prints by Paul and Prosper Henry (1886),

Figure 54 [411]

Figure 55 [411]

Figure 56 [412]

Warren de la Rue (1862) and Lewis Rutherfurd (1874). The albumen printing method had been invented only in 1850, by Louis Désiré Blanquart-Evrard, and was the first commercially exploitable method of producing a print on a paper base from a negative. It used the albumen found in egg whites to bind the photographic chemicals to the paper. The process is intriguing: A piece of paper is coated with an emulsion of egg white (albumen) and table salt. The albumen seals the paper and creates a slightly glossy surface. The paper is then dipped in a solution of silver nitrate and water, making the paper sensitive to light. The paper is dried in total darkness and is then placed in a frame under a glass negative which is exposed to direct sunlight until the image achieves the proper level of darkness. Albumen prints are placed in direct contact with the negative. The albumen print is therefore a printed rather than a developed photograph, because the image emerges as a direct result of exposure to light, without the aid of a developing solution.

An outstanding collection of early albumen silver prints were recently on display at the National Gallery in Canberra. The exhibit included Julia Margaret Cameron's "English Flowers" (1873), Augustine Dyer's "Narrative of the Expedition of the Australian Squadron to New Guinea" (1885), J.W. Lindt's "Portrait of an Aboriginal Woman" (1873–1874) and his "Studio Portrait of a Miner" (1872). The details in these albumen prints are exquisite; the tones often soft; the feelings invoked in the eye of the beholder, very deep. Albumen prints from egg whites became the dominant form of photographic positives from 1855 to the turn of the twentieth century, with a peak in the period 1860–90 (Figures 57 and 58).

Although some successful photographic images of the Moon had already been shown in public exhibitions – such as the 1851 Daguerreotype by John Adams Whipple, or photographs on paper by Warren de la Rue, Henry Draper, and Lewis Rutherfurd – they had not been made readily accessible. The year 1865 saw the invention of a mechanical printing process known as the Woodburytype (after W.B. Woodbury), which allowed for the placing of photographs in the illustrations of books. The basis of the Woodburytype is essentially an image on a carbon tissue, which consists of different thicknesses of gelatin.

Figure 57 [412]

Figure 58 [412]

This was hardened and then dried before being put in a press with a lead sheet, to produce a matching indentation in the lead. This lead plate is then inked with a pigmented gelatin, which is next printed onto paper to yield the image. Approximately one hundred images could be printed from a lead plate. One of the first books to be illustrated using the Woodburytype method with its carbon-based inks was entitled *The Moon: Considered as a Planet, a World, and a Satellite* by Nasmyth and Carpenter, published in London in 1874. Nasmyth produced twenty-four photographs consciously designed for publication in this innovative medium.

Prior to the dawn of the photographic era, seeing was the only source of knowledge available to the Victorian enquirer. The volume by Nasmyth and Carpenter was one of the first books which allowed for the placing of photographs to serve as a "reliable" record of Nature. A pair of photographs entitled "Back of Hand & Wrinkled Apple" is reproduced in Figure 59, while Figure 60 – bearing the title of "Full Moon" – is a Woodburytype photograph secured by Warren De la Rue and Joseph Beck. Of great interest is that the famous lunar photographs by Nasmyth and Carpenter (three of which are seen in Figures 61–63) are actually photographs of small plaster models of the Moon. These photographs served as very early attempts to present vivid three-dimensional relief to readers.

At this juncture, it is important to recall the seminal photographic work of the amateur astronomer Andrew Ainslie Common. He was born in Newcastle, England, on 7th August 1841. His photographs of the Great Nebula in Orion, secured in 1883, are legendary – a work for which he was awarded the Gold Medal of the Royal Astronomical Society in 1884. Mr. Common secured a number of photographs of the Orion Nebula; the effect of increasing exposure times was immediately obvious. Longer exposures would reveal more details as a greater number of photons were allowed to strike the photographic plate; his very short exposure – of six minutes – shows the famous "Trapezium." Inspection of that 1883 plate shows a cluster of four bright stars, at the heart of the Orion Nebula. Increasing the exposure time to only ten minutes shows a dramatic increase in overall detail, including the presence of fainter stars but also intricate structure in the nebula itself.

Figure 59 [412]

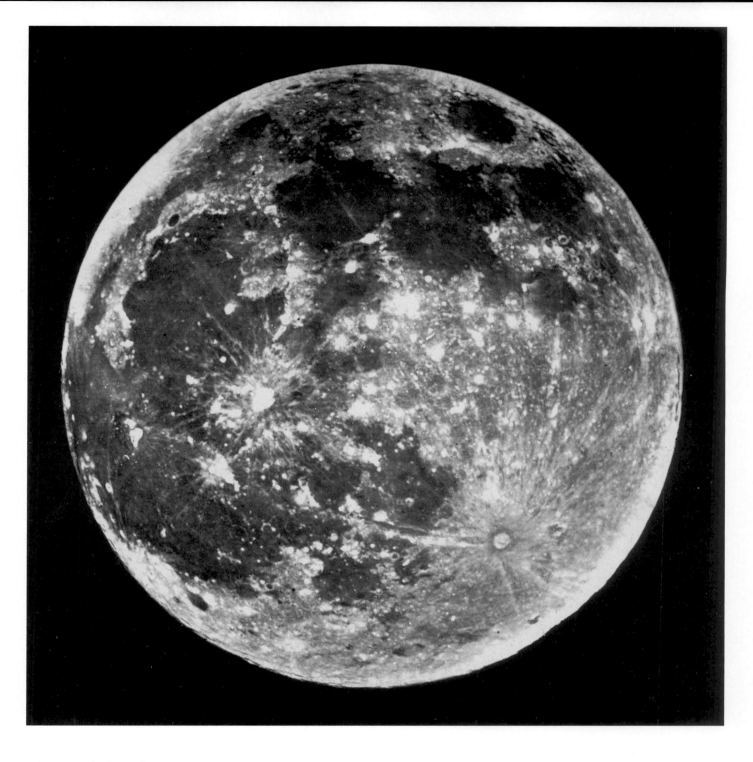

Figure 60 [412]

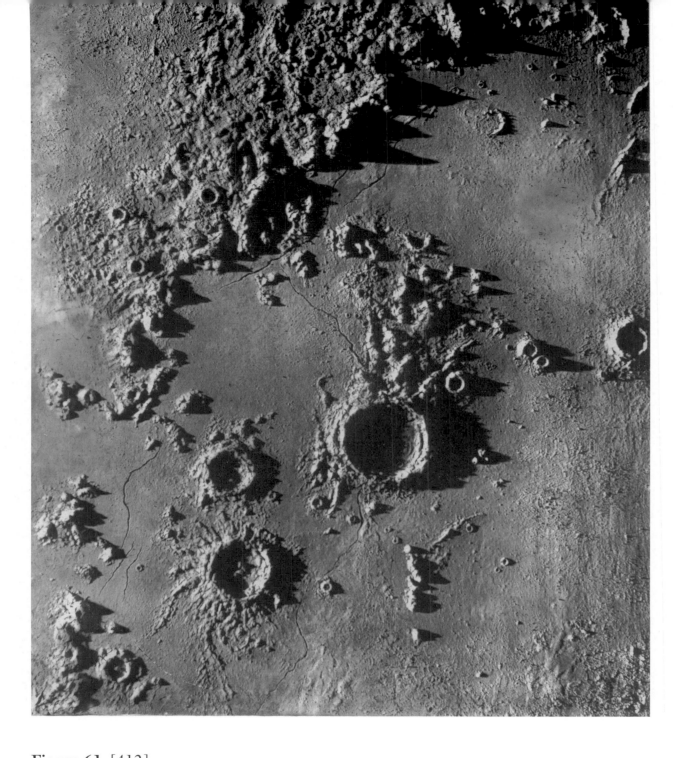

Figure 61 [412]

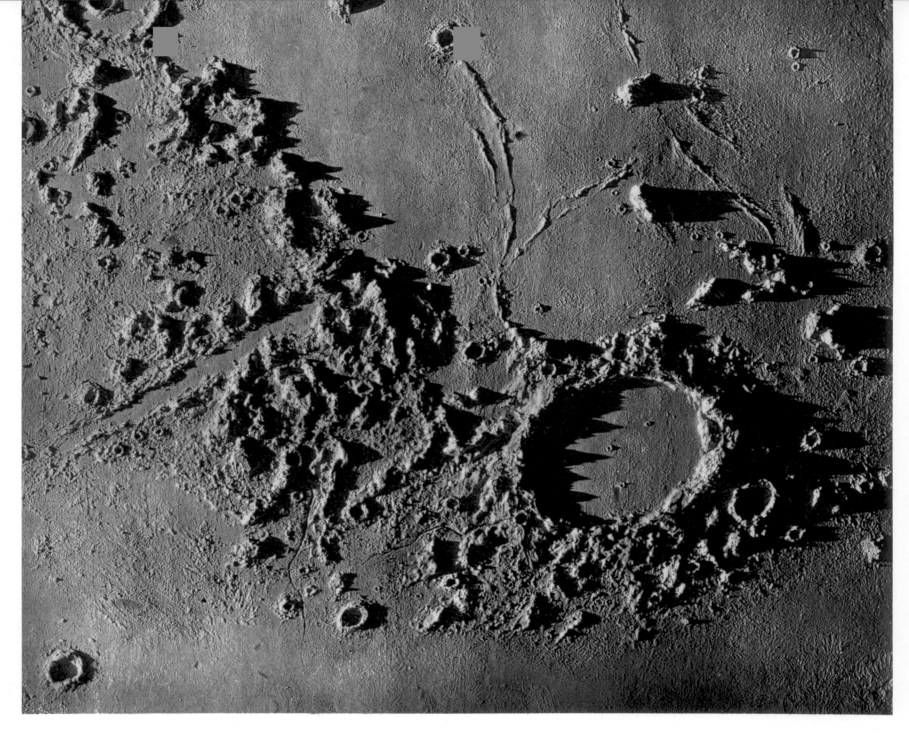

Figure 62 [413]

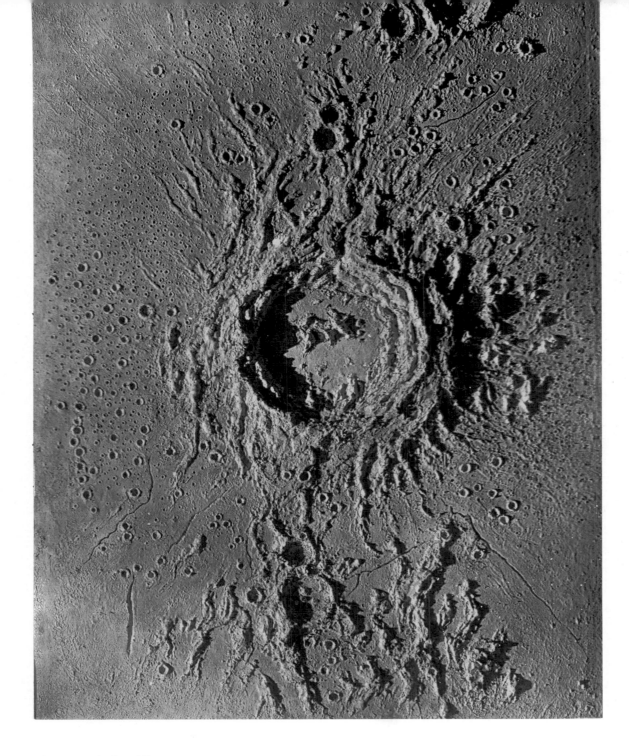

Figure 63 [413]

Mr. Common (later Dr. Common) was elected a Fellow of the Royal Society in 1885 and received an honorary LL.D. from the University of St. Andrews in 1891. The potential of using photography in astronomy was ringing a bell whose tones were loud and clear. A.A. Common was exceptionally gifted in the making of mirrors used in telescopes, such as the mirror housed in the Reynolds telescope erected in Canberra, Australia (we shall discuss the pivotal role of that telescope presently). It was A.A. Common who designed a telescope which, as we shall see later, became known as the Crossley reflector: its role in photographically surveying the heavens from the Lick Observatory in California is forever etched in history.

Photographic surveys of the heavens came into general use in about 1890. The year 1893 saw the dawning of a photographic masterpiece that came from one of the pioneers in early astrophotography, Isaac Roberts. Roberts was born at Groes near Denbigh, Wales on 27th January 1829. He was apprenticed – at the tender age of fourteen – to a builder and contractor in Liverpool, and in the years following, became an expert on matters pertaining to building and construction. He founded the building firm of Roberts and Robinson. Roberts' success in business provided a platform of personal wealth from which he could begin to explore his interest in scientific pursuits. Geology was at first his favorite subject, but he also enjoyed areas such as chemistry, microscopy and electricity. In 1878 (aged nearly 50), Roberts, then living at Rock Ferry, Birkenhead in England, acquired a 7-inch Cooke refracting telescope and a serious interest in astronomy began. Roberts was soon captivated by the idea of obtaining a complete photographic record of the skies, and by 1883 he ordered a telescope which was well suited for such purposes, from Sir Howard Grubb. The telescope had a mirror measuring 20 inches in diameter. In 1885, Roberts commenced his work of producing photographic star-charts. After attending a Photographic Convention in Paris at which a scheme for charting the entire heavens was elucidated, Roberts abandoned the idea of producing a complete survey of stars in the northern skies and focused his attention in other domains. It was at this time that astronomers were totally divided as to whether individual galaxies actually existed outside of our Milky Way. Did nebulous appearing objects always lie within the boundaries of our own spiral Galaxy, or were there other "island Universes" – other Milky Ways, each containing billions of stars in their own right? The actual structure of our Universe remained a mystery. Roberts turned his attention to primarily photographing the "nebulae" which were

generating such a controversy at the time. In 1888 he retired from business to the summit of Crowborough Hill in Sussex, some 800 feet above sea level and an ideal locale for the erection of his "Starfield Observatory" in 1890 (Figure 64). The 20-inch reflecting telescope was used for photographic work, while the smaller refracting telescope (of 7 inches aperture) was used to visually "track" the exposures as the Earth rotates.

It was at the "Starfield Observatory" that Roberts proceeded to secure many exquisite and detailed photographs of the night sky (Figures 65–71). The images were faint and necessitated lengthy exposures; it required great skill and determination to visually "guide" a telescope for periods of several hours. Roberts employed an assistant, by name W.S. Franks. In 1895, Isaac Roberts was awarded the Gold Medal of the Royal Astronomical Society for his outstanding photographs of star clusters and "nebulae" (many now known to be galaxies). The President of the Royal Astronomical Society, Captain W. de W. Abney, had this to say:

> *... this year [1895] the eye has to hold a subordinate place, giving way to the photographic plate as a recorder. The latter is a recorder in which there can be no systematic personal error as regards the relative positions of objects which cannot be discounted; and though photography in some particulars does not always speak the truth, yet for a study of the heavens its retina is capable of receiving more accurate impressions than that sensitive surface which lines the eye, and which transmits a message to the brain, more or less tainted with preconceived notions.*

Roberts photographed the Great Andromeda Nebula on December 29th 1888, with an exposure time of four hours. This exquisite famous photograph (Figure 65) reveals a brilliant central bright bulge of stars and spiral arms, delineated by young stars and by grains of cosmic dust, curling around the bulge. His photographs received wide acclaim; demand for the images was high. The contribution of Roberts (1829– 1904) is one of the most important collections of early photographs of astronomical objects published, and his work represents a great landmark in both astronomical and photographic history. In an obituary published by the Royal Astronomical Society, we read these words: "He was one of the earliest and most consistent advocates of the merits of the reflector for celestial photography, and lived to see his predilection confirmed in quarters where there had previously been a strong prejudice for refractors." A remarkable legacy of Dr Isaac Roberts, Fellow of the Royal Soci-

Figure 64 [413]

Figure 65 [413]

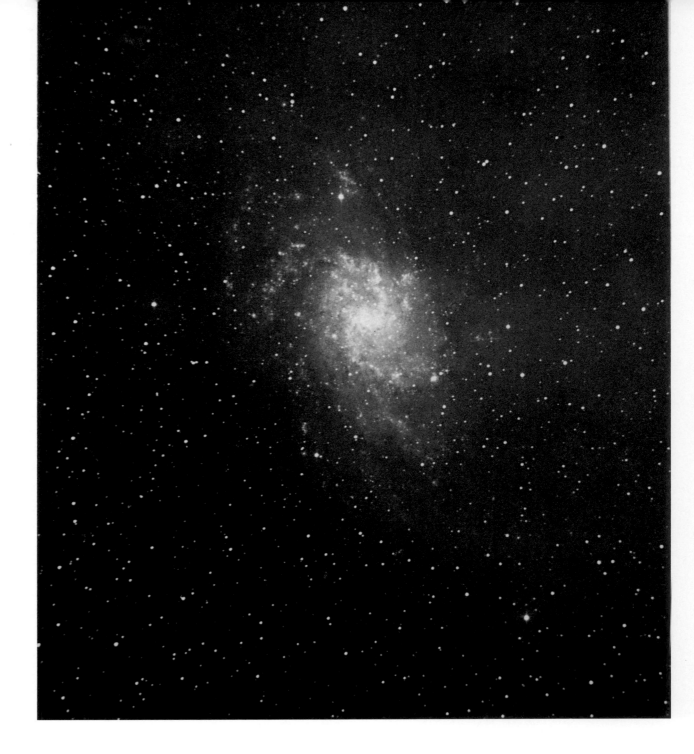

Figure 66 [413]

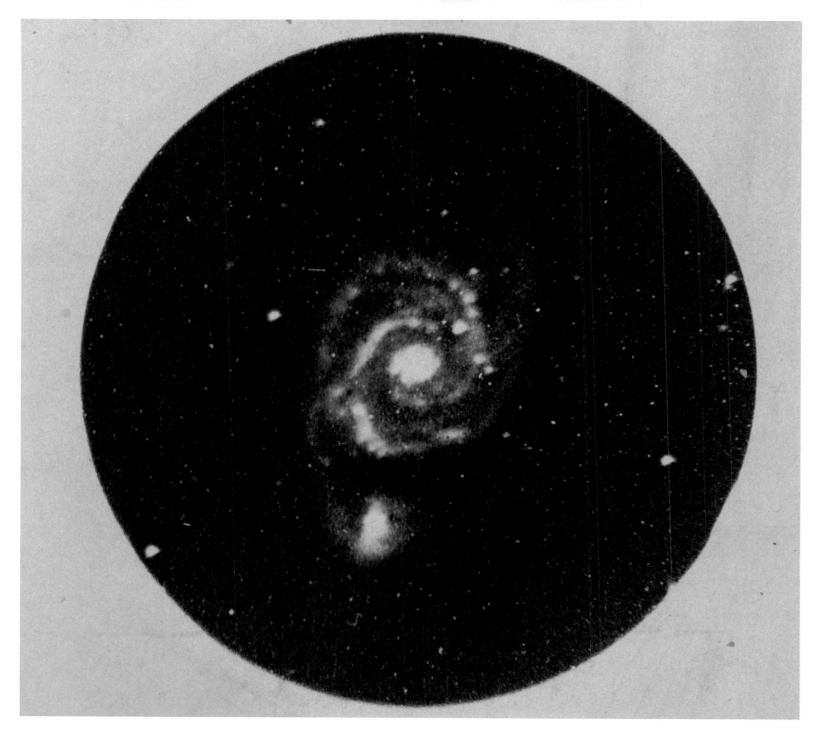

Figure 67 [413]

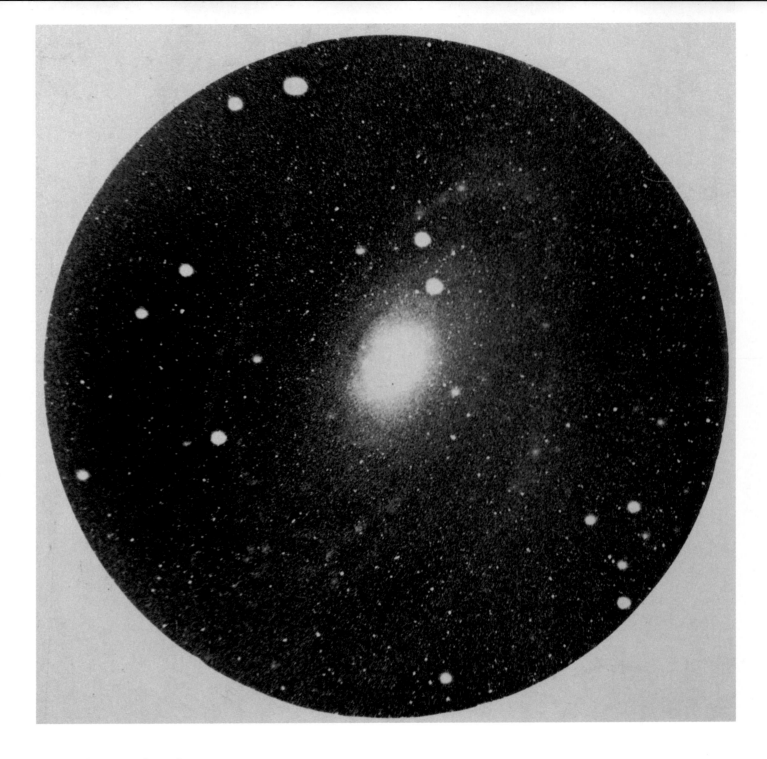

Figure 68 [413]

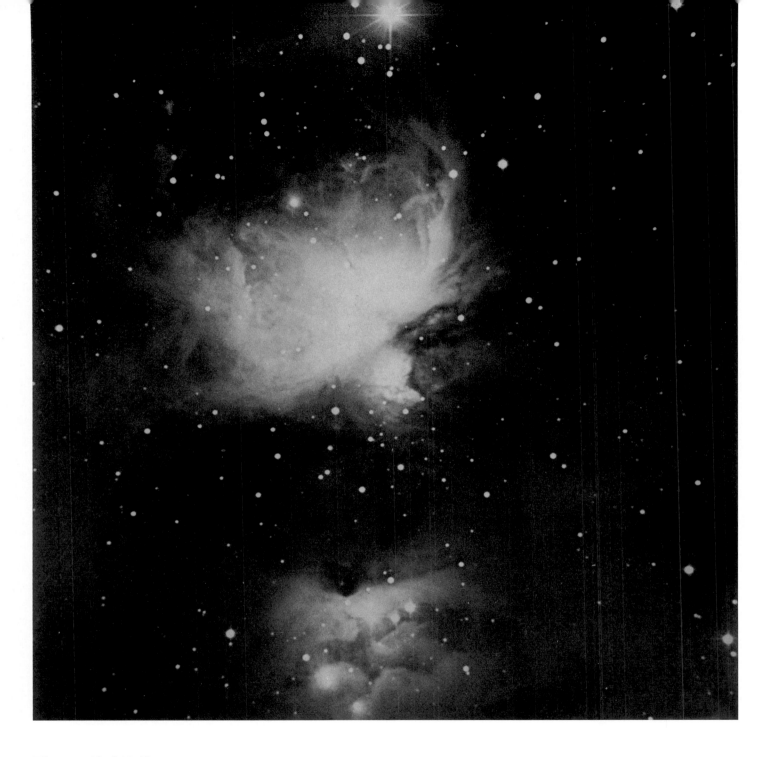

Figure 69 [414]

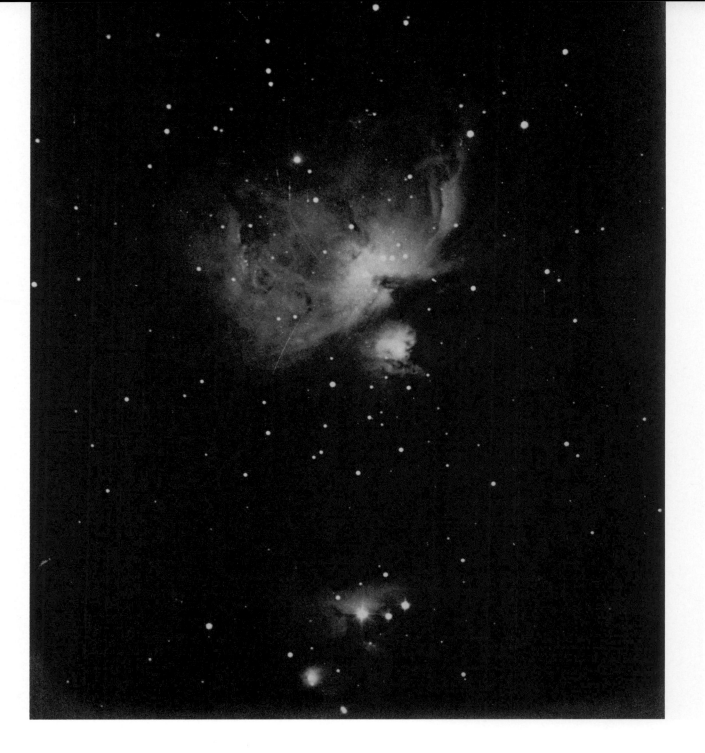

Figure 70 [414]

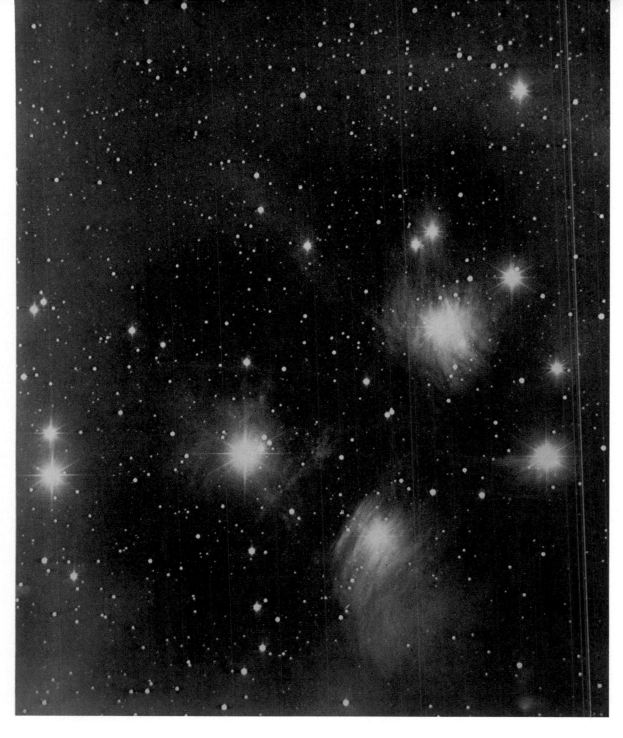

Figure 71 [414]

ety, who started off his career as a young boy of fourteen as an apprentice to a builder, after receiving only a mere elementary education at school.

———————————

That a photograph could provide a reliable, truthful and accurate image did not take root immediately. The transition from the eye, which had been trusted for generations, to photographs, was a struggle: as noted above, the President of the Royal Astronomical Society had, in 1885, alluded to this: "though photography in some particulars *does not always speak the truth,* yet for a study of the heavens its retina is capable of receiving more accurate impressions than that sensitive surface which lines the eye …" (italics, ours).

There is a most interesting volume by the German astronomer Johann Krieger published in 1898, the *Mond-Atlas,* which seeks to marry observations of the Moon by eye, with lunar photographs taken in the late nineteenth century. Krieger had secured low resolution photographs of the Moon taken at the Lick and Paris Observatories. He then enlarged these, and added exquisite details on the photographs by hand (using charcoal, ink and graphite pencil). The features which he had added were those faithfully observed by eye over long periods, at his observatory in the Munich suburb of Gern-Nymphenburg. His observatory was equipped with a fine 10.6 inch Zolliger refractor telescope. While earlier attempts at lunar cartography were solely visual, Krieger ingeniously combined both photograph and the eye. In examining some of Krieger's drawings on photographs of the Moon (Figures 72–74), one can almost perceptively experience the tension which prevailed at that time – even in the mind of Talbot, the pendulum would swing from considering photography as a means of "drawing" and of "not-drawing."

In 1874, Tissandier published a book entitled *Les merveilles de la photographie* in which he formulates the photographic method as being scientific and objective. In the 1876 English translation of Tissandier's book, we read: "It is impossible to avoid a certain emotion in contemplating the negative of a lunar photograph … it is quite certain that it is mathematically correct, for it is the light from its surface that has winged its flight to our own globe to print the picture."

Figure 72 [414]

Figure 73 [414]

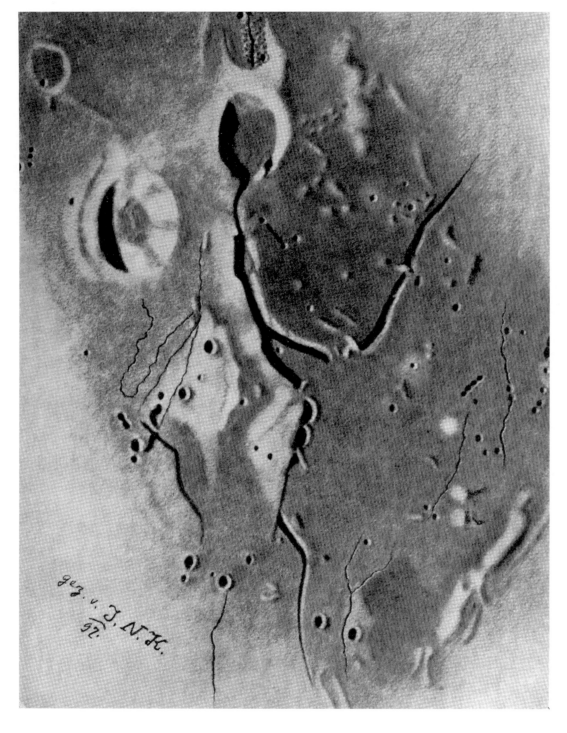

Figure 74 [414]

The use of photographs gave Krieger a firm foundation for the positional accuracy of different craters and rims, but the details added by hand were only visible visually through his telescope during moments of good "seeing." In order to explain this, it must be recalled that every time we observe the Moon, we are looking at it through our atmosphere, which can be very turbulent at times. There are nights when features on the lunar landscape may appear fuzzy and when stars themselves appear to perform cosmic waltzes in the eyepiece of a telescope, due to atmospheric turbulence. At other times, photons from outer space travel through a serene and steady path in our atmosphere. During brief moments of atmospheric steadiness (astronomers call this "good seeing"), the eye of Krieger was visually able to discern details on the lunar landscape which the low resolution photographs with their long exposure times did not. So Krieger added them by hand. (The modern digital era, which has ushered in the webcam, allows astronomers equipped with even small telescopes, to faithfully record the lunar landscape, with its imposing rims, craters and volcanic seas, or "mare." The webcam provides a veritable multitude of images, and a computer can then select those frames taken in moments of "good seeing.")

To Krieger, our terrestrial atmosphere was *the mask of the Moon*. Krieger attempted – and very successfully so – to penetrate that mask.

There is an important point to be stressed here: The nineteenth century way of speaking about a photograph was not only to regard it as the product of a machine (a camera) but it was also partnered by "the pencil of nature." The sentiment was that … we still do not know how Nature pencils herself, but we do know that … *Nature does not pencil herself in one swoop*.

Galaxies do not pencil or betray their structure in one swoop. There is an optical image of a galaxy. It "speaks the truth," but only part of the truth. The *context* is strictly the shape of the galaxy as seen in optical light. Images secured of the same galaxy, through different filters and detectors, also speak the truth – but again, a different sector of the truth as further discussed in Chapter 8.

It has been said that Nature and the capturing of Nature by means of a camera are a binary pair – sometimes aligned and at other times, opposed. The *mystery* of the "pencil of nature" …

Astronomers are yet waiting to "image" the distribution of what may constitute ninety to ninety-five percent of the mass of a spiral galaxy, but much more of that later (Chapter 11). The *mystery* of the "pencil of nature" ...

In the first letter to the Corinthians, Chapter 13, the Apostle Paul writes: "For now we see through a glass, darkly; but then face to face: now I know in part; but then shall I know even as also I am known." The above translation is from the King James Bible, but "The Message" paraphrase by Eugene Peterson resonates the meaning yet further, in terms of a fog or a mist:

> *We don't yet see things clearly. We're squinting in a fog, peering through a mist. But it won't be long before the weather clears and the sun shines bright! We'll see it all then, see it all as clearly as God sees us, knowing him directly just as he knows us!*

As we shall see in the chapters to follow, Nature is veiled. As we penetrate different Shrouds of the Night, we are afforded glimpses of what may constitute different components of a galaxy but these never appear together in one investigative process – rather, different methodologies reveal different truths. Such is the grandeur of Nature and of our Shrouds of the Night.

Enter Edward Emerson Barnard, one of the most admired astrophotographers of all time. He was born, in extreme poverty, in Nashville, Tennessee in 1857, eight years before Woodbury had invented his process of mass producing photographs in books. Barnard had lost his father prior to birth. To help secure a meager income for his mother, this young man found employment, at the tender age of nine, with a photographer named van Stavoren.

Barnard was greatly inspired by the descriptions of the heavens as given by the Reverend Thomas Dick (1774–1857). The story is an interesting one, recounted in the May 1923 issue of *The Observatory*:

Being always of a generous and trusting disposition, the lordly sum of two dollars was about this time [ca. 1870] loaned to a boy friend. The money was never returned, but in its place there was found one day a copy of Thomas Dick's collected works … the flowery language of Dick's descriptions appealed to the romantic spirit of the boy and inspired in him a desire to study the heavens.

Dick's style of writing was absolutely captivating. It immediately gripped the attention of the reader. Here is an extract of Dick's description of the sidereal heavens:

But to minds enlightened with the discoveries of science and revelation the firmament presents a scene incomparably more magnificent and august. Its concave rises towards immensity, and stretches, on every hand, to regions immeasurable by any finite intelligence; it opens to the view a glimpse of orbs of inconceivable magnitude and grandeur … it opens a vista which carries our views into the regions of infinity, and exhibits a sensible display of the immensity of space, and of the boundless operations of Omnipotence; it demonstrates the existence of an eternal and incomprehensible Divinity, who presides in all the grandeur of his attributes over an unlimited empire … Amidst the silence and solitude of the midnight scene, it inspires the soul with a solemn awe and with reverential emotions; it excites admiration, astonishment, and wonder in every reflecting mind, and has a tendency to enkindle the fire of devotion, and to raise the affections to that ineffable Being who presides in high authority over all its movements. While contemplating, with the eye of intelligence, this immeasurable expanse, it teaches us the littleness of man, and of all that earthly pomp and splendour of which he is so proud … In short, in this universal temple, hung with innumerable lights, we behold, with the eye of imagination, unnumbered legions of bright intelligences, unseen by mortal eyes, celebrating in ecstatic strains, the perfections of Him who is the creator and governor of all worlds …

Thomas Dick's writings clearly had a profound effect on the mind of Barnard. Figures 75 and 76 show the planet Jupiter as drawn by the young Barnard in Nashville, in July 1880. Barnard continued work as a photographic assistant for seventeen years; such experience proved to be invaluable for his later career. In 1883, Barnard was offered a scholarship in

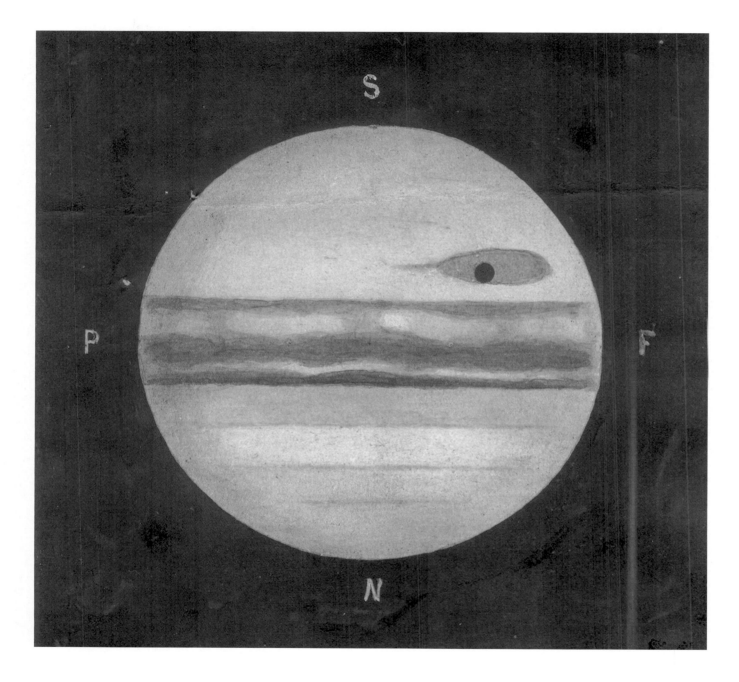

Figure 75 [414]

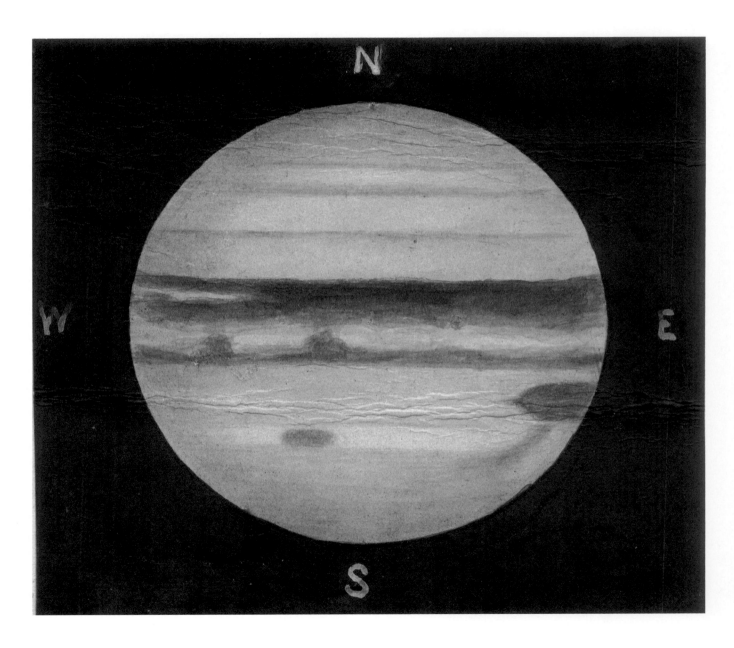

Figure 76 [414]

astronomy at the VanderBilt University, Nashville and remained there for four years; the University had a modest 6-inch telescope, of which Barnard was soon placed in charge. He graduated in 1887. The year following, Barnard became an astronomer at the Lick Observatory, California, where he remained until 1895. The Lick Observatory boasted the great 36-inch refracting telescope, and his appointment to the Lick Observatory would seemed to have offered Barnard unparalleled opportunities to regularly use this giant "eye of the sky." Not so. His relationship with the Director of the Lick Observatory deteriorated, and although Barnard went to Lick in the summer of 1888, he was not allocated a night through the eyes of the 36-inch refractor until July 1892. On the eleventh night of his observations with the 36-inch, Barnard discovered the fifth satellite of Jupiter, known as Amalthea, on September 9, 1892, adding one more moon to Galileo's *Medicean stars* (the four moons of Jupiter which were discovered by Galileo in January 1610).

At the Lick Observatory, Barnard loved to "sweep" the Milky Way Galaxy with the Crocker telescope constructed using the famous "six-inch Willard lens" originally used by a commercial photographer, Mr. Wm. Shew, in San Francisco. The lens was made in 1849 and had been sold by a dealer named Willard & Co. (An interesting historical aside: although the lens was called the "Willard lens," it was not made by Willard & Co., but by Charles Usner in New York City, who supplied stock dealers such as Willard & Co. and Holmes, Booth & Hayden with these lenses, which were used in the making of portraits during the wet-plate era of photography. The portrait lens was eventually purchased for the Lick Observatory from Mr. Shew with funds provided by C.F. Crocker – hence the name "Crocker Telescope.") The marvel was that the Willard lens had a short focal length, allowing photons from a wide-angle field to hit the photographic plate; the *wide-field* views secured by Barnard with the six-inch Willard lens and Crocker telescope (Figure 77) were absolutely breathtaking; every inch on the original plates spanned nearly two degrees, the equivalent of almost four full moons. Barnard's photographs of the Milky Way with the Willard lens were published in 1913, almost twenty years after Barnard had left the Lick Observatory. The volume was entitled: "Photographs of the Milky Way and Comets Made with The Six-inch Willard Lens and Crocker Telescope during the Years 1892–1895" (Publications of the Lick Observatory, Volume XI).

Figure 77 [414]

Figure 78 [415]

In 1895, Barnard joined the Yerkes Observatory of the University of Chicago as a professor of practical astronomy. The astronomical journals fortunately contain much information on the life of Barnard and of the instruments he used. He was awarded the Gold Medal of the Royal Astronomical Society in 1897, for "his discovery of the fifth satellite of Jupiter, his celestial photographs and other astronomical works" as elucidated in the address by President of the Royal Astronomical Society, A.A. Common. "With one notable exception (that of the Sun) every description of celestial object has come under his [Barnard's] scrutiny, and his skill as an observer is only equaled by his skill as a photographer" noted Common, who continued:

> *The astronomical photographs which Professor Barnard has made ... with the "Willard" lens of the Lick Observatory ... are the first photographs made to show the structure of the Milky Way ... we must certainly admire, not merely the skill, but the courage of a man who could, under the very shadow of the 36-inch refractor, demonstrate the merit of a lens which could be bought for a few shillings.*

How sobering that the very structure of our Milky Way Galaxy was revealed by a 6-inch portrait lens costing "a few shillings."

The greatest photographic legacy of Barnard was his magnum opus: *A Photographic Atlas of Selected Regions of the Milky Way.*

To capture the Milky Way in all its glory, Edward Barnard used the Bruce photographic telescope of the Yerkes Observatory, Chicago. Finance for the telescope had been given to the University of Chicago by Miss Catherine W. Bruce. The Bruce telescope actually consisted of *three* individual tubes bound rigidly on the same mounting: two photographic telescopes of 10-inch and 6¼-inch aperture, and a 5-inch aperture visual telescope used for tracking (guiding) of the stars as the Earth rotates. The great importance of the photographic telescopes lay in their *wide-field* coverage; the 10-inch had a 50-inch focal length and, to quote Barnard, gave "exquisite definition" over a field of about 7 degrees (or 14 full moons). The plate-holder for the 10-inch carried glass negatives 12 inches square, while that for the 6¼-inch carried glass plates measuring 8 × 10 inches.

The scale of the photographs secured with the 10-inch was exceptionally well adapted to revealing the structure of the Milky Way; every inch covered just over one degree of sky. George Ellery Hale, director of the Mount Wilson Solar Observatory owned by the Carnegie Institute of Washington, invited Barnard to Mount Wilson in 1905. A generous grant from Mr. J.D. Hooker of Los Angeles allowed Barnard to transport the Bruce telescope to the Mount Wilson site. Barnard secured forty of his fifty photographs for his *Atlas*, from one of the world's premier observing sites, in a period spanning February to September, 1905. A photograph of the senior Barnard is seen in Figure 78. He died at age 65, in 1923, four years before the *Atlas* saw the light of day. It was published in 1927 by the Carnegie Institute of Washington (as Carnegie Publication number 247).

The *Atlas* was completed by Edwin Frost, Director of the Yerkes Observatory in Chicago, and by Barnard's niece, Mary Calvert. Barnard had, however, personally examined 35 700 photographic prints to select only the best to feature in his *Atlas*, of which seven hundred were produced. The two volume *Barnard Atlas* is today an exceedingly rare jewel and very highly priced on the retail market (on those rare occasions when it becomes available, usually for auction).

It takes an observer of the utmost skill to visually track an exposure for over eight hours; Barnard exposed his negative of a region in the constellations of Scorpio and Libra for an astonishing 8 hours and 40 minutes, on April 29/30, 1905. Exposure times ranged from 50 minutes to nearly 8¾ hours; approximately sixty percent of the *Atlas* photographs were exposed for 4 hours or longer. Figures 79–96 allow the reader to personally examine a selection of these riveting photographs of our Galaxy, which leave the observer spellbound. Dusty Shrouds of the Night are everywhere.

In examining these photographs, one is repeatedly reminded of the "trailing garments" and "haunted chambers" in the poem "Hymn to the Night" by Henry Longfellow:

> *I heard the trailing garments of the Night*
> *Sweep through her marble halls!*
> *I saw her sable skirts all fringed with light*
> *From the celestial walls!*

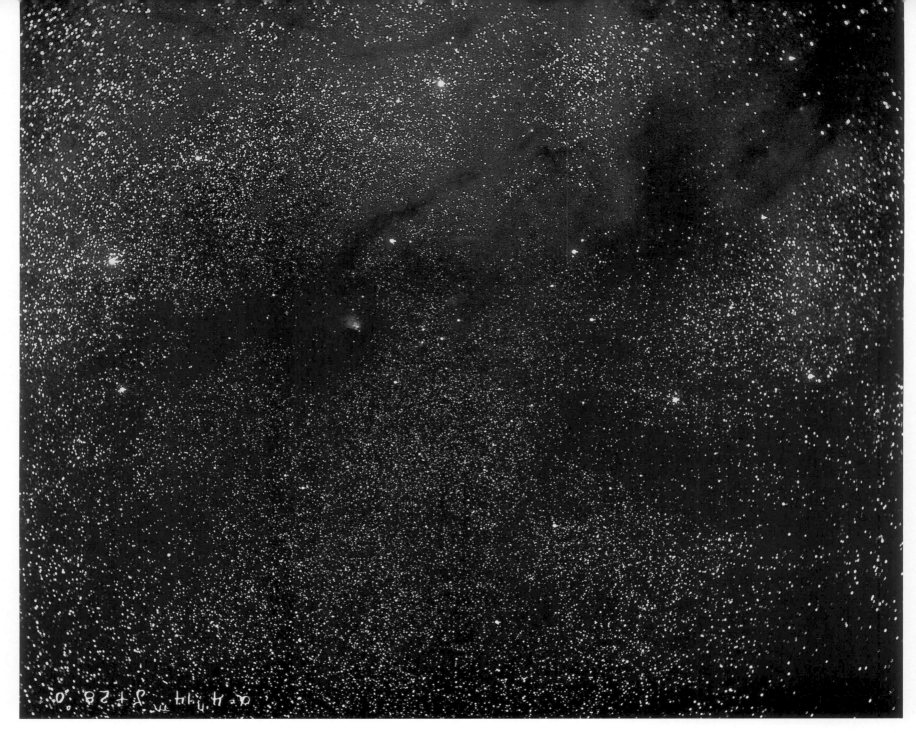

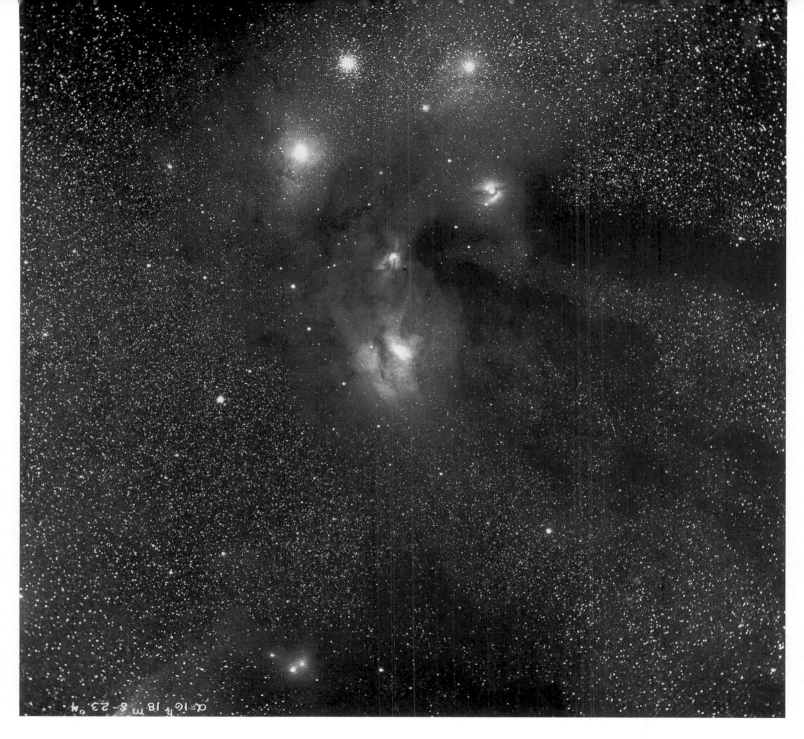

Figure 80 [415]

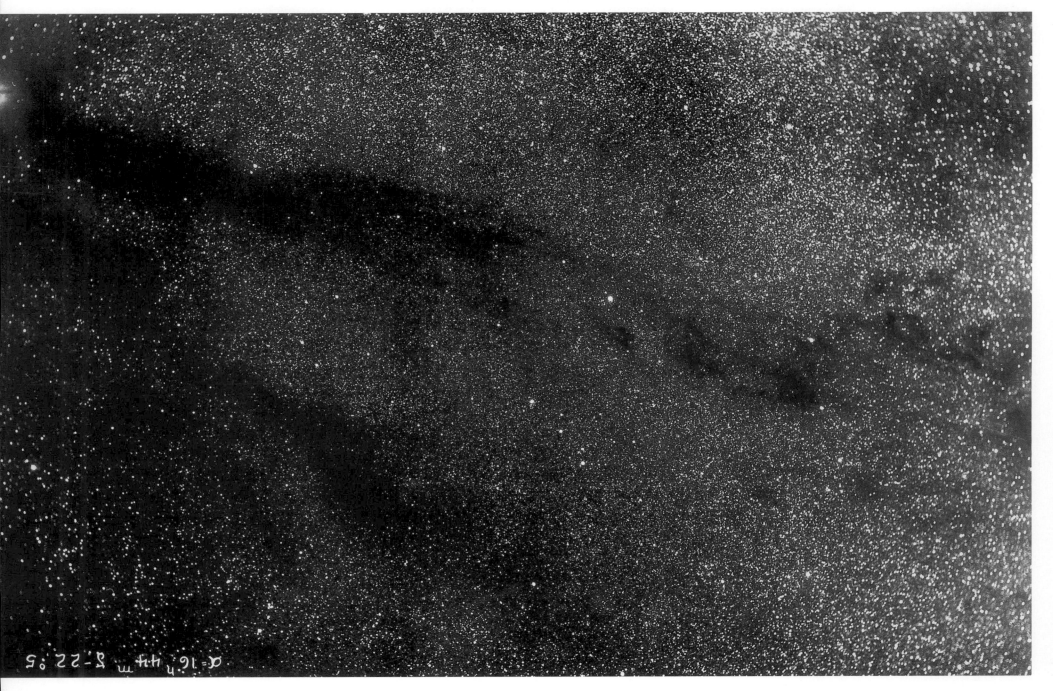

Shrouds of the Night
150

Figure 81 [415]

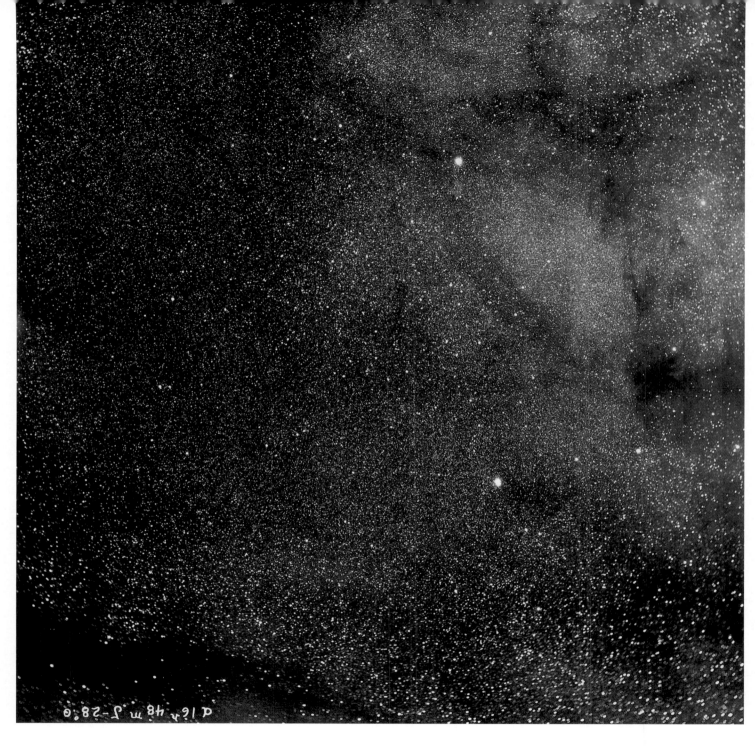

Figure 82 [415]

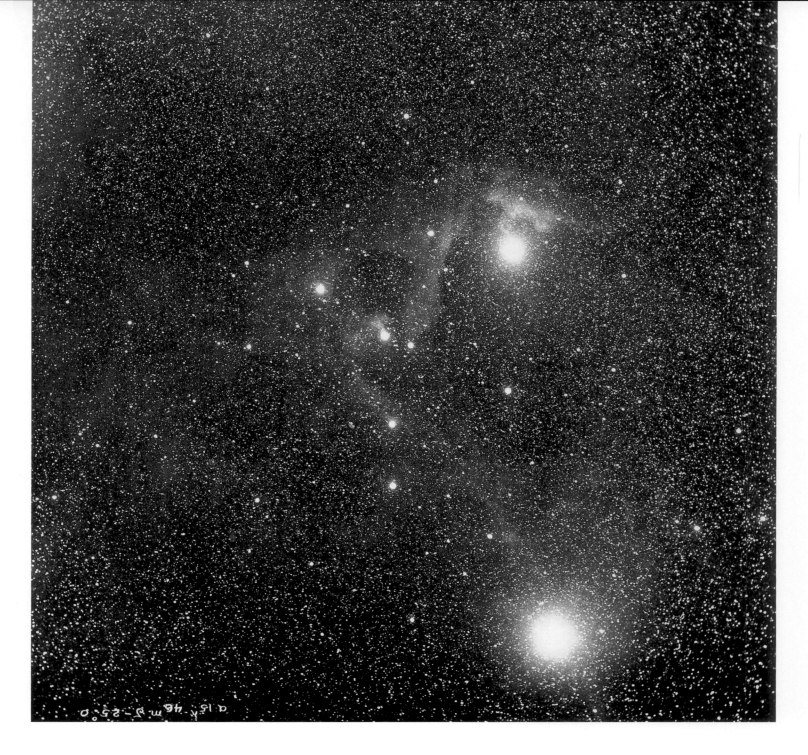

Figure 83 [415]

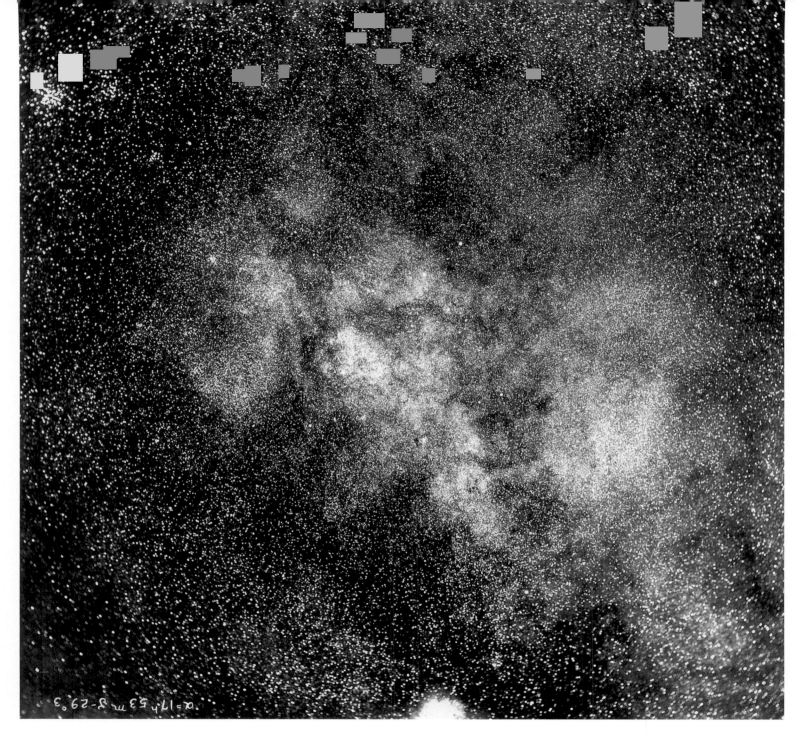

Figure 84 [415]

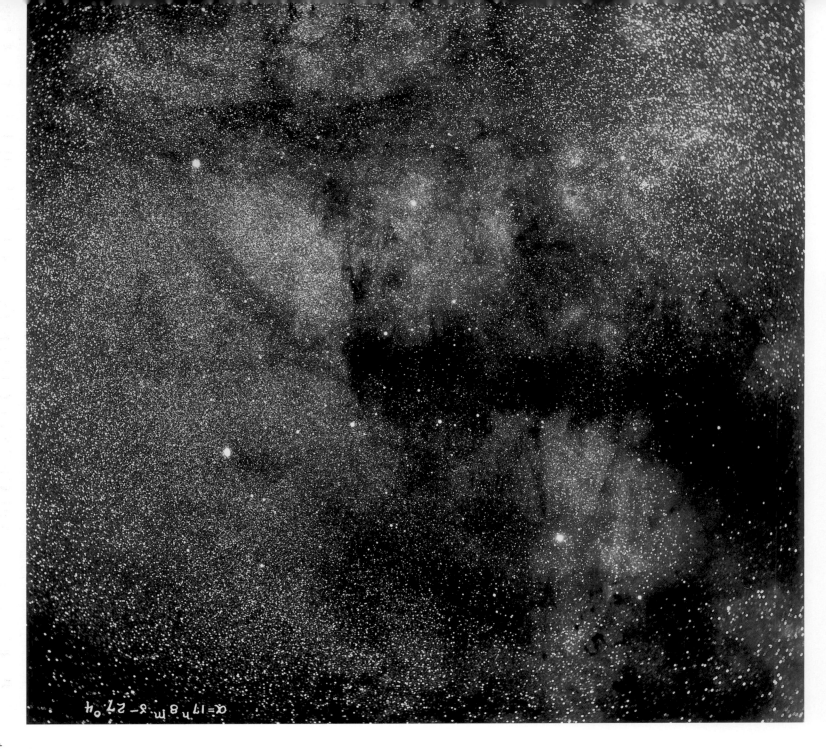

Figure 85 [416]

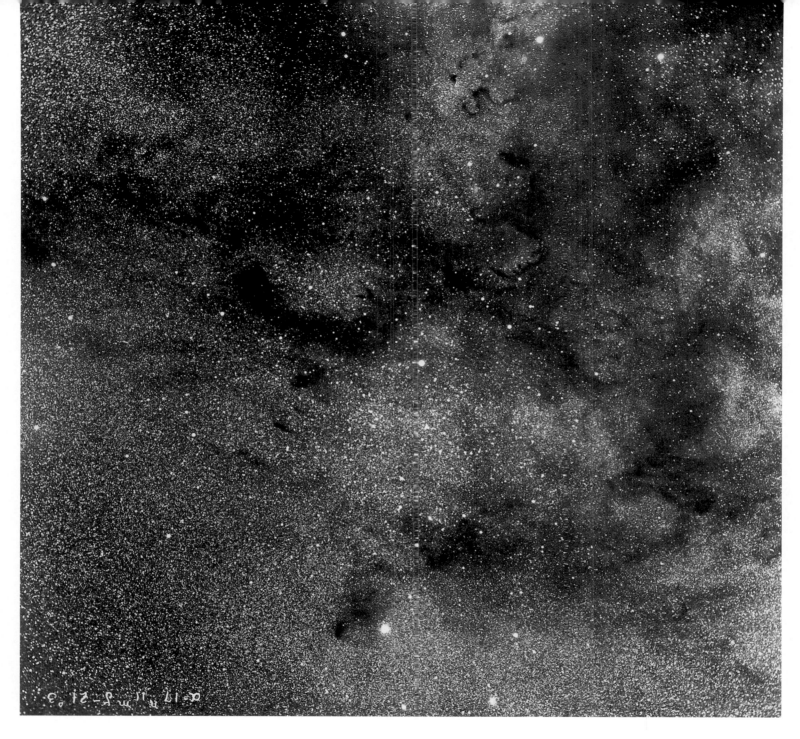

Figure 86 [416]

The Dawning
155

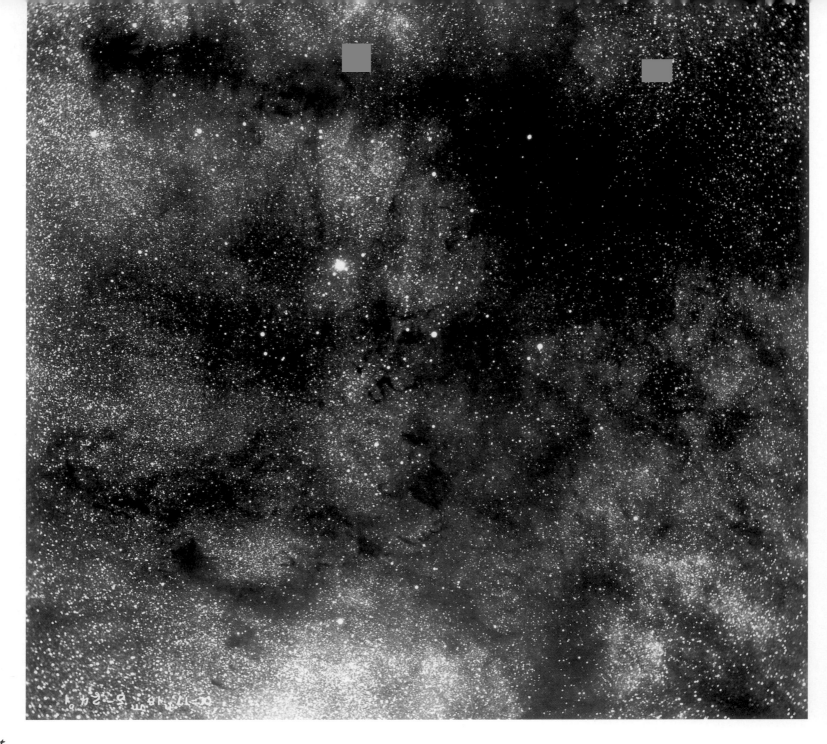

Figure 87 [416]

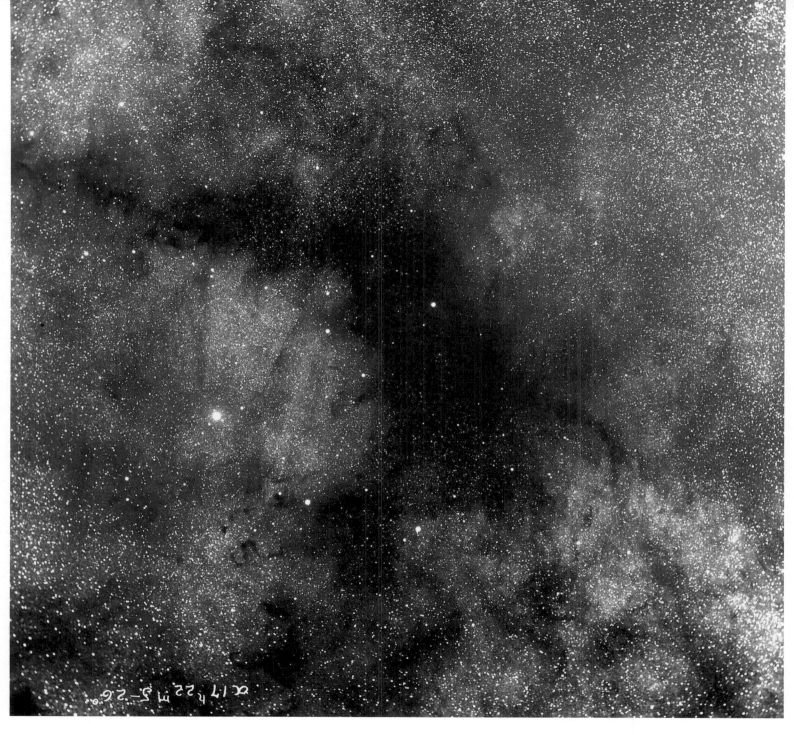

Figure 88 [416]

The Dawning
157

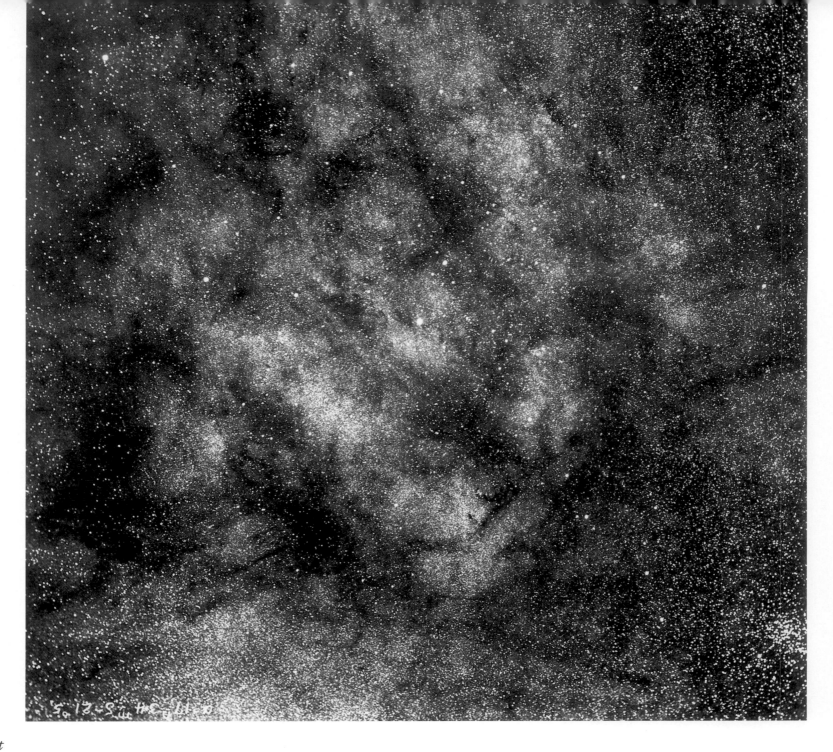

Figure 89 [416]

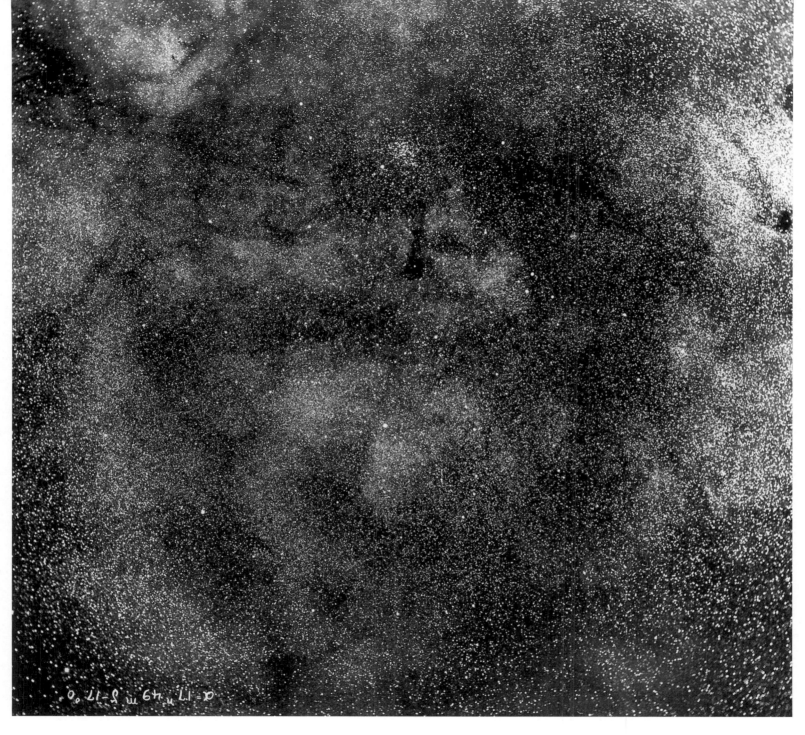

Figure 90 [417]

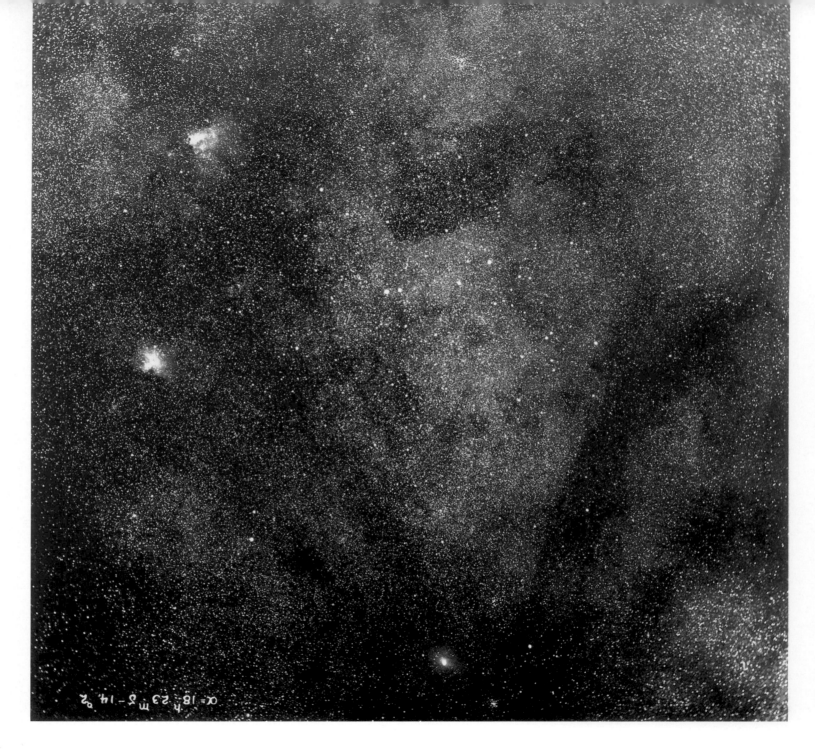

Figure 91 [417]

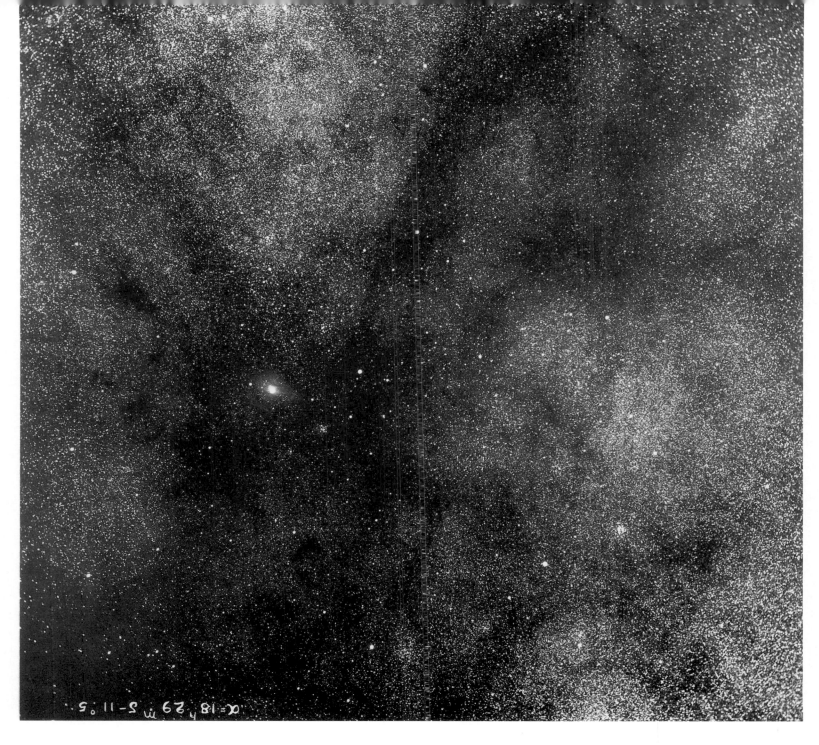

Figure 92 [417]

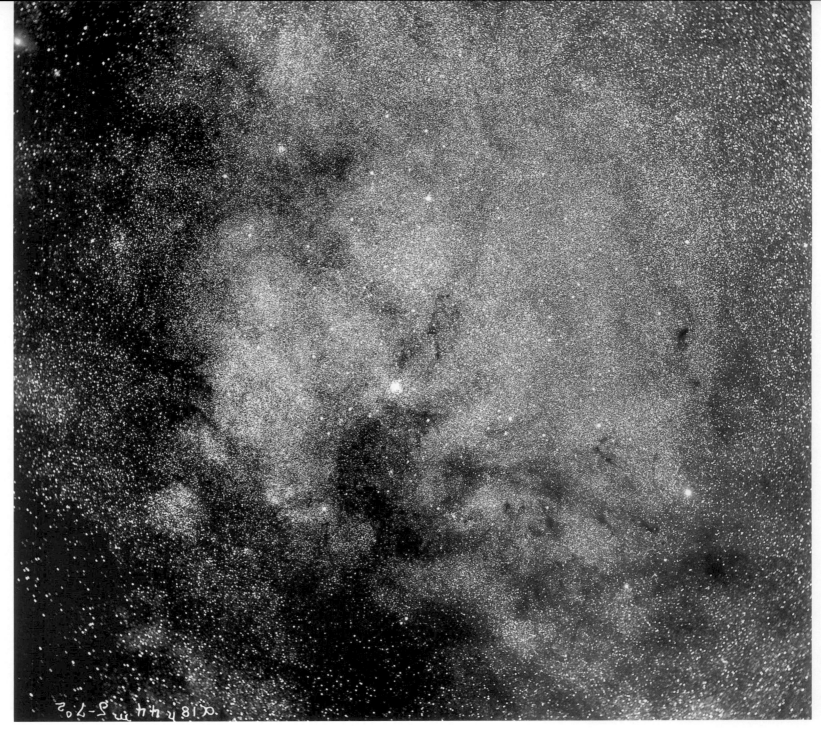

Figure 93 [417]

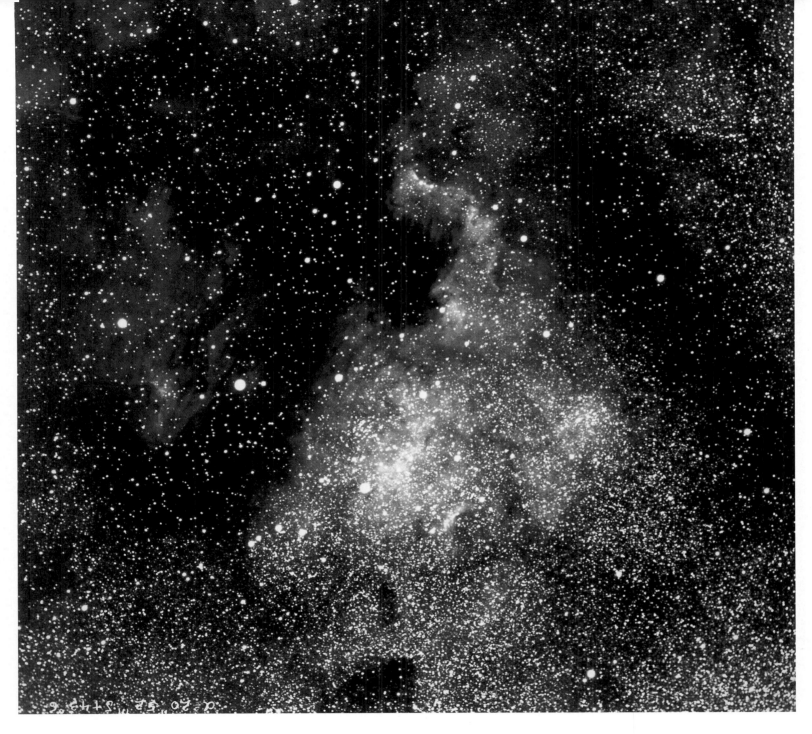

Figure 94 [417]

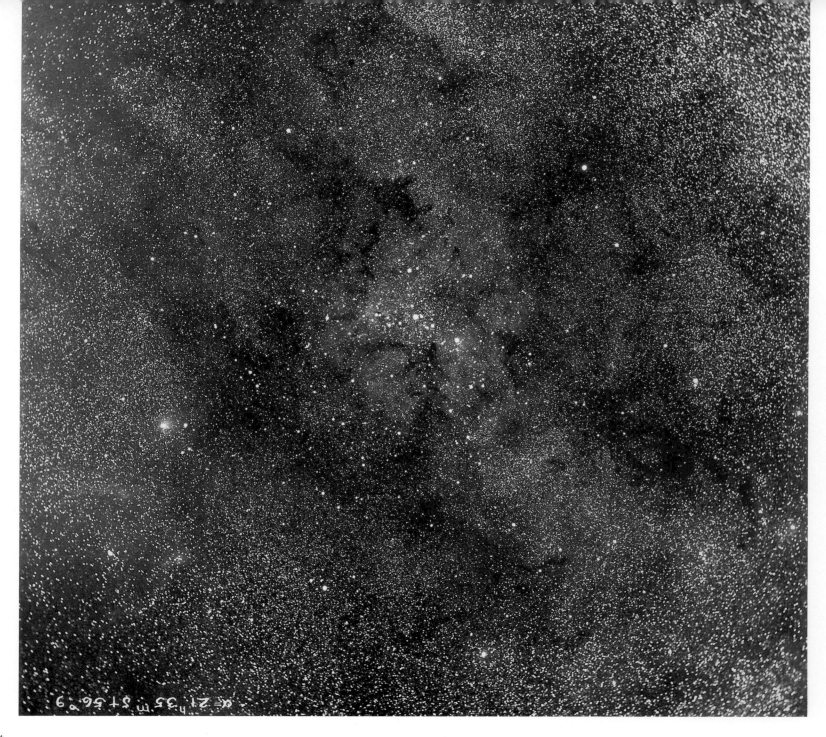

Figure 95 [418]

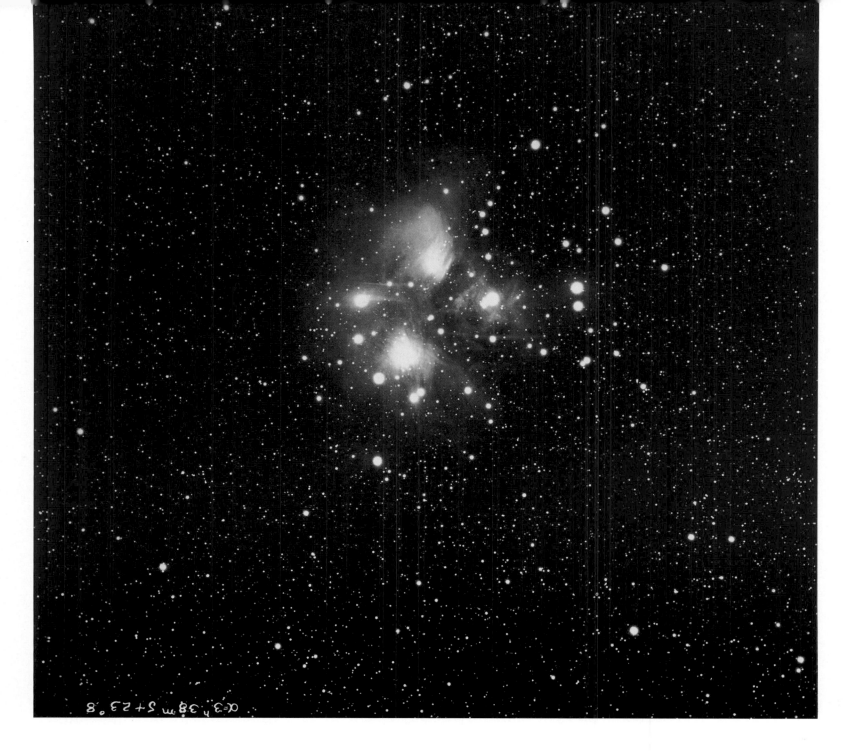

α 3ʰ 38ᵐ S +23° 8'

Figure 96 [418]

I felt her presence, by its spell of might,
Stoop o'er me from above;
The calm, majestic presence of the Night,
As of the one I love.
I heard the sounds of sorrow and delight,
The manifold, soft chimes,
That fill the haunted chambers of the Night
Like some old poet's rhymes.

Barnard's career and struggles prove a very important point: it is never a large telescope alone, which is the seed for great discoveries: it is the eye behind the telescope – the mind of the astronomer. In an obituary published by the Royal Astronomical Society, we read: "Barnard is to be reckoned as one of the greatest observers of all time, and his work may be compared with that of Tycho Brahe, J.D. Cassini, and the Herschels."

Photographic surveys of the night sky had begun in earnest. The photographic surveys of Keeler (1898–1900), Perrine (1901–1903), Curtis (1909–1918) with the Crossley reflector at the Lick Observatory in California hugely increased the number of known nebulae. Added to this were the Mount Wilson surveys by Ritchey and by Pease (1917, 1920). It was a monumental leap forward, since Henry Draper had secured the first successful photograph of a nebula – the Great Nebula in Orion, in 1880. Keeler conservatively estimated that at least 120 000 nebulae were within reach of the Crossley 36-inch reflector. Many of the exquisite photographic plates secured by Keeler are reproduced in this chapter (Figures 97–110).

By the end of the nineteenth century – when galaxies were routinely photographed in long exposure ("deep") photographic plates, there was a growing conviction among a few astronomers that many of the nebulae, the spirals in particular, were extragalactic: outside of our Milky Way Galaxy. For these astronomers, such objects were not nearby gaseous clouds in our Galaxy, but instead were believed to be "island Universes:" galaxies in their own right.

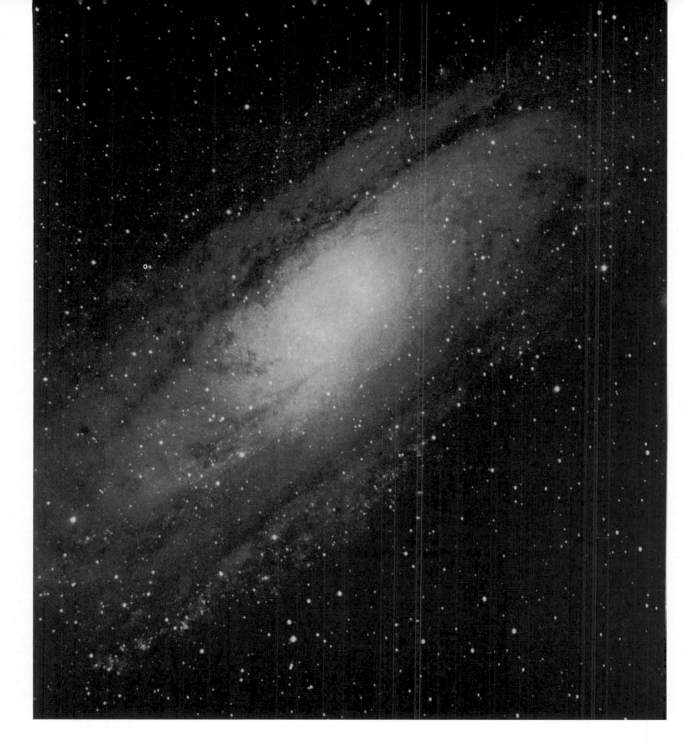

Figure 97 [418]

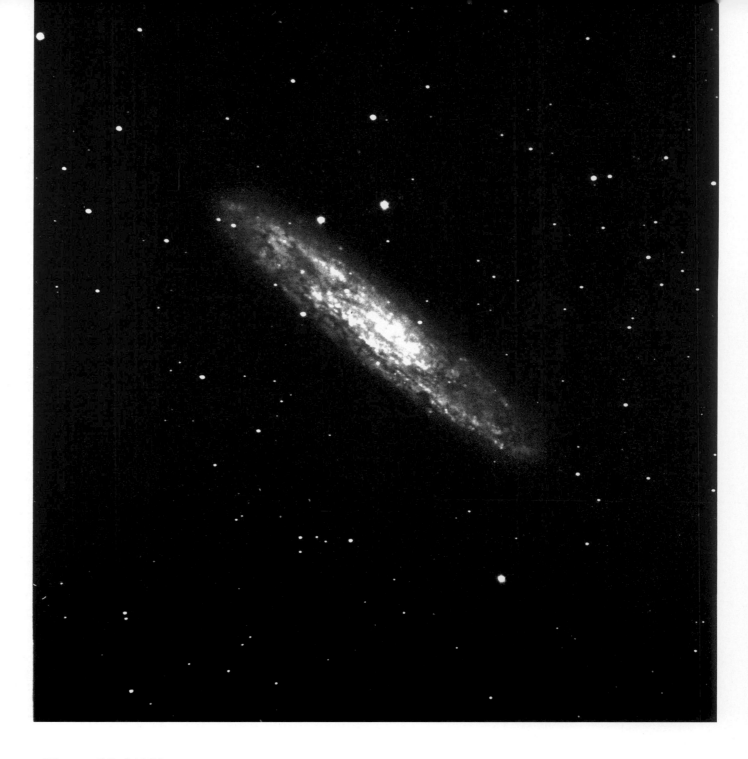

Figure 98 [418]

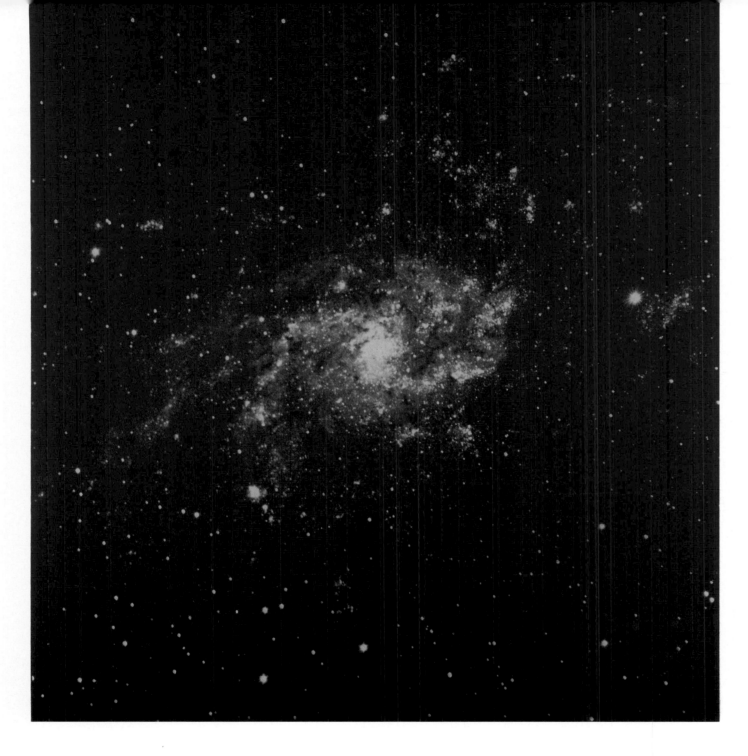

Figure 99 [418]

The Dawning
169

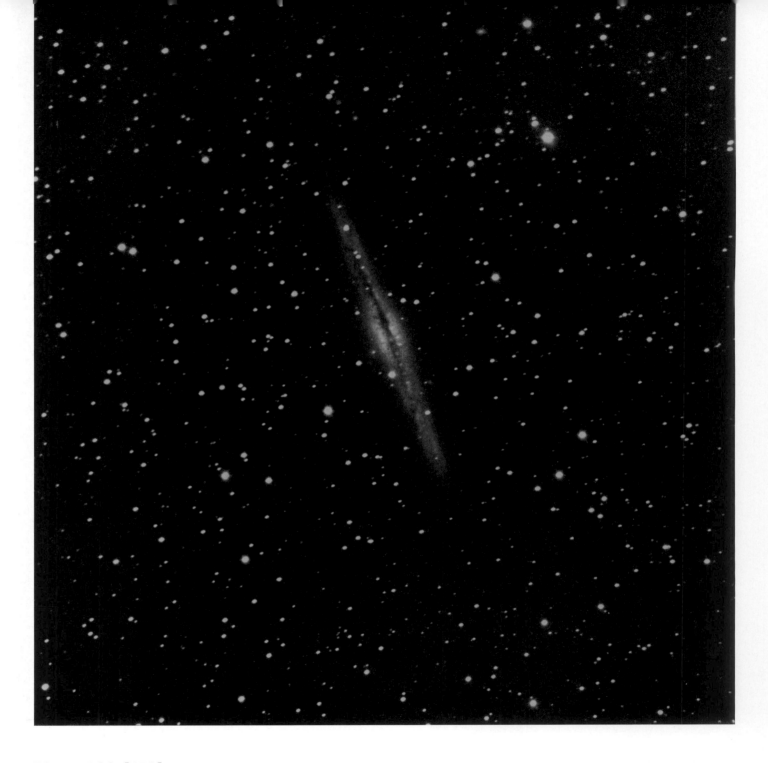

Figure 100 [418]

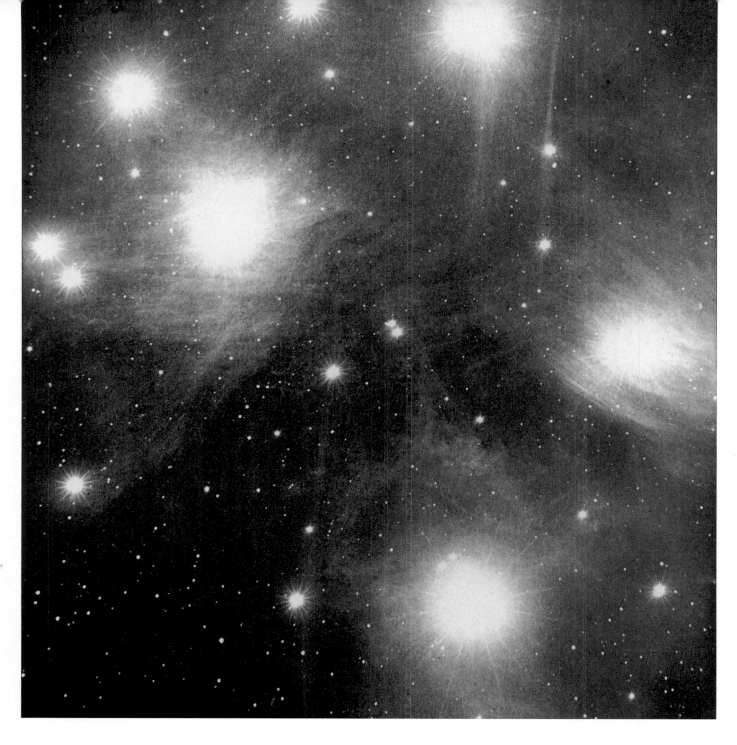

Figure 101 [418]

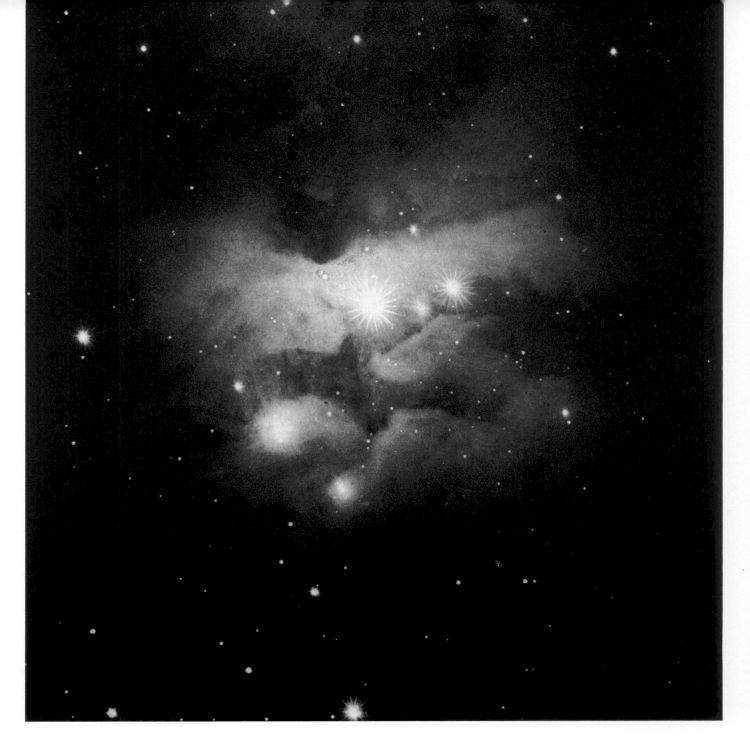

Figure 102 [418]

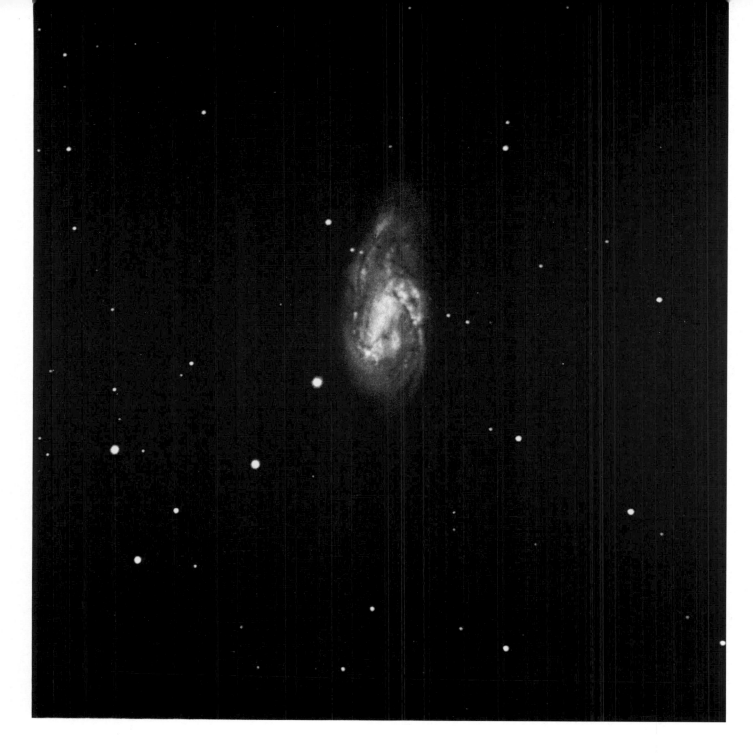

Figure 103 [418]

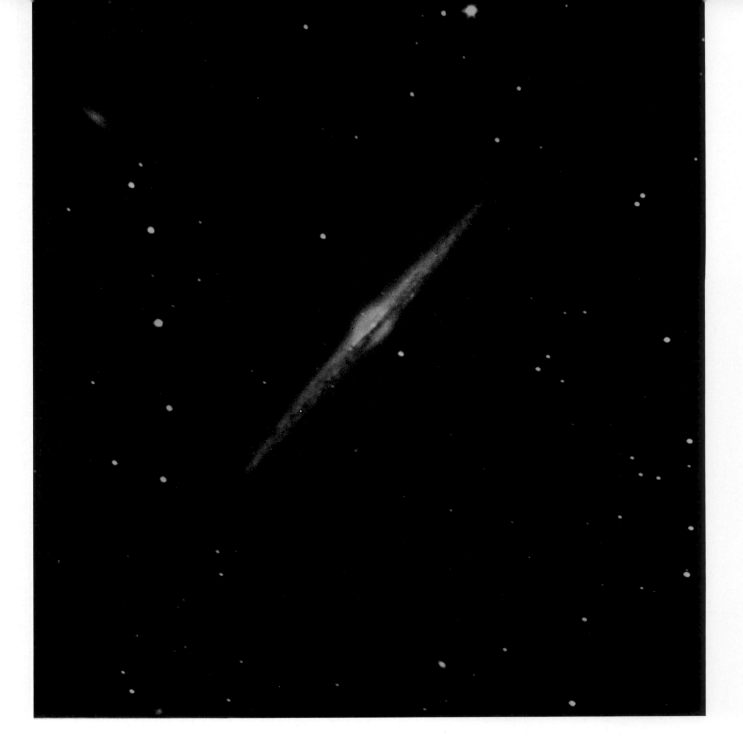

Figure 104 [418]

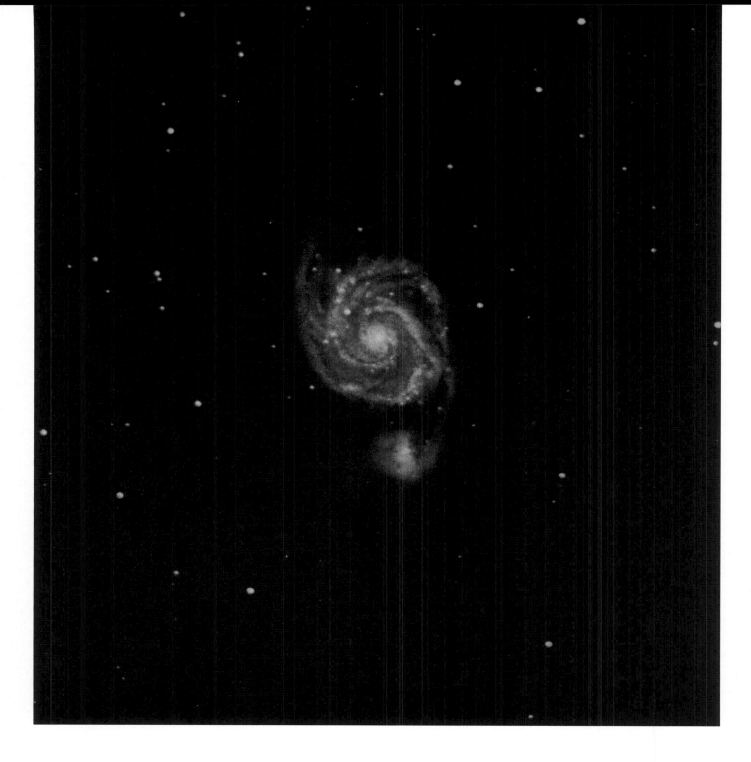

Figure 105 [419]

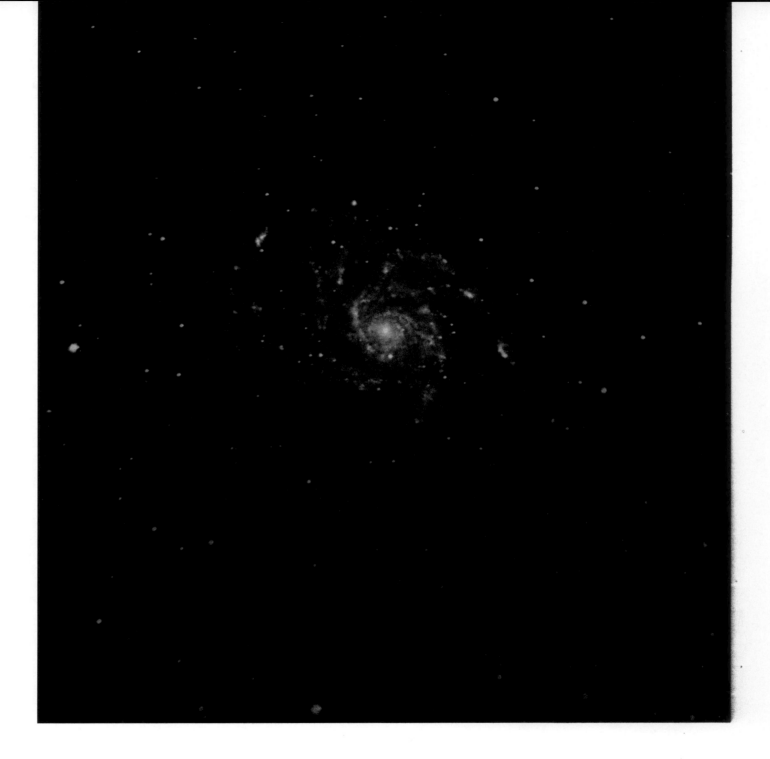

Figure 106 [419]

Figure 107 [419]

Figure 108 [419]

Figure 109 [419]

Figure 110 [419]

The great controversy about the nature of the spiral nebulae was not really resolved until Hubble had made his observations in the mid-1920s of Cepheid variables in some nearby galaxies, including the Andromeda Spiral. (Cepheid stars vary regularly in brightness over a period of time. The astronomer Henrietta Leavitt discovered that the brightest such variable stars have the longest periods. It is possible to determine the distance of a Cepheid variable star from its observed period.)

Meanwhile, astronomers had begun to use spectrometers to measure the velocities of the nebulae from their Doppler shifts. (For a galaxy that is moving away from us, the features in its spectrum are Doppler shifted towards the red end of the spectrum by an amount proportional to the velocity of recession.) By 1917, Vesto Slipher at Lowell Observatory had measured velocities for twenty-five nearby nebulae and it was already clear that some of these velocities (up to 1100 km/s) were much larger than the typical velocities of the stars near the Sun. The average velocity of his twenty-five nebulae was 570 km/s which, as Slipher wrote, "is about thirty times the average velocity of the stars. And it is so much greater than that known of any other class of celestial bodies as to set the spiral nebulae aside in a class to themselves."

In 1917, Slipher correctly interpreted this large average motion

> *as indicating that we [i.e. the solar system] have some drift through space. For us to have such motion and the stars not show it means that our whole stellar system moves and carries us with it. It has for a long time been suggested that the spiral nebulae are stellar systems seen at great distances. This is the so-called "island Universe" theory, which regards our stellar system and the Milky Way as a great spiral nebula which we see from within. This theory, it seems to me, gains favor in the present observations.*

We would have expected Slipher's velocities to have had an enormous impact on the controversy, but for some reason they did not. Was the community simply suspicious of the quality of the data? This would be surprising, because several other observers had also made measurements which agreed quite well with Slipher's. Or were these very large velocities just too much for the community to absorb at the time?

As Allan Sandage wrote in the *Hubble Atlas*, "Everyone, once his belief is set, will rationalise the facts to suit himself."

By the 1930s, the large velocities of the nebulae had clearly been accepted: Hubble had made his momentous discovery of the expanding Universe (which included some of Slipher's measurements).

There is an interesting parallel with the saga about dark matter in the Universe. In the mid-1930s, Fritz Zwicky measured the motions of galaxies within a cluster of galaxies known as the Coma cluster; he showed very convincingly that there had to be far more mass in the Coma cluster than could be accounted for by the individual galaxies. Herein lay the fingerprints for dark (nonluminous) matter; one of the most exciting arenas of astronomical research today. However, this astonishing discovery by Zwicky seemed to have made almost *no impact* on astronomers at the time. It took another thirty-five years before the subject of dark matter in the Universe came to life. Maybe again Zwicky's discovery was just too much for the community to absorb. Discoveries must be made at the right time if they are to be embraced by the community. There are no prizes for making discoveries too early.

John Reynolds: Morphologist Extraordinaire

I t was in 1926 that the most widely used galaxy classification scheme today, known as the Hubble classification, was published in the *Astrophysical Journal*. The author was the American astronomer E.P. Hubble.

Hubble recognized three principal form families, and placed galaxies into one of three principal classes: there were *elliptical* galaxies, *spiral* galaxies and those with a rather chaotic optical appearance, known as *irregular* galaxies. Spiral galaxies themselves were separated into two separate families, the *normal* spirals and those with a central elongated feature, the *barred* spirals (Figure 111).

The recognition of a bar in spiral galaxies belongs to Heber D. Curtis. Curtis had recognized a class of spirals called the *phi*-type spirals, but Hubble later suggested that the Greek letter *theta* better represented this form. To be fair to Hubble, he did consider Curtis' classification to be "easily the most significant that has been proposed up to date [1922] ..." The Curtis *phi*-class was fully recognized in Hubble's final classification system, but Hubble used the terminology of barred spirals instead. Full credit must be given to the great observer Heber Curtis, for being the first astronomer to recognize bars in spiral galaxies.

"Normal" and "barred" spirals were grouped into three principal morphological classes, of types a, b and c. Hubble used the prefix "S" for normal spiral and "SB" for barred spiral. From the multitudes of shapes and forms of galaxies presented on photographic plates, it became relatively simple to speak of three classes for normal spirals (Sa, Sb and Sc) and the three types of barred spiral galaxies (SBa, SBb, SBc).

The classification criteria for the Hubble system are threefold: firstly, the size of the central bulge compared to the flattened disk; secondly, the degree of openness or tightness of the spiral arms, and finally, the degree to which the eye can discern newly-born stars contained in clouds of hydrogen gas (HII regions in technical jargon). In general, Sa galaxies have large bulges, tightly wound spiral arms which are relatively smooth. In contrast, the bulges of Sc galaxies are invariably much smaller or even so minute, as to appear point-like as a star ("semi-stellar"); Sc galaxies spawn wide open spiral arm patterns, knotted with newly born stars flooding their environs with energetic ultraviolet photons of light. Galaxies of type a were spoken of by Hubble as *early-type*; those of type c, *late-type*.

In the pages to follow, we explore a fascinating question:

How much did other astronomers, working in the years before Hubble's epochal publication, influence Hubble's ideas on matters morphological?

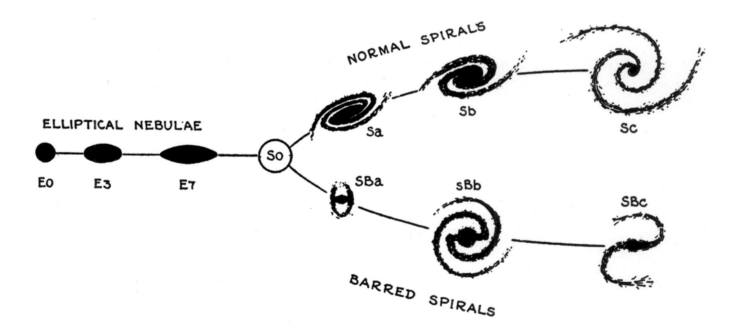

Figure 111 [419]

We followed some intriguing historical leads, by traveling to the United States and to the United Kingdom, and our findings below are based on our detailed readings of archival material at the Lowell Observatory in Arizona and the Royal Astronomical Society's archives at Burlington House in London.

The history of the International Astronomical Union's Commission on Nebulae and Star Clusters (Commission Number 28) spanning the period 1922–1925 is particularly rich and archival material is on file both in Arizona and London. Slipher, then acting director at Lowell Observatory, was the president of the Commission during those years. Commission members were the first to have an opportunity to study and react to Hubble's studies on the nebulae and their shapes. In the period 1922–1925, Commission 28 members included Slipher, Hubble, Curtis, W.H. Wright (Lick Observatory), S.I. Bailey (Harvard College Observatory), the venerable Irish astronomer J.L.E. Dreyer and France's G. Bigourdan, the Commission's first president from 1919 to 1922. Also on the Commission was England's J.H. Reynolds (Figure 112).

Herein lies a truly great story, in its own right.

The membership of the Commission clearly reads like a "who's who," containing the names of some truly great and pioneering astronomers. But Mr. Reynolds was not an astronomer by profession, at all. Here was someone whose official occupation lay completely outside the scientific arena. He was the son of a subsequent Lord Mayor of Birmingham, whose company was a major producer and supplier of metal products in Birmingham. The company John Reynolds & Sons (Birmingham) Ltd was famous for its production of cut-nails (as opposed to hand-forged nails).

We conducted a fascinating telephone interview with Mr. Dennis Stamps, a retired director of John Reynolds and Sons, who together with his wife have a considerable knowledge of the Reynolds' family history. Mr. Stamps recalls that the production of nails then was an enormously labor intensive process; cut nail factories employed operators and attendants for each machine, and the noise in those factories was deafening.

Figure 112 [419]

The production of nails was a practice not restricted to only the lower classes. In fact, Thomas Jefferson (President of the United States in the period 1801–1809) was proud of his hand made nails. In a letter he once said: "In our private pursuits it is a great advantage that every honest employment is deemed honorable. I am myself a nail maker." From president to the pioneer, nail making in those days was an very important facet of life. In fact, Jefferson was among the first to purchase the newly invented nail-cutting machine in 1796 and produce nails for sale. In pre-1850 America, nails were exceedingly scarce; it is said that people would burn old buildings to sift through the ashes for nails. John Reynolds, born in 1874, clearly had a great financial enterprise at hand from his father's company in England which produced cut nails in enormous numbers. Cut nails dominated the marketplace from about 1820 until 1910, with the advent of the modern wire nail.

John Reynolds became a highly successful and wealthy industrialist. Reynolds purchased a 30-inch mirror made by astronomer Andrew Ainslie Common for the sum of eighty pounds, and he was instrumental in the design of a 30-inch reflector telescope which subsequently was transported to Helwan in Egypt. It was the first large telescope to study objects lying well into the southern skies. The 30-inch Reynolds reflector at Helwan saw "first light" in the year 1907, when the first photographs from that telescope were secured.

In the interim, John Reynolds decided to erect his own observatory at Harborne, by making a mirror of 28-inch diameter with his own hands (Figure 113). No mean feat – a mammoth task indeed, for any amateur astronomer today! The telescope at his home "Low Wood" was obviously cumbersome to use, with Reynolds having to work from a heavy observing platform at the upper "Newtonian focus" of the tube. The 30-inch Common mirror at the Helwan Observatory was eventually upgraded and replaced, and the Common mirror made its way back from Helwan to Birmingham. Reynolds decided to replace his 28-inch mirror with the slightly larger mirror made by Andrew Common.

Reynolds was a man with a very generous spirit, and when light pollution in Birmingham became increasingly problematic, he decided to donate the instrument to the Commonwealth

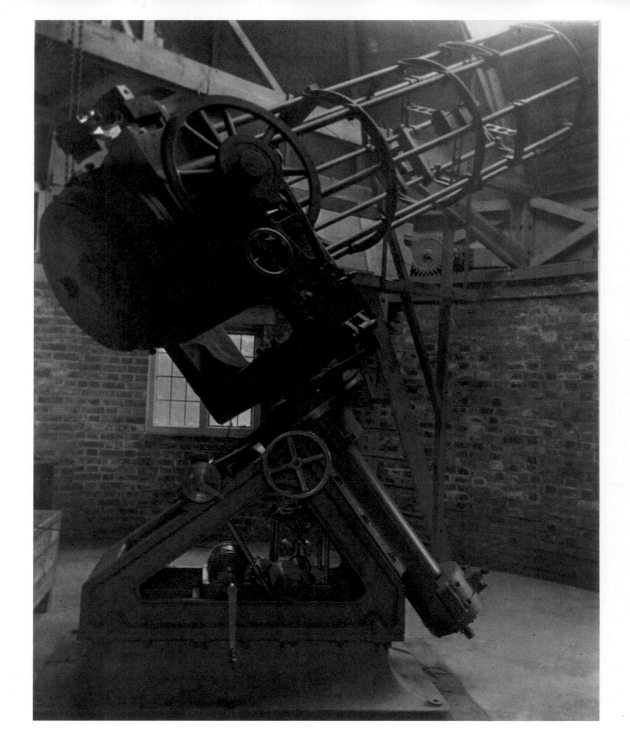

Figure 113 [419]

Solar Observatory (Figure 114) – later to become the Mount Stromlo and Siding Spring Observatories in Canberra, Australia. A steel dome of diameter 26-feet was constructed to house the telescope (Figure 115) and until the 1950s, this telescope was one of the largest operational telescopes in the Southern Hemisphere (Figure 116).

Figures 117–120 demonstrate the beauty of the night skies as captured by coauthor Ken through the eyes of the 30-inch Reynolds telescope.

Figure 114 [420]

Figure 115 [420]

Here follow some personal reflections by Ken on using the Reynolds telescope to secure his photographs:

> The Reynolds telescope was refurbished in 1971 and emerged as a modern instrument. But when I arrived at Mount Stromlo in 1967, the telescope was still in its original state. The photographic camera at the Newtonian focus, situated at the

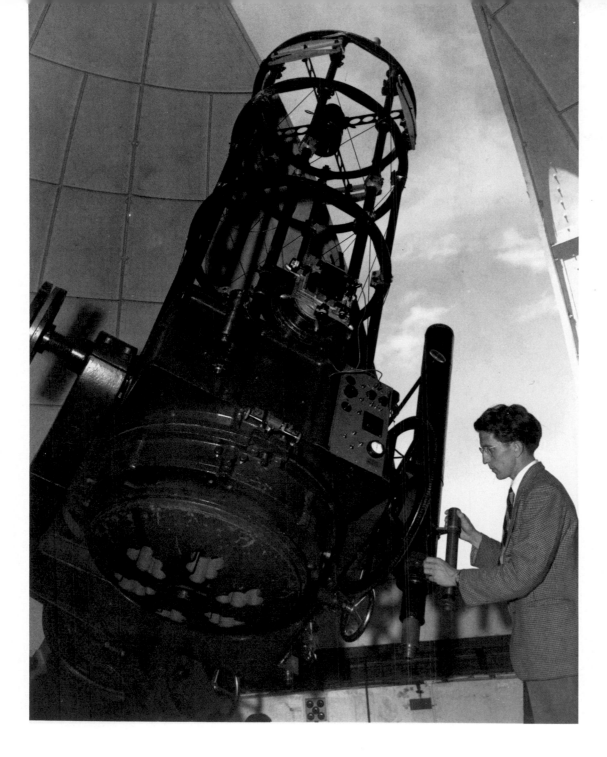

Figure 116 [420]

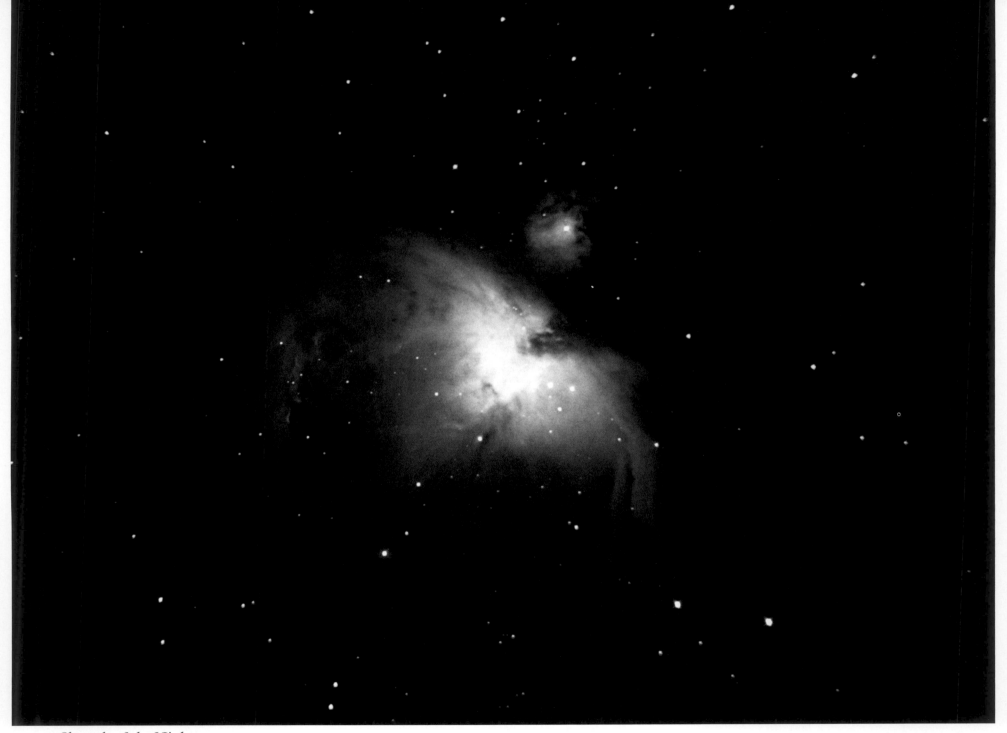

Figure 117 [420]

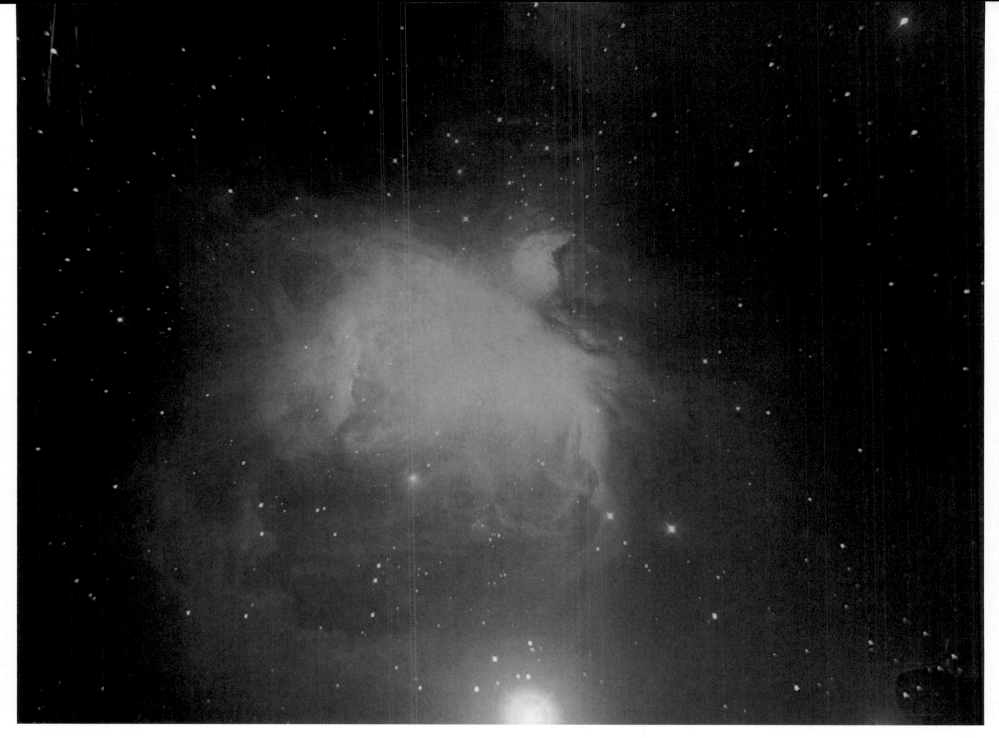

Figure 118 [420]

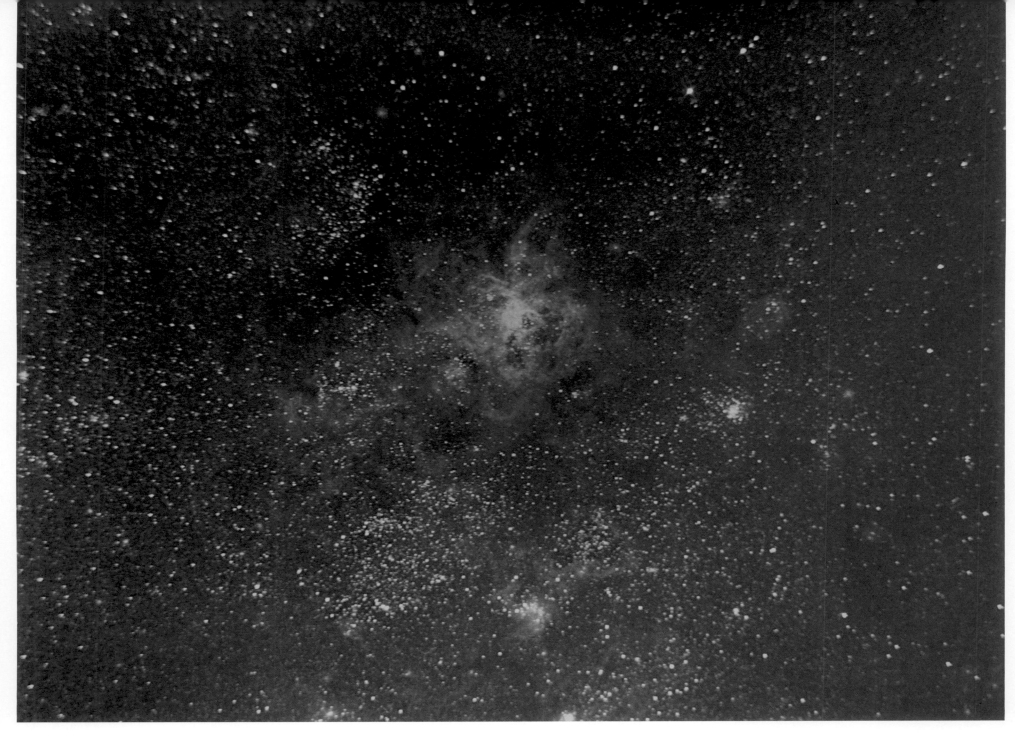

Figure 119 [420]

Figure 120 [420]

top of the telescope tube, was just as it was in the 1950s when Gerard de Vaucouleurs made his pioneering observations of southern galaxies. I used the camera to take photographs of nearby galaxies in order to measure profiles of their brightness.

Determining the brightness of features on photographic plates is a rather messy and imprecise art. The efficiency with which the older emulsions on photographic glass plates stored photons was not high and we had to soak the plates of glass in nitrogen gas to increase their sensitivity. Even with the relatively fast f/4 focal ratio of the Newtonian focus, long exposure times were needed to acquire photographs with a good tonal range.

After the photographic plate was exposed and carefully developed by hand, the distribution of densities of light within the galaxy image could be measured using an instrument known as a microdensitometer, and it was at that point that the real analysis began.

It is fitting to remember that the man after whom the telescope is named – John Reynolds – had conducted his pioneering measurements of light profiles from photographic plates way back in 1913, using essentially the same telescope configuration at his "Low Wood" observatory, before that telescope was donated to Mt. Stromlo.

Acquiring a good photograph was an adventure. Those were eyeball days. Some words of clarification. In today's modern era, astronomers track stars as the Earth rotates, by means of autoguiders. An autoguider can keep a telescope "locked on" to a bright star for hours.

Not so easy, guiding the telescope by eye.

To access the camera at the top end of the Reynolds telescope, the observer was perched on a rickety 2-m wooden stepladder which the observer had to drag around the dome as the telescope tracked across the sky. The camera itself comprised a microscope and photographic plate-holder mounted on a structure that could be moved in two directions.

The observer first pointed the telescope at a desired galaxy and then moved the microscope around to find a guide star (in other words, a star which the telescope would remain fixed on, as the Earth rotates). Then the exposure would begin.

The telescope mechanism was far from perfect and constant adjustment was essential. For two or three hours, the observer would keep an eye glued to the microscope and both hands on the adjustment screws that moved the plate holder. If the guide star drifted as the telescope tracked across the sky, the observer moved the plate holder to keep the star central in the microscope. Each hour, the observer had to close the shutter, climb down from the ladder and manually rewind the main gear drive. The goal of every observation was to produce a guided photograph of the galaxy with perfectly round stellar images.

Each exposure was a battle between the observer and the old worn-out telescope gears, with the observer visually guiding the plateholder through the microscope, as the telescope tracked erratically across the sky.

Although the photographic process was notoriously unpredictable, an amazing amount of semi-quantitative astronomy was accomplished. There were some failures but everything mostly worked out well. We all had to develop photographic skills, because we had no other panoramic detectors until the early 1980s when the first of the digital charge coupled devices (CCDs) became available.

Data acquisition and analysis then became much easier and a new era of quantitative astronomy began. I was not sorry to see the end of photography in astronomy, although I know my coauthor David deeply feels otherwise!

John Hart, Head of the Opto-Mechanical Engineering Section at the Mount Stromlo Observatory, recalls that the Reynolds telescope

was very antiquated with decorative holes in a spherically shaped counterweight at the back of the mirror cell (these decorative holes are clearly visible in Figure 116). We replaced many parts (during 1969–1971) and remachined the base and

the center section of the tube. Design and construction progressed in parallel. The existing mirror was fitted into a new mirror cell. I was a very new engineer at the time and was overawed by the responsibility of the job, which took a couple of years in total. I was in charge of the entire refurbishment. I was the only designer and had about six laboratory craftsmen in the workshop. Among the astronomers I met who used the Reynolds telescope were Gerry Kron, Ben Gascoigne and Allan Sandage. Sandage only used the Reynolds telescope a couple of times but seemed very happy with it.

Astronomer Ben Gascoigne (Figure 121) – now long retired from the staff from Mount Stromlo – was allocated nine months of observing time on the 30-inch Reynolds telescope in the early 1950s and recalls his experiences:

Time was when you worked alone, the telescope all to yourself, in the total dark, and in winter-time slowly freezing to death. But no matter how cold it had been, how difficult, or how successful for that matter, it always ended, dawn came along and you walked home, the sky all pink in the east, the birds tuning up for the day ahead, and just for a little while the world belonged to you. Nothing else I have known was quite like it, and only astronomers have experienced it.

The Reynolds telescope was used by some of the world's foremost galaxy experts of the era, including the late Gerard de Vaucouleurs. Between 1952 and 1955, de Vaucouleurs secured about 250 one-hour exposures of galaxies in the southern skies from Mt. Stromlo. The generosity of John Reynolds was indirectly crucial to the development of the galaxy classification criteria developed by Gerard de Vaucouleurs, as is clearly evident in "Memoirs of the Commonwealth Observatory No. 13" published in July 1956. The seeds of the de Vaucouleurs classification system (discussed in some detail in Chapter 11) were clearly born, in part, using the scores of galaxy photographs which Gerard de Vaucouleurs painstakingly secured in Canberra with the 30-inch Reynolds reflecting telescope.

Reynolds was an individual with enormous vision, and Hubble recognized this. It would be no overstatement to say he was England's foremost observational expert on the morphology of the nebulae, but the letters between Hubble and Reynolds have hitherto never been published.

In Figure 122 appear sections of a letter in the hand of Edwin Hubble. The letterhead is the Randolph Hotel, Oxford, written during one of Hubble's visits to England, and commences "Dear Reynolds." To show the exceptional esteem in which Hubble held Mr. Reynolds on the classification of spirals, we read in Hubble's words:

Classification of Spirals.

All suggestions on this difficult subject, coming from one of your expertise are extremely welcomed ... Could you not throw your ideas into the form of a precise classification so we could actually apply it to a large number of nebulae representing the various sizes and degrees of brightness with which we will be dealing?

These are only passing thoughts which I offer. The great thing is that the discussion is started. This will eventually lead to something acceptable to us all. Sincerely, Edwin Hubble.

(ITALICS, OURS)

Hubble's actual letter from Oxford is undated, but we know that Mr. Reynolds rose to the occasion in 1920. Six years prior to Hubble publishing his classification scheme in 1926, Reynolds devised seven bins or classes pertaining to the shapes of galaxies, which was published in volume 80 of the *Monthly Notices of the Royal Astronomical Society.*

Figure 121 [420]

Morphologist Extraordinaire

Of these Reynolds classes, Sandage comments:

> *Reynolds types I through VII are clearly identical with the Hubble spiral types Sa, Sb, early Sc, and later Sc. The correspondence is one-to-one.*

Sandage is recognizing that while Hubble has three spiral types a, b and c, the type c bin spans a *wide range* of shapes, which Reynolds had taken full cognizance of by proposing his classes I to VII.

The question before us is therefore, was Hubble aware of the classification scheme devised by Mr. Reynolds in 1920, prior to publishing his seminal classification paper in 1926? The answer is a resounding ... *yes!*

In the Reynolds archives housed at the Royal Astronomical Society, Burlington House, we found a copy of a memo from Hubble, dated July 1923, sent to Vesto Slipher as president of Commission 28. Slipher distributed the memo to members of the Commission. The front page of the memo contains the signature of J.H. Reynolds. In that unpublished memo, entitled "The Classification of Nebulae," Hubble writes to Slipher:

> *The published suggestions of J.H. Reynolds are thoroughly sound ... Reynolds introduced the term amorphous, emphasizing the unresolvable character of much of the nebulosity in non-galactic objects ... Reynolds (ref. 17) has formulated seven classes of true spirals ... the first five classes represent a series with increasing degree of condensation in the amorphous matrix of the outer arms ...*

Reference 17 in Hubble's 1923 memo is none other than the paper of Reynolds, contained in volume 80 of the *Monthly Notices* of the Royal Astronomical Society. It is abundantly clear that Hubble was fully aware of, and had very carefully studied, the classification scheme of Reynolds proposed in 1920. Although fully referenced in the 1923 memo to Slipher, Hubble moves on to publish his 1926 classification without any reference to the *source* of his classification bins ... the classes of J.H. Reynolds.

RANDOLPH HOTEL,
OXFORD.

TELEPHONE 290.

13 (3)

Classification of Spirals.

All suggestions on this difficult
subject, coming from one of your experience,
are extensely welcomed. Your terms
"massive" and "filamentous" call to mind
immediately the difference between M 31 and
M 81 among my Sb and between M 33 and
M 101 among my Sc. The exceptional cases
of patchy condensations and conspicuous
deviation from simple logarithmic spirals
are difficult to detect in the cases of
extremely small or only slightly inclined
objects. Might not these features of the larger
and more highly inclined nebulae find their
place in notes? I feel that these criteria,
significant as they may be, would be applicable
to a much smaller number of objects
than the broad and admittedly vaguer features
I mentioned.

Could you not throw your
ideas into the form of a precise classification
so we could actually apply it to a
large number of nebulae representing the
various sizes and degrees of brightness
with which we will be dealing?

These are only passing thoughts
which I offer. The great thing is that
the discussion is started. This will
eventually lead to something ac-
ceptable to us all.

Sincerely

Edwin Hubble

Address after Saturday
Mitre Hotel
Oxford.

Figure 122 [420]

Our findings are corroborated by a historical discovery made by Dr Allan Sandage (Figure 123) in Pasadena:

> *However, there is evidence that Hubble indeed was aware of the 1920 paper at some time between 1920 and 1927. Remarkably, in the bound Volume 80 of the Monthly Notices that is in the Mount Wilson Observatory library in Pasadena, there are penciled notes in Hubble's handwriting in the margin of page 746 of the 1920 Reynolds paper placed beside the descriptions by Reynolds of his binning classes. Next to each of Reynolds class II, III and IV are the Sa, Sb and Sc notations penciled in by Hubble. Also in the margin is a penciled paragraph of notes. However, much of what is there has been erased, so that although one cannot read the notes, Hubble's Sa, Sb and Sc notations are there.*

While these penciled notes are undated, the 1923 memo by Hubble (a copy of which was sent to Reynolds and which was signed by Reynolds) lays to rest a historical uncertainty unanswered up to the present time … we can definitively say that Hubble had carefully read the Reynolds 1920 paper prior to writing his seminal 1926 work.

It remains a total mystery as to why Hubble makes no mention of the Reynolds classes in his preliminary classification discussion in 1922 or in his definitive 1926 paper; how amazing, in hindsight, to study *the handwritten request of Hubble to Reynolds*, to "throw your ideas into the form of a precise classification …"

Figure 123 [420]

The kernel of the system by which astronomers continue to optically classify galaxies today was conceived in the mind of one of Britain's most gifted amateur astronomers – a man without any formal astronomical training – the great Mr. J.H. Reynolds of Birmingham.

Such was the profound respect held by astronomers of Reynolds' thoughts and writings, that he was a member of Commission 28, together with Slipher, Hubble and others.

The list of astronomers who corresponded with Reynolds included Eddington, Hertzsprung, Dyson, Hubble, Jeans, Shapley, Slipher, Smart, Milne – and scores of others.

Martin Johnson, who wrote Reynolds' obituary for the Royal Astronomical Society, recalls how "astronomers from many countries came to Birmingham to visit the Reynolds residence at Low Wood ... It is easy to recall scenes ... over many years ... Eddington, in Birmingham to give a lecture, ill and only kept on his feet by the skilled ministrations of Mrs. Reynolds, who is never dismayed by anything; Jeans ... Dyson ... Perhaps the most vivid picture is of de Sitter from Leiden, most fascinating of astronomers, arguing in the Low Wood music room about relativistic cosmology and his dislike of nineteenth century music, until Reynolds set out to convert him by playing the organ chorale-preludes which Brahms had written ..." The hospitality of Mr. and Mrs. Reynolds at their home at Low Wood was legendary, and some of the greatest astronomical minds of the age came to visit them. Figures 124 and 125 show Mr. Reynolds at meetings of the Club of the Royal Astronomical Society. In Figure 125 we see Mr. Reynolds at a dinner with the Danish astronomer Ejnar Hertzsprung, co-originator of the Hertzsprung–Russell diagram (a fundamental tool in the determination of the distances to stars).

———————

To be immortalized in the minds of students of astronomy, Hubble (Figure 126) needed a diagram to depict his classification classes. As carefully explained by Allan Sandage:

In the dry academic language of formal science, and with so few working extra-galactic astronomers at the time (perhaps only 20 worldwide), without such a diagram there was the danger that the classification system, buried in the language of the Astrophysical Journal, might lay fallow.

Why did the diagram become so overwhelmingly important? Despite the excellence of Hubble's 1926 word descriptions of the classification, the diagram is much easier to understand and to remember. It became the visual mnemonic. Indeed, we all learned to classify from it. Only later did we read the verbal descriptions in the 1926 fundamental paper. That was true in my generation. It is true now.

The British mathematical-physicist Sir James Jeans (Figure 127), one of the great popularizers of science of his time and a prolific author of popular books, such as *The Universe around Us* (1929), *The Mysterious Universe* (1930 and *The Growth of Physical Science* (1947), came to the rescue. At a meeting of the Royal Astronomical Society, there is a historic photograph (Figure 128) of Mr. Reynolds sitting in the Chair as President, with Sir James Jeans delivering a lecture.

To unravel the interplay between the works of Hubble and of Jeans, we purchased Jeans' books *Astronomy and Cosmogony* as well as *Science and Music*. In exploring the provenance of the diagram, full credit must be given to astronomy historian William Sheehan who acted as a master detective in this regard. It is abundantly clear that Jeans discussed the 1926 classification bins of Hubble and in 1929, Jeans used a Y-shaped fork diagram to graphically represent Hubble's scheme!

Historically, the roots of such detective work actually go back two decades, since there is a footnote in the book *Man Discovers the Galaxies* by Berendzen, Hart and Seeley (published in the early 1980s) that the original Y-shaped diagram may actually be found in Figure 53 of the book authored by Sir James Jeans entitled *Astronomy and Cosmogony* published in 1929.

To be historically accurate, Hubble failed to acknowledge two of his pivotal sources for those ideas which now bear his name: Reynolds and Jeans. As agreed by Allan Sandage, the graphical representation of the Hubble tuning fork must be attributed to Sir James Jeans – a scientist who adored music, and who wrote a famous book *Science and Music* on that theme.

In the Lowell Observatory archives, Hubble revealed to Slipher that he had "been trying to construct a classification of non-galactic nebulae analogous to Jeans' evolution sequence, but from purely observational material."

On theoretical grounds, Jeans predicted a sequence which was time dependent: starting off at *early* times from a rotating spherical cloud of gas which cools with time, to form, at much *later* epochs, a highly flattened disk. Jeans wrote: "After being at first almost spherical, it will become spheroidal, then will develop a sharp edge in the equatorial plane. Matter will then be shed off from this sharp edge and [start] describing orbits in the equatorial plane." Jeans envisaged spiral arms themselves to be ejected matter along the plane of the disk:

Figure 124 [421]

When first it assumes the lenticular form, the forces of gravitation and centripetal force do not suddenly become equal at all points ... Two

opposite points from the equator will be distinguished ... the rejected matter ought to form two symmetrical streamers or arms.

Hubble was deeply aware of the theoretical framework of Jeans, and of the degree of flattening envisaged by Jeans as time progressed. Hubble wrote:

Therefore the observer may well look to Jeans' theory for the thread of physical significance that shall vitalize a system of classification of non-galactic nebulae. In the scheme presently to be proposed, a conscious attempt was made to ignore the theory and to arrange the data purely from an observational point of view. The analogy however was so suggestive that at several points ... there was no hesitation in accepting the one favored by Jeans' theory of spirals.

Figure 125 [421]

Hubble was right to make a conscious attempt to ignore the theory. Although we still do not really understand how spiral galaxies change with time, it now seems likely that any such change is in the *opposite* sense to that envisaged by Jeans; that is, from Hubble's late to early types. Nevertheless, the concepts which Hubble used to describe his sequence of spiral galaxies into early and late types rested heavily on the work of Jeans, whose time sequence was from rotating spherical clouds at early epochs to flattened disks at later times.

Astronomers had used the terms "early" and "late" before Hubble and Jeans, in the context of the temperatures of star. In the early 1900s, some astronomers believed that the hot (so-called "early type") stars were young and gradually evolved into cooler "late type" stars. We now know that the situation is far more complex: both hot and cool stars can be young or old, and our Sun was not born as a hot star. Our Sun is currently a normal dwarf star but will progress with time into a cool red-giant star and eventually go through a very hot phase as it dies, with temperatures as high as 150 000 degrees Centigrade. (Astronomers categorize stars according to their intrinsic luminosity, or brightness; from highly luminous supergiant stars to intrinsically faint dwarfs and subdwarfs. The radius of a giant star is much larger than that of a dwarf star, while their masses may be comparable; the surfaces of giant stars are therefore characterized by gas densities and pressures that are low compared to those found in dwarf stars.)

Figure 126 [421]

The thinking in the early 1900s, from both a stellar and galactic viewpoint, was in terms of a sequence which progressed with time, *from* "early-type" *to* "late-type." It is curious that Hubble uses the terminology "early," "middle," and "late" type galaxies in his paper of 1926, and has a *footnote* which reads:

Terms which apply to series in general are available, however, and of these "early" and

"late" are the most suitable. They can be assumed to be a progression from simple to complex forms.

<div align="right">(ITALICS, OURS)</div>

Those terms were indeed available – from Sir James Jeans' *Problems of Cosmogony and Stellar Dynamics* published in 1919.

Response to Hubble's 1923 memo was mixed. Writing from Helwan, Egypt on July 18, 1924, the astronomer Knox-Shaw expressed his thoughts to Slipher thus:

> *I found Hubble's note on the classification of nebulae especially interesting, and I am in general agreement with his proposals, though there are one or two points on which I should like to reserve my opinion …*

In a letter from the Harvard College Observatory dated October 8, 1924, Bailey wrote:

> *The terms <u>Early,</u> <u>Middle and Late</u> should not be emphasized, since the order of evolution of these nebulae does not appear to be sufficiently well established at the present time, and it is undesirable to introduce theories into a classifica-tion, if it can be avoided*

<div align="right">(THE UNDERLININGS APPEAR ON BAILEY'S ORIGINAL LETTER)</div>

Figure 127 [421]

Prior to the 1923 Hubble memo, W.H. Wright at Lick Observatory, wrote a letter dated March 7, 1922, addressed to Slipher:

I must confess that I am rather dazed by the latter's [Hubble's] letter [dated February 23, 1922] ... One can see that the nebulae will have no private life when he has his way ... Besides my habit is to think from one plate to the next, and I am afraid I am not much on Empire Building; so I shall smooth your path by getting out of the way.

One week later, on March 14, 1922, Slipher replied to Wright:

Hubble's report dazed us too ... We know so little about nebulae today that it is no easy task to lay down a line of study that would be so good as not to need very vital alteration in even a few years time ...

The International Astronomical Union Commission on Nebulae and Clusters held its meeting at Cambridge, England, in 1925, and objected to the fact that Hubble had seemingly proposed "terms suggestive of certain physical properties of the nebulae, about which there was still much doubt." His evolutionary scheme – with such terms as early, middle, and late – did not seem justified; instead the Committee recommended adoption of "a simpler system of a more purely descriptive nature should be used."

Figure 128 [421]

Reaction from Heber Curtis was also not favorable: "I also seriously question the wisdom of the use of the terms Early, Middle, and Late, as used by Hubble ..." wrote Heber D. Curtis in an undated document circa 1927. One year later, on April 22 1928, Curtis wrote to Slipher:

My own views as to any nebular classification are so at variance with those of many others who are now more actively engaged in actual work in this field that I think you had better simply "count me out", and put it down, – "one member of the Committee dissenting", or something like that.

A sad plea indeed, from the very person who first recognized the bar phenomenon in his *phi*-type galaxy. In the mind of Hubble, he was the custodian of morphological astronomy. Others, such as Knut Lundmark, presented similar (but not identical) classification schemes, but these were not published in the mainstream journals, and Hubble closely guarded his morphological terrain.

Sandage writes:

[Hubble] guarded its priority in a revealing footnote in part I of his 1926 paper. There he comments on a classification system proposed at about the same time by Lundmark (1926, 1927). Some of Hubble's complaints, which he rarely made public, were unfounded, showing a sensitivity he generally kept hidden. Some of Hubble's accusations are addressed in a partially justifiably acerbic reply by Lundmark (1927), also in a footnote, in Lundmark's near great but largely neglected paper.

A portion of Lundmark's reply, contained in his "Studies of Anagalactic Nebulae" presented to the Royal Society of Science of Uppsala on May 6, 1927, reads as follows:

In his paper, E.P. Hubble makes an attack on me which is written in such a tone that I hesitate to give any answer at all ... I was not then a member of the Commission of Nebulae. I did not have any access whatsoever to the memorandum or to other writings of E.P. Hubble ... Hubble's statement that my classification except for nomenclature is practically identical with the one submitted by him is not correct [italics, those of Lundmark]. Hubble classifies his subgroups according

to excentricity [sic] or form of the spirals or degree of development while I use the degree of concentration towards the centre ... As to the three main groups, elliptical, spiral and magellanic nebulae it may be of interest to note that the two first are slightly older than Hubble and myself. The term elliptical nebulae thus is used by Alexander in 1852 and the term spiral by Rosse in 1845. The importance of the magellanic group has been pointed out by myself [Observatory, volume 47, page 277, 1924] earlier than by Hubble. As to Hubble's way of acknowledging his predecessors I have no reason to enter upon this question here.

Hubble's scientific achievements were grand. But on at least two accounts, Hubble was deeply inspired by the work of Reynolds. We have already discussed one of these at length: the Reynolds classification classes for spiral galaxies, published in 1920.

The second story is interesting, too: in 1913, Mr. Reynolds pioneered the measurement of the profiles of light across the bulges of spiral galaxies, beginning his investigation with the Andromeda Spiral Galaxy.

Reynolds had secured photographs of the Andromeda Galaxy with his 28-inch reflector at "Low Wood" in October 1912, and then measured the profile of light across its highly prominent bulge.

Using an instrument known as a "photomicrometer," supplied by Toepfer of Potsdam, Reynolds found that the light brightness decayed from the center, outward. Sandage calls this "the famous Reynolds profile" and notes that "Hubble (1930) later generalized [it] by making it scale free [dimensionless]." Today astronomers speak only of the Hubble luminosity profile – but why not the Reynolds (or, at least, the Reynolds–Hubble) luminosity profile? After all, it was Mr. John Reynolds who pioneered that work in 1913.

Mr. Reynolds was elected a Fellow of the Royal Astronomical Society of London in 1899, at age 25, served as Treasurer in 1929–1935 and President during the period 1935–1937. Mr. Reynolds is one of the few persons ever to rise to the rank of President of the Royal Astronomical Society, whose official occupation was not an astronomer. Reynolds was among

the last of the great amateur scientists. His technical skills in using photographic plates for quantitative intensity measurements were unsurpassed for the time and his vision has influenced generations.

In popular astronomical textbooks, we only read of the Hubble classification classes, the Hubble tuning fork and the Hubble luminosity profile for elliptical galaxies. Behind the stage loomed the giant Mr. Reynolds, a man whose name is almost unknown to students of astronomy.

Volume 80 of *Monthly Notices of the Royal Astronomical Society*, containing Hubble's penciled notes alongside the "highly neglected" 1920 paper by Reynolds is of exceptional historical value and no longer lies in the shelves of the Mount Wilson Observatory library in Pasadena; it has been removed, for safekeeping.

As fundamental as the Hertzsprung–Russell diagram is to stellar astronomy, so the Hubble tuning-fork has become a Rosetta stone in the classification of galaxies. Hubble presents the tuning-fork diagram in his famous book *The Realm of the Nebulae* (1936).

Astronomy textbooks will not change; the Hubble classification scheme and the Hubble tuning fork will continue to be taught to students worldwide; but may it be a source of much inspiration to younger readers that some of the grandest of ideas in the area of galaxy morphology did not spring forth from a professional astronomer trained at one of the world's prestigious Universities, but rather from the mind of Mr. John Henry Reynolds – a student of the heavens above – a gifted amateur who simply was *passionate* about the wonders to behold in the Night Sky, and who devoted a large sector of his energies and finances to spearheading new cosmic horizons. Although the 30-inch Reynolds telescope at Mt. Stromlo was totally destroyed by the bushfires which devastated sections of Canberra in January 2003, the building has been renovated and the legacy of Mr. Reynolds (1874–1949) forever lives on.

The words spoken by E.J. Stone (President of the Royal Astronomical Society) upon presenting their Gold Medal to Mr. Andrew Common in February 1884 ring equally true for Mr. John Reynolds:

> *The amateur who can provide himself with sufficient instrumental means for original research need fear no professional rivalry; untrammeled by the necessity of continuing observations whose value largely depends on their continuity, having the power of taking up any subject he pleases, pursuing it so long as he believes in the possibility of success, without fear or responsibility of wasted time and wasted means, he possesses advantages which are priceless in the tentative and experimental stages of any work ... It is in work of this class that the most striking advances in our science must be expected; and such work will most certainly repay, by the gratification of personal success, the efforts of those who devote themselves to original work in our science, and the field of research presented is absolutely priceless.*

Why Hubble behaved in the manner he did, we will never know. Personal, intimate reflections by him are forever gone: personal notes destroyed after his death. Tragically, Hubble was a man with a mask. Few ever penetrated it.

"Every one is a moon, and has a dark side which he never shows to anybody," wrote Mark Twain. Perhaps the words below, also by Mark Twain, are appropriate:

> *It's just the way, in this world. One person does the thing, and the other one gets the monument.*

————————————

Beneath these masks, different galaxies are lurking; new schemes of classification are waiting to be devised, not in the optical, but in the infrared regime, wherein we penetrate smoky and dusty Shrouds of the Night.

The Dust Penetrated Universe: Hidden Symmetries

f course, old red stars become visible at longer wavelengths even without dust, since that is where they radiate most of their energy and light. However, the situation becomes greatly skewed in the presence of cosmic fog.

A simple analogy may be in order: a ship approaches a harbor at night. The captain does not see the harbor in much detail. His view is dominated by the brilliant light of the harbor lighthouse, just as our view of the spirals is dominated in visible light by the brilliant hot stars and the regions of star formation. Now imagine that the night is foggy. The captain sees even less of the harbor, just as our view of galaxies is affected by the fog of cosmic dust. So the Captain's view of the harbor is misleading because of two critical issues: once by the brilliance of the optical light beaming from the lighthouse, and secondly by the fog enveloping the actual lighthouse. How strikingly does our full moon mask the presence of fainter stars (Figure 129).

Astronomer Ben Gascoigne recalls the great obscuring effects of dust when he first observed a class of variable stars in the Small Magellanic Cloud, using the 30-inch Reynolds reflecting telescope:

> *There was one major surprise, obvious from the first night of observing. All eleven of our Small Magellanic Cloud Cepheids were strikingly blue, definitely bluer than the Cepheids in the galaxy ... it was hard to believe that the [Milky Way] galaxy could contain enough dust to redden its Cepheids to the extent we had found.*

(ITALICS, OURS)

Figure 129 [421]

Of course cosmic dust has absolutely nothing to do with dark matter that dominates the mass of galaxies: the dust mass in a typical spiral galaxy represents an insignificant fraction of the total mass of the galaxy. But herein is an absolutely crucial point: a substance's effects should never be judged by its mass alone. *How much, after all, does a fog weigh? Almost nothing; yet it is capable of blinding pilots, diverting flight paths, shutting down airports.*

Think for a moment of an erupting volcano. Particles of ash may effectively obscure the entire volcano. And so it is, with galaxies. The effects of dust or smoke particles in Shrouds of the Night are enormously effective. The penetrating power of the near-infrared allowed us to see, for the first time, a majestic *new view* of the structure of spiral galaxies.

Instead of volcanic masks, think of the Asaro mudmen wearing their historic masks (Figures 2 and 3). In optical light, we can photograph their masked faces, dancing with the majestic Eastern Highlands as a backdrop. Let us now suppose that we were to ask them to remove their masks: a very different image emerges: the effects of the mask are gone, and rich facial structure is revealed. We see their true eyes, their actual noses and facial structure: how *impossible* to predict, a priori, what their faces would look like before we ask them to remove their masks! A rich duality in structure – that of the mask and that behind the mask – emerges.

The Australian Aborigines capture this kind of duality of structure in their x-ray paintings. While their paintings of a fish and a turtle have the unmistakable outline of these creatures, they also unveil their hidden skeletal backbones and organs, as if seen with x-rays ... these arresting x-ray paintings, one of which is seen in Figure 130, are drawn as if we could penetrate the very inner morphologies – much as we do with our galaxies in the infrared.

Just as Röntgen a century before had opened up a new era to penetrate the skeletal frame encased in a mask – our skin – so too, can our infrared images allow us to unveil the actual *backbones* of galaxies.

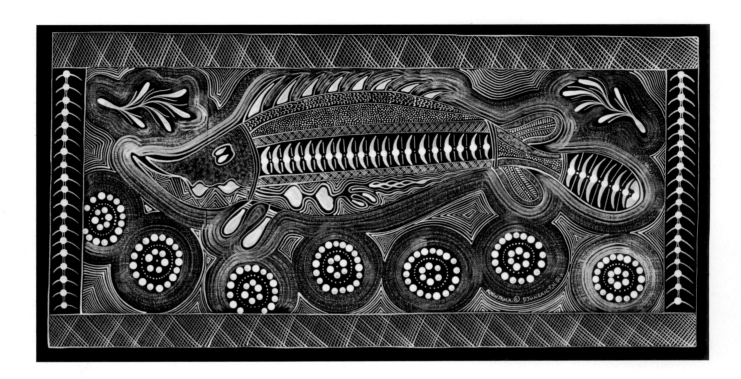

Figure 130 [421]

When galaxies are imaged photographically in the visual domain of the electromagnetic spectrum, the focus is obviously on the young and brilliant spiral arm tracers – the young Population I component – the icing or frosting on the cake, as it were.

The young Population I component – the mask – is relatively very light: only about five percent of the total luminous mass. The grand photographic surveys of earlier epochs give us a very incomplete picture of what spiral galaxies actually look like. Behind the fog lies the older Population I component of stars, where ninety-five percent of the galaxy's total luminous mass is distributed.

It soon became apparent that it was impossible to predict what the dust penetrated image of a galaxy might look like: each image behind the Shroud was a grand revelation, in its own right. The words of Benjamin Franklin (1706–1790) ring in our ears:

Like a man traveling in foggy weather, those at some distance before him on the road he sees wrapped up in the fog, as well as those behind him, and also the people in the fields on each side, but near him all appears clear, though in truth he is as much in the fog as any of them.

The setting: the Mauna Kea Observatories in Hawaii. The galaxy: one of the largest spiral galaxies yet identified, known as NGC 309. We had, for years, known that this galaxy was so large, that neighboring spiral galaxies (such as Messier 81) could comfortably fit in between its gargantuan spiral arms (see Figure 131). The challenge: to image this galaxy using near-infrared camera arrays, which had then only recently been declassified by the US military and made available for general use.

When the dust penetrated image of NGC 309 first appeared on our computer screens, we questioned whether the telescope had actually been pointed at the correct object! Figure 131 shows an optical image of the galaxy and Figure 132 the near-infrared view. We simply could not believe our eyes! What emerged from behind the shroud was a two-arm grand design spiral, with a small central bar, barely discernable on optical images. (Grand design spiral galaxies are famous for their prominent and well-defined spiral arms, which can be traced over large angles and which cover a large fraction of the disk of the galaxy. They truly are *grand* in design. In contrast, flocculent spiral arms as seen in Figure 140 and Figure 152 are short, fleece-like and the multi-arms in these galaxies cover only small areas of the disk.) Could it be that NGC 309 was hinting at a fundamental new and general Hidden Symmetry in Nature: that behind the dust shrouds of many spiral galaxies could lie beautifully symmetric stellar backbones?

Upon writing up our findings (which subsequently appeared on the cover of the British scientific journal *Nature*), we noted that NGC 309 seemed to *change* its Hubble type, when imaged through its Shroud of the Night. Could it be true that Nature was to present astronomers with a daunting new view of galaxy structure, which may be unrelated to their optical Hubble types?

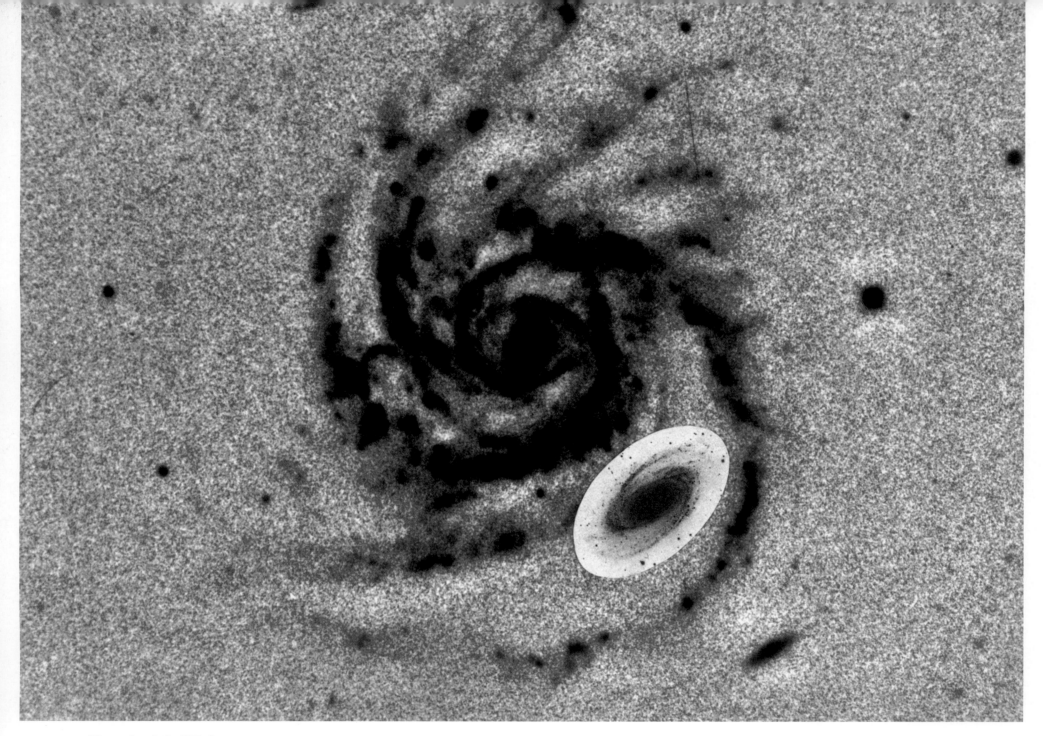

Figure 131 [421]

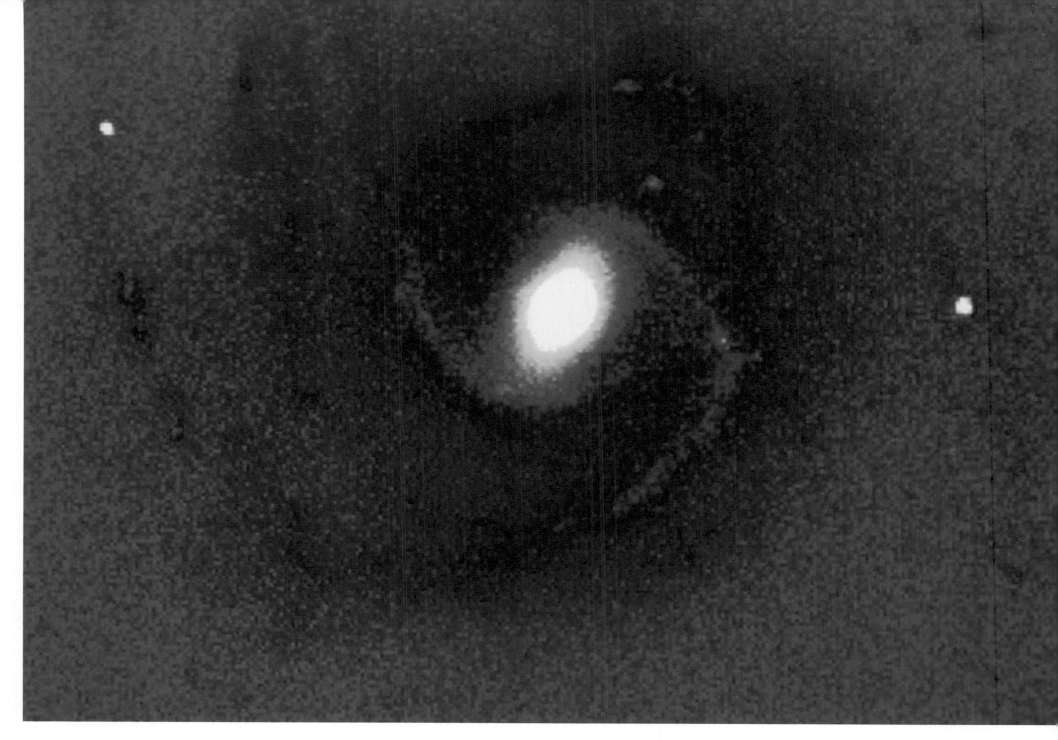

Figure 132 [421]

The possibility of such a result had been anticipated by astronomer Vera Rubin and her collaborators. Dr Rubin and her team had studied dozens of spiral galaxies, and had noted that Sa, Sb and Sc spiral galaxies could all have the same *shape* of their rotation curve, and so belong to the same "form family." The implications of Rubin's studies are profound: galaxies of Hubble types spanning Sa to Sc may have *similar* backbones of stars in the near-infrared; for it is the stellar backbones of galaxies to which Rubin's "form families" of rotation curves are inextricably tied.

Earlier, in 1957, Fritz Zwicky commented on a comparison of blue and yellow plates of the Whirlpool Galaxy, Messier 51, and its companion NGC 5195. The plates were taken using the 200-inch reflector at Mt. Palomar. In a famous book entitled *Morphological Astronomy*, Zwicky's mind panned the future:

> *We are confronted with the possible case of being a normal spiral when seen in the light of its blue stars [young stars] and a barred spiral in the light of the yellow-green stars [older stars].*

The photographic work of Zwicky was extended by astronomers Stewart Sharpless and Otto Franz, who published an important paper in 1963, entitled "Composite Photography of Galaxies." In 1964, the astronomer Merle Walker (then at the Lick Observatory, California) produced composite photographs of our nearby spiral galaxy Messier 33, using negatives taken in blue and infrared light with the 120-inch reflector at the Lick Observatory.

Composite photography (Figure 133) uses photographs taken in two different spectral regions (for example, blue and yellow), and contact positives are made from these. What changes as one images galaxies from blue to yellow light? There is less star formation and less obscuring effects of dust seen in the yellow images, so that more light is seen from the older stars. The positive corresponding to the one spectral region was then superposed upon the negative corresponding to the other. The composite photographic technique was a first, early step to "penetrate the dust mask;" to see old stars which do not contribute a major share of the light, but which do contribute a major portion of the mass in the optical extent of a galaxy. "Such a method is potentially an important one

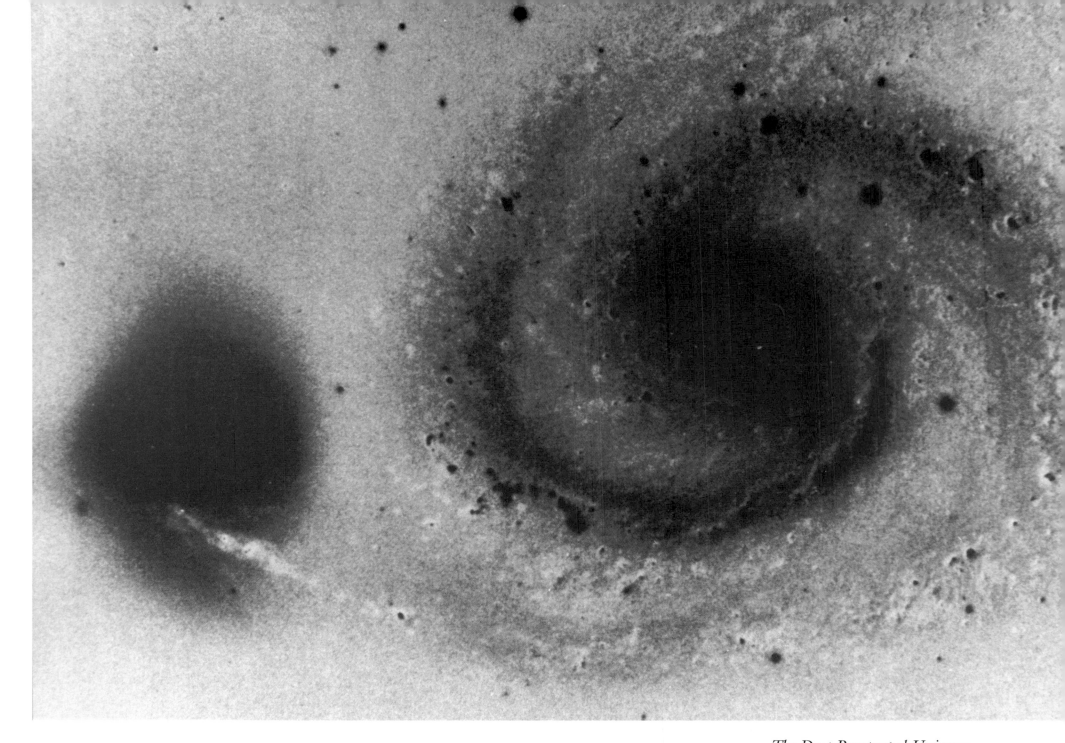

Figure 133 [422]

for the study of the morphology of galaxies" wrote Sharpless and Franz. The methodology used by Sharpless and Franz was first described by Charles Fehrenbach and Alice Daudin, in 1945.

Clearly, we desperately needed images of other galaxies. In 1993, Harry van der Laan, then Director-General of the European Southern Observatory, invited David to work at their Headquarters in Garching (near Munich) for several months, and, during that time, we had access to their telescopes at La Silla. One telescope in particular had been fitted with a special near-infrared camera. As we image galaxies further and further toward the near-infrared, the pervasive influence of dust grains gradually declines and the contribution of older stars increases. What emerges through the dusty Shrouds of the Night is the dominance of an older population of stars: it is this older population which forms the backbone of these spirals.

As noted in Chapter 3, we spent one entire night imaging NGC 2997 in the Atacama desert in Chile, soaking up near-infrared photons (Figure 21). It was indeed painstaking to construct the mosaic from multiple images, but so worthwhile, for we were successfully penetrating its dusty shroud (Figure 22).

The duality of spiral structure was, once again, seen to full advantage: our infrared view of this galaxy (Figure 21) reveals two smooth arms but one arm appears to be more dominant than the other; moreover, the famous optical spur simply does not have any prominent counterpart at all. It was also intriguing to note that remnants of light from some dust-enshrouded younger ionized hydrogen regions actually remained visible behind the Shroud of NGC 2997.

———————————————

We well remember our excitement after examining infrared images of the companion galaxy to the Whirlpool Galaxy, Messier 51. After all, the Whirlpool Galaxy and its companion (designated NGC 5195) have been photographed by both professional and amateur astronomers countless numbers of times over the years.

The companion looks so *irregular* on optical photographs (Figures 134 and 135), as if severely disturbed by a close encounter with the majestic spiral Messier 51. Could it not, however, be that NGC 5195 is proudly wearing its mask of cosmic dust and gas?

Penetrate the Cosmic Shroud of NGC 5195, and behold its magnificent, symmetric structure (Figure 136): no longer does chaos reign supreme, but its backbone of old stars is *stunningly symmetric*. Together with its symmetric disk is a hint of an incipient two-armed spiral galaxy.

If one were to first show a student an infrared image of this galaxy as seen behind its cosmic shroud, and then ask the student to *determine* what the galaxy might look like optically – this would be an impossible task, because of the duality of spiral structure. NGC5195 just looks so dramatically different when penetrating its dusty Shrouds of the Night.

An object of intense astrophysical interest is our closest active radio galaxy, known as Centaurus A (Figure 137). Its complex and intriguing optical structure was noted by Sir John Herschel who observed it from the Cape of Good Hope. In 1954, the astronomers Baade and Minkowski suggested that Centaurus A actually represented two galaxies in collision.

What is so striking in Figure 137 is the colossal mask of dust striding across the central region of the galaxy. What might be lurking behind the dust mask of Centaurus A? In the year 1999, a group of French astronomers led by F. Mirabel generated an infrared view of Centaurus A. In collaboration with French astronomer M. Sauvage, we generated specialized dust maps, to probe the actual distribution of the dust grains – in order words, to effectively probe the shape of the mask.

The Mirabel images and our dust maps beheld a great secret: right in the central region of Centaurus A lay what appears to be the remnant of a spiral galaxy (Figure 138). Baade and Minkowski were correct; it is conceivable that optical images show that which has remained

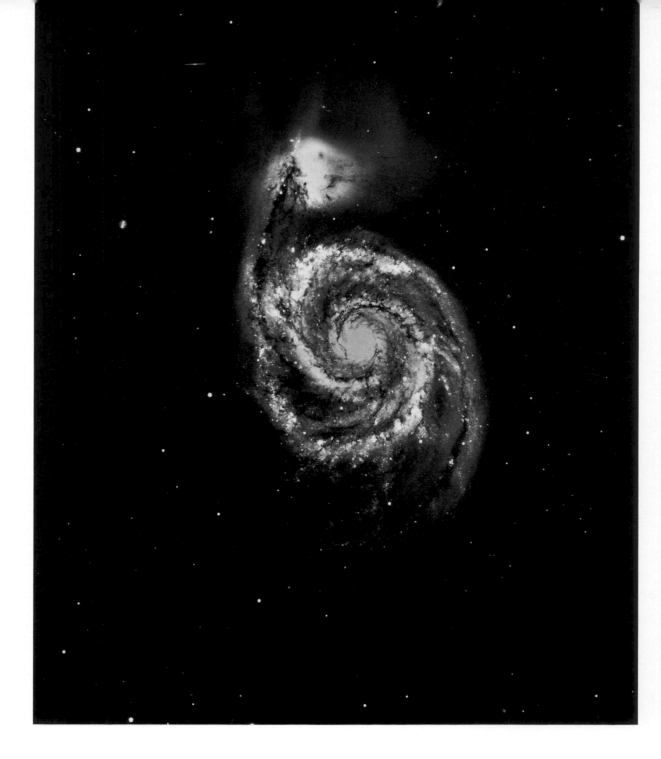

Figure 134 [422]

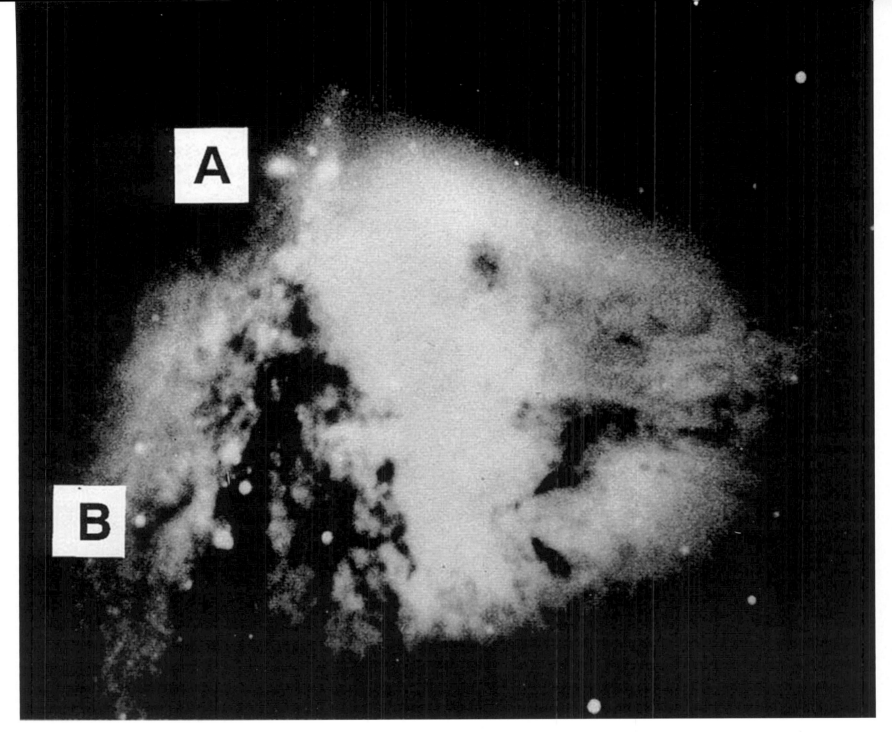

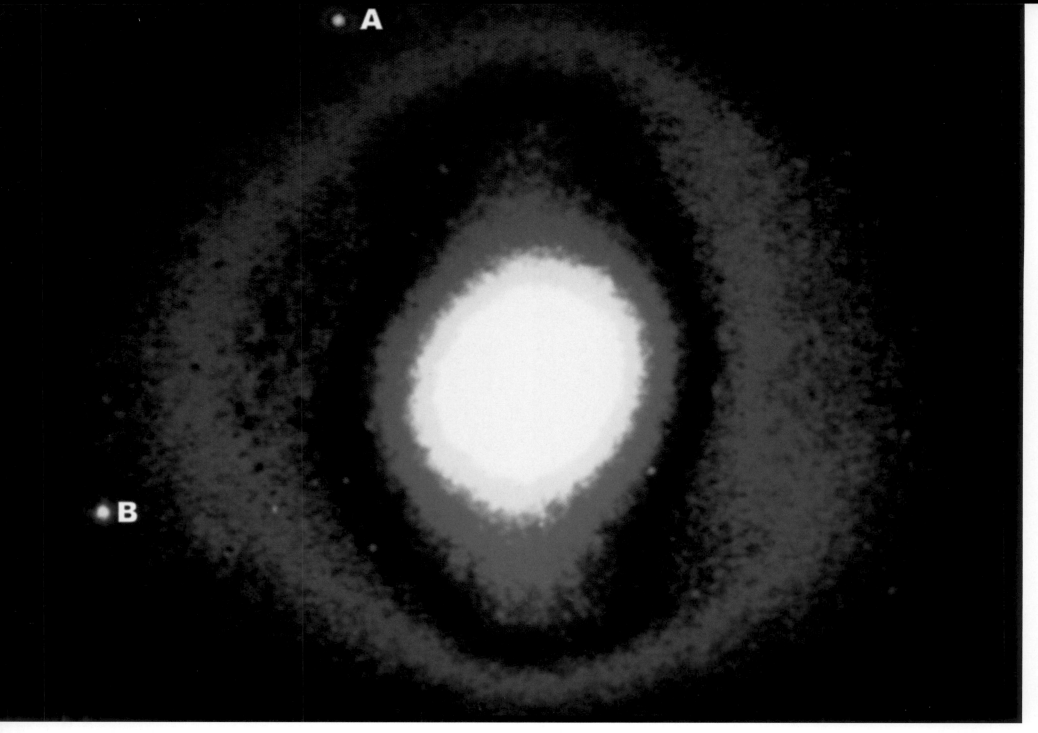

Figure 136 [422]

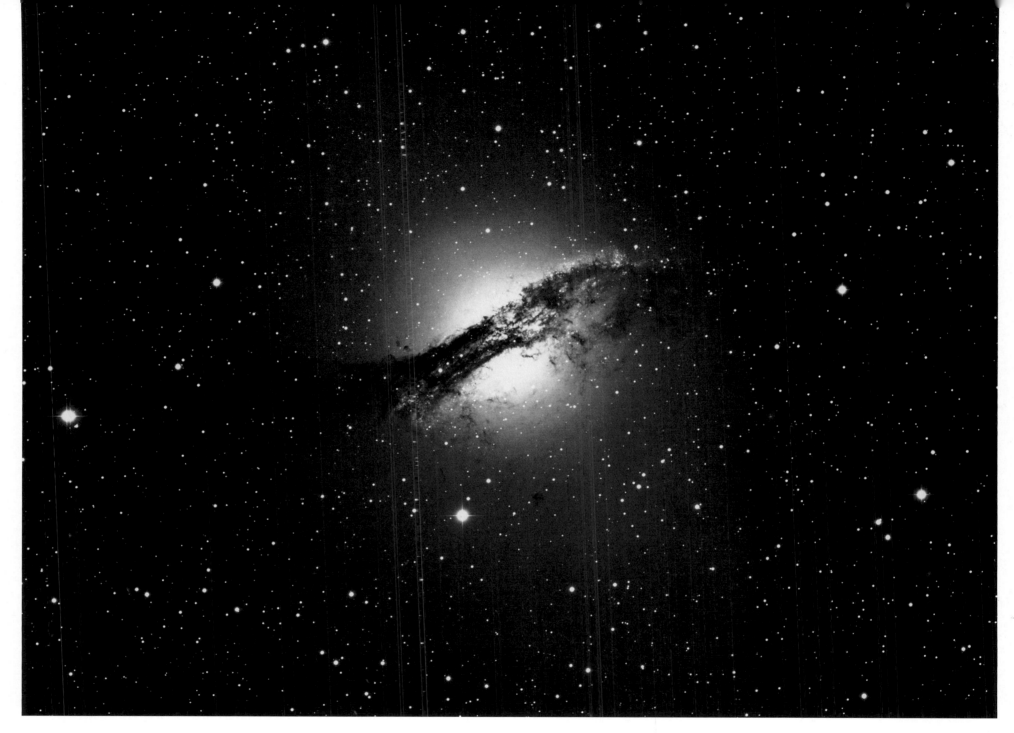

Figure 137 [422]

The Dust Penetrated Universe

The Dust Penetrated Universe

229

of a spiral galaxy after colliding with a large elliptical galaxy, forming the imposing structure which we see today.

Worlds in collision ... galaxies in collision. It is no wonder that Centaurus A shows the most exquisite outer loops of stars when images of this merging system are made. Figure 139 shows one such view, generated by a team of astronomers led by E. Peng and which included one of the authors (Ken). Centaurus A truly spawns vast arrays of shells of stars, as these two worlds collided ...

How vastly different do infrared images of Centaurus A appear to optical ones; the dust mask of Centaurus A carefully retained its inner secrets, securely kept locked in time and space for epochs of millions of years, until instruments on our Earth revealed the inner spiral galaxy not even two decades ago (Figure 138). The grand dust shroud of Centaurus A had at last been penetrated.

———————————

One of the most famous spiral galaxies in the southern skies is the galaxy designated NGC 253 in the constellation of Sculptor. An optical image (Figure 140) shows a plethora of short, fleece-like spiral arms, with no apparent regularity whatsoever. As with NGC 309, a grand revelation awaits the investigator behind its dusty Shroud of the Night (Figure 141). In infrared light, NGC 253 exquisitely reveals a hidden symmetry of two dominant spiral arms and a bar beneath the galactic froth.

———————————

Enter the world's grandest infrared space telescope, the Spitzer Space Telescope, named after one of Princeton's foremost astrophysicists, the late Lyman Spitzer, Jr. The Spitzer Space Telescope is the last in NASA's Great Observatories Programme; the first is the *Hubble Space Telescope*, deployed by the Space Shuttle *Discovery* in 1990. The second Great Observatory was launched and deployed by the Space Shuttle *Atlantis* in 1991 and was known as the *Compton Gamma-Ray Observatory*. This mission collected data on some of the most violent physical processes in the Universe, characterized by their extremely high energies. It was

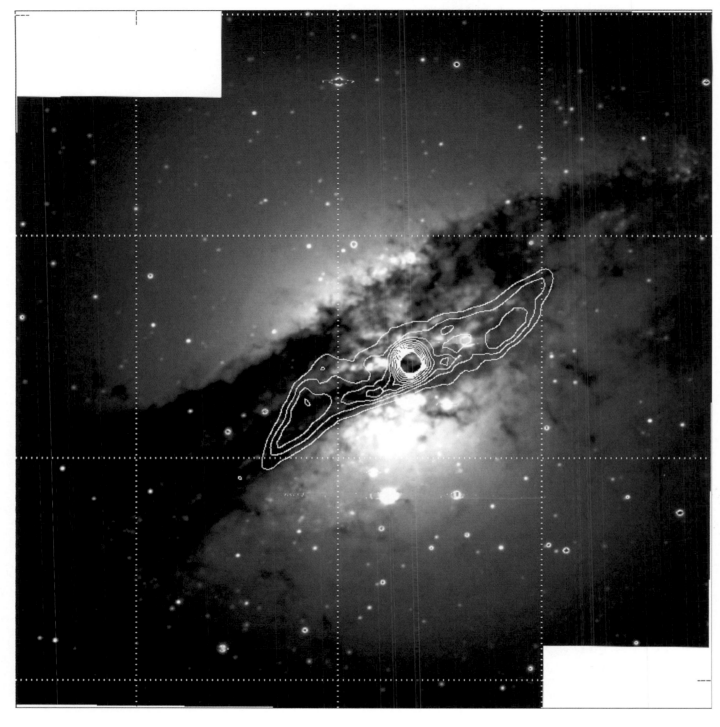

Figure 138 [422]

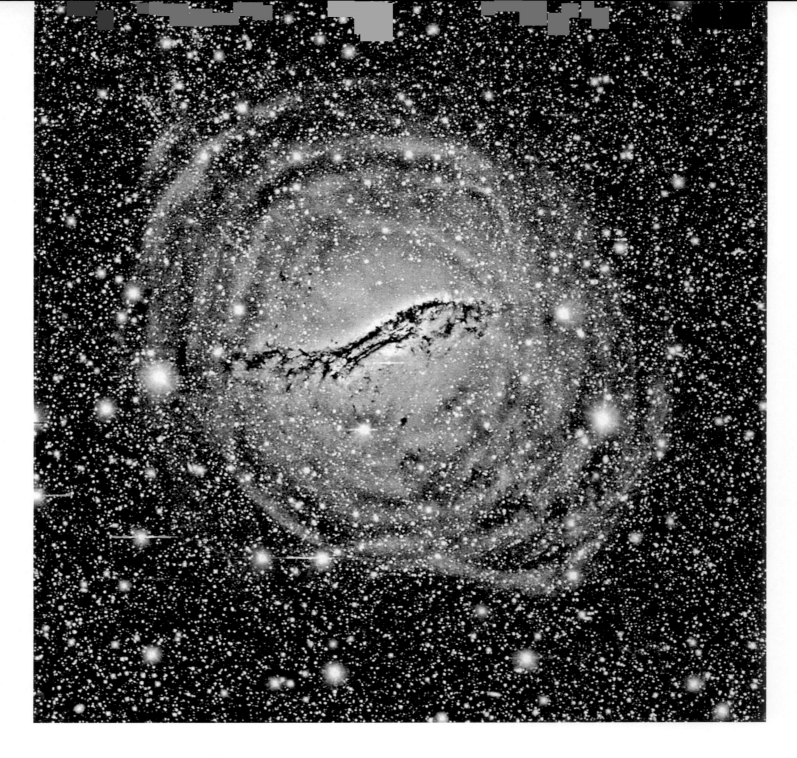

Figure 139 [422]

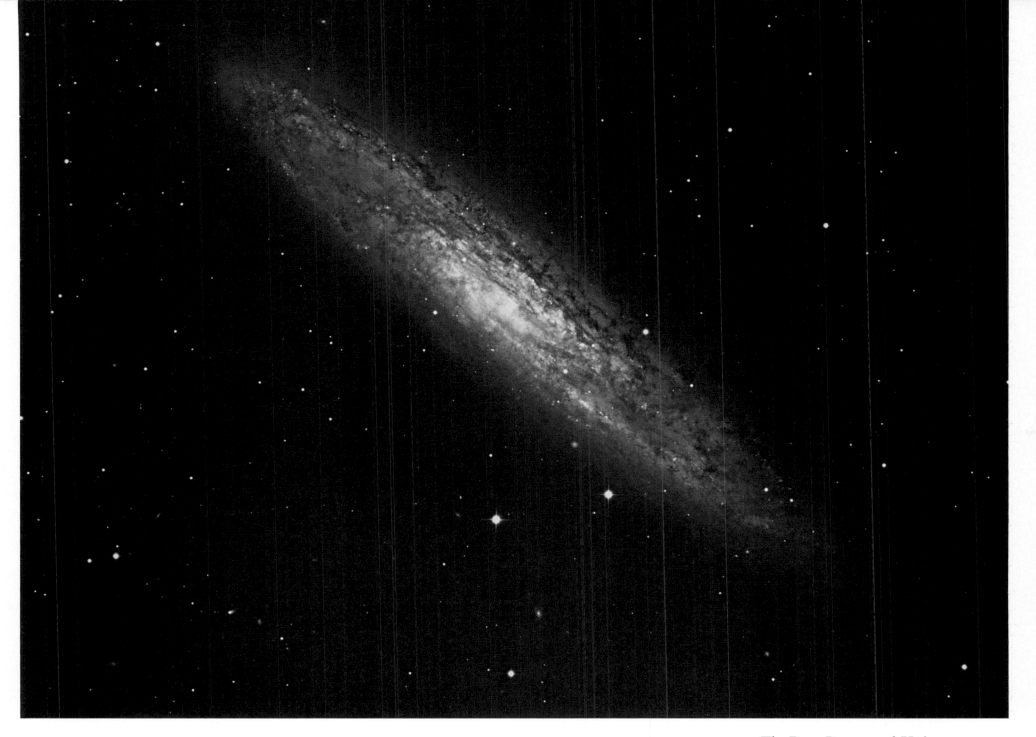

Figure 140 [422]

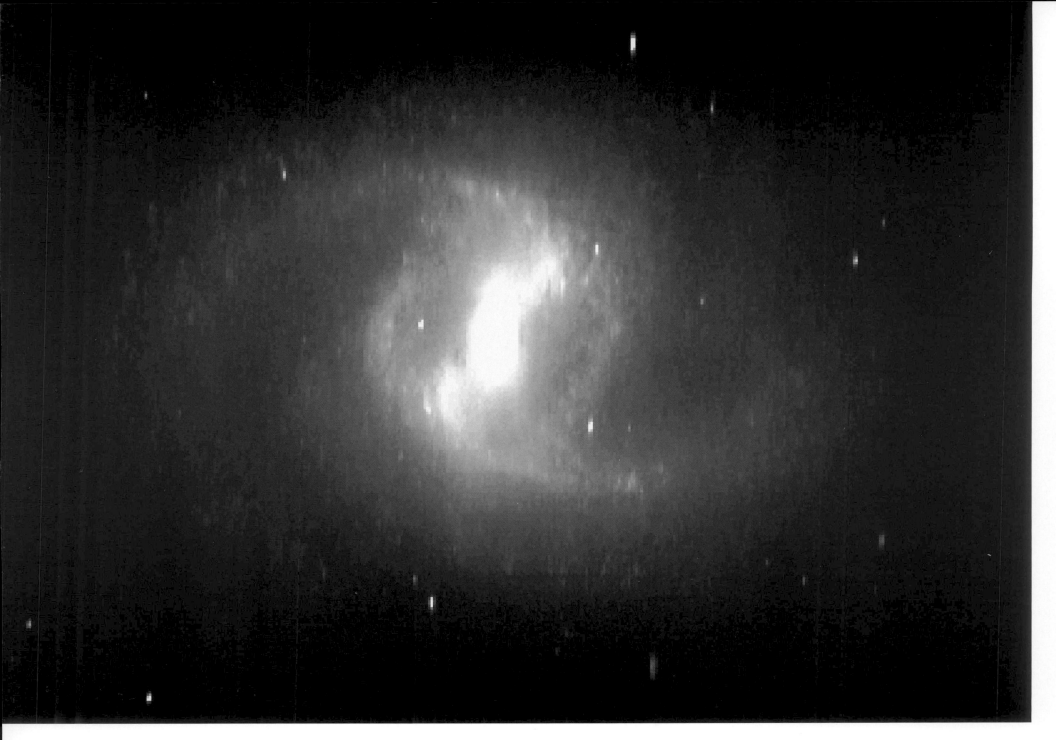

Figure 141 [422]

safely de-orbited in 2000. The third member of the Great Observatory family, the *Chandra X-Ray Observatory* (CXO), was deployed from the Space Shuttle *Columbia* and was boosted into a high-Earth orbit, in July 1999. This observatory is observing such objects as black holes, quasars, and high-temperature gases throughout the x-ray portion of the spectrum. Finally, the *Spitzer Space Telescope*, launched in 2003 on a Delta-II rocket.

The marvel of the Spitzer Space Telescope is that astronomers can actually see the radiation emitted from tiny molecules and minute grains of dust – instead of dark dust rifts and patches, one views *glowing* shrouds of dust! We have been privileged to study images of galaxies secured through the eyes of the Infrared Array Camera (abbreviated as IRAC) on-board the Spitzer Space Telescope. IRAC is the brainchild of pioneer Giovanni Fazio (Figure 142) at the Harvard–Smithsonian Center for Astrophysics, who together with his highly dedicated team, devoted over 15 years from the first conceptual phases of the camera to its final construction prior to launch. Fazio and team are truly to be saluted on the work of a masterpiece.

Turn the eyes of IRAC toward our closest spiral galaxy, the majestic Andromeda Spiral (Figure 143), which is located at a distance of about 2.5 million light years from us, with an estimated diameter of 140 000 light years.

In the historic photographs by Barnard, Roberts, Keeler, Hubble and others, the Andromeda Spiral Galaxy looks so quiescent; so tranquil – so calm. However, appearances can be so deceiving.

Images secured with IRAC reveal *two glowing rings of fire* (Figures 144 and 145). The outer ring has a diameter of approximately 65 000 light years. The second ring of dust immediately beckoned our attention; it betrayed a crucial secret. A feature kept *secret* for over 200 million years. The dimensions of this ring are some 4900 light years by 3300 light years. Why had it never been discovered before? The amazing inner ring is completely hidden, in optical light, by the luminous stars in the central bulge of the Andromeda Galaxy!

What event could have caused these extraordinary set of rings, whose centers do not coincide with the center of the Andromeda Galaxy (Figure 146)?

The penny dropped. Key insights were provided by French astronomers Francoise Combes and Frederic Bournaud.

A *head-on galaxy collision* of the Andromeda Spiral Galaxy with one of its companion galaxies, Messier 32! One smaller galaxy heading for an almost direct hit with a much larger one. The Andromeda Galaxy has over two dozen companion galaxies, one of which was catalogued by Messier as number 32 in his list (hence the name, Messier 32).

The culprit in this galactic "hit and run" is M32 colliding with the Andromeda Spiral! One may think of a simple analogy – that of tossing a stone into a pond of water. Rings or ripples are created, traveling outward with time.

Our team included members from South Africa, the United States and France. French team members Frederic Bournaud and Francoise Combes began to simulate the history of

the Andromeda Spiral. Using highly sophisticated computer codes, it was discovered that Messier 32 has indeed collided almost head-on with the Andromeda Galaxy, creating a pair of off-centered rings observed by the Spitzer Space Telescope.

Messier 32 had impacted the disk at over 250 kilometers per second, creating two rings of fire, whose outward expansion velocities are about 50 and 18 kilometers each second, respectively. In cosmologi-

Figure 142 [422]

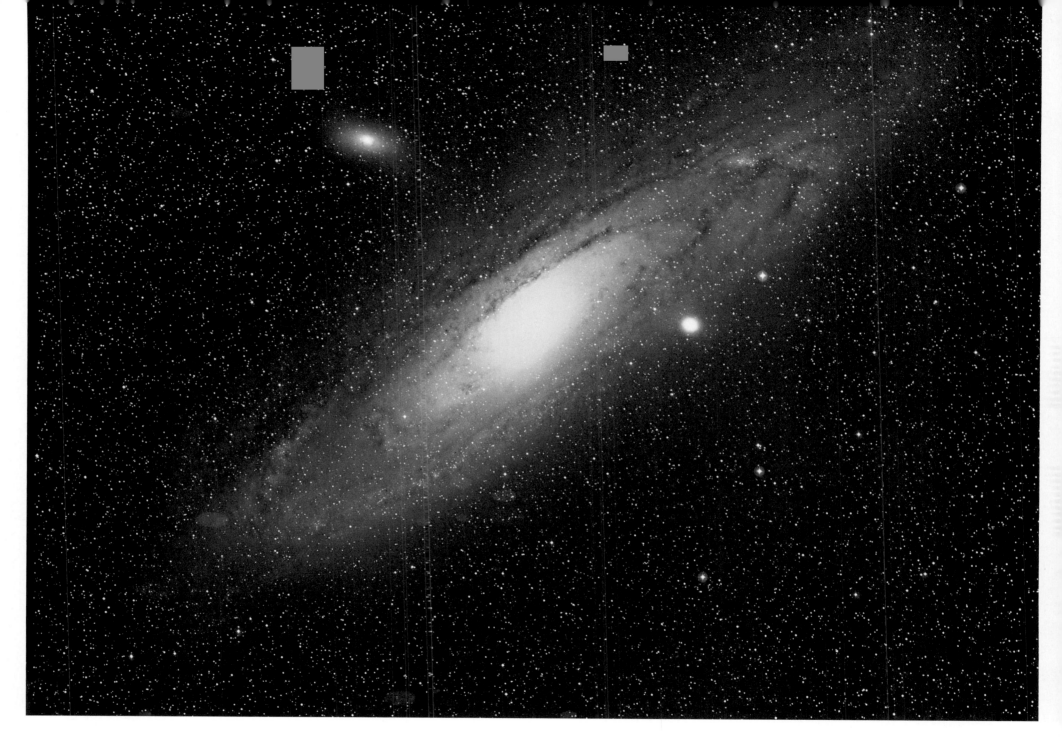

Figure 143 [423]

cal terms, the time of collision is remarkably short: only 200 million years ago. On Earth, the continents had not yet separated but dinosaurs indeed roamed freely.

It was an astronomical task for Pauline Barmby at Harvard University and her team to image the Andromeda Spiral Galaxy with the Infrared Array Camera on-board the Spitzer Space Telescope. That galaxy covers such a huge angular size in the sky: over six full moons. The field of view with the infrared camera IRAC is reasonably small, and so the telescope was moved in 700 different positions to cover the entire galaxy.

Exquisite hidden structures are revealed behind the mask of dust, so beautifully drawn by Trouvelot in 1874 (Figure 147). The Empress Andromeda is found to wear new clothes, when examined not in the optical, but in the infrared section of the spectrum. Seeming

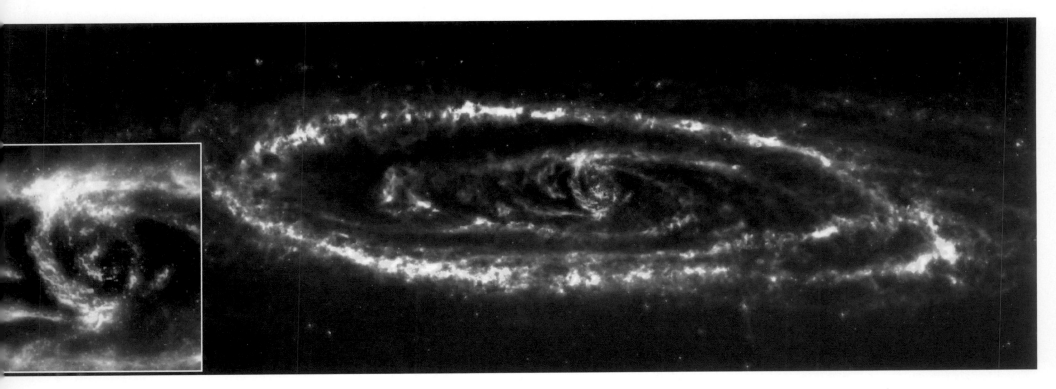

Figure 144 [423]

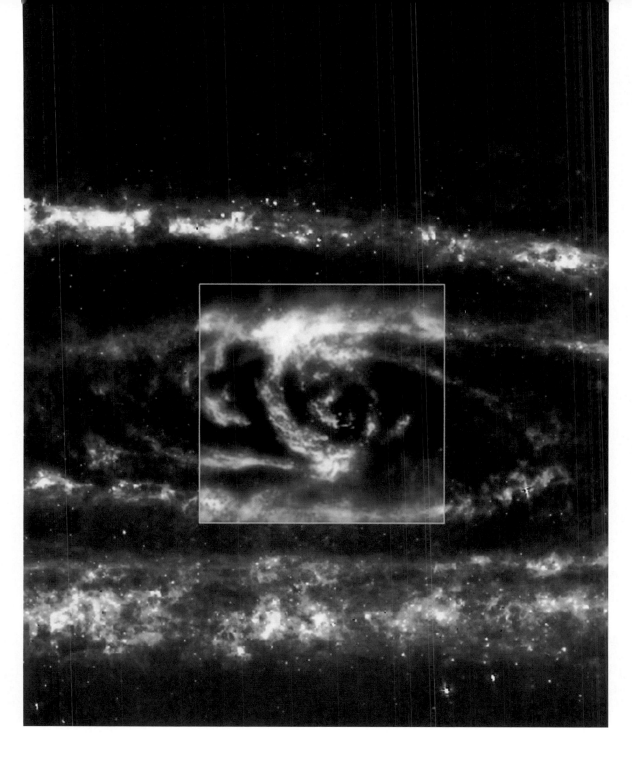

Figure 145 [423]

The Dust Penetrated Universe
239

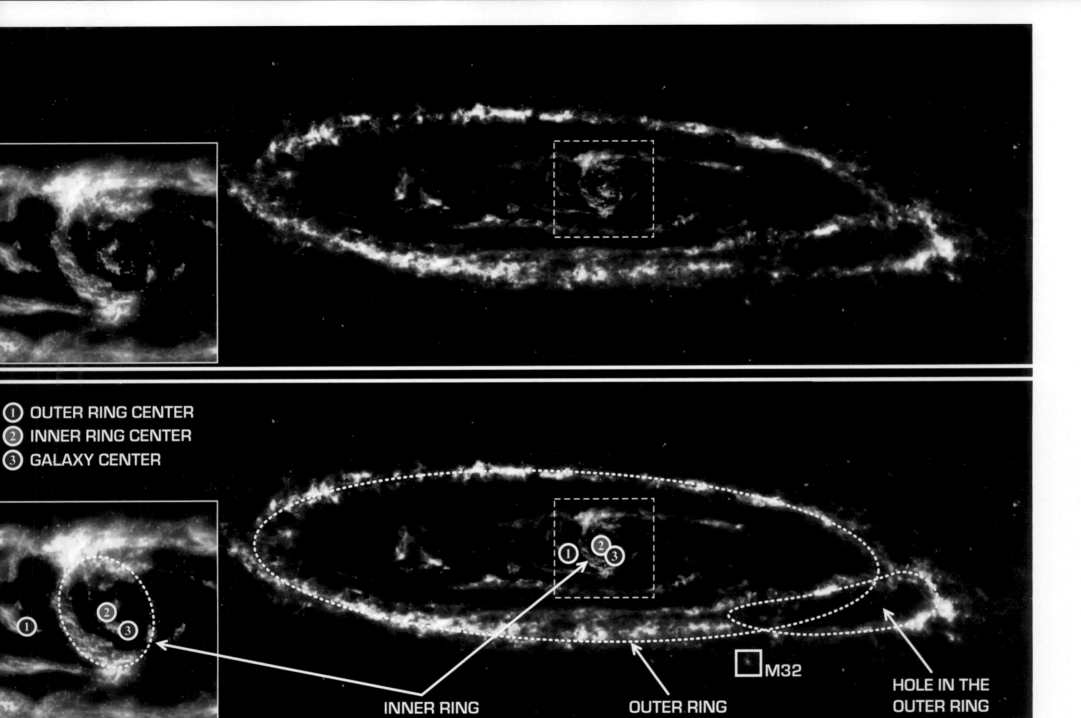

1 OUTER RING CENTER
2 INNER RING CENTER
3 GALAXY CENTER

INNER RING

OUTER RING

M32

HOLE IN THE
OUTER RING

Figure 146 [423]

tranquility is replaced by expanding rings of fire. Just as in our analogy of throwing a stone into a pond of water discussed above: One small galaxy had plunged head-long almost through the center of the Andromeda Galaxy, creating two outwardly expanding rings of dust imaged using the Spitzer Space Telescope. The two rings truly *glow* in these images; hence the use of the word "fire."

Galaxy morphology can dramatically change over *very short* periods of time; in the case of the Andromeda Spiral, the morphology we see today (Figures 144–146) originated from a collision only 200 million years ago. Members of the genus Allosaurus would have been roaming the Earth (Figure 148) ... the drawing serves to highlight the recent timescale of the tumultuous event, gauged in millions (rather than billions) of years.

Many years have passed since 1918, when the astute eyes of Heber Curtis led him to the "bar phenomenon." *The Lick Observatory Volume 13, containing Curtis' paper, forever stands out in the history of galaxy morphology.* Never could Curtis have dreamt, however, what he had truly opened up to the world – that the new view of galaxies in the dust penetrated Universe would reveal a *ubiquity* of extragalactic bars outside of the Milky Way.

In fact, over seventy percent of spiral galaxies in our local Universe show bars, even if we see no evidence for the oval or bar in optical images. In some instances, these bars are very striking, covering possibly a third of the diameter of the disk in a typical image. In other cases, the bar is simply a small feature near the center of the galaxy.

How do stars move within these bars? We know that the bars are themselves rotating but a little more slowly than the galaxy as a whole. Opinion changes about whether the bars are made up always of the same stars, or whether stars pass through the rotating bar, somewhat like water particles passing through a water wave. The current viewpoint is that stars become trapped in the bars. One can imagine that the bar is made up of stars following noncircular, elongated orbits, all locked together by gravity to form the rotating bar. The stars themselves move in the elongated bar but, at the same time, are also the building blocks of the elongated bar itself. The presence of mass has an associated

Figure 147 [423]

gravitational field; it is the gravitational field of the bar which causes the individual orbits of the stars to be elongated, and it also keeps the orbits elongated in the same direction. These elongated orbits actually constitute the bar feature so ubiquitously lurking behind cosmic Shrouds of the Night. If the orbits of the stars were not elongated but almost

Figure 148 [424]

circular, then one would not have a bar at all – simply a galaxy possessing symmetry about some axis.

Similarly, if the orbits were elongated but drifted away from being all elongated in the same direction, then again one would not form a bar. The existence of the rotating bar needs the elongated orbits to be locked together and remain elongated in the same direction. There is no room here for individuality.

At this juncture, an analogy may be useful. One of us (Ken) is an avid bird-watcher, traveling across the globe to see new and rare species of birds. Let us imagine arriving at a site on some birding expedition, and watching an elongated flock of birds flying overhead. The ground based birdwatcher of course views the flock from an appreciable distance and the observer takes cognizance of the fact that the overall morphology or shape of the flock is elongated. Within the flock, however, individual birds are flying around; they are by no means stationary and furthermore, each bird is not always in the same locale *within* the flock. *The birds themselves define the shape of the flock.* To maintain the shape of the flock, however, the birds must not venture outside its elongated boundary. Some cooperation is needed! It is much the same for the stars that constitute the plethora of bars in our local Universe. The stars move around within the bar, defining the shape of the bar, but they must stay within the bar itself.

The disks of spiral galaxies are truly flat, typically 100 000 light years in the plane of the galaxy (for a galaxy such as the Milky Way) and some 10 000 light years in thickness. Bars may have the same thickness as that of the disk – or sometimes even thicker. Stars within a bar would typically move at speeds of 100–150 kilometers each second in the plane of the galaxy, and possibly 30 kilometers each second in the direction perpendicular to the plane. The shape of the bar itself rotates, but more slowly in angular terms than the stars of the disk just beyond the ends of the bar. Astronomers can actually measure the rotation speed of bars (known technically as their pattern speeds) using spectrometers on large telescopes.

There is no obvious reason why the bar itself needs to be rotating. In principle, it could be fixed in space and still be defined by the orbits of the stars within it. Nature is so rich in structure and in diversity: in reality, astronomers observe that the bars themselves do rotate.

Given that millions of stars within the bar of a galaxy are all in motion in elongated orbits described above, it may well be asked how bars are ever able to maintain any shape at all. The answer lies in a concept known as precession. As each star moves in its elongated orbit, the long axis of each stellar orbit also rotates in space, precessing at the same speed as the bar, so that the bar itself maintains its identity. A star whose orbit has precessed so that it no longer lies within the bar does not contribute anything to the presence of the bar. Astronomers call this complex phenomenon *figure rotation*.

Classification of galaxies has invariably been qualitative, placing galaxies in their respective classes by visual inspection of photographic or digital images. The challenge before us has been to move away from qualitative schemes, to those wherein measurable parameters are made, not by eye, but by computer: in other words, to quantify key parameters of galactic backbones. Not the flesh, but the skeletal structure, using our x-ray analogy. To effectively accomplish this challenge, we must first penetrate our Shrouds of the Night.

David has spent some two decades attempting to *quantify* the shape of spiral galaxies behind their dust masks, working closely on different aspects of this research with teams of astronomers from France, Germany, Italy, Mexico, Spain, the United Kingdom, the United States of America, Finland and others. Figures 149 and 150 (developed in collaboration with Ivânio Puerari from Mexico and Ronald Buta from the United States) shows our criteria for classifying spiral galaxies in the near-infrared, once we unmask these systems behind their Shrouds of the Night.

One important physical parameter which we use in our near-infrared galaxy classification scheme is the angular pull or torque provided by a rotating bar of stars. We have developed techniques which enable *a computer* to detect a bar (see Figure 149) and then, to determine its angular gravitational "tug." We recognize seven classes of "bar strength."

The angular pull or tug of a rotating bar influences the behavior of gas, and affects the way in which young stars are distributed in the disk of a spiral galaxy. The stronger the bar, the stronger the angular tug and the greater the effectiveness with which the bar influences the motions of stars

and gas. For example, the shapes of galactic rings are tied to the way in which the bar pulls on the stars. The bar can also help to generate some dramatic events near the centers of galaxies.

Many galaxies have massive black holes residing at their centers. The tug which the bar exerts on the gas can funnel some gas into the central parts of the galaxy. This can have very violent consequences. Gas passing close to a central black hole liberates energy in the form of intense radiation extending over the entire range of the spectrum, from gamma rays (whose wavelengths are even shorter than x-rays) to radio waves, with wavelengths of a meter or more. These dramatic events are called *active galactic nuclei*. Even if this funnelled gas does not reach the central black hole, it can erupt in a giant flash of star formation called a "star burst." Active galactic nuclei are often seen near the centers of barred galaxies.

Secondly, we believe that the degree of openness of the spiral arm pattern of old stars (in technical terms, its pitch angle) is another quantitative parameter, which a computer can readily measure. In Figure 150, we propose using three separate classes (unrelated to the Hubble classification from optical images) for the backbones of spiral galaxies: the alpha, beta and gamma bins.

Our colleagues have empirically demonstrated how the pitch angle of spirals seen in infrared images is related to the *shape* of the rotation curve. (A rotation curve simply shows how fast stars or gas orbit the center of a galaxy, plotted as a function of radius.) We believe that the alpha, beta and gamma classes yield important insights into the physics of galaxies in the post Hubble era, because the shape of the rotation curve is inextricably tied to the distribution of both stars *and* of dark matter in a galaxy.

When one studies the appearance of the spiral arms of principally old stars, we find there is little correlation with Hubble's qualitative classification, as alluded to in important earlier studies by Vera Rubin (Carnegie Institute of Washington) and her team of researchers. In Figure 150, it should be remarked that spiral galaxies such as Messier 83, classified by Hubble as "late-type," reside in our tightly wound "alpha" bin. Our classification recognizes the duality of spiral structure found in our local Universe and seeks to classify spiral galaxies behind their Shrouds of the Night using three criteria: the number of dominant spiral arms in the infrared, the bar strength and the openness of the spiral arm pattern of old stars.

NGC 3631 NGC 4254 NGC 5850

NGC 4548 NGC 1169 NGC 4314

NGC 1073 NGC 4123 NGC 1300

Figure 149 [424]

Figure 150 [424]

Our quantitative classification scheme may schematically be depicted in a fork with three prongs, as in Figure 150. An optically *late-type* Sc galaxy can fall into our *alpha* class: one example is NGC 5861 (Sc in the optical domain, but class *alpha* behind the mask). Moreover, an optical *early type* Sb can be classified as a member of our wide open *gamma* class, as seen in the galaxy NGC 7083 (Hubble type Sb).

Moreover, the reader will note that it is possible for spirals of a given Hubble type to be distributed within all three dust penetrated classes. For example, NGC 3992, NGC 2543, NGC 7083, NGC 5371 and NGC 1365 illustrated in Figure 150 are all Hubble class b in the optical domain; behind their dust masks, however, NGC 3992 belongs to class *alpha*, NGC 2543 to type *beta*, while the three remaining type b spirals NGC 7083, NGC 5371 and NGC 1365 belong to the open *gamma* class.

At a recent conference held in the ancient city of Rome, we emphasized an important uncertainty principle which has emerged from our investigations. The uncertainty is this: we simply cannot predict what the optical image of a galaxy will look like from its near-infrared counterpart. A human analogy: given an optical photograph of the human mask of the skin, it is impossible to predict what the spinal column will exactly look like. But our flesh always responds to the movement of our backbone – our skeletal structure. In much the same way, masks of gas and dust are highly responsive to the smallest of changes in the backbones of old stars. In a mathematical sense, there is a degree of chaos (uncertainty) in our cosmic masks of swirling gas clouds and dust.

Astronomer Frank Shu gives a weather analogy:

> *It's like the weather, which is also a chaotic system. Make all the measurements you can, still no one can predict the weather seven days from now. You can guess the weather tomorrow with some precision, but you really cannot guess well for a week later, no matter how fine are your observations because of the chaos in the system. We need to be prepared for this in our subject.*

Dust grains scatter starlight from neighboring stars on the grandest of scales. The famous "Barnard loop" (Figure 151) in the constellation of Orion sweeps out twenty degrees – the equivalent of forty full moons – in our skies. The Barnard Loop, in our Milky Way Galaxy, spans almost six hundred light years across; dust grains within the Loop scatter ultraviolet light from nearby stars in Orion. Such "reflection nebulae" can occur on much larger scales. For example, astronomer Steven Gibson and his collaborators have found that "reflection nebulae" in the Large Magellanic Cloud may occur on scales of the order of three thousand light years across. Very hot, young stars in the north-western sector of that neighboring galaxy illuminate dust grains which then scatter ultraviolet photons of light into our line of sight. A few years ago, an almost straight "strip" of light in the disk of the spiral galaxy NGC 2841 was discussed in the literature by astronomers Bruce Elmegreen, Richard Wainscoat and coauthor David. We had never seen anything like this, before. Could it be a mammoth reflection nebula? Could dust grains in the disk of NGC 2841 be scattering light from stars in the *bulge* of this galaxy? The answer is yes! The "strip" (arrowed in Figure 152) spans about 6500 light years and is reflected starlight from the luminous bulge of NGC 2841. This "reflection nebula" is over ten times the diameter of the Barnard Loop in our Galaxy and is the largest we have yet studied.

We were much inspired by a pioneering study conducted in 1976 of filaments of dust scattering light from the plane of our Milky Way, at relatively high latitudes of about 50 degrees; these high-latitude reflection nebulosities were identified by Dr Allan Sandage on high-contrast photographic prints. The spatial extent of these wispy clouds in one of Sandage's fields covers about 3 × 4 degrees, which translates to linear sizes of about 35 light years × 45 light years (assuming a distance to these filaments of approximately 650 light years). These structures may be associated with a larger feature known as the North Celestial Pole Loop, whose diameter is some 40 degrees in the sky and which, at a distance of 650 light years, would span about 450 light years across – similar in size to the famous Barnard Loop.

Readers may well enquire as to the *smallest* reflection nebula studied by astronomers. This is probably a nebula discovered by E.E. Barnard in 1890. Wispy tendrils of interstellar grains of dust in a cloudlet known as the Barnard Merope Nebula reflect starlight from the star Merope in the Pleiades star cluster. The nebula cannot be seen in conventional photographs

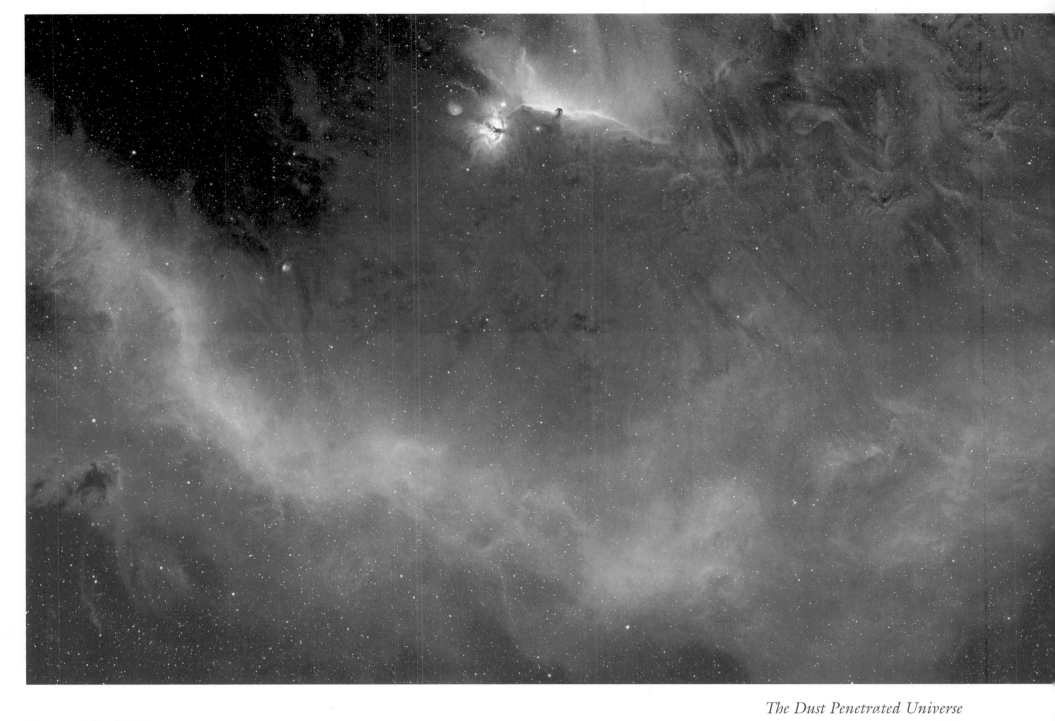

Figure 151 [424]

The Dust Penetrated Universe

251

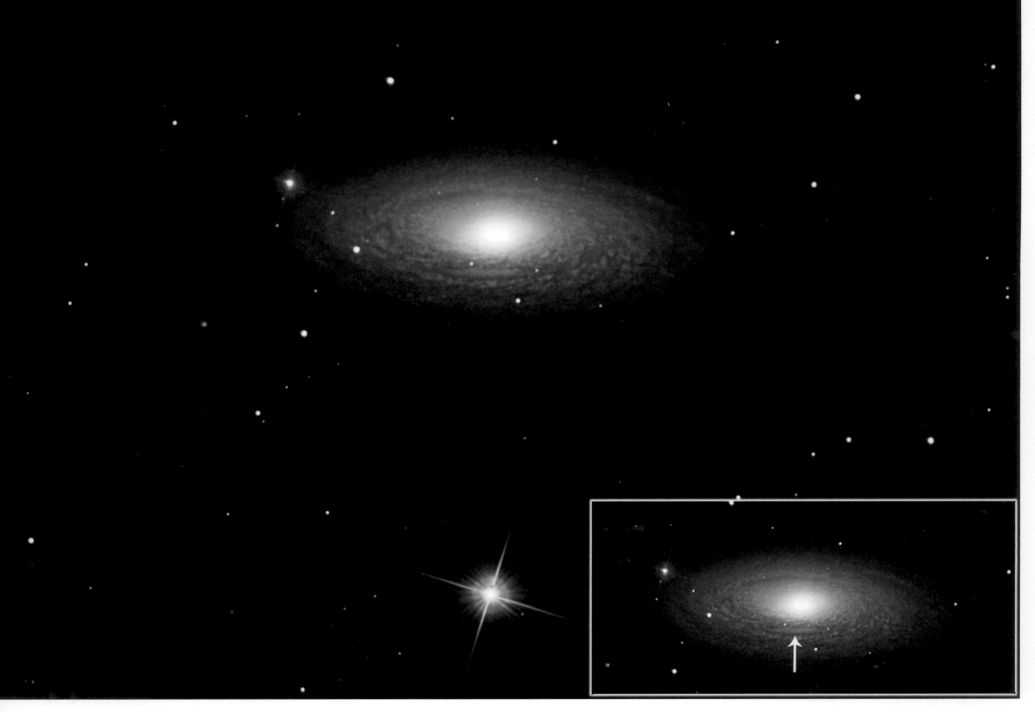

Figure 152 [424]

of the Pleiades (such as Figure 96 and Figure 101), due to the overwhelming brightness of Merope itself. The cloudlet shows a rich and complex structure, as it passes Merope and in the process, is being shaped by the radiation field of that star. Its size is not measured in light years but rather in astronomical units, where one astronomical unit denotes the average distance of the Earth from the Sun. The Barnard Merope Nebula is a few thousand *astronomical units* in size.

Penetrating shrouds of cosmic dust or fog we must. In the words of Irish dramatist and novelist Samuel Beckett (1906–1989),

> *We may reason on to our heart's content, the fog won't lift.*
>
> (THE NARRATOR IN *THE EXPELLED*)

Allow British author H.G. Wells (1866–1946) to have the final say:

> *The science hangs like a gathering fog in a valley, a fog which begins nowhere and goes nowhere, an incidental, unmeaning inconvenience to passers-by.*
>
> (*THE WORKS OF H.G. WELLS*, VOLUME 9 (1925))

Shrouds of the Night are ever active – responding as do musical strings to the smallest degree of bowing – and we further explore this theme in the next chapter.

The Grand Bow

The bow whispers to the arrow before it speeds forth – "Your freedom is mine."
(R. Tagore)

iola. Cello. We have an image of spiral galaxies as great stringed instruments, instruments being plucked or bowed, in which the strings of gas and dust typically measure some 100 000 light years across.

The setting: The National Gallery in Canberra.

The occasion: A string trio. Serena McKinney (violin), Katie Kadarauch (viola) and Arnold Choi (cello), who had recently performed at the famed Carnegie Hall. As we sat spellbound listening to the meticulous vibrations of the strings on a Nicolaus Gagliano violin (circa 1760), a Giovanni Grancino viola (circa 1695) and a Carlo Tononi cello (circa 1725), we were transported to magical moments outside of time. One point is, however, strikingly clear: without the bowing of the strings – without the grand bow – there would be no musical tones or harmonics. As in music, so in spiral galaxies do we encounter waves with the full complexity of modes.

No bowing of the strings of the cello, of the violin, of the viola … no grand bow … no music. Sitting at the National Gallery in Canberra, what we visually saw was each musician bowing their different strings, but what is actually happening is that multitudes of different sound waves of different frequencies are being produced in the auditorium. It is not a static, but a highly dynamic, interplay. To describe this interplay from a mathematical point of view, one can say that the shape of any bowed string can be represented in terms of an infinite number of *waves* or *modes*.

The genius who developed the mathematical technique used in both worlds of music and in our infrared images of galaxies was none other than Jean Baptiste Joseph Fourier, born at Auxerre in France on March 21, 1768. His mother died while Joseph was only nine years old; his father died the following year. Fourier's first schooling was at Pallais' school, run by the music master from the cathedral in Auxerre. There Joseph Fourier studied both Latin and French and showed great promise. At the tender age of thirteen, mathematics became Fourier's chief focus of interest. By the age of 14, Fourier had completed a study of the six volumes of *Cours de mathématiques* by Bézout. Fourier analysis, Fourier series and Fourier transforms all bear the name of this most talented genius. Notable students of Joseph Fourier included legendaries Gustav Dirichlet and Claude-Louis Navier. Fourier was elected a Fellow of the Royal Society in 1823. When Gustave Eiffel built his famous Parisian Eiffel tower, he included the names of 72 prominent French scientists on plaques around the first stage, and one of these is Joseph Fourier.

Fourier expressed his thoughts:

> *Mathematical Analysis is as extensive as nature herself.*

and

> *Mathematics compares the most diverse phenomena and discovers the secret analogies that unite them.*

Fourier died in 1830; could Fourier ever have imagined that his exquisite mathematical analyses would be used in the 21st century to study symmetries in the disks of galaxies behind Cosmic Shrouds of the Night?

Galaxies, such as the River of the Night, our Milky Way, are highly dynamical entities. One can think of a series of waves of gas propagating through the disk. A simple analogy may be in order. Let us consider a pond of water into the center of which is thrown a stone. Waves of water will propagate outward, hitting the wall of the pool. They will then be reflected, journeying back toward the center of the pool, and so forth. Some of the wave-crests will be enhanced (we term this "constructive interference") while incoming and outgoing waves may essentially "cancel" one another out; mathematically, we call this destructive interference.

The medium in which the waves in the disks of galaxies propagate is twofold: gas and stars. When examining the "backbones of the night" with infrared cameras, we are actually imaging waves of stars moving inwards and outwards of the disk. Ultimately these waves might be reflected off the inner *bulge* of stars, producing constructive and destructive interference patterns.

The actual material in the mask – the gas – is highly responsive, just like the responsiveness of water in a pond when it reacts to a plunging stone. Some of the most far reaching ideas pertaining to the underlying structure we see in spiral galaxies dates back to 1964, when C.C. Lin and his [then] undergraduate student Frank Shu (who studied under Lin at the Massachusetts Institute of Technology), presented their research work in a paper entitled "On the Spiral Structure of Disk Galaxies." We celebrated the 40th anniversary of that seminal paper at an International Galaxy Conference held in South Africa in 2004.

In our preceding chapter, we carefully noted that when we penetrate shrouds of cosmic dust and peek through these cosmic veils, the patterns we observe in the stars behind the mask can be radically different to that imaged optically in the icing on the cake itself – the dust mask.

In our interpretation of what lies behind Shrouds of the Night, David has worked closely with Giuseppe Bertin in Pisa, one of the mathematicians who developed a theory known as the "modal theory" of spiral structure. In that theory, spiral arms of galaxies may be thought of as the manifestations of sets of traveling waves. Areas of enhanced surface brightness in the infrared may be regarded as regions where waves of principally old stars have constructively interfered with one another.

The players and bowers of our strings on the scales of galaxies spanning possibly a hundred thousand light years – sometimes much more – are varied.

In some examples, the intrusive player may be another galaxy – such as when the galaxy Messier 32 collided almost head-on with the Empress of the Night, the Andromeda Spiral Galaxy. Disturbances in the wave trains or modes may be very striking indeed, when such worlds in space (galaxies) collide. The dynamic interplay is analogous to the pizzicato

plucking of a string. The player's finger in the Andromeda Spiral would be the interloper Messier 32, which lies external to the "strings" of spiral structure which existed in the disk of the Andromeda Galaxy prior to the collision with Messier 32.

The strings are the Shrouds of the Night: masks of gas and dust, which are highly responsive. In many examples, the bow is the backbone of old stars, inducing waves in the masks. Another efficient bowing mechanism could be the ingestion of gas from vast filamentary wells outside galaxies, renewing spiral forms – which otherwise would die away with time.

In other cases, Nature provides us with a grand bow in the form of a bar of stars – many of these veiled behind their dusty masks. The interplay between a bar of stars and its bowing on the strings (masks of gas and dust in the parent galaxy) is highly dynamic – the presence of bars creates inflows of gas, radially toward the centers of galaxies – such cosmic bows ever draw their masks, creating motions of gas clouds on mammoth scales; motions which, over aeons of time, may actually destroy and then reform the presence of a bar.

What actually occurs as the grand bow itself is played? Gas in the disk is trapped in a spiral-shaped potential well. This gravitational well pulls a young star from its orbit in the neighborhood of a spiral arm. A *tug-of-war* ensues. The spiral arm pulls the star outward, increasing its radius from the center. However, as the radius increases, its velocity decreases, because of a fundamental law, known as the conservation of angular momentum. Young stars lag behind and begin to pile up, much like a traffic jam on Earth … creating those fiery lights which so often outline or delineate spiral arm structure seen in the optical images of Hubble and Keeler, for example.

Some spiral pinwheels of the night may present to us lively allegro moltos, others a more tranquil andante; whatever the cosmic orchestra may present to us, we live in an epoch wherein astronomers are able to untangle these spiral modes using Fourier transforms birthed so many years ago, in the mind of Joseph Fourier.

Astronomer Ron Allen at the Space Telescope Science Institute in Baltimore shares his thoughts:

We're now looking at a transition to a possible change in the way we look at galaxies. Sometimes ... we see disks that have a spiral structure that we couldn't have dreamt existed from looking at the optical picture ... we've got a possibility here of applying the morphology to a physical framework, perhaps in a way that none of us could have dreamt of before we had the capability of sweeping the dust away from the galaxy in a figurative sense.

What is bowing the gas mask of NGC 309 (Figure 131)? What generates those gargantuan shock-waves of gas, spawning myriads of young stars and blazing regions of ionized hydrogen gas?

What we see optically is the *result* (not the cause) of a grand bow at work: a small bar and patterns of waves of old stars interacts with a highly complex mask of dust and gas. The grand bow is seen in full action behind the dust shroud!

It is what the hidden grand bow does, which creates the music. As we have repeatedly seen, we cannot, a priori, tell from the music what our Cosmic Fiddler of the Night is up to!

We have noted that, on photographs, NGC 253 is a flocculent spiral galaxy (Figure 140), with fleece-like spiral arms. In the dust penetrated view, the galaxy betrays a remarkably regular pattern: its hidden symmetry, behind the mask, is strikingly revealed. Behind the masks of dust and gas lies the hidden grand bow: a bar, and a regular, classic two-armed spiral.

In our music analogy, the whole is composed of the sum of its parts. We may think of the composer Arvo Part with his tonal technique "tintinnabuli" which produces a profound, mysterious and moving rendering of the *Te Deum*. Impinging on the ear are the sounds of music akin to a Gregorian chant, with careful use of varying choral forces, strings, piano and "ison," sometimes represented by the organ (the ison is a long drawn-out musical base note). Different choral voices add a profusion of sound to his *Te Deum*, but the whole is the sum of each part.

Backbones of the night reveal far more *restrained* structures of stars lying in one or usually at most two spiral arms. Very seldom are backbones of three or four spiral arms imaged behind

the mask. Our Local Universe presents astronomers with a ubiquity of low-order modes or waves in the dust-penetrated infrared regime. This is in stark contrast to the myriads of multi-arm features and "spurs" which such ordered backbones may generate in the optical mask. Backbones of the night are generally very much older than the masks of young stars and of dust; while they do their cosmic plucking with care, their lively "allegros" in the mask are often enchanting to behold.

The unique note from a violin, whether it be mellow or jarring, is a product of *unique* events: these include the characteristics of the violin (for example, what the belly and the back are made of, its thickness, and what the strings are made from), combined with the *specific way* that the violin has been played by the musician.

Likewise, each galaxy has a unique history, with its own, unique harmonics or modes.

It is the music of each galaxy.

From simple tunes and a few simple notes, they expand into fugues by ...

> *a variety of devices of fragmentation and reassociation, of turning it upside down and back to front; by overlapping these and other variations of it into a range of tonalities; by a profusion of patterns of sequences in time, with always the consequent interplay of sound flowing in an orderly way from the chosen initiating ploy (that is more technically, by inversion, stretto, and canon etc.) Thus does a J.S. Bach create a complex and interlocking harmonious fusion of his seminal material, both through time and at any particular instant, which, beautiful in its elaboration, only reaches its consummation when all the threads have been drawn into the return to the home key of the last few bars – the key of the initial melody whose potential elaboration was conceived from the moment it was first expounded.*

A. Peacocke

As we have repeatedly seen, the grand bows are, most often, bars in the disks of spiral galaxies. It is largely from these rotating bars that galaxy taxonomy is born. The diversity of the "bar phenomenon" beckons loud and clear.

A note of caution, pertaining to galaxies masked in their icings of dust in our younger, distant, seemingly chaotic Universe: we cannot, with present technology, penetrate their Shrouds of the Night, simply because they are moving away from us with such enormous speeds, that special filters on-board future space-borne telescopes will be necessary to do such mask penetrations properly.

When astronomers use the traditional near-infrared filters to study such distant galaxies, they invariably sample photons in the ultraviolet region of the galaxy's spectrum! The most distant known galaxies at the time of writing have their ultraviolet region of the spectrum (a wavelength of 0.35 microns) redshifted to about 4 microns in the mid-infrared. This is because the galaxy's entire spectrum has been shifted toward the red end of the spectrum on account of its speed away from us. What is essential is a very large telescope in space (much larger than the Hubble Space Telescope) equipped with special mid-infrared filters (not near-infrared filters, such as those which we have used in this book). Only with such mid-infrared filters can we see these very distant young galaxies in their "restframe near-infrared." Distant galaxies may appear to be highly chaotic and disordered, but this could well be a result of cosmic masks: again, one tends to concentrate on the brilliant light-beacons of young stars, while magnificent symmetries may be simply shrouded by particles of dust, as in our Local Universe. Such are the challenges awaiting the James Webb Space Telescope, to be in an orbit on the far side on the Moon and scheduled to be launched in 2013.

It is clear that many distant galaxies are very dusty indeed; it is intriguing to see just *how well* dust particles have evidently been manufactured in our early (young) Universe.

In other distant galaxies, peculiarity may remain the norm, for their dust penetrated backbones of older stars may still be in the process of formation. At such primordial epochs, the grand bow may possibly appear to be broken – fragmented. Such bows may be drawing at strings which optically may appear broken, too.

There is a wonderful San story, entitled "The Broken String:"

People were those who
Broke for me the string.
And so
The place became like this to me,
On account of it.
Because the string was that which broke for me.
And so
The place does not feel to me,
As the place used to feel to me,
On account of it.
For,
The place feels as if it stood empty before me.
Therefore,
The place does not feel pleasant to me,
On account of it.

Strings can be broken: on musical instruments, by people; on galactic scales, by multitudes of interactions and mergers. Dust penetrated images of some distant galaxies may remain chaotic when imaged through the eyes of forthcoming space-borne telescopes – perhaps the young Universe is simply the place we are not yet that familiar with – after all, the Universe now, is not the place it used to be.

Penetrating the Mask of Time

osmic dust masks change with *time*. Herein unknowingly, we encounter yet another mask: the mask of time itself! All knowledge and all data ever secured by Mankind is secured within the confines of time. Can time ever be "penetrated?" Would it ever be possible to envisage a "timeless" Universe – one with only space dimensions, which no dimension of time? The answer is yes, as will become evident in our discussion of superspace below. In this chapter, we pursue thoughts which occurred to us while traveling to Papua New Guinea: our progress through superspace is actually reflected in primitive notions of time.

Where could one go to perhaps best understand the concept of time? Let us interact with people in the remote areas of Papua New Guinea. A land containing remote highlands and deep valleys. A unique environment to explore the mind of Man, without heavy influence of Western culture.

Papua New Guinea is a land where cannibals and head-hunters once roamed free, for centuries. But what lies in the minds of these people? How do *they* understand time, for are they not closest to it? *Adam in Ochre, Adam in Plumes, Adam with Arrows* are but three of the myriads of titles of books written about these regions.

David undertook a journey spanning fourteen flights and a seven day boat ride to attempt to glimpse and conceive the concept of time in the jungles of Papua New Guinea and environs (see Figures 153–156). We visited the island of Kiriwina, beloved by the great anthropologist Malinowski, who writes:

> *The Trobriand Islands, situated at the east end of New Guinea, are an archipelago of flat coral islands and reefs ... they are rather densely populated – the total number of inhabitants may be estimated in 1920 at about 10,000 ...*

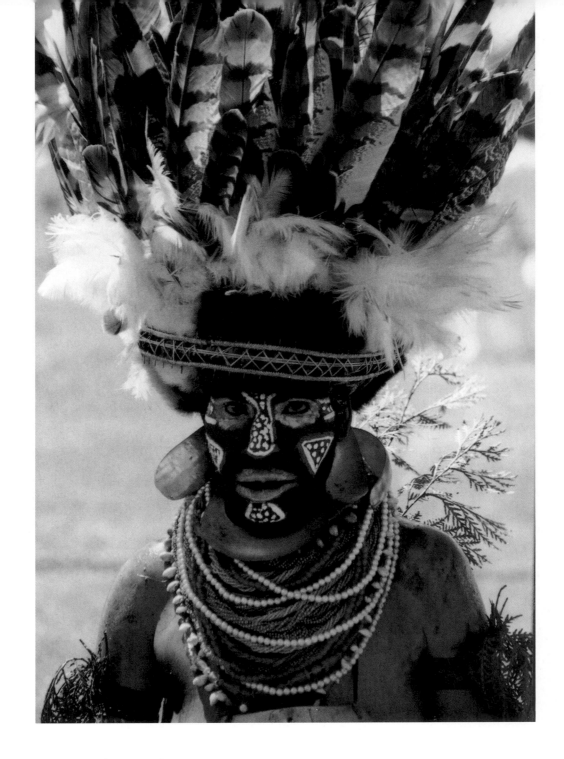

Figure 153 [424]

Through the work of Malinowski, we understand why the Trobriand Islands (of which Kiriwina is the largest) are indeed one of the most sacred areas for anthropological studies.

People might say that Papua New Guinea and its surrounding islands may have very little to teach us with regard to time, but a great surprise lies in store: in a grand sense, the Papuans we interacted with are so very advanced in their concepts of space and of time!

Figure 154 [424]

Figure 155 [425]

Figure 156 [425]

Penetrating the Mask of Time

There are over 800 languages in Papua New Guinea, but there is a common lingo called Pidgin English ("Tok Pisin"). The Papua New Guinea lingo for East is "san i gerap" (the sun gets up). A constable is known as a "polis boi" (police boy). Afternoon is "apinun" and eventually is "baimbai" (by and by).

On Kiriwina, we saw the *masawa*, or large, sea-going outrigger canoe; the ceremonial exchange of shell valuables, the *Kula*, was carefully explained to us. We identified with the playfulness or *mwasawa* of children and we walked past a *liku*, or small yam hut or food crate. We handled necklaces of shell disks, the *soulava*.

In Papua New Guinea, time is definitely *temporal*. It is determined by the wanderings of material bodies. Time to many Papuans is measured by the wanderings of the Sun, the Moon and the onset of darkness. Time in the culture of Papua New Guinea is not measured by some external parameter. To the people of Papua New Guinea, *space is more fundamental than time*.

There are myriads of legends and stories to demonstrate this crucial aspect in the Mind of the Papuan. Here is how just one of the legends begins:

> *Many years ago, when the world had just begun, a crab decided to travel to the setting place of the sun.*

In other words, to this tribe, there is a spatial emphasis (the setting place of the Sun) at a time of beginnings – it is not when, but where.

And how is time determined? The flow of time from a lofty tree house (Figure 155) would be determined by the movements of heavenly bodies such as the rising of Sun, the rising of the Pleiades star cluster ("the Seven Sisters") or merely by penumbral shadows which lengthen as our closest star apparently journeys toward the horizon at twilight hour. Without the Sun and darkness, there would, in their understanding, be no time.

There is a wonderful piece of folklore entitled "The Stars Helped a Man" from the West Sepik Province in Papua New Guinea, as transcribed by Thomas Slone, a staff scientist at the University of California at Berkeley. We relate portions below:

Long, long ago, a man took his bow and arrows then went to hunt for wild game in the forest at night. The man walked a very long distance to a mountain. He worked hard, but he did not find any game, so his eyes became sleepy. When he was about to sleep, he put his bow and arrows at his side then fell dead asleep. The man was dead to the world, so he did not know what was happening about him. A masalai [ghost] man was also looking for game. He hunted and hunted, but did not find any game. When he was walking along, he smelled the man nearby. When the ghost [masalai] man looked, he saw the man but he thought that a piece of tree had broken and was lying there. The masalai stood and watched carefully, then he saw the man there. The masalai was very happy. He said, "Oh my, I tried hard to find game and now it's come to me." So, he dumped the man into his net bag and carried him towards his home. However it was too bad that the masalai man dwelled on an island. When the masalai arrived on the beach, he put the man in the net bag on his back and began to swim to the island. The masalai man swam and swam, and the waves rose and fell strongly. The man inside the net bag felt cold and thought, "Oh my, where am I now?" When he opened his eyes, he saw the waves. The man had a good idea because when he was running through the forest, he had put a small piece of sharp bamboo into his loincloth. So when the masalai was still carrying him, he removed the bamboo and began to cut the net bag.

When they approached the island, the man saw a log drifting in the sea and coming towards them. He took the log inside the net bag, and he swam back to the beach.

The story then relates how furious the *masalai* was in realizing that he had been deceived, and starts to diligently search for the escapee, who by this time had climbed a coconut palm.

The masalai took his axe and began to cut the coconut palm. It was too bad for him that the man thought of something. When the coconut palm was about to fall, he jumped to another coconut palm. They did this for a long time until many of the coconut palms on the beach were gone. The stars looked at the man going around and they were sorry for him. Quickly, they made a ladder and threw it down to the man on top of a coconut palm. The man was happy for this, so he went up the ladder, and the stars pulled him up.

The story unfolds of the man inviting the stars to his village, to celebrate with some food especially prepared for the occasion. He tells his fellow kinsmen:

> *I'll call out to some men to come and meet me. They'll come, but you men will not be able to see them [the stars]. I alone will see them and talk with them.*
>
> *When everything was ready, he sent a message to the stars. They then descended to meet with him. They ate, then the stars went back to their places. When the stars returned, they lit up the night. Before, they never lit up the night. However after this party, they began to light up the night. When the men of the village saw this, they thought that this time the stars helped a man.*

Such richness and diversity of thought is contained in this story: from the origin of the stars' shining to a ladder extending upwards, as in Jacob's ladder. Yet again, this folklore clearly shows the measurement of time as related to temporal events: swimming to the island, the waves rising and falling, the opening of the man's eyes in the net bag, the placing of the log inside the net bag, the climbing of a tree, the intimacy of the stars coming down to the man's village for food … and the stars subsequently lighting up the cosmic dome above.

Let us next cast our mindsets to the land of Mexico, and to their grand volcano Popocatepetl. How would time be measured by ancient hunters or gatherers near Popocatepetl, as they viewed spewing volcanic eruptions? They would obviously see thick ash clouds rising. There would be no watches. What might be a concept of time in the mind of such a person? How would the gatherer understand that there is a movement or *flow* of cosmic time? No doubt, by the number density of the rising ash particles; the thickness of ash clouds spewing majestically above the volcano; in modern terminology, by the "optical depth" of the cloud.

Time to this ancient gatherer, would be measured by the degree of fogginess through these smoke clouds. In other words, it would not be incorrect in this context to say that *time* and *spatial descriptions* (such as the density of smoke particles) are simply equivalent!

In Papua New Guinea, we have stressed that there are temporal labels of time. We may define *time* to be the equivalent of (or measured by) *temperature*, for example. If one defines time to be equivalent to temperature, we may think of our expanding Big Bang cosmos and how it continually cools down. We may, alternatively, define *time* in terms of *volume* of the cosmos. How big is the cosmos? Its observable horizon expands by one light year, each year. When the cosmos was ten years old, it was ten light years across. At an age of one million years old, our observable Universe would span one million light years in extent. Fourteen thousand million light years old (its current age): we see galaxies close to fourteen thousand million light years away! The volume is presently on the increase: the volume of our expanding Universe increases as time flows. *Volume* (a spatial concept) and *time* gather equivalent footings.

What about the beginnings of our Universe? How is time measured at those unimaginably tiny epochs, of billionths upon billionths of a second?

Enter Philo, a first century Jewish scholar in Alexandria.

Philo boldly asserts that God does not create the world *in time*. He asserts that God creates time *along with the world*.

Philo eloquently argues that there is no "pre-existing" time: there is no "before" the Big Bang. He writes:

> *Time began either simultaneously with the world or after it. For since time is a measured space (emphasis added) determined by the world's movement, and since movement could not be prior to the object moving, but must of necessity arise either after it or simultaneously with it, it follows of necessity that time is also coeval with or later born than the world.*

Time presents a mask as we approach cosmic beginnings. Time is veiled. Shrouded. How do we penetrate the time mask? Can it be achieved in terms of spatial descriptions alone?

Lucasian Professor of Mathematics at Cambridge, Stephen Hawking, and his colleague, James Hartle at the University of California, imagine a "Superspace" of all possible three-

dimensional spaces. Herein lies their point of genius: a curve in Superspace demarcates or measures time!

Back to the volcano analogy. When ash particles start rising, that provides one *spatial* "snapshot." As the eruptions proceeds, we have a sequence of *spatial*, three-dimensional, snapshots. To *measure time* is equivalent to *moving along a curve* in *Superspace*, wherein selecting any one point along the curve is to select a different spatial snapshot of Popocatepetl.

In the minds of Hartle and Hawking, our Universe moves along a curve in Superspace. Of course one can elegantly transform that curve into a more familiar notion of four-dimensional space-time, but the Universe, from its grand beginning to the present epoch, may be regarded as the collection of multitudes of different, three-dimensional, snapshots, of different temperatures, or of different volumes, and so on. *We then mysteriously move behind the time mask, into a world of space alone!*

> *A moment in time but time was made through that moment: for without*
> *the meaning there is no time, and that moment of time gave the meaning.*

wrote the British poet T.S. Eliot in his work "Choruses from 'The Rock.'"

The Australian poet Kenneth Slessor articulates his thoughts on the richness of time thus:

> *Time that is moved by little fidget wheels*
> *Is not my Time*

While four-dimensional space-time does have a beginning, the union of all three-dimensional spaces does not. Superspace always exists …

Hawking asserts: "The Universe would be completely self-contained and not affected by anything outside itself. It would just be."

Time and space enter the discussion on *comparable* footings! If we only think of space, and of Superspace in particular, there is no beginning (mathematically, "time $t = 0$") to grapple with; strangely, the Universe may then be said to have a finite past, but no "beginning" since "beginning" is transformed into a spatial "snapshot." The first spatial snapshot is no more important, or less important, than any other snapshot as one travels a curve in Superspace.

The time mask begins to be penetrated; while the laws of physics break down at conventional "time zero," "the beginning" of the Universe would really just be the first snapshot of the Creation Event, in Superspace! Time is masterfully transformed away.

Professor Christopher J. Isham (Imperial College, London) yields a theological overtone:

> *From an aesthetic point of view, there is something rather attractive about the completeness of space-time as represented in the Hartle–Hawking proposal; one can almost imagine the Universe being held in the cup of God's hand.*

There are many other *temporal* labels of time. In the wonder of the microcosm, we could define time in terms of the number of differentiated cells in the liver, the heart and the brain. Think of a fertilized ovum, four days old, gliding into the uterus of its mother. An ovum four days old, looking very much like a little solar system. What is time to the foetus? If we so wish, time could be defined as the number of undifferentiated versus differentiated cells. As there is a progression in what *we* call time, what the ovum sees is an increase in the number of cells which are going to be differentiated – from stem cells, to become portions of the liver, the heart, the brain, and so on. We may then think of a foetus three months old. Masterful photographs from the womb show a space traveler in a capsule, complete with his or her lifeline, the rugged halo, or chorionic sac. The number of differentiated cells has increased. It marks the flow of time. It is the increased number of differentiation in cells, from the heart, to the liver, to the brain, to the eyes.

Next, envisage a foetus 4½ months old. The hands are formed – yet another exquisite work of art. Did not Chesterton say that art is the signature of man?

In our world of Superspace, as we approach what Polkinghorne, Penzias and others see as the "Creation Event," the underlying equality of space and time asserts itself aggressively! In the Trobriand Islands, we saw faces of wonder everywhere. Wonder at our sunglasses. Wonder at our camera lenses. Wonder at what lies *behind the mask of sunglasses.*

As conceived by Hartle and Hawking, the history of our Universe is a curve in Superspace, the union of every possible three-dimensional curved space. That space *in which* the Papua New Guinean are all too familiar with: their world of setting Suns, of rising Moon and stars, and of the early-morning Mount Hagen mists – Shrouds of the Dawn.

Eyes to the Future: Where Eagles Soar

 uietness at the Walter Sisulu Botanical Gardens near Johannesburg, South Africa, where the seeds contained in this chapter were recorded and transcribed from tape. A long and relaxed discussion between Ken and David. As the authors cast their eyes to the future, highlighting some of the major questions and problems to hopefully be solved in the future, black eagles, *Aquila verreauxii*, soared loftily above us in the African skies … hence the title of our chapter.

Below we present some of the key challenges and enigmas in understanding galaxies, currently facing astronomers today:

I. The Three Masks of our Milky Way Galaxy

In this book, we have, at length discussed dusty Shrouds of the Night – apart from their dust content, these masks also contain fiery young blue stars, which obscure our view of what spiral galaxies actually appear like, beneath their Shrouds. However, we encounter an even more dramatic mask, which we term the *mass mask*. When galaxies are imaged behind their dust masks, they reveal the impressive backbones of spiral galaxies, as we have repeatedly seen – but it should always be remembered that the actual mass of stars in the disk of a spiral galaxy such as our Milky Way or the Andromeda Spiral is only a *small fraction* of its total mass. In the inner parts of a spiral galaxy, the stars do indeed contribute most of the mass, but as astronomers probe their disks further and further out in radius, another component of the mass dominates. This is the "missing mass" or enigmatic dark matter (discussed in greater detail later on in this chapter).

The first recognition of dark matter in spiral galaxies (as detected from the manner in which the galaxies rotate) was made in 1970. There is a fascinating historical interlude here yet again, this time not from the pen of Edwin Hubble or John Reynolds but from the pen of Princeton astrophysicist, the late John Bahcall.

David shares his thoughts on these letters:

During my visit at the Mt. Stromlo Observatory to complete this book, I came upon a fascinating letter written by John Bahcall, addressed to the astronomer Bart Bok, then in Arizona. The letter is dated December 23, 1982. In it, Bahcall cites a paper published in 1970 in which we find these words:

> *... there must be undetected matter beyond the optical extent of NGC 300 ... For NGC 300 and M33, the 21-cm data give turnover points near the photometric outer edges of these systems ... there must be in these galaxies additional matter which is undetected ... Its mass must be as least as large as the mass of the detected galaxy ...*

In another letter, Bahcall comments that this 1970 paper "is the earliest explicit recognition of the problem that I know about from rotation curves." Who was the author of this 1970 paper? I must confess that at first, I was not sure who Bahcall was referring to in his letter to Bok, but upon reading carefully, the penny dropped: John Bahcall was referring to research conducted in 1970 by an astronomer who has an office only two doors away from my office at Mt. Stromlo – coauthor of this book, Ken! Detective trails sometimes lead to the living and not only to the dead ...

Back to the main story ...

While the constituents of dark matter still remain a great mystery (as discussed in the next section below), it constitutes about ninety to ninety-five percent of the total mass of a typical spiral galaxy, so that drawings (Figure 157) and photographs (Figure 158) of the stars themselves give astronomers a very restricted view of the way in which matter in a spiral galaxy is actually distributed. The stars merely form a tiny fraction of the total mass; the disks of spiral galaxies are immersed in extensive envelopes of dark, unseen matter.

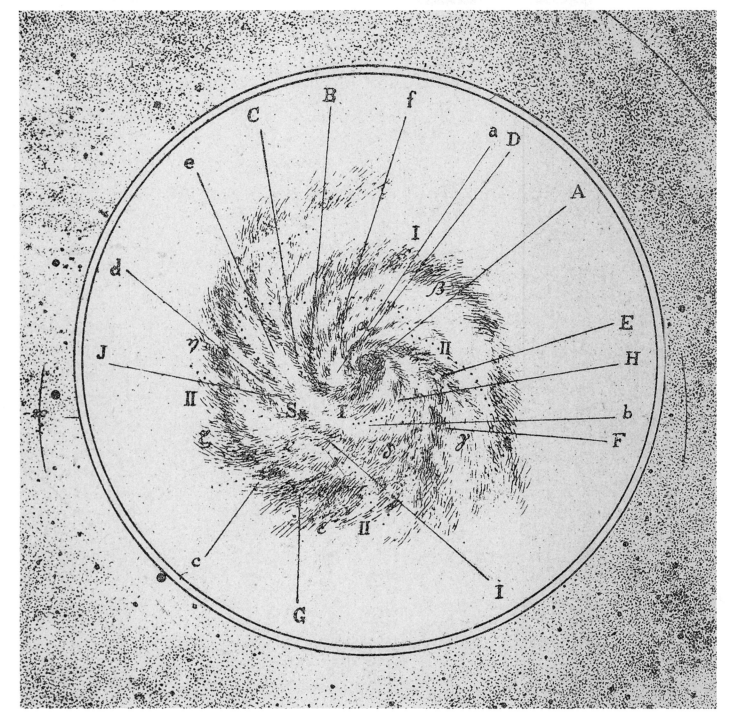

Figure 157 [425]

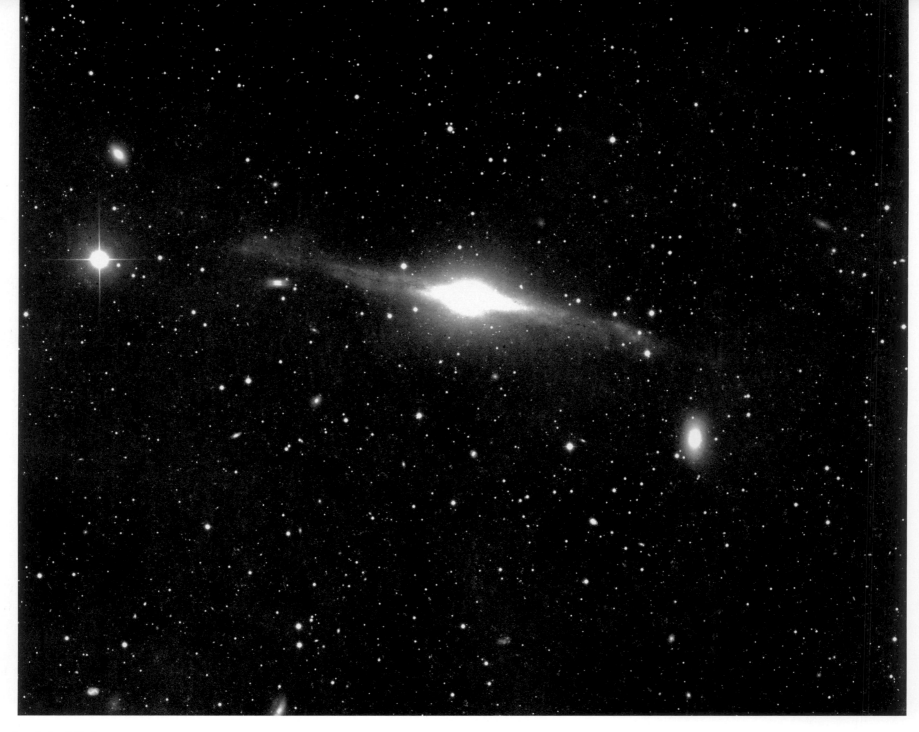

Figure 158 [425]

At Mt. Stromlo, we still have access to a "light table," a device very rarely used today. It has an illuminated piece of glass which lights up when switching on a diffuse light source below. On the light table itself is placed a negative, much like a radiologist today might examine an x-ray, by placing it on a light table with diffuse light illumination. Before the digital era, astronomers would sit for hours at such light tables, carefully scrutinizing their glass negatives exposed at a telescope.

It is with awe and wonder that we gazed upon a negative of one of the most massive galaxies known – the galaxy NGC 5084 (a positive version appears in Figure 158). The galaxy has been carefully studied by one of us (Ken) and associates several years ago, who determined a mass of possibly 10 times the mass of our Milky Way Galaxy. NGC 5084 is seen "edge-on" – as if viewing a thin plate from one side. How intriguing to almost walk back decades in time, by actually examining these negatives of NGC 5084 visually on a light table, and to realize that while there must be a gigantic halo of dark matter in which the galaxy NGC 5084 is embedded, there is not the *slightest* visual hint of its existence. All looks so perfectly normal around the environs of NGC 5084; there is no obvious dimming of background galaxies *in any way* at all. Peeking through the microscope at the negative of NGC 5084, the environs of NGC 5084 look so quiescent. The constituents of what dark matter is actually made of, forms one of the most major discoveries awaiting astronomers. Dark matter – by all accounts a vast constituent of our cosmos – matter which has mass, but which emits absolutely *no light* whatever. The eye sees nothing amiss: the visual presence on the surroundings of galaxies such as NGC 5084 (Figure 158) and scores of other spiral galaxies with their dark matter halos, is zero.

A thought for the future. Imagine if astronomers could construct a special telescope (which obviously no-one has yet invented) which could directly image how matter in a spiral galaxy is distributed. Such a telescope would image dark matter *as well as* luminous matter. Galaxies such as NGC 5084 would look supremely different through such mass-detecting telescopes, for their dark matter halos would be imaged too!

Dark matter itself is a mask: although it does not actually obscure any stars in galaxies, it is a mask in the sense that its presence means that astronomers are afforded a misleading picture as to how the total mass in spiral galaxies is distributed.

Johann Wolfgang von Goethe elucidated: "Wo viel Licht is, ist starker Schatten" or translated, "Where there is much light, the shadows are deepest."

The mysteries in our starry skies of dark matter … the "shadows" of dark matter … run very deep.

There are thus several levels of masking in our majestic cosmos. If our interest is to study the formation of young bright stars – those fiery energetic furnaces delineating the arms of so many spiral galaxies – then one should examine optical images, such as those secured photographically or digitally. However such young stars themselves mask the bulk of the older stars, which we would therefore miss!

If astronomers wish to study the underlying population of old stars in a spiral galaxy, they need to image the galaxy in the infrared, penetrating the dusty Shrouds of the Night. In this chapter, we have alluded to yet a third mask – a mask containing nonluminous, dark matter. To see most of the mass of a spiral galaxy necessitates a new *mass telescope*.

Enter the fourth mask, which astronomers may term the *dynamical mask* of a galaxy.

One of our most important diagnostics in trying to understand spiral galaxies is to measure how the stars actually move. For example, most of the stars in the disk of a spiral galaxy move in almost circular orbits around the galaxy center. The implication is that the gas from which those stars have formed, has already settled into the disk before most of the formation of stars takes place. Yet implicitly intertwined is a story forever masked … forever lost: it is the story of what happens during the settling process itself. What does the birthing process of spiral galaxies actually reveal? After all, a galaxy becomes quite different from what it was before. Has it not changed from a rather chaotic system into a well-ordered disk? We are reminded of the vibrant youth of the boy in William Wordsworth's "Ode: Intimations of Immortality from Recollections of Early Childhood (V)"

> *Our birth is but a sleep and a forgetting;*
> *The Soul that rises with us, our life's Star,*
> *Hath had elsewhere its setting,*

And cometh from afar;
Not in entire forgetfulness,
And not in utter nakedness,
But trailing clouds of glory, do we come
From God, who is our home.
Heaven lies about us in our infancy.
Shades of the prison-house begin to close
Upon the growing Boy,
But He beholds the light, and whence it flows,
He sees it in his joy;
The Youth, who daily farther from the east
Must travel, still is Nature's Priest,
And by the vision splendid
Is on his way attended;
At length the man perceives it die away,
And fade into the light of common day.

We may see a young boy or girl now, but each one has emerged through a birthing process, the exact details of which are veiled in the mists of time.

A crucial point therefore is that a *lot of information is lost* during the settling (or birthing) process of a galaxy. By examining stars in the disk of a galaxy now, it is almost impossible to learn much about the properties of the galaxy *before* the disk formed. One can think of this loss of information as the *dynamical mask*.

A spiral galaxy may present a rather well-ordered dynamical face to us now, with the stars moving mostly in near-circular orbits. Yet behind this mask lies a history untold ... the chaos which invariably initially reigned supreme before the disk settled. *It is as if a cosmic iron has smoothed away the primordial history of every spiral galaxy;* their birthing processes rapidly are washed away, as with a young child running on a beach at the sea-shore; the child so enjoys leaving footprints in the sand – but these footprints are quickly washed away by the crashing waves of our tumultuous oceans. Those early footprints, almost forgotten, as in a sleep, in the words of Wordsworth.

Most of the *fossil history* of spiral galaxies has forever been lost in the processes which led to the formation of galactic disks. If one wishes to recover information about the galaxy in its early history, one may have to look at *chemical fossils* or signatures rather than dynamical signatures. The way in which stars move today obscure most of the dynamical *fossil* information. In this sense, this Dynamical Shroud of the Night is different from the dust and mass masks which we have been discussing. The dust and mass masks obscure the underlying information but the information about stars and mass is inherently still there. With a dynamical mask, the information is gone.

The words of Henry Longfellow ring in our ears:

> *I heard the trailing garments of the Night Sweep through her marble halls.*
> ("Hymn to the Night")

After the sweeping, all is apparently clean. It is akin to an archaeologist who may be studying some ancient manuscripts from a long-gone civilization by candlelight; accidentally the candle sets the manuscripts alight and all information is lost. The archaeologist is forced to seek for clues elsewhere pertaining to the very early days of such a civilization!

One of the great challenges of the new millennium is to learn how to penetrate these various masks to unravel the real structure of spiral galaxies, as well as to try and discover how such spiral pinwheels were actually birthed.

Astronomers use a novel archaeological approach to probe the primordial history of our Milky Way. The goal is to discover what happened when the Milky Way itself (Figures 159 and 160) was being assembled … the birthing process of our Galaxy. We seek fossil remnants – footprints in the sand, as it were – of star forming events which occurred very long ago. These fossils speak with a more feeble voice, when contrasted to our geological fossils of long-lost plants and animals.

The astronomical fossils are often groups of stars which share common *motions* in space and with common *chemical* properties – properties which have been preserved since these stars formed. Unfortunately for us, gas clouds and spiraling waves of stars seek to change or

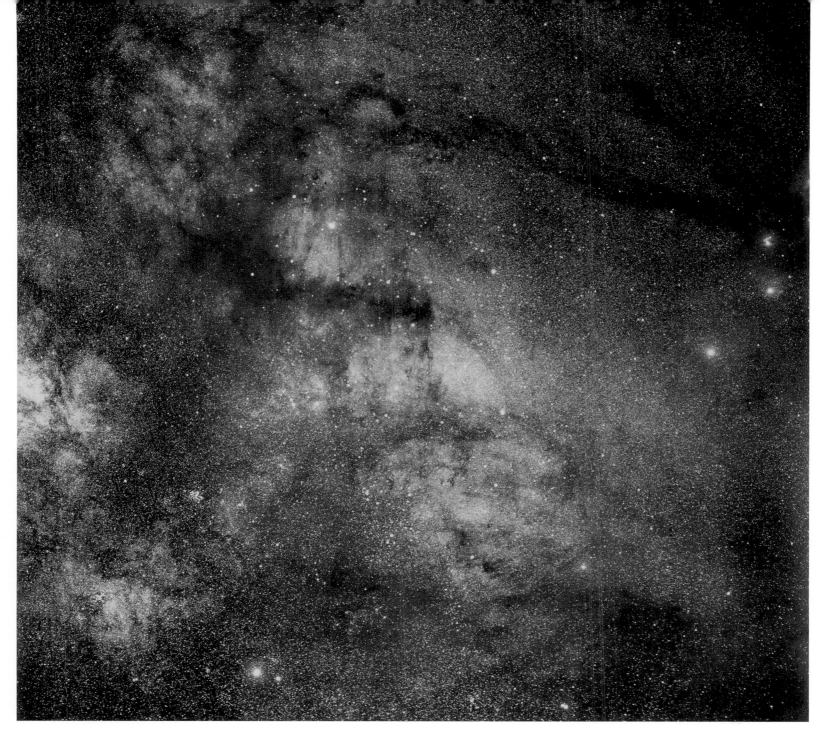

Figure 159 [425]

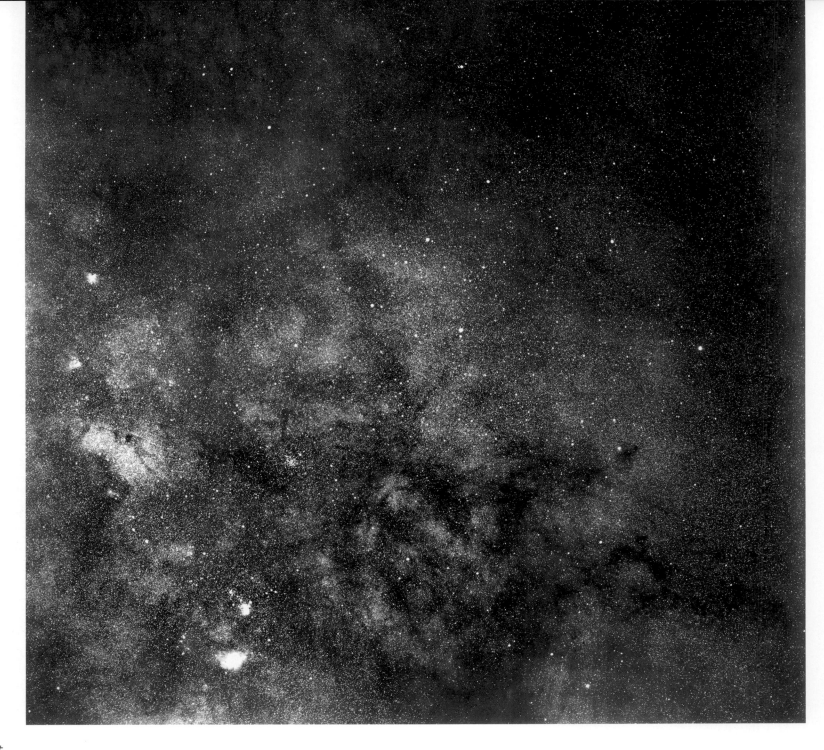

Figure 160 [425]

to perturb the motions of stars in their orbits. For some stars, their stellar orbits have carried them around the Milky Way more that fifty times; their orbits will most certainly have changed during such aeons of time. One therefore cannot always rely on common stellar motions as evidence of astronomical fossils.

For the future, we believe in chemical tagging, much like human beings may be genetically tagged by their DNA. The goal: a *chemical identification* of stellar fossils in our Galaxy. How do astronomy detectives set upon finding these primordial fossils, with their feeble voices? The technique relies on the patterns of chemical abundances of heavy elements, such as calcium, silicon, iron and barium – the amounts of which do not change as the stars age. Although this is technically more challenging, astronomers can rely on stars maintaining their distinguishing chemical properties as they march forward in their galactic orbits. Chemical archaeology will allow astronomers to penetrate the dynamical mask, and allow us to study a primordial cosmic landscape of our River of the Night – the Milky Way. Such a landscape will not have been created by paint, but by the distinguishing footprints or signatures of the chemical elements of the stars.

II. Dark Matter – What is it, and What Shapes are the Dark Halos of Dark Matter Enveloping Spiral Galaxies?

The evidence for the dark matter comes from the way in which the rotation speed of stars and of gas in galaxies varies as we go further and further out from the center. We can plot the velocity of stars in their orbits versus their distance from the galaxy center, and in this way generate a graph known technically as a "rotation curve."

As an analogy, let us consider the motion of planets in our solar system. Mercury orbits the Sun at an average speed of 47 kilometers per second, while Pluto orbits the Sun at only one-tenth of this value: 4.7 kilometers per second. Newton's laws of motion beautifully *predict* such a decrease in velocities: Pluto is one hundred times farther out from the Sun than Mercury, and the square root of 100 is 10. The reason for the observed decrease in the orbital velocity of our planets is that 99.99% of the mass in our solar system is contained in the Sun itself, at the very center of the solar system.

The contribution of mass from all the planets including Jupiter hardly affects the orbital velocities of the planets. When we examine the orbital velocities of stars in spiral galaxies, the situation is *remarkably* different. In the inner parts of spirals, the gravitational field appears to be produced mainly by the stars as we see them in the infrared. But when one looks further out in radius, alarm bells start ringing; one finds that the stars are not sufficient: the gravitational field becomes dominated by some unknown form of dark matter. In our Milky Way, the dark matter becomes gravitationally important near the location of the Sun, about 26 000 light years from the center of our Galaxy, and becomes progressively more important as one moves further out in the Galaxy.

We have earlier noted that most of the stars and gas in the disks of spirals are moving in more or less circular orbits around the center of the galaxy. This rotation is not rigid, like a rotating dinner plate, but usually shows a lot of shear, akin to bath water going down a plughole. The angular velocity (the rate of spin) decreases towards larger radii. For material to go around in circles, a gravitational inward pull is needed. If this gravitational tug of war were not there, the laws of Sir Isaac Newton would predict that matter would simply move in a straight line. Astronomers can observe how fast stars are moving at any chosen radius, and it is a simple task to compute how much mass is present inside that radius.

Two masses enter the discussion: firstly, the mass computed using Newton's law of gravity (such a mass is deduced from the way in which stars move around the galaxy center). Secondly the mass of stars that we can actually see from our infrared images plus the mass of gas measured using radio telescopes. In most galaxies, astronomers find nothing strange happening in the inner parts of the disk: the matter there is in the form of stars and gas. At larger radii, bells ring loud and clear: The amount of matter (as computed from Newton's laws) in the outer parts of galaxies becomes much larger than the available visible mass in the form of gas and stars – by a factor which increases with increasing radius and can get as large as ten to twenty! In other words, only about five to ten percent of the mass of a typical spiral galaxy is in the form of stars and gas that we can detect. The other ninety to ninety-five percent lurks in some unknown form of dark matter.

Our argument of course assumes the validity of Newton's laws. One calculates the mass of a galaxy as deduced from his laws, using the rotation curves of either stars or of hydro-

gen gas. There is a clear implication: either galaxies have vast amounts of material in some unknown form, or Newton's laws are no longer valid at large distances from the centers of galaxies! Most astronomers find the latter possibility rather unpalatable. It would imply that our familiar inverse square law of gravity – that the gravitational force is proportional to $1/(\text{distance})^2$ – would have to be modified in the outer regions of galaxies. The most prominent alternative theory to modifying gravity was put forward by Moti Milgrom, who proposes that Newton's laws need to be modified when accelerations become very small.

Although the masses of galaxies are huge relative to the mass of the Sun, the radii of the orbits of the stars and gas in galaxies are even larger relative to solar system dimensions. The acceleration for a circular orbit is simply V^2/R, where V is the rotational velocity and R is the radius of the circular orbit. The Earth orbits the Sun in a nearly circular orbit. If one assumes the Earth's acceleration around the Sun to be one unit, the acceleration of the Sun in its almost circular orbit around the galaxy is only about one hundredth millionth (10^{-8}) of that of the Earth's acceleration. It is very small indeed; of course further out in the Galaxy it becomes even smaller. Some astronomers have postulated that Newton's laws may break down at such very small accelerations and that this could explain why the mass of galaxies appear to be increasing so rapidly as a function of radius.

Such a breakdown in Newton's law is very difficult to test, because we do not encounter such extremely low accelerations in controllable situations. In the solar system, one would have to travel to huge distances from the Sun, about 10 000 times the Earth–Sun distance, far beyond the outer planets to the famous Kuiper belt, to find such low accelerations. Indeed, how many solar system objects may exist at such large radii, from where our Sun would appear as a much fainter star in the sky, is unknown. When the Pioneer 10 and 11 spacecraft (launched in 1972 and 1973, respectively) were at about 20 times the Earth–Sun distance, a minuscule unexplained acceleration of these spacecraft was detected.

It may be that such minute accelerations are simply due to unmodeled spacecraft systematics. The outward journeys of such spacecraft are precarious, having to continually interact with the solar wind (streams of high energy particles which originate from the Sun); gas particles also scatter off the spacecraft. The unexplained acceleration is so small that it could possibly be a statistical anomaly caused by differences in the way data was collected over the lifetime

of the Pioneer probes. Numerous changes were made over this period, including changes in the receiving instruments, reception sites, data recording systems and in the recording formats. In principle, however, the tiny unexplained accelerations of the Pioneer 10 and 11 spacecraft in the outer reaches of our solar system could also be caused by some new physical phenomenon.

Astronomers have attempted to devise other astronomical methods to test whether Newtonian gravity breaks down at low accelerations, but Milgrom's theory has thus far survived all of these tests. This does not necessarily imply that his theory is correct; it simply means that it is not obviously incorrect. If Milgrom is correct, the galaxies would not contain dark matter and the galactic "dark matter" problem would disappear.

Returning to the more conventional viewpoint that Newtonian gravity is correct at all accelerations, one must squarely face the problem of dark matter. Of what is such nonluminous matter composed – matter which contributes approximately ninety percent of the mass of spiral galaxies? At this juncture, no-one knows! Favorite astronomical dark matter candidates, such as the remnants of "dead" stars (white dwarfs, neutron stars, black holes) or the very low-mass brown dwarfs, now seem very unlikely. Such astronomical candidates can contribute only a small component of the enigmatic dark matter in galaxies. A small fraction of the dark matter might be in the form of very cold molecular hydrogen gas, as postulated by astronomers Francoise Combes and Daniel Pfenniger. However, most of the dark matter is believed to be nonbaryonic.

The majority consensus is that galactic dark matter is in the form of exotic subatomic particles left over from the early, hot Universe. Neutralinos, photinos, axions are among the candidates. These particles are predicted by theoretical physicists but they have not yet been observed in the laboratory. Very exciting research is progressing in many physics laboratories, aimed at detecting these subatomic particles experimentally.

These are difficult experiments, because such particles interact very weakly with matter so that they are not easy to detect experimentally. For example, *these particles can pass right through the Earth without any interaction at all.* Hundreds of millions of these particles could be streaming through your heads as you read these sentences. If the galactic dark matter is made of axions,

which have very low mass, there might be a staggering 10 000 000 000 000 (a 1 followed by 13 zeros) of these particles in every cubic centimeter of laboratory space.

In summary, there are two roads ahead:

> *Two roads diverged in a wood, and I –*
> *I took the one less traveled by.*
> *And that has made all the difference.*
>
> (EXTRACTED FROM A POEM BY ROBERT FROST)

Those journeying along the first road are the majority of astronomers, who believe that dark matter exists, and consequently that in excess of ninety percent of mass in the galaxies is nonluminous. Those on the road less traveled would be a smaller group of astronomers, who suggest that Newton's theory of gravity breaks down where the accelerations of stars moving in their orbits about the centers of galaxies, become minute.

Let us return to the concept suggested earlier of a mass telescope: some futuristic sort of telescope with which one could image *mass* without imaging light. *Galaxies would be much larger than we see them in light.* For the Milky Way, our stellar disk extends to some 65 000 light years in radius, while the dark matter is known to reach out to at least seven times that amount, to a radius of nearly 500 000 light years. In an inner radius of 32 000 light years, our Galaxy would look rather similar in mass as it does in light. The bulge may appear to be slightly more prominent in mass; one would of course see the disk but it would show much less spiral structure than it does in light. Beyond a radius of about 32 000 light years, however, the dark halo would be the most important component of mass.

The actual shape of a halo of dark matter is not known. In all likelihood, it is approximately spherical, as suggested by models or simulations of the development of galaxies (including their halos of dark matter) on powerful computers.

There are also clues pertaining to halo shapes which come from a neighboring galaxy to our Milky Way, known as the Sagittarius Dwarf Galaxy. This small, dwarf galaxy is being tidally

destroyed or ripped apart from the gravity of our Galaxy. The debris does not lie randomly scattered in space, but rather lies in a plane almost perpendicular to the plane of the disk of our Galaxy. If the halo of dark matter about our Galaxy were very flat, then the orbits of its debris would be forced to wobble away from its original location and would no longer lie in a plane. Far more likely, therefore, is that the halo of dark matter in which our Milky Way Galaxy is embedded has an approximately spherical shape, which extends out to a radius of at least 500 000 light years.

Another interesting question to ask is this: How do astronomers actually know that the Milky Way's halo of dark matter extends so very far in space? The strongest evidence comes from the observation that the Andromeda Galaxy is *approaching us* at 118 kilometers each second. Andromeda and the Milky Way are both giant spirals with similar luminosities and rotation curves. Although the Andromeda Galaxy and the Milky Way belong to our expanding Big Bang Universe, they are relatively so close to each another that the gravitational force between them – the force of mutual attraction – has overcome the expansion of the Universe, and they are now approaching each other! To achieve such turnaround in the lifetime of the Universe requires a certain amount of mass. Indeed, one requires a halo of dark matter about our Galaxy and the Andromeda Spiral of enormous proportions (compared to their optical sizes) in order to fit enough total mass into the halo, so that gravitational forces can be strong enough to cause the two galaxies to approach each other. Both galaxies are comparable in mass, based on their rotational velocities, and this observation is invoked in simulating the future collision of the Milky Way and Andromeda.

Would the dark halos seen through our hypothetical mass telescope appear continuous? Probably not: theory predicts that that halos of dark matter should be rather lumpy, but the observational evidence for this lumpiness is not yet very compelling.

With our futuristic mass-detecting telescope, one would see our Milky Way Galaxy looking *radically different* from its appearance in light, with about 20 times as much mass in this huge dark halo as there is in the stars of the bulge and the disk.

III. "Cosmic Rain" and "Cosmic Irons"

Galaxies contain stars, and galaxies also contain gas. The stellar birthing process requires gas on a continual basis – no fresh gas, and star formation slows down or even halts! Without regular fill ups of petrol, the car journey stops. Where does the supply of cosmic gas come from? From whence is the source of the cosmic rain of gas onto our Galaxy – rain absolutely critical to maintaining the formation of those stellar fires of the night?

Astronomers have measured how the rate of star formation has changed in our Galaxy since its formation. The surprising result is that, although there have been periods in which the star formation rate has fluctuated up or down, on average the rate of star formation has hardly changed over the last ten billion years. The grand puzzle is: where does the gas come from to sustain this steady rate of star formation?

Surveys with radio telescopes show that only *a few percent* of the mass of the disk of our Galaxy is in the form of gas (mostly hydrogen and helium), from which new stars are forming. While most of this gas is in well-ordered circular motion around the Galaxy, we do indeed observe gas raining in to our Galaxy from outside!

The raining in of infalling gas has been extensively studied by our colleague Francoise Combes and her collaborators. We do not yet have an agreed scenario as to where this outside gas comes from. According to current opinion, it may simply be gas which could have been ejected from our Galaxy very early in its lifetime and which is now gradually raining back on to our Galaxy to "feed" and to sustain its steady rate of formation of stars. Another very interesting and plausible possibility, favored by Francoise Combes and others, is that cold gas rains onto galaxies from vast filaments known as the cosmic web. The infalling gas in these cosmic filaments could be very cold indeed – there is no theoretical reason why the gas temperature could not be as low as a mere few degrees above absolute zero. Such gaseous filaments would remain undetected by conventional radio telescopes. The cosmic rain falls gently: only a few solar masses per year over the entire disk of our Galaxy will fuel and sustain the formation of stars; remember that a even a few solar masses of infall each year, when summed up over a period of one billion years, amounts to billion times the mass of our Sun.

*Rain! whose soft architectural hands have power to cut stones, and chisel
to shapes of grandeur the very mountains.*

(HENRY WARD BEECHER)

Whatever the source of the gentle infalling clouds of cosmic gas, such rain will shape the architectural appearance of our Galaxy, because its spiral arms will be rejuvenated by the birth of new stars resulting from such infalls.

The infall of gas raises another intriguing question. The disks of spiral galaxies become fainter towards their outer regions. When astronomers measure how this surface brightness changes with radius, in almost every example the decrease follows an exponential function with radius. Simply put, if one plots the logarithm of the surface brightness against the radius, the plot will very closely resemble that of a straight line. Astronomers still do not really understand why most disks of spiral galaxies follow this exponential law. For a long time, astronomers thought that the exponential law was fully operative at primordial epochs: very early in the life of a spiral galaxy, as it was forming. In all likelihood, however, the disks of spiral galaxies are probably being built up at a steady rate right throughout their lives, just as in our Galaxy. Mysteriously, the infall of gas, followed by the formation of stars, steadily builds up the disk of our Galaxy over a period spanning 10 billion years – or maybe even longer. Nevertheless, the disk of our Galaxy (and multitudes of others) still maintains a distribution in light which is exponential. Why?

Accretion itself, is a complex and ever changing process. Not only is there accretion by means of cosmic rain onto our Milky Way, but there are also other forms of infall, too. Our Galaxy is surrounded by a number of dwarf companion galaxies, and these smaller galaxies are occasionally dragged into our Galaxy (as a result of gravity) and disrupted. One such event is taking place as we write this chapter; as discussed above, the Sagittarius Dwarf Galaxy is currently being broken up and disrupted by the gravitational field of the Milky Way. The stars in the debris are spread out over more than 60 degrees of sky; the equivalent of 120 full moons.

The debris of accreted and shredded satellites is relatively easy to identify, because the orbits of the stars in the debris pass through the disk of the Milky Way only rarely; their orbits are

much less disturbed than stars in the disk of our Galaxy. Several groups of stars with common motions have already been identified as the remains of broken satellites. The history of our Galaxy is clearly filled with myriads of details yet to be fully understood.

There are so many unknowns – so many clues to be filled in – with such a tumultuous history, we are reminded of the work of Joseph Mallord William Turner's famous painting "Snowstorm," which Kenneth Clark describes as follows:

> *But in Turner's Snowstorm nothing comes to rest. The swathes of snow and water swing about in a wholly unpredictable manner, and their impetus is deflected by contrary movements of spray and mysterious striations of light. To look at them for long is an uncomfortable, even an exhausting, experience.*

Why should the disks of spiral galaxies, including our own Milky Way, be described by such smooth exponential functions?

It is indeed as if a mammoth *cosmic iron* has continually been in operation, smoothing out the distribution of stars in the disk into this exponential form.

Such a cosmic iron may actually be extragalactic bars, bars which so often lurk behind dusty Shrouds of the Night. As we have seen, over seventy percent of spiral galaxies in our local Universe have been discovered to contain a bar. Bars are highly effective in redistributing the mass of gas in the disk of a spiral galaxy: the disk of a barred spiral galaxy can be "ironed out" to present a smooth "exponential" law in the distribution of its stars. By no means have all the pieces of the puzzle come together; *cosmic irons* remain but one of the many issues which one will need to explore further, in the years to come.

IV. Were Carbon Stars Rampant in our Early Universe?

There is a fascinating link between gas raining onto the outer disks of spiral galaxies and the "stuff" of which we are made: carbon. Such infalling gas may be the perfect nurseries for carbon-producing stars!

Over ninety percent of all stars which have already reached the end of their (thermonuclear) lives in the Universe had masses between one and eight times the mass of our Sun. Stars with masses heavier than about 1.5 times the mass of our Sun pass through a late stage in their development where they become exceedingly bright carbon stars. Such stars blaze with luminosities ranging from four thousand to thirty thousand times the luminosity of our Sun. These carbon stars are relatively cool (typically 2500–3000 degrees Centigrade) and are unstable, pulsating with periods between one hundred to one thousand days.

The outer envelopes of such stars are rich in carbon, dredged up from their nuclear-burning interiors. Carbon forms the basis of life on Earth, and there are principally two mechanisms by which carbon can be released into space. The first is by means of an exploding star (such as the famous Crab Nebula in Taurus, seen to explode in the year 1054 AD) and the second, by means of these immensely interesting carbon stars. Carbon stars continually lose mass by means of stellar winds. During the phase of outward blowing stellar winds, these stars play an absolutely crucial role in spewing elements such as carbon into space. We are indeed made of carbon based stardust produced in stars.

The typical ages of carbon stars range between one-half to two billion years; astronomers refer to carbon stars as being of "intermediate-age" – neither young nor old. Of greatest interest is the actual "carbon star bearing epoch" – a time, which only lasts for about a billion years – during which these stars are extremely luminous in the near-infrared. In fact, studies have shown that the presence of only *two or three* carbon stars in intermediate age clusters of stars belonging to the neighboring Large Magellanic Cloud can contribute to about one-half of the total near-infrared brightness of the entire cluster! They are true light beacons in space.

Henry Wadsworth Longfellow in his poem entitled "The Lighthouse" expresses the brilliance of each light beacon thus:

> *Steadfast, serene, immovable, the same, Year after year, through all the silent night*
> *Burns on forevermore that quenchless flame, Shines on that inextinguishable light!*

We have been deeply engrossed in another detective trail: to find luminous carbon stars in the outskirts of spiral galaxies. The reason is that such stars can yield vital insights

into the direction in which the disks of spiral galaxies grow. If cosmic gas rains onto the outer regions of a spiral galaxy, a tell-tale signature could be the presence of carbon stars. These stars are neither very young, nor very old, but rather of intermediate age, as discussed above. If these brilliant light beacons are pervasive in the outer disks of spiral galaxies, the implications would be that the disk of a galaxy *grows with time*, from the inside, outwards.

The actual contribution of carbon stars to the overall light of spiral galaxies remains poorly established. Relative to the inner regions of spiral galaxies, astronomers do know that the average ages of the outer regions are somewhat younger … conceivably, prime hunting ground for intermediate-aged carbon stars.

In 2004, we discovered spectacular arcs of carbon stars in the outer domains of one of our closest spiral galaxies, known as the Triangulum Spiral Galaxy (Figure 161). The Triangulum Galaxy, nearly 3 million light years away, was probably discovered by Giovanni Hodierna before 1654; it was independently rediscovered by Charles Messier in 1764, where the galaxy appears as number 33 in his catalogue; hence the designation Messier 33 (M33). M33 was also catalogued independently by William Herschel on September 11, 1784. The Triangulum Spiral was amongst the first "spiral nebulae" identified as such by Lord Rosse.

We imaged the Triangulum Galaxy through the eyes of the orbiting Spitzer Space Telescope, using a special camera discussed earlier – a camera designed by Giovanni Fazio (affiliated to the Harvard–Smithsonian Center for Astrophysics and the Harvard College Observatory) and his associates.

We also confirmed the carbon-status of stars in the outer arcs of M33 using giant Keck telescopes atop the extinct Mauna Kea volcano in Hawaii. We believe that infalling gas continues to rain onto the Triangulum Galaxy, and that the disk of the Triangulum Galaxy subsequently grows from the inside, outward.

Based on such studies, we have good reason to believe that most galaxies will pass through a first carbon phase, when the Universe was only about ten percent of its present age and when

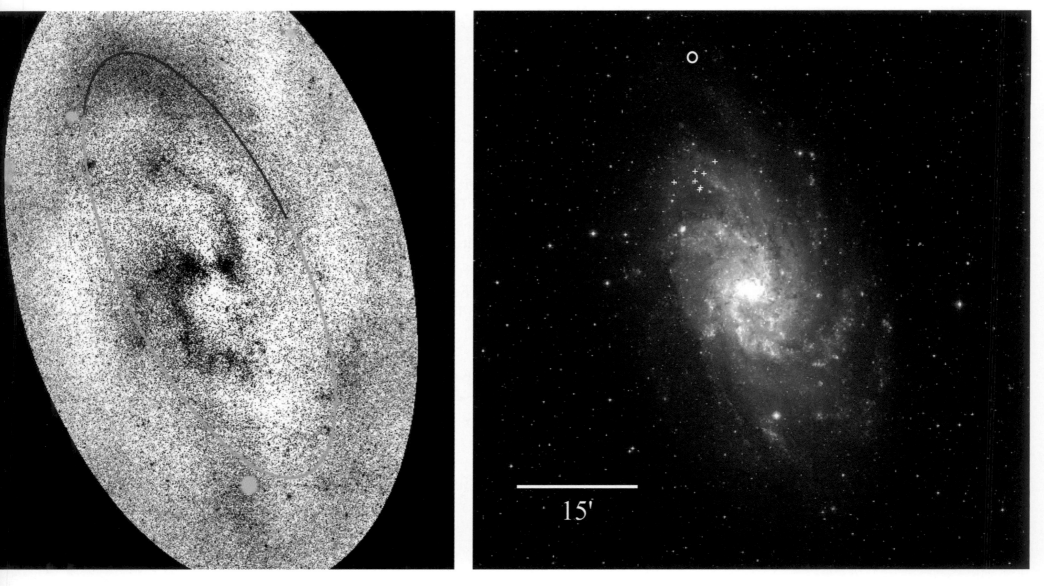

15'

Figure 161 [425]

carbon stars were rampant. Using the Large Magellanic Cloud as a guide, carbon stars are found in large numbers between ages of about one-half to two billion years. It is therefore perfectly conceivable that galaxies which undergo an early burst of star formation will have their infrared light output greatly boosted one-half of a billion years later, and that this prodigious output of light will fade away after some two billion years.

There may be an epoch starting about a half a billion years after the onset of star formation in our Universe, characterized by large numbers of carbon stars. Why have astronomers not yet detected this epoch, when carbon stars were rampant? The reason is simple: the parent galaxies, containing carbon stars, would be moving away from us at great velocities in our ever expanding Universe. Their enormous output of radiation would be masked, this time by the recessional speed of the galaxy to which these stars belong. Radiation from carbon stars would no longer reign supreme in the near-infrared; their near-infrared photons would be shifted red-ward, toward the mid-infrared …

A crucial role will be played by the James Webb Space Telescope (abbreviated JWST) – a large, infrared-optimized space telescope, which as noted earlier, is scheduled for launch no earlier than June of 2013. This space telescope, to replace the Hubble Space Telescope, is principally designed to study the earliest galaxies and some of the first stars formed after the Big Bang. These young objects move away from us at high speeds and the best observations for such objects are only available in the mid-infrared. JWST will have a large mirror, 6.5 meters in diameter and a sunshield the size of a tennis court. Both the mirror and sunshade would not fit onto the rocket fully open, so both will fold up and open only once that space telescope is launched. The James Webb Space Telescope will reside in an orbit about one and a half million kilometers from the Earth.

Detectors such as the Mid-Infrared Instrument on board the James Webb Space Telescope should prove pivotal in the detection of a time when carbon stars first glowed as fiery lights in our early Universe. We eagerly await to see *that* epoch, when highly luminous carbon stars – enriched in that element carbon of which every reader is made – may have first dominated the radiation fields of many young galaxies, billions of years ago.

V. Why do Computer Models Produce only "Small" Galaxies?

Stars in the disk of our Milky Way Galaxy have been detected at a radius of nearly 60 000 light years. One of the major problems at present is how to make realistic galaxies using a computer. The challenge before astronomers who deal with theories of galaxy formation, is to produce galaxies on computers which are as large as the observations of spiral galaxies in our skies indicate. In these computer simulations (otherwise known as computer modeling), galaxies form from infalling fragments of gas as well as dark matter – the dark matter gradually forms a dark, nonluminous halo while the gas settles into the shape of a flattened disk and subsequently forms stars. In these primordial galaxy formation epochs, a considerable amount of angular momentum (or momentum of spin) is transferred from lumpy clouds of gas into the dark matter, through a gravitational process known as dynamical friction. The effect of this, is that the disk of gas then shrinks in size; in shrinking, it spins faster, so that the loss of angular momentum from the disk actually makes it *smaller* and rotate *more rapidly*.

An analogy may be helpful. Let us envisage a planet orbiting a parent star. If one removes angular momentum or orbital spin from the planet, it will no longer orbit fast enough to stay at its original radius, so it will migrate inwards ... but then our planet would have to move or rotate in its orbit more rapidly in order to retain the balance against the gravitational force field of the star.

The disks of spiral galaxies which emerge from state-of-the-art computer simulations are too small. For a bright galaxy such as our Milky Way, the computers yield a simulated or modeled Milky Way spanning only 20 000 light years in radius, which is too small by a factor of three. Moreover, computers yield spiral galaxies which typically spin about twice as fast as the real disks which astronomers observe in spiral galaxies.

What could be missing from these highly sophisticated computer simulations? One way to suppress the loss of angular momentum is to temporarily expel the gas from the young galaxy, so that it does not transport its angular momentum to the dark halo.

This may happen when the first bursts of star formation occur as the galaxy is being formed. Star formation would eject energy into the gas, so that the gas becomes hot and flows into the outer vicinities of the galaxy.

In the time that the gas takes to recover from this stellar push and settle back into the disk, the dark halo settles down and the gas can then smoothly flow back into the inner parts of the galaxy without losing its angular momentum. This inflow is a gradual process and is probably still on-going in spiral galaxies. As noted above, astronomers do see direct evidence for infalling gas clouds onto galaxies. This gentle cosmic rain provides the crucial refueling process of gas to sustain the star formation rate in our Milky Way, which has been roughly constant throughout its existence. Without cosmic rain, it would be impossible to sustain the birth of stars in other spiral galaxies, too, over periods spanning billions of years.

Instead of each galaxy being an island isolated in space, it is becoming increasingly more evident that cosmic pinwheels continually change within their masks of nonluminous dark matter. It is only when we really try and penetrate these masks that we may attempt to understand the very important process of exactly how to make big galaxy disks which are in accord with current observations of bright spiral galaxies such as our Milky Way.

Dark matter holds its secrets intact. We need to think – and think very carefully.

A poignant thought by Albert Camus:

> *In order to understand the world, one has to turn away from it on occasion.*

VI. What Generates Spiral Structure in Galaxies?

Any viable theory of spiral structure must carefully factor in the appearance of spiral galaxies at optical wavelengths and those behind their Shrouds of the Night. We have seen many examples where spiral structure may look quite similar in some cases and totally

different in others, when imaged through their dusty masks. Another interesting point worthy of comment is this:

In spiral galaxies, astronomers often see disks of gas extending far beyond their disks of stars. What is a surprise is that, in some instances, one can actually "see" spiral structure in the very extended disk of gas. The density of the gas is much too low in those environs for the spiral structure to form by mechanisms which only rely on the gravitational force field of the gas. Although such galaxies are relatively rare, their existence gives us a clue that *some other factor* may be involved in the formation of spiral structure.

Is there just one unifying force, or more?

> *That very law which moulds a tear*
> *And bids it trickle from its source,*
> *That law preserves the earth a sphere,*
> *And guides the planets in their course.*

(SAMUEL ROGERS, "ON A TEAR")

Samuel Rogers is of course referring to the force of gravity, but there are others forces operative in galaxies, such as magnetic fields. And there is the dark matter in which galaxies are embedded, whose constituents are unknown.

There may be a marriage between spiral structure and halos of dark matter; the two could be inextricably linked. For example, if the halo is not quite spherical but perhaps elongated rather like a rugby ball, its stirring of the disk of gas could generate spiral waves in the gas. Computer simulations of the growth of galaxies shows that such slightly football-shaped dark halos might be realistic and typical.

Nature is complex; it may be fair to say, that spiral structure in galaxies is quite likely generated by more than one mechanism. This would be true even for our closest spiral galaxy, the Andromeda Spiral, whose morphology we have discussed earlier (Figure 143).

A poignant thought from C.S. Lewis:

> *Man's conquest of Nature turns out, in the moment of its consummation, to be Nature's conquest of Man.*
>
> <div align="right">(THE ABOLITION OF MAN)</div>

Unfortunately, even infrared images do still not completely unmask our spiral galaxies. Even in the infrared, the images still contain a *percentage* of light from young stars; the question before us is, how large is the percentage? For example, our dust-penetrated infrared images sometimes still show fiery ionized hydrogen regions in the spiral arms; the amount of light generated from young red supergiant stars in the near-infrared is also still a controversial issue, believed to be small (but in localized regions of a galaxy, the light from these supergiants may be high). If one could find a simple way of unambigu-ously extracting the light of young stars from the distribution of old stars, it would be possible to put constraints on theories regarding the spiral structure of galaxies. Those challenges still lie before us.

Another perplexing issue is the strength or dominance which spiral arms can attain, when imaged behind their masks.

"Long on the wave reflected lustres play" penned Samuel Rogers in his *Pleasures of Memory* (pt. I, l. 94), but it is the "height" which some waves can attain which is so astounding.

Astronomers sometimes find a *very strong* underlying spiral structure in certain spiral gal-axies: NGC 309 is a good example, with a spiral strength (or amplitude) of sixty per-cent above the average infrared light of the disk (see Figure 132). Many other examples have been studied by our team of investigators, and by other colleagues. High amplitude, "strong" spiral arms in the near-infrared (such as those found in NGC 309) place impor-tant constraints on those assumptions which astronomers make when trying to understand spiral structure in galaxies.

Astronomers generally invoke the assumption of *linearity* when modeling the gravita-tional field of a spiral galaxy; linear systems are subject to the principle of superposition,

meaning that their behavior is simply the sum of their parts. In contrast, a *nonlinear* system is not equal to the sum of its parts and it becomes very difficult to predict the behavior of these nonlinear systems as time progresses. Nature presents us with myriads of nonlinear systems – including galaxies! When modeling spiral structure in galaxies, it is common practice to *approximate its gravitational field* as linear, where the growth of spiral waves as a function of time can be predicted. As noted by the theoretician Giuseppe Bertin in Pisa, "strong" spiral arms in the near-infrared are a clear indication that a nonlinear theory would be required, for which the mathematics becomes exceedingly difficult. Fortunately, that the high amplitude waves which we find in NGC 309 are smooth and wave-like (sinusoidal) in their azimuthal profile does suggest, in the words of Bertin, that "the application of a linear theory is likely to be adequate." The current formulation of the elegant "modal theory" for spiral structure developed by Giuseppe Bertin, C.C. Lin, and their collaborators is linear; therefore, it predicts the amplitude profiles but does not predict the amplitude scale of the spiral structure (or modes) in the density distribution of old stars.

In our development of new theories, we may well reflect on the methodology of Nicolaus Copernicus. Georg Rheticus, a student of Copernicus, wrote:

> ... *my teacher [Copernicus] always had before his eyes the observations of all ages together with his own, assembled in order as in catalogues; then when some conclusion must be drawn or contribution made to the science and its principles, he proceeds from the earliest observations to his own, seeking the mutual relationship which harmonizes them all ... he then compares with the hypothesis of Ptolemy and the ancients; and having made a most careful examination of these hypotheses, he finds that astronomical proof requires their rejection; he assumes new hypotheses, not indeed without divine inspiration ... by applying mathematics, he geometrically establishes the conclusions which can be drawn from them by correct inference; he then harmonizes the ancient observations and his own with the hypotheses which he has adopted; and after performing all these operations he finally writes down the laws of astronomy ...*

VII. Football Shaped Dark Halos and Spiral Structure

The central bars in spiral galaxies are known to be very efficient mechanisms for driving spiral structure, much like a rotating rod of steel in water. If indeed more conspicuous (stronger) spirals are driven by more conspicuous (stronger) bars, the intriguing question arises as to what drives a spiral arm pattern in a galaxy without a central oval or elongated bar.

Admittedly these situations are not that common, but such galaxies certainly do exist: the beautiful spiral NGC 2997 discussed in earlier chapters, is one example of a galaxy which does appear to be almost devoid of any bar in its old population of stars (Figure 21).

A key point here lies in the actual shape of the halo of dark matter in which a galaxy is embedded. If the dark halo is somewhat football-shaped, and the football is rotating, then the angular pull or torque on the gas from the halo of dark matter may be large enough to induce a spiral structure in the gas! Football-shaped halos of dark matter; clearly stuff for the next decades of astronomy, and beyond!

We wish to allude to an important point here: it is often not appreciated how extensive the disks of spiral galaxies can be, outside of their optical boundaries. Figures 162–168 produced by the famous Australian astrophotographer David Malin show the exquisite structure in the outer disks of several famous spirals: NGC 2997, NGC 1566, Messier 83 and others. David Malin has overlaid in color, the normal optical image of each galaxy in these accompanying figures.

These outer disks are believed to contain the same population of (principally old) stars which we see when we image galaxies in the near-infrared, behind their masks of dust. The reason we cannot capture these amazing outer disks is that although their dust content must be low and almost devoid of brilliant young blue stars, they are exceedingly faint: far too faint to be detected using traditional infrared detectors. Historically, astronomers resorted to special methodologies in their darkrooms.

In the photographic era, it was common practice at certain observatories to "stack" the images. What we mean by this, is that several long exposures photographs of a galaxy

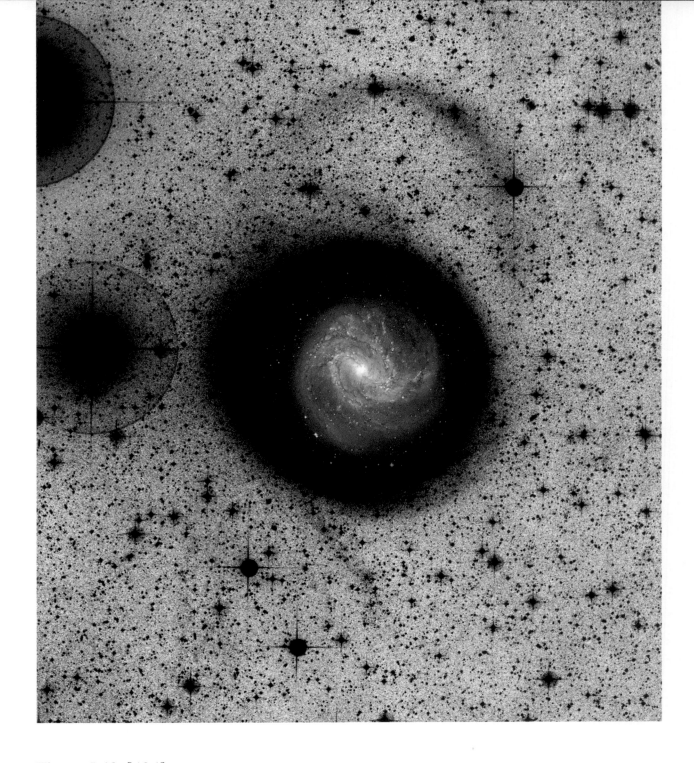

Figure 162 [426]

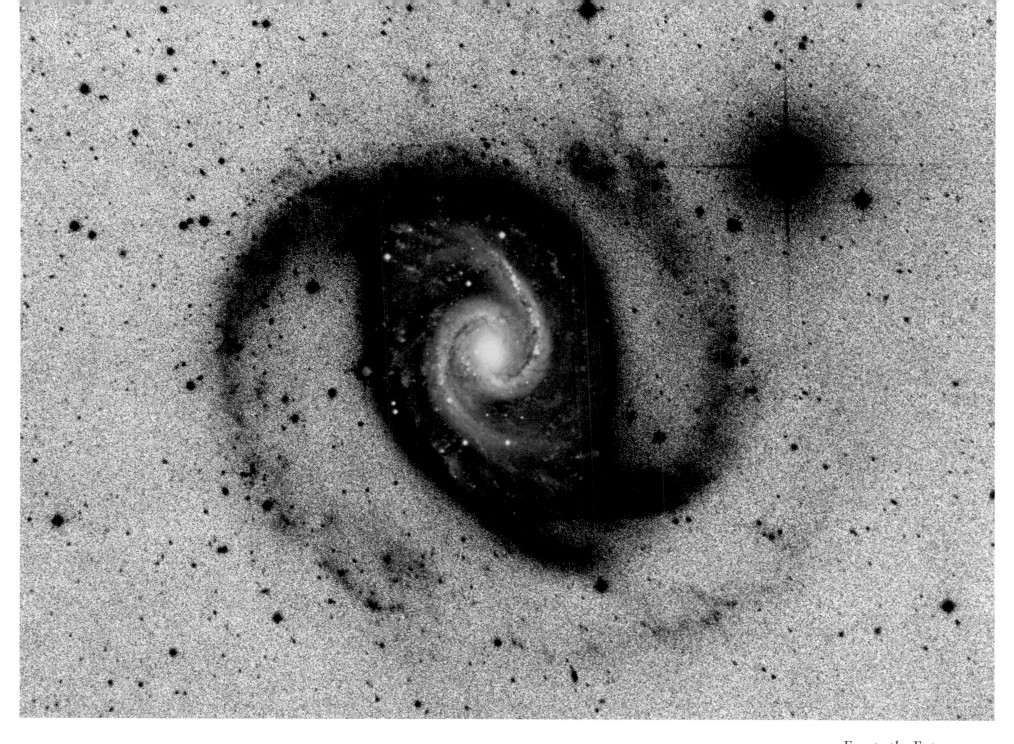

Figure 163 [426]

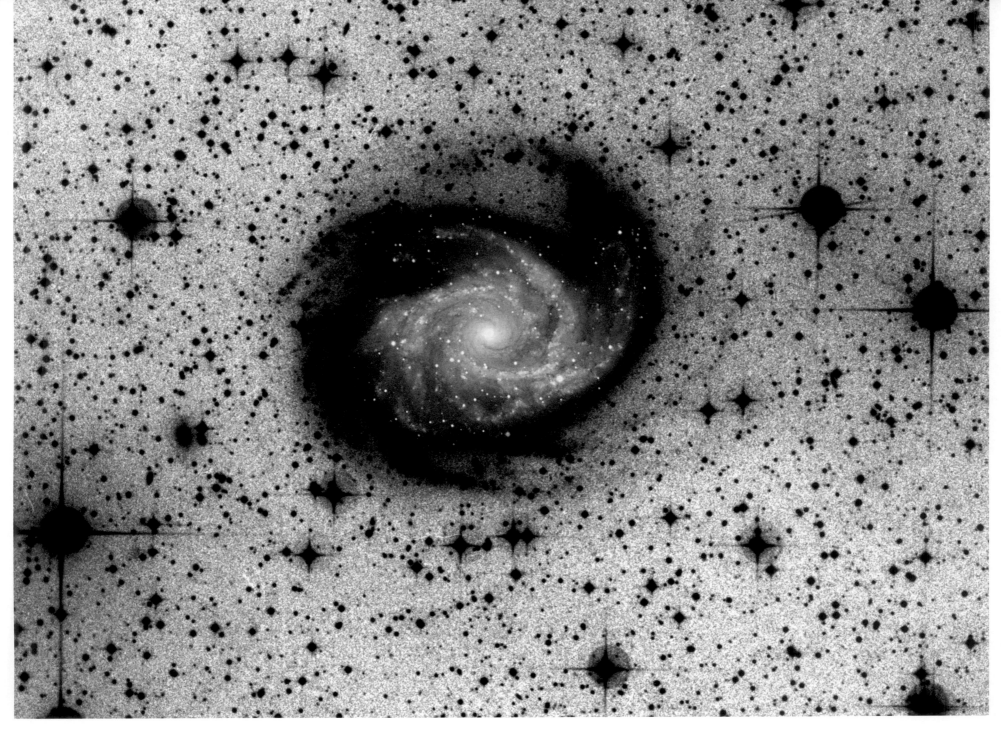

Figure 164 [426]

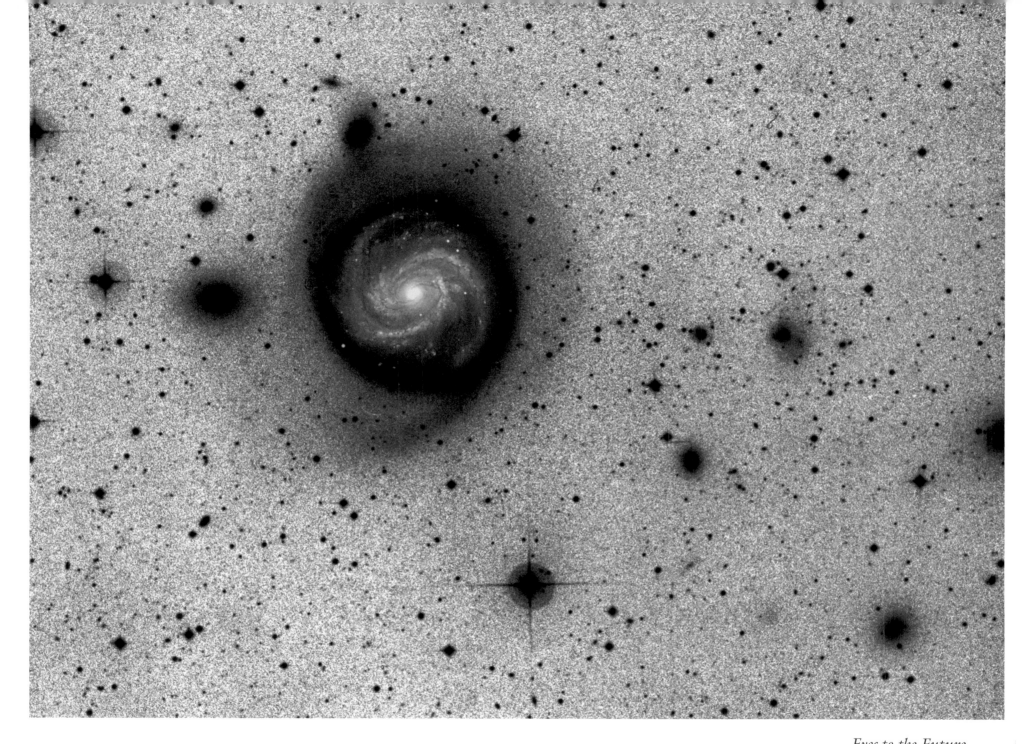

Figure 165 [426]

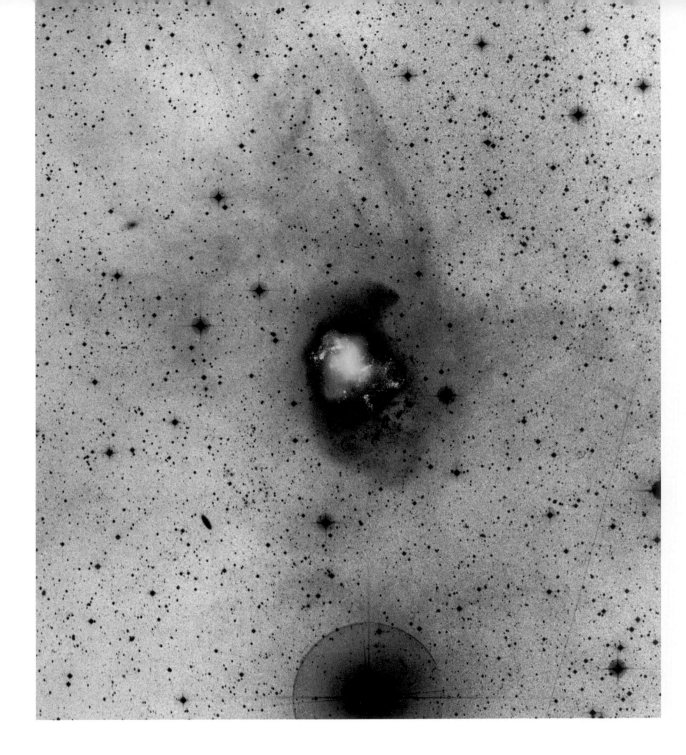

Figure 166 [426]

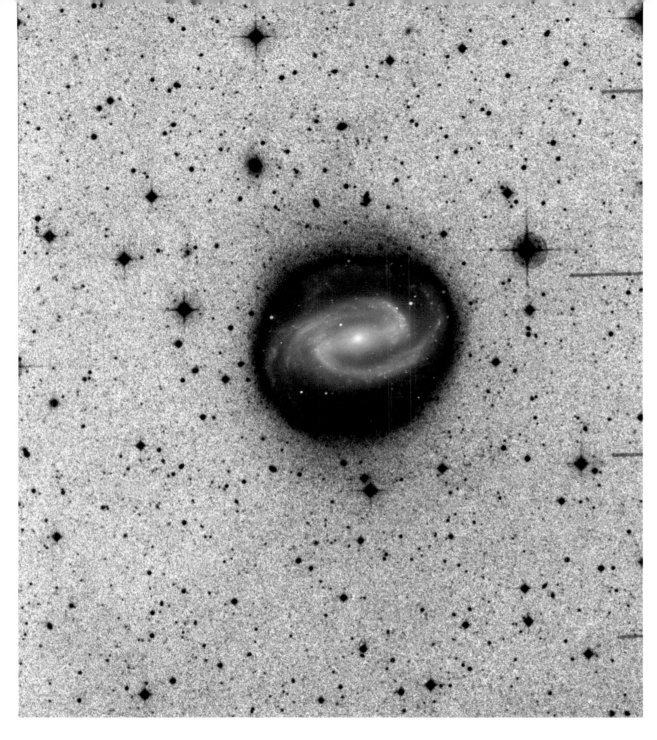

Figure 167 [426]

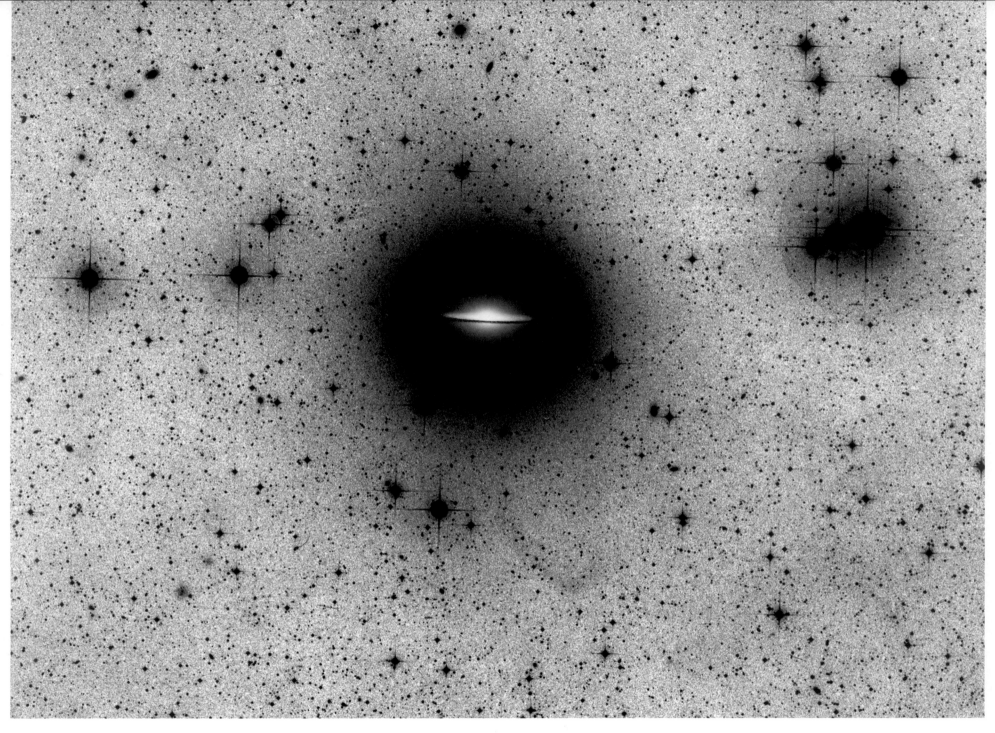

would be secured. The grain structure in every photographic plate is different – and one can think of the grain structure as the "noise." Photons from the galaxy are "the signal." To increase the signal, one needs to decrease the noise by "stacking" the images: in simple terms, one sequentially *projects* several positive images of a galaxy onto a sheet of paper – or film. Prior to projection, careful registration (alignment) of every photograph is, of course, absolutely crucial.

To enhance the faint outer disks further, David Malin would "stack" photographs of galaxies which had each been "photographically-amplified" before the "multi-image" or "stacking" process, as in Figures 162–168. With the advent of digital camera-arrays, the combination of many separate long-exposure images is done on computers – without the need to spend hour upon hour in a darkroom. We used the same "stacking" procedure at the darkrooms of the European Southern Observatory in Garching (near Munich) to record extremely faint details in the outer regions of a stellar nursery in our Galaxy, known as the Rosette Nebula (Figure 9).

Nowadays, with digital detectors on giant telescopes, astronomers can image individual stars in the faint outer disks, even beyond the photographic boundaries seen in these figures. In a recent study by Ken and colleagues using the 8-meter Gemini South telescope in Chile, stars in the outer disk of the galaxy NGC 300 were studied which lie seventy percent further in radius than those seen in conventional optical images of that galaxy.

It is intriguing to contemplate that the old stars in these faint *outer* disks must be responding to the dark matter halo in each galaxy in which they are embedded – the halos are dynamically "live" and the interaction of stars and dark matter must be continuously taking place. We know that the *dark matter* distribution must be *following or responding to the gravitational field of the stars* within the optical boundary, but the reverse is true outside of their optical limits, where the dark matter content dominates. There, *the stars* in the exceedingly faint outer disks (so brilliantly captured by David Malin in Figures 162–168) must be *following the dark matter* halo. These images serve to highlight the dynamic interaction between the structure of spiral galaxies which we see in optical images and their mysterious halos of nonluminous matter.

VIII. The Origin of Dust Grains and of Giant Molecular Clouds

In order to better understand the distribution of dust in our masks, some key clues are provided by studying galaxies which are orientated "edge-on." An outstanding example is the Sombrero Hat Galaxy. Optical images show its huge central bulge cut by a dramatic lane of cosmic dust which lies in the disk of this galaxy (see Figure 169).

In the infrared, the dust becomes transparent and the dust lane disappears: astronomers see only the bulge and the bright disk of stars. In spiral galaxies that are seen perfectly edge-on, one cannot see the spiral arms. They lie forever obscured in the disk, seen at ninety degrees from our vantage point. The dust, which lies in a thin flat layer in the plane of the disk, absorbs much of the light from the disk. All we therefore see in optical images is the thin dust lane neatly bisecting the bright stellar disk. As we image spiral galaxies at longer and longer wavelengths, the dust becomes less and less opaque as we penetrate their masks.

When astronomers actually penetrate the mask of edge-on spiral galaxies, the dust is almost transparent, so that the dust lane disappears and a bright disk of stars emerges from behind the interstellar dust.

In spirals like our Milky Way which are actively forming stars, we know that the dust layer is *very thin* (only 500 light years in thickness) and is closely tied to the thin layer of gas in these spirals. So Shrouds of the Night in such examples are very thin indeed. The gas simply appears to have settled down into a thin layer and has taken the dust with it.

What about the dust in galaxies in which there is essentially no gas? Some of the edge-on galaxies that we have studied are the lenticular class. These galaxies are technically known as S0 galaxies. Lenticular galaxies have flat disks (like spiral galaxies) but their disks have no real spiral structure or gas layer, and their star formation has ceased. In these galaxies, we observe that the dust lane is much thicker, about 1000 light years in thickness, similar to the thickness of the disk of old stars. It is evident that some Shrouds of the Night can be spatially much thicker than in our Milky Way, especially in galaxies devoid of star formation.

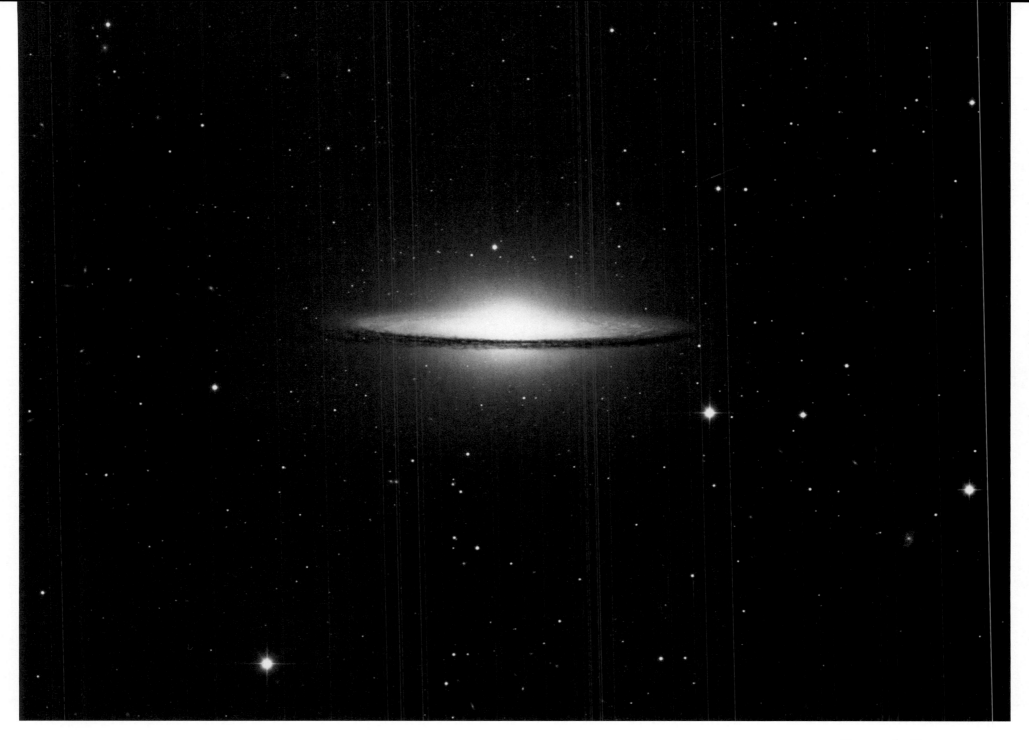

Figure 169 [426]

Eyes to the Future
313

In optical images, the dust in these edge-on lenticular galaxies makes the disk of stars disappear completely. As we image these lenticular galaxies at longer wavelengths and the dust becomes transparent, one suddenly sees a bright disk of stars in place of the dark dust lane. What does this say about the origin of the dust in such systems which are not forming stars?

The thickness of our dust Shrouds in such examples is clearly inextricably linked to the thickness of the disk of old stars, and not of the gas, in these relatively gas-free galaxies. This is quite plausible, because, as discussed in an earlier chapter, cosmic dust grains are believed to be produced by cool old stars, such as carbon stars and other highly evolved stars. The thickness of the dust and of the disk of old stars is very similar, because the dust grains actually originate in the atmospheres of the old stars themselves. The stars are producing their own smoke-screen as they die.

While we now know that cosmic masks come in a variety of thicknesses, how do the grains of cosmic dust from the atmospheres of cool stars actually get organized into giant clouds of molecules, from which young stars are birthed?

The whole story of the production and of the time development of dust grains still requires a great deal of research. Astronomer George Herbig stresses this very point, when we asked him to cast his eye forward to some of the outstanding issues still to be solved. He asks a simple, but profound, question: "Where does the material that we see in molecular clouds come from, and how does it become organized in that fashion?"

IX. Are Bars in Spiral Galaxies Frozen in Time?

When galaxies were classified on photographic plates, they were thought to maintain their patterns for all time. Hubble designated spirals into classes a, b or c. They were either unbarred or they had bars. Ideas have since dramatically changed. We now believe that the morphology of galaxies may well *change with time*. The effects of cosmic rain of gas onto galaxies, though gentle, has profound implications over long periods of time; are not some rocky pebbles on Earth eroded in a similar fashion, by gently flowing streams of water which

gradually round the pebbles? Infalling gas clouds can actually disrupt and eventually dissolve a bar of stars; a galaxy may then spend some time as a purely unbarred system before having its bar rejuvenated by infalling gas, as Francoise Combes and others have beautifully demonstrated.

Galaxy bars are not frozen in time. Rather, astronomers are contemplating a new, richly dynamic and ever-changing scenario, wherein spiral galaxies continue to form and change during their lifetimes. Galaxies may be barred, then show no bar, and finally build up their bar structure once again. It is possible that such changes along and between the prongs of the tuning fork are driven by the infall of gas, as Jerry Sellwood and Ray Carlberg suggested in 1984, as well as by occasional collisions and mergers with neighboring galaxies.

We do know that "early type" galaxies (those on the left of the tuning fork in Figure 111) are more massive on average than the "late-type" ones (on the right of Figure 111), but it is truly the "late-type" systems which are now in a stage of active evolution or change. It seems that change progressed more rapidly in the larger (more massive) galaxies, and that the bulk of star formation activity in the Universe has by now "downsized" to the lower mass, later-type systems.

As time progresses, the baryonic component of these galaxies (in the form of stars and gas) gradually increases due to infalling cosmic rain of gas; their dark matter mass may also increase significantly over time. Hydrogen gas in our Universe is exceedingly abundant; in our Sun, almost seventy-four percent of its mass is in the form of hydrogen.

There is a ubiquity of reservoirs of hydrogen gas surrounding spiral galaxies. What are their masses? In extreme cases, astronomers using radio telescopes observe reservoirs of hydrogen gas whose mass is *ten times* that locked into the stars; most of the gas is located in the outer parts of these galaxies. This is a different kind of mask. In the optical and infrared, these galaxies are usually inconspicuous, rather small specimens known as "dwarf galaxies," but when we image these dwarfs with radio telescopes, they may in fact be very large.

Bars not frozen in time, ever developing? Some dissolving, while others are growing with time? Maybe!

In theory, the rotation rate of a bar can assume a very wide range of values, including zero. Techniques have been developed to measure the rate at which bars rotate; they show that most bars are rotating almost as rapidly as they can be. In fact, if they were rotating much more rapidly, their centrifugal forces would make them fly apart! How intriguing to envisage that bars in galaxies might not long-lived but transient, dissolving into more symmetric structures and then reforming themselves again several times during the age of our Universe …

We do not know whether a particular bar can survive right through the life of a galaxy. We have noted that over two-thirds of spiral galaxies in our local Universe have bars at their centers. Why? One school of thought argues that the infall of gas into galaxies can destabilize the disk of a galaxy and allow its bar to form again. The implication is that galaxies which are now barred may not have been barred at an earlier phase of their history, and vice versa.

So far, these ideas are solely based on theoretical concepts. It is a well nigh impossible task to observationally test whether the bars that we see in spiral galaxies now, have been present since the birth of their parent galaxy. The reason is simply this: although it is easy to measure the age of the stars in the bar, it is difficult to determine the age of the bar itself. For example, a newly-formed bar could be made from old stars.

Do astronomers know of any feature which might represent the destruction of a dissolved bar? Tentatively, the answer is yes. When one studies the images of barred galaxies, the bar is often immersed in a bright and almost symmetrical region, termed a "lens." Lenses are believed to represent the debris of previous generations of bars. Sometimes lenses are seen in galaxies which are currently not barred; the lenses could simply be the debris of disrupted bars in such systems. To test whether lenses may be the product of dissolved bars is extremely challenging from an observational point of view.

Astronomers who eventually do find direct observational tests for bar dissolution – and whether these dissolved bars actually form lenses – will add greatly to our understanding whether the bar phenomenon is transient or frozen in time.

X. A Grand Puzzle – What Triggers the Formation of Stars?

Star formation is a very important part of modern astrophysics. One of the great quests is to understand how the rate of star formation in the Universe has changed from the very early Universe to the present epoch. This is still a controversial subject. It does seem clear that the rate at which stars formed in the Universe was much higher 6–8 billion years ago, mostly in the more massive galaxies, than it is now. Just how large the star formation rate was at even earlier times is still uncertain, partly because of the effects of dusty masks in these young galaxies that are observed at early epochs.

One of the difficulties in studying star formation rates is that we do not understand star formation itself! The reader may be alarmed at this, but our knowledge of how gas is *triggered* to form stars is still very rudimentary. For example, the Large Magellanic Cloud, so beautifully seen from South African and Australian skies, is rapidly converting its gas into stars, but we do not really understand *why* this is happening.

Why does the Large Magellanic Cloud show a magnificent pattern of huge gas bubbles everywhere (Figure 170) but no regular spiral pattern? Star formation here could be stochastic (random). As has been emphasized at our international conferences on galaxies held in South Africa, we really do not understand what kick-starts the star formation process in this breed of galaxy.

There does indeed seem to be an element of unpredictability. One of the major thrusts for morphology in the new millennium will be to understand better how stars form. Our understanding needs much enlightenment; we want to know enough so as to begin with the observed infrared backbones of galaxies and *predict* what the optical images would look like: star formation is a vital link in this process.

If one could make this prediction, then one would understand the Hubble sequence. At the present time, we do not understand star formation and our knowledge of spiral structure is still rudimentary. Our understanding of galaxy morphology is thus truly precarious.

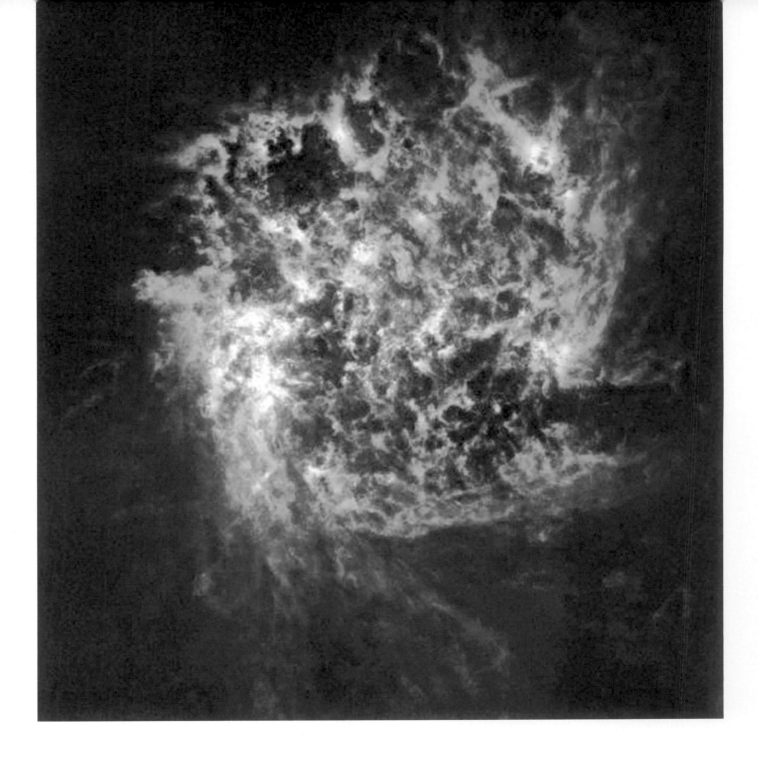

Figure 170 [426]

But there is no need for despair. In 1835, the philosopher Auguste Comte remarked about the stars:

> *We see how we may determine their forms, their distances, their bulk, their motions, but we can never know anything of their chemical structure or their mineralogical structure*
>
> (EMPHASIS, OURS)

How insights do change. It was in the same period that Joseph Fraunhofer passed sunlight through a prism, revealing its spectrum, and today we *do know* a lot about the chemical compositions of stars!

XI. Snowflakes and Symmetries – *Strena seu de niue sexangula*

Symmetry should clearly be at the *heart* of new classification schemes in the near-infrared (Figure 171). Near-infrared observations show an ubiquity of one and two-armed spirals; three armed spirals are rare; we have not yet observed any spiral galaxy with four, five or six spiral arms of old stars.

Symmetry was much on Kepler's mind, in his Latin monograph *Strena seu de niue sexangula* published by Godfrey Tampach in 1611. The English title is: *A New Year's Gift, or On the six-cornered snowflake*. Kepler's introduction recounts that on crossing the Karlsbrucke bridge (built in 1352) over the Vltava river, he noticed a star from heaven, a snowflake, fall on the lapel of his coat. Kepler decided to give it (or rather, his speculations on it) to his patron, Counsellor Wacker of Regensburg, as a gift. He asks the question: Why are snowflakes six sided? Why do they possess a six-fold symmetry? This led Kepler to focus on the *facultas formatrix* (formative faculty) or morphogenetic field.

A slight diversion here, but a most interesting one. Imagine filling a large container with small equal-sized spheres. The density of the arrangement is the proportion of the volume of the container which is taken up by the spheres. In order to maximize the number of spheres

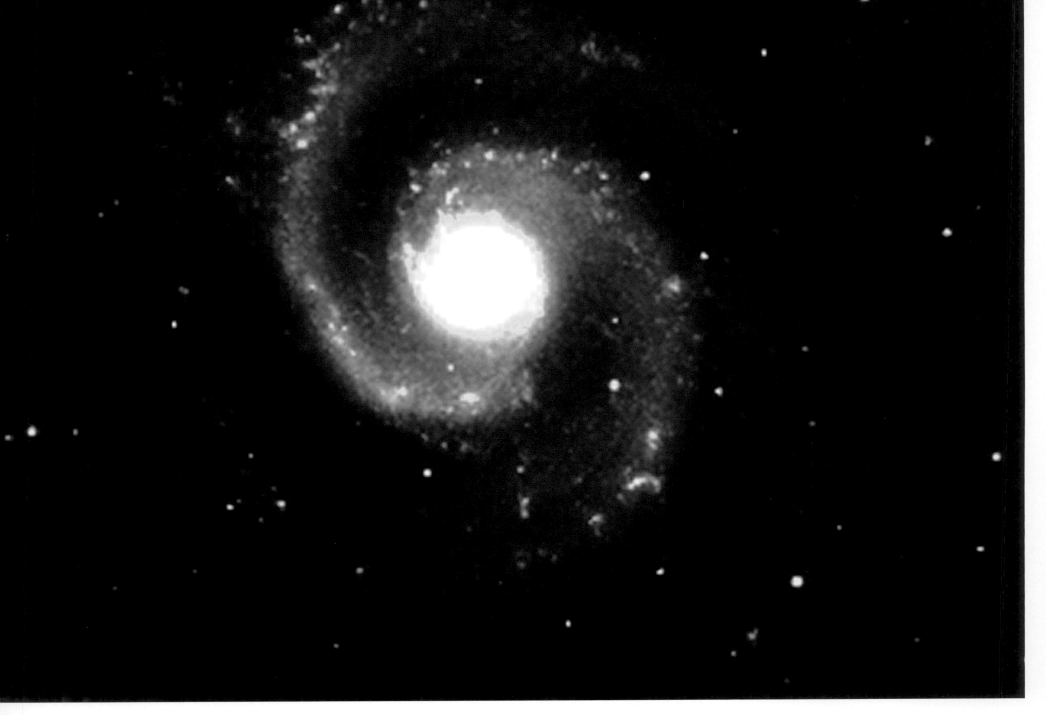

Figure 171 [426]

in the container, one needs to find an arrangement with the highest possible density, so that the spheres are packed together as closely as possible. Experiment shows that dropping the spheres in randomly will achieve a density of approximately sixty-five percent. However, a higher density can be achieved by carefully arranging the spheres as follows:

Let us start with a layer of spheres in a hexagonal lattice, then place the next layer of spheres in the lowest points one can find above the first layer, and so on – exactly as oranges, for example, are stacked in a shop. This natural method of stacking the spheres creates one of two similar patterns called cubic close packing and hexagonal close packing. Each of these two arrangements has an average density just over seventy-four percent. The Kepler conjecture says that this is the best that can be done – no other arrangement of spheres has a higher average density than this:

> *Coaptatio fiet arctissima, ut nullo praeterea ordine plures globuli in idem vas compingi queant.*

which translates as follows:

> *This packing is the closest possible, and with no other stacking more spheres can be brought together in the same room.*

In terms of this "packing problem," Kepler was over 350 years ahead of his time; extensive and exhaustive computer calculations by Professor Thomas Hales showed that Kepler was correct; the Kepler conjecture is now very close to becoming a theorem.

Writing in the British journal *Nature*, Professor Ian Stewart at the University of Warwick comments: "Kepler thought his way to a version of the atomic lattice of a crystal: a tightly packed assembly of identical units … Only in 1998 did Thomas Hales prove that Kepler was right."

The marvel of one snowflake, with its six-sided symmetry! What lessons to be learnt from the wondrous world of the microcosm. We need to understand why Nature so largely favors two-armed spirals of old stars. *Why two-fold symmetries?*

Each snowflake so minute – each, a star from heaven in its own right. Lessons from the microcosm, the small.

The words of Francis Bacon ring in our ears:

The eye of the understanding is like the eye of the sense; for as you may see great objects through small crannies or holes, so you may see great axioms of nature through small and contemptible instances.

XII. Were Bars Common in the Early Universe?

The high redshift (young) Universe, as spectacularly imaged in very "deep" (long) exposures of the Hubble Deep Field and Ultra-Deep Field, shows many galaxies which present a rather chaotic and disorganized morphology. At a recent conference on galaxy morphology in South Africa, one of the delegates was ready to abandon the current Hubble classification entirely, specifically because many galaxies at high redshift "are such a mess." The shapes of galaxies may, however, actually be more orderly at high redshift than they look! The large velocities at which these galaxies are moving away from us implies that the wavelength of the light coming to us is redshifted: very different from the original wavelength at which it left the galaxy.

For example, when astronomers say that galaxies in the early Universe have a redshift of 4, for example, they mean that the wavelength of the light as we see it is (4 + 1) times longer than the wavelength at which it was emitted by the galaxy. Images taken of such galaxies in the *infrared* are actually revealing to us the masks in the *optical and ultraviolet* "rest-frames" of the galaxy. The effects of dust and of star formation are strongly enhanced in the optical and ultraviolet, as we have repeatedly seen in earlier chapters of this book. Bars in our nearby Universe are very common. Does this fraction dramatically change with the age of a galaxy, as we probe the structure of galaxies at earlier and earlier epochs? In order for us to truly exit our Dark Ages in this regard, we need to be able to penetrate the masks of these galaxies, which are traveling away from us at huge velocities.

It is fitting here to pay tribute to the amazing insight of Gerard de Vaucouleurs, who strove to understand galaxies long before it became possible to penetrate dusty masks. With his experienced eye, he was able to examine photographs of galaxies secured using a blue filter

and was "somehow" able to discern what lay underneath the mask. For example, he classified the almost edge-on spiral NGC 253 from such images. What is truly remarkable is that de Vaucouleurs was able to "see" the optically well-concealed underlying bar in NGC 253 (Figure 140), and his classification corresponds closely to what we now observe in the new view of galaxies provided by infrared detectors!

It should be remembered that Gerard de Vaucouleurs also discerned the true structure of the Large Magellanic Cloud. In de Vaucouleurs' time, most astronomers regarded the Large Magellanic Cloud as an irregular galaxy, without any defining structure like spiral arms or a central bar.

It was de Vaucouleurs who correctly recognized that the Large Magellanic Cloud was one of a class of so-called *Magellanic spirals*, which have a small bar located not quite in the center of the galaxy. Moreover, its spiral arms are not symmetrical – one arm to the north is much more prominent than two stubby southern counterparts.

As noted earlier, Sir John Herschel, working at the Cape in South Africa, had produced an amazingly accurate drawing of the Large Magellanic Cloud as seen with the naked eye. Herschel's perceptive drawing, published in 1847, shows not only the bar of the Large Magellanic Cloud, but also its dominant spiral arm to the north and the embryonic arms to the south (see Figure 172). An early claim of spiral structure in the Large Magellanic Cloud by means of photography only came 43 years later, when H.C. Russell from Sydney used a 6-inch aperture portrait lens in 1890 (Figure 173). However, the prevailing view, pre-1950, was that the Large Magellanic Cloud was an irregular galaxy. This view was forever changed in the years spanning 1952–1955 when de Vaucouleurs photographed the Large and Small Magellanic Clouds from Mt. Stromlo. de Vaucouleurs made a Christmas card from Herschel's drawing and sent it to one particular astronomer who was very resistant to the idea that the Large Magellanic Cloud was a spiral galaxy!

In hindsight, one of de Vaucouleurs' most important achievements as a morphologist concerned the nature of the central bars in spiral galaxies. He recognized that it is not merely a question of whether galaxies have bars or do not have bars. He saw from his optical photographs what we can now see much more clearly in the infrared images: many galaxies have relatively small inner

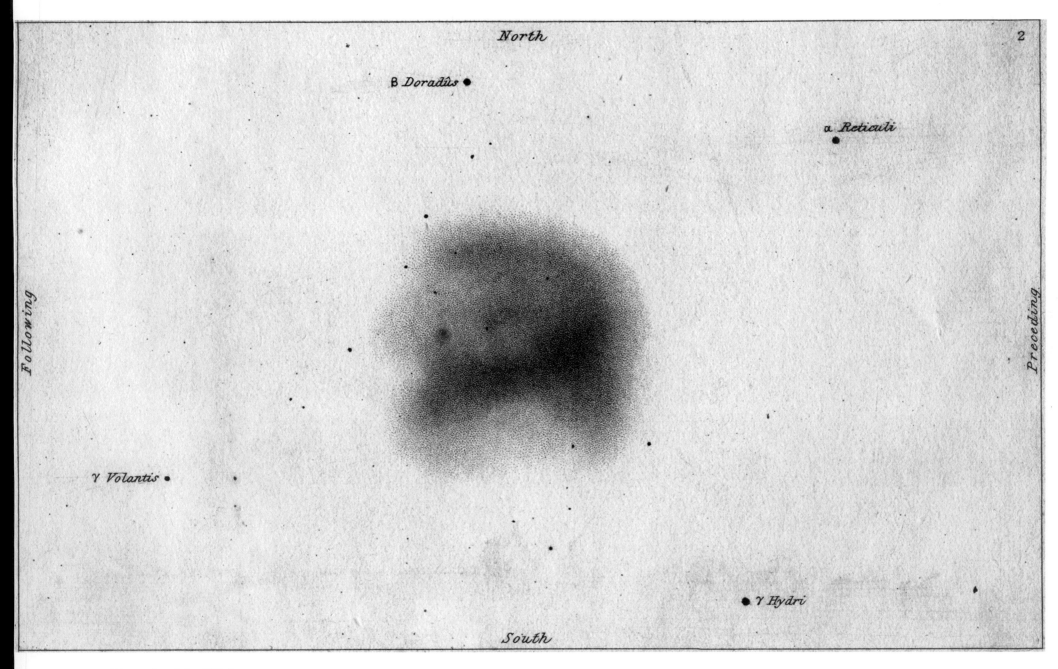

North

β Doradûs ●

α Reticuli ●

Preceding.

γ Volantis ●

● γ Hydri

South

Shrouds of the Night
Figure 172 [427]

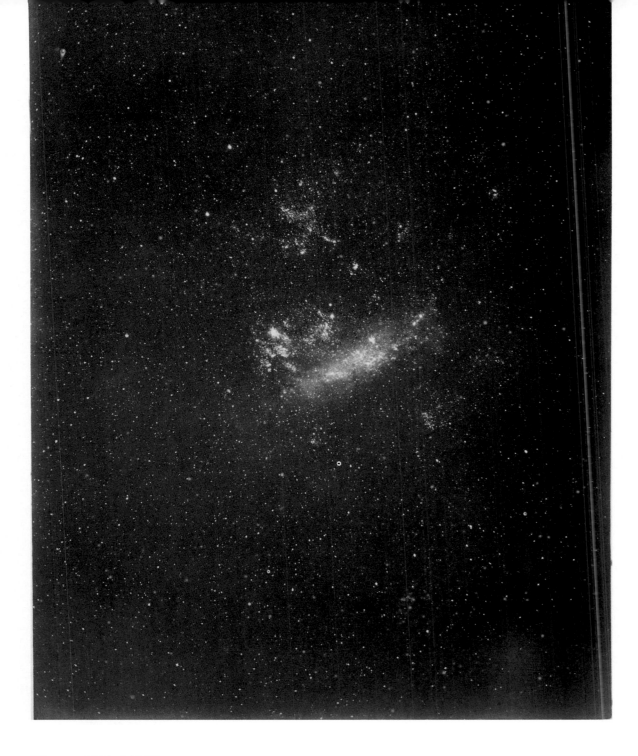

Figure 173 [427]

bars. He introduced a classification branch to include these "weakly barred" galaxies. Ordinary unbarred spirals are designated SA, galaxies with strong bars are classified SB, while intermediate systems with weak bars are denoted as SAB. Our Milky Way has a weak central bar, so is a member of the SAB class. de Vaucouleurs recognized the diversity of the underlying barred structure of galaxies, which we can now quantify by measuring the torques (angular pulls) of bars seen in our infrared images. We know from near-infrared surveys that about two-thirds of spiral galaxies display some level of bar structure in their inner regions.

de Vaucouleurs was probably not as concerned as we are about the dynamical importance of bars. As a morphologist, *with a remarkably trained eye*, he meticulously studied photographs (many secured with the Reynolds telescope discussed earlier), and he could see which features which varied from one galaxy to another; such as the presence of inner bars as well as the grandeur of inner and outer rings. Some astronomers thought that this level of detail in classifying galaxies was not warranted, but we now know otherwise: our understanding truly depends on knowing the details.

XIII. Galaxy Classification in the Post-Hubble Era

The division of galaxies into "barred" (SB) and "normal" (S) spirals is a fundamental aspect of the Hubble galaxy classification system. We have noted how the "tuning fork" (Figure 111) was revised by de Vaucouleurs, whose classification volume recognized apparent "bar strength" (SA, SAB, SB) as a continuous property of galaxies. However, the SA, SAB, and SB families are purely *visual* judgments – judgments which may have little bearing on the actual bar strength in a given galaxy. No actual measurements are required – but a set of trained eyes! Until very recently (some six years ago), published bar judgments were based entirely on optical images, where both the effects of cosmic dust and of young stars can either mask a bar completely or give the false impression of a bar in a nonbarred galaxy.

Near-infrared camera arrays, which principally trace the old stellar population in both normal and barred galaxies, now facilitate a *quantification* of bar strength in terms of their gravitational forces. In an earlier chapter, we have seen (Figure 150) that we propose using

three separate classes (unrelated to the Hubble classification from optical images) for the backbones of spiral galaxies: the alpha, beta and gamma bins.

As in the snowflake, at the heart of our galaxy classification scheme lies *symmetry*. Not a six-fold symmetry as in the exquisite and historic photographs of snowflakes by the famed Wilson Bentley from Vermont, but rather a two-fold symmetry, found in multitudes of nearby spiral galaxies.

Figure 150 shows examples of near-infrared images of galaxies which have two dominant spiral arms, which technically belong to the "second Fourier" mode. What will galaxies in our much younger Universe look like, behind their dusty Shrouds of the Night? Could such a classification scheme be used, at least in part, for the backbones of old stars? One point is clear: galaxies which appear chaotic in optical images may look much smoother when imaged behind their masks of dust. We recently had an interesting telephone conversation with Allan Sandage, and he agreed that we should not throw away morphological lessons learnt in our nearby Universe. Only time will tell.

For one, studies of galaxies with look-back times between 3 and 8 billion years shows a bar fraction as high as thirty to forty percent – and that is the bar fraction in *optical* light. There is every reason to believe that the bar fraction may rise yet higher – as astronomers have learnt from near-infrared imaging of spiral galaxies in our nearby Universe. Clearly, measuring the angular pull or torque of bars both in our local *and* higher-redshift Universe may be very important.

The fraction of Curtis' bars in those galaxies which formed *very soon* after the Big Bang is unanswered. Some of these galaxies may simply be too gaseous and too unstable to form their first bar – but it is questions such as these which keep astronomers exploring the Holy Grail of Nature's mysteries. We have already emphasized that as far as spiral structure is concerned, "we see though a glass, darkly" (to quote the Apostle Paul). Spiral structure may well be a *transient* phenomenon. If one compares how a spiral looks now and say one rotation period later, they may well look rather different. In this "Eyes to the Future" section, it is clear that we need as complete a description as is possible, of the basic properties of galaxies behind their masks.

XIV. Time Allocation Committees – Could Hubble have done it Today?

One may understand the cosmos, but never the ego; the self is more distant than
any star ... One sees great things from the valley; only small things from the peak.

(G.K. CHESTERTON)

The era in which Hubble and others worked was characterized by having almost unlimited access to large telescopes at their observatories. We now live in an epoch when astronomers apply to telescope allocation committees to have their observing projects approved; if successful, astronomers are typically granted a few nights only, especially if an application is being made to use one of the world's *giant telescopes.*

Hundreds of astronomers toil away at their telescopes and workstations to move astronomy forward. The scientific edifice will be the better for the pebbles or bricks or boulders that we contribute. "That is good enough for me," said George Herbig at the Institute for Astronomy in Hawaii.

I have never regarded myself as highly intelligent, but make up for that by work-
ing long and hard and taking advantage of a good memory. I was immensely
fortunate in working in the decades before external funding became so crucial
and before time allocation committees became the obstruction to experiment and
innovation that they are today. I had almost unlimited access to the Lick tele-
scopes, and in those simpler, less competitive times, it was easier to make interest-
ing publishable discoveries. Given my limitations, I don't know how I would fare
if I were entering astronomy today.

(ITALICS, OURS)

Proposals to these committees, which may venture out onto unchartered territories ... proposals containing possible brand new paradigms, very seldom see the light of day (or night). Moreover, if a request for telescope time were to challenge one or more results of someone who has been a giant in the field for many years that application will inevitably be stepping on that senior astronomer's world view, and the request for telescope time may bluntly be denied. The words of G.K. Chesterton above, ring loud and clear.

Would Galileo ever have had the joy of discovering his beloved *Medicean stars*, those four Galilean moons orbiting Jupiter, if he first had to apply for permission to use a telescope? Since Galileo's observations would definitively overrule the existing belief of the time (that the Earth is the center of the Universe), authorities would have been under the greatest of pressures not to yield to Galileo's request for telescope time.

Of course no such procedures existed; Galileo constructed his own telescope, and later said:

> *We have here a splendid argument for taking away the scruples of those who are so disturbed in the Copernican system by the attendance of the moon around the earth while both complete the annual orbit around the sun that they conclude this system must be overthrown as impossible. For our vision offers us four stars wandering around Jupiter while all together traverse a great circle around the sun.*

Unless one belongs to an institution which has its own telescopes, it is necessarily true that the current way of allocating time on telescopes does constrain the kind of astronomy which one can undertake. Time allocation committees are under great pressure and are often risk-averse. Unless the members of the committee are confident of a successful outcome for an experiment, they are unlikely to allocate time to do it. *This means that astronomers working with publicly funded telescopes often cannot attempt the high-risk, high-gain experiments in which the outcome may not already be evident.*

Working at an observatory with smaller, more modest telescopes, Ken shares his thoughts thus:

> *We can still attempt some of these experiments. We can test exciting ideas that are not guaranteed to work out. If they do work, then we can propose for time on a publicly funded facility. Without access to institutional telescopes, the kind of research one can do is constrained to safer and more predictable observations. This certainly has a significant effect on astronomy now. Another restraining influence is the long lead times for the proposal process at national and international observatories. One really needs to have a long-range view:*

to know what one is going to do at least six months ahead. This means that you cannot just have a bright idea and go ahead and test it, which is possible where telescope time is allocated on shorter cycles. Some observatories allocate telescope time on a three-month cycle, which provides more flexibility for pursuing new ideas. Most national telescopes allocate time only twice a year. This makes a real difference to the style of research that can be done (in addition to the usual difficulty of getting a risky proposal accepted because these telescopes are very oversubscribed).

The great discoveries made concerning galaxies and their myriads of shapes found would have been totally impossible if morphologists of the stature of Reynolds and Hubble were only to be granted a few nights a year on a large telescope. For morphological studies of galaxies, these astronomers required large data sets – large numbers of (photographic) images were essential to the future of morphological astronomy. Hubble had almost unlimited access to telescopes at Mt. Wilson. He could carefully test an idea over much time (if necessary, by using a telescope for periods of a few months or even years).

Astronomer Ben Gascoigne (whom we met earlier in Chapter 7) did so much of his pioneering observations of variable stars in the Large Magellanic Cloud by having the Director at Mt. Stromlo, Sir Richard Woolley, allocate *nine months* of time to him and to his colleague, Gerry Kron. The instrument: the 30-inch Reynolds reflector. While the German astronomer Walter Baade had access to the giant 200-inch reflector telescope in California, Ben recalls how thrilled he was to be given unlimited access to the Reynolds instrument in the early 1950s. At this time, Gascoigne, Kron and Baade were intensely interested in determining distances to nearby galaxies. From the northern hemisphere, Baade could observe Cepheid variable stars in the Andromeda Spiral, but not in the Magellanic Clouds – which are solely the domain of observers in the southern hemisphere. Those Magellanic Clouds held many secrets: it is no wonder that they have been referred to as "Rosetta Stones." The results of nine months of observing time with a modest telescope, in Gascoigne's own words:

... the dust content of the galaxy [the Milky Way] came out three times greater ... the Magellanic Clouds twice as far away [as hitherto assumed], the cosmic

distance scale twice as large, and the Universe twice as old … And the piece I liked, the key observations were made with a 30-inch [the Reynolds telescope], as opposed to Baade's 200-inch.

One of the reasons why quantitative infrared classification schemes are relatively recent is that only small amounts of telescope time, usually on modestly sized telescopes, are granted by telescope allocation committees. It has taken over fifteen years to build up our data samples, starting with NGC 309 in the early 1990s. Imagine imaging a few hundred or more galaxies in the infrared, using some of the largest telescopes, just like Hubble did in the optical … George Herbig's reflections above are worth a second read.

But all is not gloom! If one's greatest desire is to be an astronomer – if the hidden flame to research our cosmos burns ever brightly within – that ambition will always remain. To quote Mark Twain:

> *When I was a boy, there was but one permanent ambition among my comrades in our village on the west bank of the Mississippi River. That was, to be a steamboatman. We had transient ambitions of other sorts, but they were only transient. When a circus came and went, it left us all burning to become clowns … now and then we had a hope that if we lived and were good, God would permit us to be pirates. These ambitions faded out, each in its turn; but the ambition to be a steamboatman always remained.*
>
> (LIFE ON THE MISSISSIPPI)

The style of observational astronomy has changed in the last decade in response to these pressures. Firstly, the electronic age has ushered in access to vast surveys of the sky, as well as to publicly available images secured at observatories around the globe. It is the responsibility of the International Virtual Observatory Alliance (IVOA) to make available, on-line, a plethora of vast amounts of data banks and images covering wide ranges of the spectrum. The first major discovery to be made with the Virtual Observatory was reported by the Astrophysical Virtual Observatory in 2004, when astronomer

Padovani and team members discovered thirty one previously undetected powerful supermassive black holes in the so-called GOODS (Great Observatories Origins Deep Survey) fields.

Astronomers from emerging astronomical communities that seek to benefit from the global availability of virtual observatory facilities and technologies need only to have access to a computer, *and no telescope*! Secondly, astronomers today can participate in some very large and hugely exciting projects involving space-borne and ground-based telescopes – if they choose to work in a team. In fact, it is possible now to do much more ambitious projects than ever before, because of enormous strides in "the new technology." Vast amounts of data can be acquired and managed. However, for these large projects, it is necessary to work in large groups. Collaborations of twenty or more people are now common, in order to get sufficient telescope time and to get the work done. As Andrew Carnegie once said:

> *Teamwork is the ability to work together toward a common vision. The ability to direct individual accomplishments toward organizational objectives. It is the fuel that allows common people to attain uncommon results.*

The scientific goals for such collaborations need to be broad and safe, and it is usually mandatory to make the data available quickly to the wider astronomical community. If one can make a strong and appealing enough scientific case – and if one has a large team of excellent collaborators – one might conceivably still be allocated enough large telescope time to possibly image a thousand galaxies in the infrared, using large format infrared detectors.

But the methodology is different. It is a different style of doing research from the style which Edwin Hubble enjoyed. The enjoyment of large collaborative projects depends very much on the collaborators one chooses!

Some individuals do flourish in a large team. Today, many astronomers are involved in a variety of different projects. An individual, who is part of one of these large projects and who can *see* far beyond that which is immediately obvious with the data, can sometimes take over *aspects* of the project intellectually – if he or she is prepared to make the effort to do it.

It was Teilhard de Chardin who wrote:

The whole life lies in the verb seeing.

Although a large group of people may be involved in the observing and data analysis, only a few people are sometimes ready to do the *thinking*. To again quote Mark Twain:

Men think they think upon the great political questions, and they do; but they think with their party, not independently; they read its literature, but not that of the other side.

(CORN-PONE OPINIONS)

The largest of telescopes are required to capture photons of light whose travel time may be in excess of ten billion years, and we are fortunate to have access to such telescopes. There are, however, alternative ways to studying the early Universe without having to apply for observing time on these giant telescopes. For example, the oldest objects in the Milky Way were formed in the same epoch in the early Universe as the most distant galaxies which we can now observe. If one wishes to learn about the early days of the Universe, one can study these very faint galaxies at the limits of observability with the largest telescopes, or one can study in much more detail the ancient objects in our own Galaxy that formed at the same epoch!

Ancient objects in our Galaxy are so much closer, that one can make measurements which are simply impossible for faint galaxies. We can make very detailed chemical analyses of these very old stars, to understand how the chemical elements were built in the early Universe. This so-called "near-field cosmology" approach is hugely exciting.

But yet it were a shame for these later ages to rest our selves meerely upon the labours of our Fore-fathers, as if they had informed us of all things to be knowne, and when we are set upon their shoulders, not to see further then they themselves did.

wrote Sir Isaac Newton.

In the end analysis, it will always be the Mind of the Astronomer driving our wonderful science forward.

Taking us through the dark matter veil, and so many other challenges. Data acquisition is merely a tool in the astronomer's hand.

We gain long-sought economical goals by replacing Man with Machine, but allow us to reflect on a poem written by Lawrence Andersen, entitled "The Harbor Light":

> *The ancient lighthouse stands along the shore,*
> *But it has not a keeper anymore.*
> *Skilled hands that kept the lenses bright;*
> *A guide for some lost seaman in the night;*
> *The tender who turned upon the sea his watchful eye,*
> *And, sleepless listened for the searching sailor's cry,*
> *Has taken his last ride back to the shore.*
> *The spiral stairway hears his steps no more,*
> *And no more will his keen eye, or ear*
> *See signals of distress, or hear*
> *Cries of despair above the wind-flung sea.*
> *Technology now switches on the light,*
> *And times the beam that penetrates the night.*
> *We've gained a long-sought economic goal;*
> *Retained the Harbor Light, but lost its soul.*

Moments of profound insight await those who walk the shores of data, and who then *truly see*. Marcel Proust's words ring loudly: "The voyage of discovery is not in seeking new landscapes but in having new eyes."

Planets Orbiting other Stars

 round many of the stars in our Galaxy may be planets – solar systems, in their own right. The last decade has witnessed an explosion in the discoveries of these extrasolar planets, as they are called (extrasolar: outside of the domains of our solar system). The first confirmed planet orbiting a "Sun-type" star was discovered by astronomers Mayor and Queloz in 1995. Over 200 extrasolar planets have been identified, with the number ever increasing. A significant fraction of these planets are the so-called "Hot Jupiter" planets; these are planets whose masses are similar to that of Jupiter, but which have orbital periods of only a few days (in contrast, the planet Jupiter takes nearly 12 years to orbit our Sun). Typical distances may be only ten percent of Mercury's distance from the Sun; hence the name "Hot Jupiters."

One may well ask how such extrasolar planets can ever be detected, since they lie within the blinding light of their parent stars. The methodology is simple, but intriguing. As planets circle their parent stars, they induce a gravitational tug of war, and very small changes in velocity of the star can be measured, using a spectrograph. It was in this way that astronomers Udry and collaborators discovered a planet whose mass is only five times that of the Earth, in orbit about a star known as Gliese 581. The orbital period is just under thirteen days. The parent star, approximately twenty light years distant, has only one percent of the Sun's total luminosity, but the "Earth-sized" planet orbits the star at only seven percent of the Earth–Sun distance.

Another method is as follows: If such planets pass in front of their parent stars as seen from the vantage point of our Earth, a temporary signature will be a minute decrease in light intensity as a small fraction of the starlight is blocked. Such disk crossings may take place on a timescale of a few hours. An analogy in our solar system would be a Transit of Venus, when

Venus majestically marches across the disk of our neighboring star, the Sun. Such periodic *transits* provide one simple method for the detection of extrasolar planets.

Few topics excite the human mind more than the search for Worlds orbiting other stars.

Enter John Wilkins (1614–1672), a founding member of the Royal Society. In 1638, the twenty-four year-old John Wilkins wrote a brief, speculative volume entitled "The Discovery of a World in the Moone, or, a Discourse Tending to Prove, that 'tis probable there may be another habitable World in that Planet."

The formative education of the young John Wilkins was impressive. In *The mathematical and philosophical works of the Right Reverend John Wilkins* published in London in 1708, we glean some important insights:

> *He was taught his Latin and Greek by Edward Sylvester, a noted Grecian, who kept a Private School in the Parish of All Saints in Oxford: His Proficiency was such, that at Thirteen Years of Age he entered a Student in New-Inn, in Easter-Term 1627. He made no long stay there, but was removed to Magdalen Hall ...*

Now the historical documentation pertaining to the founding of the Royal Society reads:

> *Memorandum November 28 1660. These persons following according to the usual custom of most of them, met together at Gresham College to hear Mr Wren's lecture, viz. The Lord Brouncker, Mr Boyle, Mr Bruce, Sir Robert Moray, Sir Paule Neile, Dr Wilkins, Dr Goddard, Dr Petty, Mr Ball, Mr Hooke, Mr Wren, Mr Hill. And after the lecture was ended they did according to the usual manner, withdraw for mutual converse.*

It was John Wilkins and others to whom Christopher Wren delivered his lecture at Gresham College on that historic occasion in November 1660 when the Royal Society was founded, with twelve present.

In the Second Charter of the Royal Society, one of the two Secretaries named was again John Wilkins. (The Second Charter of the Society received the Royal Seal on 23 April 1663 and King Charles II presented the new Society with a silver mace which has the emblems of England, Ireland, Scotland and France on its head.)

J. G. Crowther credits John Wilkins in the title of his book as follows: *Founders of British science : John Wilkins, Robert Boyle, John Ray, Christopher Wren, Robert Hooke, Isaac Newton.*

In

The Discovery of a World in the Moone

Wilkins writes:

> *I must needs confesse, though I had often thought with my selfe that it was possible there might be a world in the Moone, yet it seemed such an uncouth opinion that I never durst discover it, for feare of being counted singular and ridiculous …*

He eloquently continues:

> *Now if our earth were one of the Planets […] then why may not another of the Planets be an earth?*

In other respects, the propositions by Wilkins are off the mark:

> *That those spots and brighter parts […] in the Moone, doe shew the difference betwixt the Sea and Land in that other World; The spots represent the Sea, and the brighter parts the Land; That there is an Atmo-sphæra, or an orbe of grosse vaporous aire, immediately encompassing the body of the Moone.*

Wilkins speaks of a Sea on the Moon, and of a lunar atmosphere, "an orbe of grosse vaporous aire". He argues in his final proposition that it is probable that the Moon may be inhabited,

but of what kind, he is uncertain. In the words of John Wilkins: "'tis probable there may be inhabitants in this other World, but of what kinde they are is uncertaine."

Some of Wilkins' propositions of 1638 have been proven true with time: "That the Moone is a solid, compacted, opacous body; That the Moone hath not any light of her owne; That there are high Mountaines, deepe vallies, and spacious plaines in the body of the Moone." (A modern rendering of the text, that the Moon does not have any light of its own and that there are high mountains, deep valleys and spacious plains, is correct.)

Eighty-five percent of stars in our Universe lie in galaxies less massive than our Milky Way Galaxy; it is a sobering thought that only fifteen percent of stars in the cosmos are to be found in galaxies which contain more mass than our Galaxy. The Milky Way is indeed a "massive galaxy," and it is within this Galaxy, with its one hundred thousand million stars, that we – self-aware human beings – find our home. John Howard Payne (1791–1852) eloquently wrote:

> *I gaze on the moon as I tread the drear wild,*
> *And feel that my mother now thinks of her child,*
> *As she looks on that moon from our own cottage door*
> *Thro' the woodbine, whose fragrance shall cheer me no more.*
> *Home, home, sweet, sweet home!*
> *There's no place like home, oh, there's no place like home!*
>
> ("HOME, SWEET HOME")

An interesting question to pursue – but a very difficult one – is whether life could exist in the vast number of lower-mass galaxies which populate our cosmos. Although these lower-mass dwarf galaxies (whose masses can be ten thousand times lower than that of the Milky Way) contain most of the stars in the Universe, there is an important difference between stars in dwarf galaxies and our Sun. The fractional amount of iron and most other chemical elements is much lower in the dwarf galaxies, and we must ask – is there enough to sustain life? No one knows for sure.

At this juncture, it may be opportune to briefly discuss the production of elements in our cosmos. The Periodic Table (first discovered in 1869 by Dmitri I. Mendeleev) shows all the elements in order of increasing atomic number – the number of protons in each nucleus. The lightest element (and most abundant in our cosmos) is hydrogen, the first element in the Periodic Table. Next is helium, followed by lithium and beryllium. The Periodic Table (extended since the life of its founder Mendeleev) contains 110 elements, and ends with the unstable elements bohrium, hassium, meitnerium and darmstadium (discovered in 1964).

Intriguing processes known to astronomers and physicists as "neutron capture" dominate the production of elements heavier than iron. When a star whose mass is considerably heavier than our Sun reaches the end of its life, it will explode as a supernova. The explosion releases large quantities of neutrons – and approximately *one-half of all the elements heavier than iron* are produced via a "neutron-capture" mechanism, known as the "r-process" (where the "r" designates *rapid*). The neutrons are literally captured onto seed nuclei of iron in a timeframe of approximately one second! Gold, so important to the economic history of both our countries, comes almost entirely from the r-process in massive stellar explosions.

The other mechanism which produces the remaining fifty percent of all elements heavier than iron is the "s-process." Here the neutron capture rate is slow ("s" for *slow*), typically thousands of years. The s-process does not occur in cataclysmic explosions but rather in the cores of red-giant stars. The neutrons are produced in nuclear chain reactions which involve carbon burning to oxygen – and neon burning to magnesium. Each of those reactions liberates one neutron. In our Sun, eighty-five percent of the element barium has, for example, resulted from the slow capture of neutrons, leaving only fifteen percent to be produced from rapid neutron capture. The s-process is responsible for eighty-nine percent of the production of strontium. The s-process ends with the production of lead. In striking contrast, however, even heavier elements such as thorium and uranium are solely produced by the *rapid* capture of neutrons most likely associated with celestial fireworks – the explosion of a star – while other elements in the Sun, such as uuropium and iridium are almost exclusively produced by this process as well.

Astronomer Anna Frebel and her collaborators have recently identified a "uranium" star. The star, technically known as HE 1523–0901, is very "metal-poor" – with an abundance

of elements heavier than iron almost *one thousand* times lower than that found in our Sun – but the star does contain uranium, as well as thorium. Herein lies the secret: the ratio of uranium to other elements (specifically thorium and iridium) acts as a "stellar chronometer," by which the age of the parent star can be calculated. As noted above, uranium can only be produced by means of the rapid capture "r-process," but we do not yet understand why some otherwise metal poor stars can be so enriched in these heavy r-process elements.

This intriguing "uranium star," lying in the halo of our Milky Way, ranks amongst the oldest of stars ever identified. Its age may exceed 13 billion years; in other words, it could have been formed *less than* one billion years after the Big Bang.

What a niche area was opened to the astronomical community by Joseph Chamberlain and Lawrence Aller in 1951, with their discovery of "metal-poor" stars … an area of much pioneering research today.

What is curious about those stars most deficient in heavy elements, is that they display *"astounding overabundances of some or all of the Carbon Nitrogen Oxygen Group"* (to quote the Mt. Stromlo astronomer, John Norris). Carbon, nitrogen and oxygen – key elements for life as we know it – are in incredible abundance, relative to iron. Again, we do not understand why some of these metal-deficient stars are so abundant in carbon, oxygen and nitrogen. For some reason, most of the element building reactions in these stars went in the production of carbon, nitrogen and oxygen rather than the heavier elements. Current ideas include very massive stellar explosions known as *hypernovae*, and a less exotic scenario involving the transfer of gas in two stars which are in close orbit about one another.

———————

As far as speculating about the possibility of life in other solar systems … for life as we know it, a plethora of conditions are required. For example, it seems that carbon and oxygen are essential. Also, the temperature must be suitable, and one needs a planet with strong enough gravity to retain the oxygen so that it does not completely evaporate from the atmosphere. To have the gravity large enough, a rocky planet seems essential. Regarding the production of carbon and oxygen, it is extremely fortunate that certain chain reactions are favored by

the unique properties of the nuclei involved, and this contributes to the relatively high abundances of carbon and oxygen in our Universe.

A major problem about the speculation of life around metal deficient stars would be to produce a *rocky planet* with a metallic core. If indeed a rocky planet *could be made* around such a star – rich in carbon but very deficient in iron – it is not beyond our present knowledge to speculate that life, even in very primitive forms, may just be able to exist around such stars, whose light rays may have beamed for over twice the age of our Sun. Life does not exist on the Moon, as envisaged by Wilkins in 1638. But the *desire* to find life elsewhere in our cosmos grows with intensity each passing decade. Since Wilkins wrote his book, much time has passed, but the quest for *Other Worlds* is as challenging as ever.

Dwarf galaxies constitute the greatest *number* of galaxies in our local (nearby) Universe, but could life ever exist in these systems? Does one need a much larger and more massive galaxy – such as our Milky Way, with its higher abundance of heavy elements – to contain us, as self-aware human beings?

The halls of the heavens echo no answer.
The search for extrasolar planets remains vibrant.
The mystery of life itself.

When Sir John Eccles was awarded the Nobel Prize for his pioneering research on the brain, he had this to say to university students at his banquet speech on December 10, 1963:

> … in this present age we have tremendously underestimated the importance of biology. Possibly life is only in this planet, and even here only in an infinitesimally small fraction of the matter of this earth; yet it is of transcendent importance to us. We are of it … But as yet these great opportunities are relatively neglected as our scientific vision turns outwards from ourselves to the immensities of space and time and to the ultimate structure of matter. I am passionately devoted to the study of life, and particularly to the higher forms of life. For me the one great question that has dominated my life is: "What am I?" What is the meaning of this marvellous gift of life? The more we know, the more the mystery grows.

In the search for life beyond our solar system, a cautionary bell does need to be rung:

Even if conditions on an extrasolar planet were fully conducive for life to develop, that does *not* a priori guarantee that life *will* develop. Recalling conversations with astronomer Donald Menzel, Harvard zoologist Ernst Mayr wrote:

> *I was forever astonished how certain he (Menzel) was that if life had ever originated on Mars (or been transported to Mars), this would inevitability lead to intelligent humanoids. The production of man was for him like the end product of a chemical reaction chain where the end product can be predicted once you know with what chemicals you had started. He took it virtually for granted that if there was life on a planet it would in due time give rise to intelligent life.*

In a letter addressed to David from Ernst Mayr, dated 9 July, 1991, he had this to say:

> *The question of the probability of extraterrestrial life is a difficult one. Biologists almost unanimously consider it almost totally improbable; almost all those who disagree are physicists.*

Even if the Universe expands at the right rate; even if the basic physical forces are finely balanced in favor of the formation of galaxies, suns and planets, there is no guarantee that a large and old Universe will necessarily give rise to *self-aware* human beings.

Eccles submitted that evolutionary processes could not account for self-awareness in people. He did not submit to Naturalism (explained further below). The Nobel laureate had this to say:

> *The amazing success of the theory of evolution has protected it from significant critical evaluation in recent times. However it fails in a most important respect. It cannot account for the existence of each one of us as unique self-conscious beings.*

Naturalism makes the claim that the observable events are explained only by natural causes, without assuming the existence (or nonexistence) of God. Naturalism claims that "all phenomena or hypotheses commonly labeled as supernatural, are either false, unknowable, or not inherently different from natural phenomena or hypotheses."

Naturalism should not, in any way, be confused with evolution. One either embraces naturalism (there is no God) or theism (God exists and has created the world). There is no conflict between theism and guided evolution but there is every conflict between naturalism and unguided evolution, as explained below.

Evolution (or natural selection) does not dictate what we believe – it is only concerned with how we behave. Darwinism would select that behavior which enhance survival of the fittest.

Professor Alvin Plantinga, John A. O'Brien Professor of Philosophy at the University of Notre Dame, paints the picture thus:

> *So suppose Paul is a prehistoric hominid; a hungry tiger approaches. Fleeing is perhaps the most appropriate behaviour ... this behaviour could be produced by a large number of different belief-desire pairs. perhaps he thinks the tiger is a large, friendly, cuddly pussycat and wants to pet it; but he also believes that the best way to pet it is to run away from it ... or perhaps he thinks that he is about to take part in a sixteen-hundred-meter race, wants to win, and believes the appearance of the tiger is the starting signal; or perhaps ... Clearly there are any number of belief-cum-desire systems that equally fit a given bit of behaviour.*

Professor Plantinga continues to give other examples which illustrate how Paul's beliefs could for the most part be false, but adaptive nevertheless:

> *Perhaps Paul is an early Leibnizian and thinks everything is conscious (and suppose that is false). Perhaps he is an animist and thinks everything is alive. Perhaps he thinks all the plants and animals in his vicinity are witches, and*

his ways of referring to them all involve definite descriptions entailing witch-hood. Paul's beliefs could be for the most part false, but adaptive nevertheless.

So it is clear that at the heart of unguided evolution is always behavior which ensures survival; evolution does not concern itself with what a homonid may, or may not, believe.

At the heart of the debate is the origin of our cognitive faculties. Either we are created in the image of God, or we are not. If we embrace naturalism, there is no reason to suppose that our cognitive faculties are reliable – after all, our beliefs are, in that hypothesis, a product of a brain produced by unguided evolution. And we have seen above that Darwinism does not care what we believe. To the naturalist, our cognitive faculties are selected for survival and not truth.

A hominid is equally able to feed, flee, fight and reproduce whether he or she believes the Earth is flat or approximately spherical, slightly flattened at the Poles.

Back to our early Leibnizian or animist Paul above. He may believe that the Creator – God – is a delusion produced by neurophysiological processes in our brains, but in making that statement, he is using his cognitive faculties to do so. Cognitive faculties which have also led him to many other false beliefs, one of which could be his belief in naturalism itself.

So, in the words of Professor Plantinga, there is a "defeater" to naturalism:

> *The naturalist can be reasonably sure that the neurophysiology underlying belief formation is adaptive, but nothing follows about the truths of the beliefs depending on that neurophysiology. If this is so, the naturalist has a defeater for the natural assumption that his cognitive faculties are reliable – a reason for rejecting that belief, for no longer holding it. And if he has a defeater for that belief, he also has a defeater for any belief that is a product of his cognitive faculties. But of course that would be all of his beliefs – including naturalism itself.*

Darwin himself expressed this doubt: "With me," he said, "the horrid doubt always arises whether the convictions of man's mind, which has been developed from the mind of the

lower animals, are of any value or at all trustworthy. Would any one trust in the convictions of a monkey's mind, if there are any convictions in such a mind?" (In *The Life and Letters of Charles Darwin Including an Autobiographical Chapter*, ed. Francis Darwin. London: John Murray, Albermarle Street, 1887.)

Naturalism argues for unguided evolution. Because naturalism has a defeater, whatever naturalism argues for (unguided evolution; there is no God or anyone like God) cannot be rationally believed. Plantinga has argued that "Naturalism, therefore, is in conflict with a premier doctrine of contemporary science (evolution)."

Professor Jim Beilby in St. Paul, Minnesota, sums up the situation carefully:

> *It is the conjunction of naturalism and evolution that suffers from the crippling deficiency of self-defeat, a deficiency not shared by the conjunction of theism and current evolutionary doctrine.*

The theist does not have a defeater for his or her theistic beliefs. He or she believes that the origin of their cognitive faculties are reliable, for every person is created in the image of God. Thomas Aquinas in his *Summa Theologica* expands on what this means:

> *Since human beings are said to be in the image of God in virtue of their having a nature that includes an intellect, such a nature is most in the image of God in virtue of being most able to imitate God. Only in rational creatures is there found a likeness of God which counts as an image. As far as a likeness of the divine nature is concerned, rational creatures seem somehow to attain a representation of [that] type in virtue of imitating God not only in this, that he is and lives, but especially in this, that he understands.*

Are men and women a mere sideshow in the rich story of the cosmos which has unfolded over a period of early fourteen billion years, or is the observer *central* to the story? Is it our signature on the celestial canvas which *unmasks* the purpose of the entire story?

The Insignificance of Man?

o wonder that people often believe they are zeros, nonentities lost in a sea of space and time.

"Behold a Universe so immense that I am lost in it. I no longer know where I am. I am just nothing at all. Our world is terrifying in its insignificance." So wrote Bernard de Fontenelle (1657–1757), capturing the mood of his generation as the true extent of the Universe became known. The early scientists who had sought to fathom God's ways in creation had discovered a Universe so vast that God's greatest creation, humanity itself (Figure 174), seemed like a mere candle flickering in the dark of a medieval cathedral.

In 1543 Copernicus' *De Revolutionibus* was published and we perceived ourselves to be living in a heliocentric world, but Copernicus never sought to demote humankind, as we shall see later. As telescopes were pointed to the heavens, astronomers have found our Sun to be but one of 100 000 million stars in the Milky Way Galaxy. Today we know that if we were to count all the stars in the Milky Way at a rate of one every second, the process would take over 2500 years!

In this chapter we wish to tackle de Fontenelle's fear of the immensity of the Universe with its implications of the apparent irrelevance of mankind, and of the insignificance of our human world.

Astronomers find the observable extent of our Universe to be very large. We have, at length, discussed the work of Edwin Hubble in relation to the morphologies (shapes) of galaxies and in galaxy classification studies. In 1929, Hubble published a famous cosmology paper

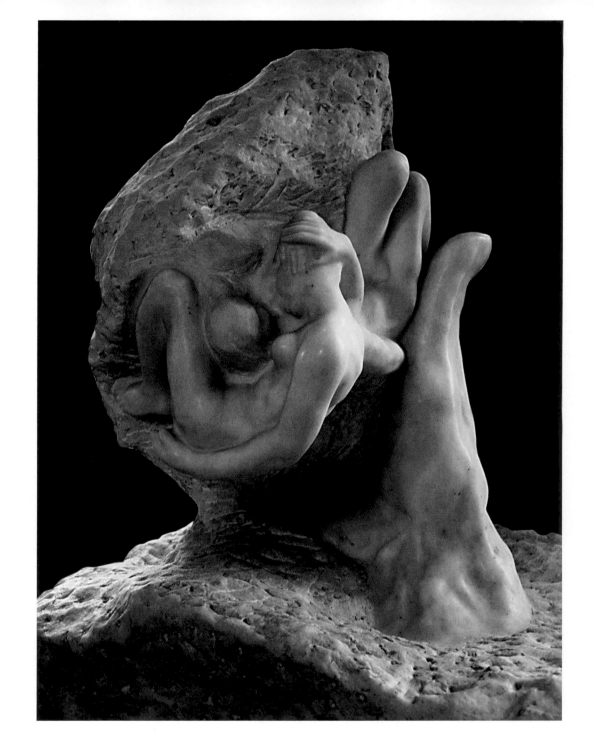

Figure 174 [427]

in the *Proceedings of the National Academy of Sciences*. That pioneering paper, together with further observations published in 1931, established beyond any doubt that the Universe is in a continual state of expansion. Galaxies recede at speeds dependent on their distances from us. With large telescopes, we can image objects moving away from us at speeds of an amazing 275 000 kilometers per second, which is over ninety percent the speed of light! We live in an expanding Universe.

I. An Expanding Universe

Going backwards in time from today we would see the present outward-moving systems of galaxies contracting, and at all points in the Universe the density of matter would become higher and higher. But let us spend a few important moments dispensing with a very popular (but wrong) concept of what the Big Bang is, and what it is not. For, contrary to popular belief, the Big Bang is not a point in space from which matter explodes outwards.

The most widely accepted model of our expanding Universe is that of a "Big Bang." Unfortunately this phrase suggests that all matter once existed *somewhere* as a superdense ball of matter which suddenly exploded, scattering debris throughout space like an exploding bomb. But this picture is too simple. It presupposes that *space already existed* before the explosion and that the Big Bang was merely the mechanism that flung the stars and galaxies out into space. It suggests that before the bang there was empty space, like an empty room, with a highly concentrated dot of matter at its center. It suggests that after the bang the galaxies moved out to fill space, like furniture fills a room.

But the Big Bang is also concerned with *the formation of space* itself! There was no "room" within which the explosion could occur. Analogies are inadequate but it is something like representing the early Universe as an expanding balloon painted with dots; every dot represents one galaxy. At this juncture, our three-dimensional minds tend to play a trick on us: students often ask, "what lies outside the balloon?" This is an important question. In our analogy, the balloon is not expanding into a *pre-existing space* – the balloon represents the Universe of both space and time.

It was the genius of Albert Einstein who developed his general theory of relativity within this four-dimensional "space-time" framework. Initially the dots (galaxies) are relatively close to one another, but as the balloon expands they lie further and further away from each other.

So, in cosmology, the Big Bang represents an *interval of time* in the early history of the Universe when matter everywhere, at all points, was concentrated at immense densities and temperatures. Going backwards in time from today we would see the present outward-moving galaxies contracting, and at *all points* in the Universe, the density of matter would become higher. If the Universe is infinite now, it *has always been* infinite. If it is finite now, there is and was no "beyond" in the usual sense of the word.

If the Universe is infinite (open) now – shaped like an open saddle – it has always been infinite. If the Universe is finite (closed) now, there is and was no "beyond" in four-dimensional "space-time."

The Big Bang models therefore have a boundary in time. By convention, they start at time $t = 0$. But our Universe may not have a spatial boundary. For if the Universe is positively curved or "closed," it has no boundary in space. The analogy is of a person traveling in a fixed direction on the surface of the Earth; he or she never comes up against any impassable barrier or falls over any "edge." The person will eventually return to their starting point. However, present astronomical observations suggest that the Universe is "open" – actually, almost flat – and not "closed." If so, the expansion will continue forever, the Big Bang will have occurred only once, and space unfolds along an open boundary.

What can we know about the early moments of the Universe? Can we wind the clock back, right to $t = 0$? The *cosmic microwave background radiation* (CMBR) is a relic from the time of the Big Bang epoch when the Universe consisted of an exceedingly hot, opaque soup of charged particles and radiation. Now the Universe is much colder: a mere three degrees above absolute zero (or minus 270 degrees Centigrade), but this faint relic of the Big Bang still permeates our entire Universe in terms of its microwave glow. Its discovery by radio astronomers Arno A. Penzias and Robert W. Wilson provided a major piece of evidence in support of a hot Big Bang cosmology.

II. Our Cosmological Dark Age

The photons that make up the cosmic background radiation were emitted 300 000 years after the creation event, when the radius of the observable Universe was 1/1000th its present value. We cannot look back any farther: no photons can reach us earlier than this since in those first 300 000 years photons were interacting too strongly with matter to move any appreciable distance before scattering. The early Universe was opaque: it holds its mysteries intact. We speak of this period as our *cosmological dark age*. But when the Universe was 300 000 years old, it had cooled enough for electrons to combine effectively with protons to form transparent, neutral hydrogen. A new epoch in cosmological history had begun. The Universe changed from being opaque and dominated by radiation to a new state where it was transparent, so that matter such as stars and galaxies could be seen. Cosmologists call this transition the *epoch of decoupling* of matter and radiation.

We live in a *lumpy* Universe, filled with galaxies, clusters of galaxies and even superclusters. The lumpiness we observe in our Universe *now* must have been present in the Universe *then* (the early Universe). What we now observe as galaxies must have once been "gravitational seeds" or energy density fluctuations which acted as embryos from which galaxies and other large scale structures grew gravitationally. In other words, the mass distribution in the Universe at the era of decoupling was not perfectly smooth, but rather exhibited small fluctuations which would later grow in amplitude to become galaxies and clusters of galaxies.

The *Cosmic Background Explorer* (COBE) and the *Wilkinson Microwave Anisotropy Probe* (WMAP) satellites were launched by NASA to specifically map variations in the brightness temperature of the microwave sky. Microwave maps are "snapshots" of the Universe showing radiation which has been traveling for approximately 14 billion years. These maps provide unique opportunities to view the gravitational seeds predicted by a Big Bang model.

Maps from COBE and WMAP show that the cosmic background radiation is extremely uniform wherever we look. It varies by less than one part in 100 000. Stephen Hawking,

Lucasian Professor of Mathematics at the University of Cambridge (the same chair once held by Sir Isaac Newton) hailed the COBE maps as "the discovery of the century, if not all time." Astronomers are actually seeing the birth of the Universe: they have detected *minute structure* in the microwave background radiation. The ripples reported are the very fluctuations imprinted on our cosmos that led billions of years ago to the formation of galaxies. Without these minute fluctuations there would have been no stars, no Sun, no human observers 14 billion years later. COBE team leader George Smoot remarked: "What we have found is evidence for the birth of the Universe. It's like looking at God."

That the Universe has not always existed – that it had a beginning – has not always been popular. It has immediate philosophical and theological implications. Sir Arthur Eddington once wrote, "Philosophically, the notion of a beginning to the present order of Nature is repugnant to me." But in general relativity theory, regions where all known laws of physics break down cannot be avoided. These regions (not necessarily point-like) are called "singularities" and it has been proved that, under very general conditions, solutions to Einstein's equations will always contain a singularity.

To be fair to the cosmological community, we do wish to point out that not all cosmologists accept the Big Bang model. Some cosmologists, such as Fred Hoyle, Thomas Gold, Hermann Bondi and others formulated an alternative model of the Universe (technically known as "steady state" cosmology) in 1948. Such a cosmology asserts that the Universe is eternal – in other words, that it is without a beginning and without an end. A refined version was proposed in 1993 by Fred Hoyle, Geoffrey Burbidge and Jayant Narlikar. In a nutshell, these cosmologists believe that the Universe undergoes alternative cycles of expansion and contraction. The typical period for one cycle would be about 40–50 billion years. In their mathematical model, new matter is created in each cycle to form stars and galaxies.

Most cosmologists, however, adhere to the view that the Universe *did* have a beginning, in a hot and dense Big Bang state. While "steady-state" Universes may be mathematically elegant, it is generally believed that the cosmic microwave background (as observed by the COBE and WMAP satellites) dealt a death-blow to steady state cosmology, wherein new matter is continually being created.

III. The Age of the Universe

Galaxies, such as our Milky Way, are not isolated: they generally lie in small groups, or in larger clusters which sometimes contain thousands of member galaxies. (Our Milky Way does not lie in a large cluster, but rather in a small group of over thirty members, known as the "Local Group" – see Figure 175. It is some 10 million light years across. The two most massive members of the Local Group are the Milky Way and the Andromeda Spiral Galaxy.) Light from the relatively nearby Virgo and Fornax clusters of galaxies has taken some 60 million years to reach our eyes; Light from the most distant objects ever observed has taken billions of years to reach our telescopes; our observable Universe is estimated to be approximately 14 billion light years across.

The Universe is very old. After many decades of uncertainty, we now know from the WMAP observations of the cosmic microwave background that the age of the Universe is close to 14 billion years.

We can say that 14 billion years ago, the density was immensely high. This is what cosmologists mean when they refer to the "age of the Universe."

Bernard de Fontenelle knew only a little of what we know today. Yet he felt lost as he pondered the distances between planet and planet, star and star. Today we know the Universe is about fourteen billion years old, and some fourteen billion light years across. Is Mankind simply irrelevant? Are we a chance event in one minute part of an ever expanding cosmos? Is life, as Bertrand Russell once defined it, "an accidental co-location of atoms?"

The fact that we are here, as self-aware carbon based beings, requires the entire Universe to have certain properties. One of these is that it cannot be small.

In the initial formation of the Universe, an extremely delicate balance had to be established between the densities of the "blobs" of matter destined to form galaxies, and the expansion rate of the Universe. If the early Universe expanded too slowly, regions of higher density

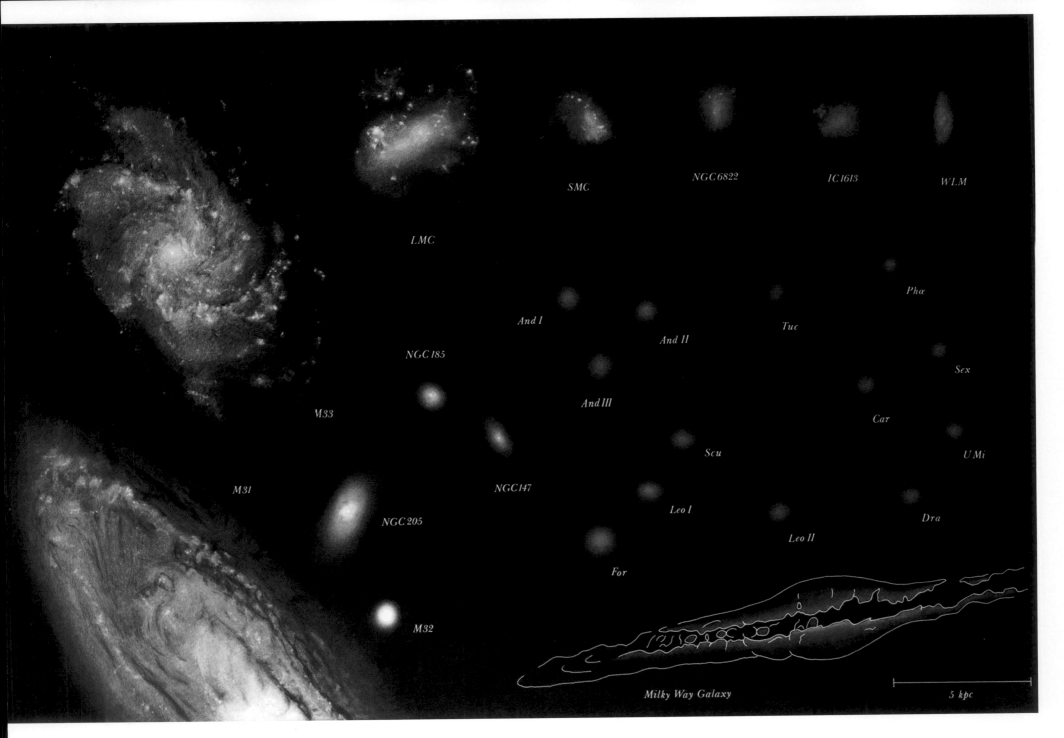

SMC

NGC 6822

IC 1613

WLM

LMC

Phœ

And I

Tuc

And II

NGC 185

Sex

And III

Car

M33

Scu

U Mi

M31

NGC 147

Leo I

Dra

NGC 205

Leo II

For

M32

Milky Way Galaxy

5 kpc

Figure 175 [427]

(which could have formed galaxies) would have had time to collapse in on themselves. Today there would be no constellations, no stars and no suns to support any life.

On the other hand, if the early Universe expanded too quickly, the same regions of matter of higher density would have continued to expand outwards indefinitely. The star systems could not have been held together by gravity to form galaxies. Again, no stars, no suns.

The balance is critical. In the early Big Bang scenario, a reduction in the rate of expansion by only one millionth, millionth when the temperature was 10 000 million degrees would have caused the Universe to recollapse when its radius was only $1/3\,000^{th}$ of its present value. In the most modern version of the Big Bang (the inflationary Big Bang models) the balance at early times is even more critical: a change of one part in 10^{55} (a decimal point followed by 54 zeros and a 1) would have meant we would not have had an opportunity to come into existence. Put simply, the early Universe expanded at just the critical rate to produce galaxies … and hence life.

We live in a finely tuned Universe. By very reason of our existence, the Universe must have special, and not arbitrary, properties.

IV. The Necessity for an Immense Universe

To address the fear of de Fontenelle:

> *Could our Universe harbour beings made of carbon based star-dust from those majestic Shrouds of the Night – if it were not as large (and as old) as astronomers find it to be?*

The key point here is that the observable extent of a Universe expanding from a highly dense Big Bang state is inextricably bound up with its age. A Big Bang Universe one year old would be one light year in observable radius. A Big Bang Universe one million years old would be one million light years in observable extent. Each year our observable horizon increases by

one light year, so that the Universe we find ourselves in now must be at least 14 000 million light years in size because it is at least 14 000 million years old. Cosmologists John Barrow and Frank Tipler explain:

> The requirement that enough time pass for cosmic expansion to cool off sufficiently after the Big Bang to allow the existence of carbon ensures that the observable Universe must be relatively old and so, because the boundary of the observable Universe expands at the speed of light, very large.

We can therefore say that no one should be surprised that the Universe is so large. We could not exist in one that was any smaller!

> A naïve person looking at the cosmos has the impression that the whole thing is extravagantly, even irrelevantly, large. This extravagant size is our primary protection against a variety of catastrophes

writes Princeton physicist Freeman Dyson.

In our own Milky Way Galaxy, stars that are chemically like the Sun do not appear until the Universe is about four billion years old. *Parameters conducive to life required a Universe which was not small.* Even at that time the observable Universe was already about 4000 million light years in extent.

Cosmologist Bernard Carr sums up the scene. He writes:

> Until recently, the progress of science seemed to involve a continual denigration of Man – we are insignificant as judged by scale and duration and life itself appears to be no more than an accident, a result of random chance processes. However, recent developments in cosmology suggest that the existence of life is very sensitive to the initial conditions of the Universe and to the values of the physical constants. This has led to the Anthropic Principle, the proposal that the existence of life imposes a selection effect on where and when we observe the Universe – and even on the nature of the Universe itself.

An important point here (as carefully elucidated recently by Canadian historian Dennis Danielson) is that Copernicus himself never viewed his Sun-centered model as *denigrating* men or women – or of God Himself. To Copernicus, God was the Architect of the Universe. Copernicus wrote:

> *And behold, in the midst of all resides the sun. For who, in this most beautiful temple, would set this lamp in another or better place, whence to illuminate all things at once? ... Truly indeed does the sun, as if seated upon a royal throne, govern his family of planets as they circle about him.*

To Galileo, it was an *Earth-centered* Universe which *would* denigrate men and women, the Earth being in Galileo's writing "the sump where the Universe's filth and ephemera collect." The poet, novelist and philosopher Goethe (1749–1832) was therefore wrong when he wrote in 1808 about the "colossal privilege" of an Earth-centered cosmos:

> *Perhaps no discovery or opinion ever produced a greater effect on the human spirit than did the teaching of Copernicus. No sooner was the earth recognized as being round and self-contained, than it was obliged to relinquish the colossal privilege of being the centre of the Universe*
>
> (ITALICS, OURS)

To Galileo, a great stride *forward* which would elevate the status of humankind was made by Copernicus. Galileo wrote: "As for the earth, we seek ... to *ennoble* it when we strive to make it like the celestial bodies, and, as it were, place it in heaven ..." (as quoted by Dennis Danielson. Italics, ours).

The writings of Thomas Traherne (ca 1637–1674) are most insightful here. Traherne was a contemporary of Sir Isaac Newton (1642–1727) and lived in the wake of the Copernican Revolution. "Traherne's life spanned less than forty years, a time not only of catastrophic events but also of the beginnings of major shifts in religion, philosophy and science, which shook the foundations of authority and belief. He wrote against a background of growing atheism ... Traherne was profoundly aware of the currents of his age, theological, political, sociological and scientific" comments the Cambridge scholar Jan Ross.

Did Traherne view the Earth as a pale, insignificant, blue dot? Absolutely not. In his work entitled *The Kingdom of God*, Traherne imagines a Celestial Stranger viewing and visiting our planet from outer space. He writes:

> *Had a Man been allwayes [sic] in one of the Stars ... at vast and prodigious Distances from the Earth, acquainted with nothing but the Azure Skie [sic], and face of Heaven, little could he Dream of any Treasures hidden in that Azure vail [sic] afar off, or think the Earth (which perhaps would be Invisible to him, or seem, but a Needle's Point, or Sparkle of Light) in any Measure Capable of such a World of Mysteries as are comprehended in it ... He would think himself faln [sic] (fallen) into the Paradise of God, a Phoenix nest, a Bed of Spices, a Kingdom of Glory.*

A far cry from a pale, insignificant globe of dirt and of purposelessness. Rather, a Paradise of God. Traherne writes of the inhabitants of this Sparkle of Light, the Earth:

> *How Blessed are thy Holy People; how Divine, how highly Exalted! Heaven itself is under their feet! A people satisfied with Favour! The fat places of Eternitie [sic] are faln [sic] to their Province! The Lines are faln [sic] unto them in pleasant places, yea they hav [sic] a Goodly Heritage!*

> *Thus would a Celestial Stranger be Entertained in the World ...*

Traherne continues: "How is it (the Earth) Exalted, and Magnified; How is it Honored! ... It (the Earth) is apparently the Darling and the Bride of Heaven! ... Men that trample the Earth under feet, are the Creatures for whom this Marriage (of Earth and Heaven) is made, and theirs is the Benefit of all the union ..." (Explanatory words, in parenthesis, are inserted by the authors.)

We have retained the original spelling and use of capitals by Traherne, from a transcription entitled "The Works of Thomas Traherne" edited by Jan Ross. The lost manuscript by Traherne was only discovered in 1997, by Jeremy Maule, Fellow of Trinity College, Cambridge. *The Kingdom of God* appears in folios 148–370 of the manuscript MS1360, housed in the

Lambeth Palace Library. It lay unknown and unpublished for over three hundred years. We refer the reader to the remarkable historical research of Dennis Danielson for further insights in the myth of the pale blue dot being a fruit of the work of Copernicus. The key point, as elaborated by Danielson, is that Copernicanism never demoted humankind.

Bernard de Fontenelle saw the human world as terrifyingly insignificant. We have turned the argument on its side: without a cosmos spanning 15 billion light years, we could not be reading this chapter.

American astronomer Allan Sandage was asked the question, "If you could design the Universe any way that you wanted to, how would you do it?" In reply, he said:

> If I were present at the creation, would I give the Creator better advice? And you are asking for that better advice. I wouldn't want to destroy all the mystery, as we do in reductionist science. The greatest mystery is why there is something instead of nothing, and the greatest something is this thing we call life. I am entirely baffled by you and me ... Perhaps the Universe is the only way it can be for us to exist. If that's true, to ask to create a different Universe is to ask to enter into genocide. Now that's the anthropic principle, but the more I think about how everything is so finely tuned, the more that principle makes sense.

It is our signature on the picture that gives it value. The whole canvas of our observable Universe is so framed, in terms of both size and age, that it might display our name (Figure 176). We awake from de Fontenelle's terror as though from a bad dream. We may be "the focus" after all.

Figure 176 [427]

The Mind of God

ark Twain, in the *Adventures of Huckleberry Finn*:

> *It's lovely to live on a raft. We had the sky up there, all speckled with stars, and we used to lay on our backs and look up at them, and discuss about whether they was made or only just happened. Jim he allowed they was made, but I allowed they happened; I judged it would have took too long to make so many. Jim said the moon could 'a' laid them; well, that looked kind of reasonable, so I didn't say nothing against it, because I've seen a frog lay most as many, so of course, it could be done. We used to watch the stars that fell, too, and see them streak down. Jim allowed they'd got spoiled and was hove out of the nest.*

> *What language is thine, O sea?*
> *The language of eternal question.*
> *What language is thy answer, O sky?*
> *The language of eternal silence.*

> (R. TAGORE)

What about the really big question which follows the preceding chapter? Does God exist? Is the language of the Universe one of eternal silence?

> *Kosmos [sic], the adornment, the orderly arrangement, the ideal beauty, harmony, and grace, of the Universe! Is there or is there not in the mind of man*

*a conception answering to these magnificent, these magical words? Is their sound
an empty clang, a hollow ringing in our ears, or does it stir up in the depths of
our inward being a sentiment of something interwoven in our nature of which
we cannot divest ourselves, and which thrills within us as in answer to a spell
whispering more than words can interpret?*

asks Sir John Herschel (quoted from Herschel's 1848 review of a book entitled *Kosmos* by
A. von Humboldt).

Earlier, his father Sir William Herschel (1738–1822), who discovered the planet Uranus and
two of its moons (Figure 177), said that: "The undevout astronomer must be mad."

In preparing this chapter, David drew up a questionnaire which he distributed to many of his
colleagues. We thus surveyed the thoughts of a number of astronomers as well as the mind of Sir
John Eccles, who was awarded the Nobel Prize in Medicine-Physiology. We communicated with
Sir John shortly before his death in Switzerland. Some of the replies received read as follows:

George Herbig (Institute for Astronomy, University of Hawaii) writes:

> *I have no religion, although exposed to the Methodist-Episcopal church as a child.
> Does God exist? I enjoy immensely the art and music and architecture that
> religion has brought about, but cannot take seriously the Old Testament vision of
> God, or the strictures and ceremonies of organized religion.*
>
> *Possibly our marvelous Universe, and all the physics, chemistry, biology, astron-
> omy … within it is the creation of some super-entity that designed it all and set
> it in motion, and now sits back to contemplate the result. If so, is that God? Is it
> likely to respond to our prayers, entreaties, sacrifices, burning of incense?*

Paul Hodge (University of Washington):

> *I believe that God exists, but am not sure whether God is a He, a She or some
> Terrifying Mathematical Equation. I don't think it matters which. What does*

Figure 177 [427]

matter is that each of us should do what we can to make our stay on Earth a positive force in which we consider the happiness, the welfare and the place of other people, other beings, and other things.

Guillermo Gonzalez (author of *The Rare Earth*):

My real passion is trying to learn more about God by studying His Creation.

William Keel (University of Alabama):

The deepest questions must be answered by turning inward and outward in spiritual (rather than material) senses – the existence and nature of God, from which all the other answers proceed. I see astronomy – tracing the threads of the grand tapestry of Creation – as in a supporting role, but not necessarily one that is crucial even to my own views. To follow my frequent practice of citing C.S. Lewis, you won't see God in space unless you can find Him on Earth.

Ken Freeman:

My lack of doubt about God's existence is at a personal level, in that I am conscious of his presence every moment of the day. I could no more doubt his existence than doubt my own.

Ben Gascoigne (Emeritus Professor, Mount Stromlo):

You feel as if it [the Universe] has been designed by purpose.

Owen Gingerich (Figure 178):

Dare a scientist believe in design? There is, I shall argue, no contradiction between holding a staunch belief in supernatural design and working as a creative scientist, and perhaps no one illustrates this point better than the seventeenth-century astronomer Johannes Kepler. He was one of the most

*inventive astronomers of all time, a man who played a major role in
bringing about the acceptance of the Copernican system through the accuracy
of his tables of planetary motion ... Could the unknowable have revealed
itself? That the unknowable might have communicated with us defies logic,
but it does not contradict coherence. For me, it makes sense to suppose that*

Figure 178 [427]

the transcendence, the ground of being, in Paul Tillich's formulation, the serendipitous creativity of Gordon Kaufman's In Face of Mystery, has revealed itself through prophets in all ages, and supremely in the life of Jesus Christ.

It was Galileo who wrote that the reality of the world was dually expressed in the Book of Scripture and in Nature, and these two great books could not contradict each other, because God was the author of both. So, just as I believe that the Book of Scripture illumines the pathway to God, I also believe that the Book of Nature, in all its astonishing detail … suggests a God of purpose and a God of design. And I think my belief makes me no less a scientist.

(QUOTED FROM THE WILLIAM BELDEN NOBLE LECTURES BY OWEN GINGERICH, HARVARD UNIVERSITY. SUBSEQUENTLY PUBLISHED BY HARVARD UNIVERSITY PRESS IN A BOOK ENTITLED *GOD'S UNIVERSE* BY OWEN GINGERICH.)

David Block:

In the course of human history, the Logos (I Am) enters our confines of space and of time. We cannot think outside of time, so God enters the confines of Time. We cannot think outside of space, so God enters Space. To me, the miracle of the Incarnation as announced to shepherds abiding their flock (Figures 179 and 180) by night is indeed the Creator taking off his timeless "I Am" mask to enter our one dimensional time line. We see through a glass, darkly, so God penetrates the Shroud of the Night; thereby identifying with our dreams, our anxieties and our fears. The Magi (Figure 181) find Emmanuel – God with us – in Bethlehem. That perfect balance between God's transcendence ("I Am") and his immanence ("Here I Am") is found in Jesus, the luminous figure of the Nazarene.

Sir William McCrea:

As we have seen repeatedly, we cannot formulate any science without reference to the observer and, again as a matter of history, progress in fundamental science has been made by increasingly recognizing the role of the observer. It seems

to me therefore that we cannot think about the Universe without the concept of personality. Cosmology requires, I venture to assert, the concepts of Creator and of personality, and together these mean God.

Giovanni Fazio:

In my mind a conflict between believing in God and believing in the Big Bang theory of the Universe never existed. In fact, just the opposite has occurred. The incredible beauty, wonder, and simplicity of the Universe have helped me to strengthen my belief in God and to seek deeper knowledge about this relationship.

Figure 179 [428]

I believe the Universe evolved by the laws of physics, but I also believe that it was God who originated these laws.

Sir John Eccles (Nobel laureate in medicine-physiology):

I maintain that the human mystery is incredibly demeaned by scientific reduction-ism, with its claim in promissory materialism to account eventually for all of the spiritual world in terms of patterns of neuronal activity. This belief must be classed as a superstition … we have to recognize that we are spiritual beings with souls

Figure 180 [428]

Figure 181 [428]

existing in a spiritual world as well as material beings with bodies and brains existing in a material world.

Each soul is a new Divine creation which is implanted into the growing foetus at some time between conception and birth. I submit that no other explanation is tenable; neither the genetic uniqueness with its fantastically impossible lottery, nor the environmental differentiations which do not determine one's uniqueness, but merely modify it.

Eccles paints the human mystery in terns of wonder (Figure 182).

Nobel laureate C. Townes (who, in 1954, together with Arthur Schawlow, invented the maser – <u>m</u>icrowave <u>a</u>mplification by <u>s</u>timulated <u>e</u>mission of <u>r</u>adiation, using ammonia gas and microwave radiation – the maser came before the optical light laser was invented by Townes' doctoral student at Columbia University, Gordon Gould), writes about science and religion:

But what of the concept of "proof"? Certainly, many would argue that proofs give scientific ideas a kind of absolutism and universalism that religion lacks. In truth, however, we can never prove anything completely. Even scientifically and mathematically, we can never be absolutely sure our conclusions are correct. Our

science is based on postulates, or assumptions, which, like faith, we may believe in firmly, but cannot prove absolutely.

Townes continues:

Throughout my career, I have had to convince others to let me keep following my own instincts and interests, an experience shared by many academic scientists.

Figure 182 [428]

And as I have had the chance to explore and try to understand the Universe around me, I have felt enriched, not just by the usefulness of science, but also by its awesomeness and connectedness to all of the world's dimensions. I have been both religious and scientifically oriented since childhood, and the two realms have always fit together from my point of view. What is the world all about? What is its purpose? How is it made? How does it work?

Blaise Pascal, in his work *Pensees*, speaks of the twisted and turned knot of our condition and concludes:

This shows that God, in His desire to make the difficulties of our existence unintelligible to us, hid the knot so high, or more precisely, so low, that we were quite unable to reach it. Consequently it is not through the proud activity of our reason but through its simple submission that we can really know ourselves.

To some of us, God has placed eternity in our hearts. Einstein said: "It is only to the individual that a soul is given."

Many seek some echo of response in the Universe at large to the chord struck within. Kepler put it thus:

There is nothing I want to find out and long to know with greater urgency than this. Can I find God, whom I can almost grasp with my own hands in looking at the Universe, also in myself?

In a course of lectures delivered at the University of Oxford, C.S. Lewis, writing from Magdalene College, expresses these thoughts:

I hope no one will think that I am recommending a return to the Medieval Model. I am only suggesting considerations that may induce us to regard all Models in the right way, respecting each and idolizing none. We are all, very properly, familiar with the idea that in every age the human mind is deeply influenced by the

accepted Model of the Universe. But there is a two-way traffic; the Model is also influenced by the prevailing temper of mind. We must recognize that what has been called "a taste in Universes" is not only pardonable but inevitable. We can no longer dismiss the change of Models as a simple progress from error to truth. No Model is a catalogue of ultimate realities, and none is a mere fantasy. Each is a serious attempt to get in all the phenomena known at a given period, and each succeeds in getting in a great many. But also, no less surely, each reflects the prevalent psychology of the age [emphasis, ours] almost as much as it reflects the state of that age's knowledge. Hardly any battery of new facts could have persuaded a Greek that the Universe had an attribute so repugnant to him as infinity; hardly any such battery could persuade a modern that it is hierarchical.

[We find it fascinating to read these comments by C.S. Lewis, for the Universe is indeed hierarchical, though not in the concentric sense of Ptolemy; astronomers see a hierarchy of structures ranging from galaxies to clusters of galaxies, superclusters and the largescale filaments that delineate the structure of the Universe today.]

To continue the quote:

It is not impossible that our own Model will die a violent death, ruthlessly smashed by an unprovoked assault of new facts – unprovoked as the nova of 1572. But I think it is more likely to change when, and because, far-reaching changes in the mental temper of our descendants demand that it should. The new Model will not be set up without evidence, but the evidence will turn up when the inner need for it becomes sufficiently great (emphasis, ours). It will be true evidence. But nature gives most of her evidence in answer to the questions we ask her. Here, as in the courts, the character of the evidence depends on the shape of the examination, and a good cross-examiner can do wonders. He will not elicit falsehoods from an honest witness. But, in relation to the total truth in the witness's mind, the structure of the examination is like a stencil. It determines how much of that total truth will appear and what pattern it will suggest.

(C.S. LEWIS IN *THE DISCARDED IMAGE: AN INTRODUCTION TO MEDIEVAL AND RENAISSANCE LITERATURE*)

Our minds are indeed stencils, wherein are embedded our belief systems, our prejudices, which pencil and trace our answers to the Grand Questions.

Astronomer Ben Gascoigne hits the nail on the head:

How did the laws of physics come into being?

Why do the laws of physics have the specific form which they do?

Philosopher William Craig enquires further: "I find that most scientists do not reflect philosophically upon the metaphysical implications of their theories … the ultimate question remains why the Universe exists rather than nothing."

Why is there a Universe? Why does anything exist at all?

We live in a Grand Cathedral of Nature, to quote Henry Longfellow:

The vast cathedral of Nature is full of holy scriptures, and shapes of deep, mysterious meaning; but all is solitary and silent there; no bending knee, no uplifted eye, no lip adoring, praying. Into this vast cathedral comes the human soul, seeking its Creator; and the universal silence is changed to sound, and the sound is harmonious, and has a meaning, and is comprehended and felt.
(FROM LONGFELLOW'S *HYPERION*)

From Tagore's eternal silence, to Longfellow's meaningful and harmonious sound.

The vast cathedral of Nature, indeed. As depicted in drawing (Figure 183); as recorded in the digital age (Figure 184).

A final resounding question, from Sir John Templeton:

Would it not be strange if a Universe without purpose accidentally created humans who are so obsessed with purpose?

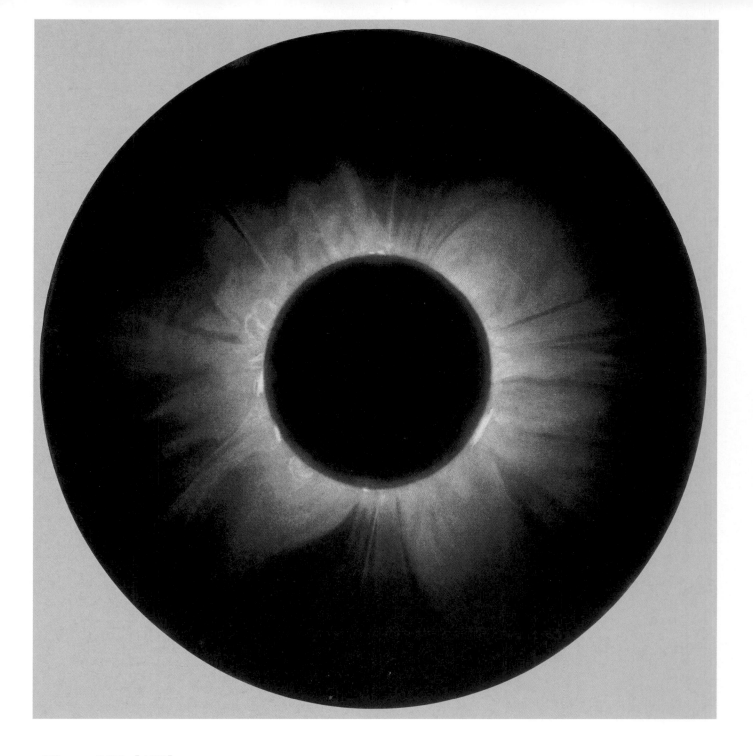

Figure 183 [428]

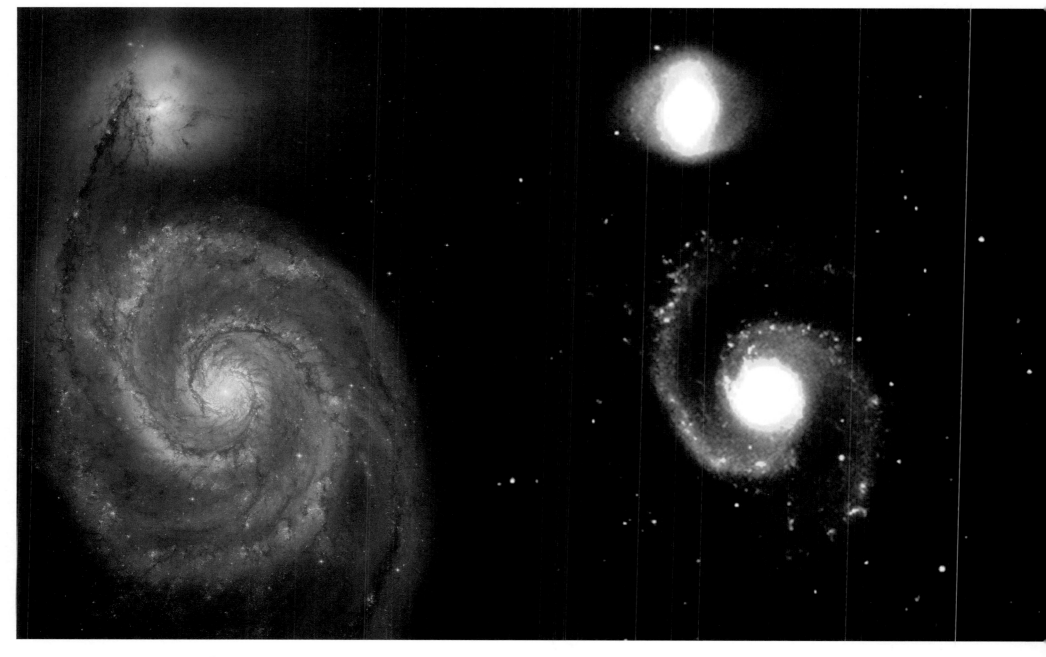

Figure 184 [428]

Scholium

ove. Hate. The raging human temperament.

We are reminded of the seasons of life (youth: springtime, manhood: summer; riper years: autumn; latter age: winter's chill) as portrayed in "The Shepheardes Calender" [sic] by Edmund Spenser (1552?–1599). Spencer likened love and passion in manhood to heat and a drought, caused by a comet or star:

> *...he proportioneth his life to the foure seasons of the yeare, comparing hys youthe to the spring time, when he was fresh and free form loues follye. His manhoode to the sommer, which he sayth, was consumed with greate heate and excessiue drouth caused through a Comet or blasinge starre, by which he meaneth loue, which passion is comenly compared to such flames and immoderate heate ...*

A modern-day rendering could be: "he proportions his life to the four seasons of the year, comparing his youth to the spring time, when he was fresh and free from love's folly. His manhood to the summer, which he said, was consumed with great heat and excessive drought caused through a Comet of blazing star, by which he means love, whose passion is commonly compared to such flames and immoderate heat ..."

The emotions of shepherd Colin in "The Shepheardes Calender" [sic] where we read "Colin cloute a shepheardes boy complaineth him of his vnfortunate loue, being but newly (as semeth) enamoured of a countrie lasse called Rosalinde ... fynding himselfe robbed of all former pleasaunce and delights, hee breaketh his Pipe in peeces [sic] ..." (The reader is referred to Figure 185 for the accompanying woodcut illustration – over 400 years old – showing Colin's Pipe lying in pieces on the ground.)

The emotions of man and woman, boy and girl, juxtaposed against the silence of comets (Figures 186 and 187) and of the stars.

The extract below poignantly describes a little boy, filled with anger and bitterness, who sits on the ridge of a roof, and who subsequently feels so ashamed, as he looks upon the Milky Way. It was a time of sunflowers; of wooden ladders and of the ox-wagon (Figures 188 and 189).

Figure 185 [428]

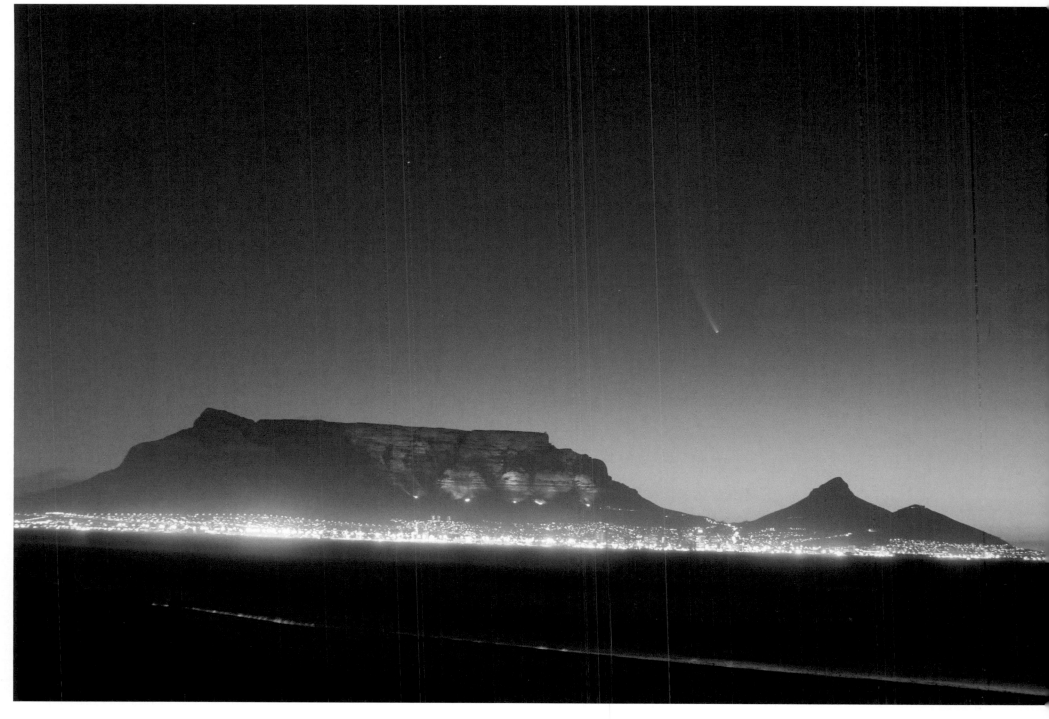

Figure 186 [429]

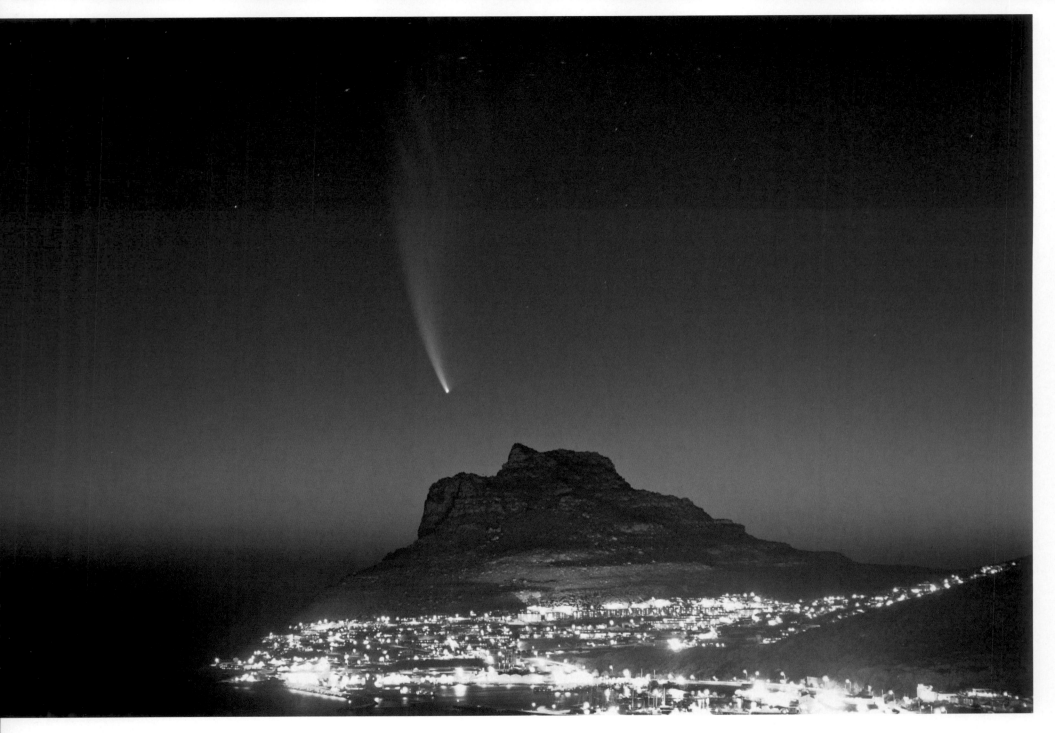

Figure 187 [429]

It is extracted from a wonderful novel *The Story of an African Farm* written by South African born writer Olive Schreiner (1855–1920), who so poetically expresses the unspoken voices of our Milky Way, with its imposing Shrouds of the Night.

He opened the door and went out into the starlight.

He walked with his eyes bent upon the ground, but overhead it was one of those brilliant southern nights when every space so small that your hand might cover it shows fifty cold white points, and the Milky-Way is a belt of sharp frosted silver.

Figure 188 [429]

Figure 189 [429]

He lifted the black damp hair from his knit forehead, and looked round to cool his hot face. Then he saw what a regal night it was. He knelt silently and looked up. A thousand eyes were looking down at him, bright and so cold. There was a laughing irony in them.

"So hot, so bitter, so angry? Poor little mortal?"

He was ashamed. He folded his arms, and sat on the ridge of the roof looking up at them.

"So hot, so bitter, so angry?"

It was as though a cold hand had been laid upon his throbbing forehead, and slowly they began to fade and grow dim ... Those stars that shone on up above so quietly, they had seen a thousand such little existences fight just so fiercely, flare up just so brightly and go out; and they, the old, old stars, shone on forever.

"So hot, so angry, poor little soul?" they said.

The "riem" [a thong of ox leather] slipped from his fingers; he sat with his arms folded, looking up.

"We," said the stars, "have seen the earth when it was young. We have seen small things creep out upon its surface – small things that prayed and loved and cried very loudly, and then crept under it again. But we", said the stars, "are as old as the Unknown." (See Figure 190).

He leaned his chin against the palm of his hand and looked up at them. So long he sat there that bright stars set and new ones rose, and yet he sat on.

Then at last he stood up, and began to loosen the "riem" from the gable ...

Why hate, and struggle, and fight? Let it be as it would.

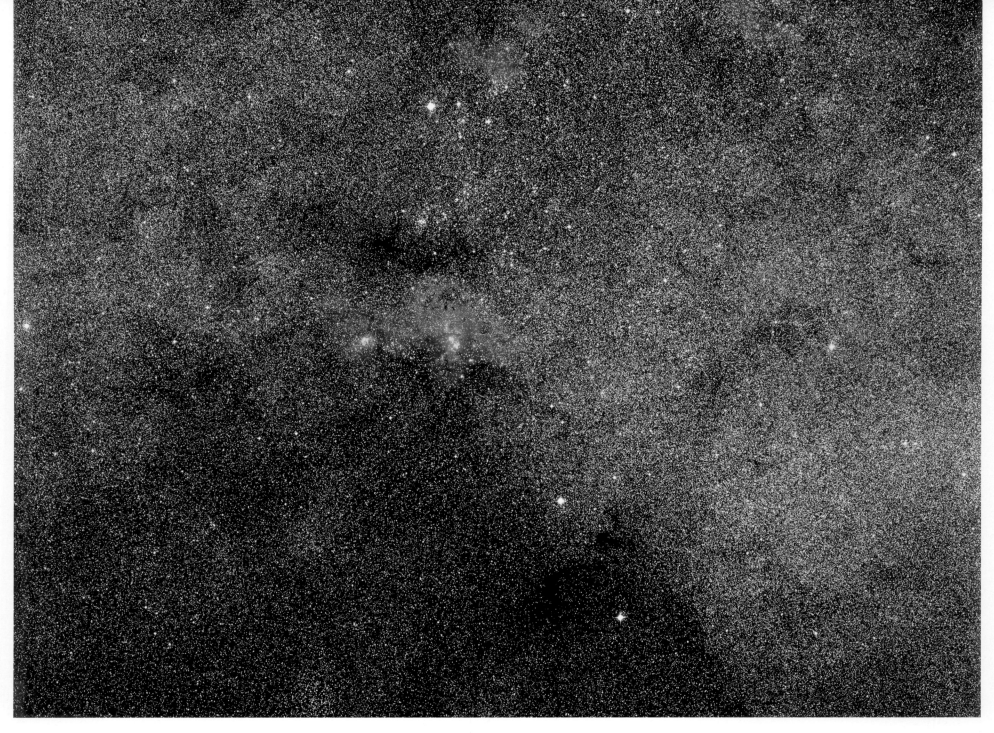

Figure 190 [429]

He twisted the "riem" round his arm and walked back along the ridge of the house."

The pioneering steps of Joseph Nicéphore Niépce, who secured the First Photograph (Figures 191 and 192) in ca. 1826, and an exquisite heliograph from a print in 1827 (Figure 193), may indeed have appeared small then – but are giant leaps now. They are photographic *incunabula* indeed.

The transition from a lens-less pinhole camera (Figure 194) to cameras housing photographic glass plates (Figures 195–199) to that of the era of digital camera arrays (Figures 200–204) …

In reviewing Figure 197, where "the stars are more thicke then grasse" [sic], we are reminded of "An Hymne of Heavenly Beautie" [sic] by E. Spenser, which, in the original wording, reads in part:

> *Looke thou no further, but affixe thine eye*
> *On that bright, shynie, round, still-moving Masse,*
> *The house of the blessed God, which men call Skye,*
> *All sowd with glistering stars more thicke then grasse*
> *Whereof each other doth in brightnesse passe …*

Today mankind is beholding the first real dawn of astronomical science. Yesterday was the preparation for that dawn – how splendid were the pioneers of that time! – tomorrow we shall be overwhelmed by the vastness of sidereal discoveries and progress. And a century hence those who come after us will discern clearly and naturally how and why the Cosmos is unbounded. None of us today can wholly comprehend and explain such an infinity of Space; but all of us tomorrow will be able to understand and to explain why the Cosmos could not be limited – that it had to be absolutely illimitable.

(CHARLES NEVERS HOLMES, 1918)

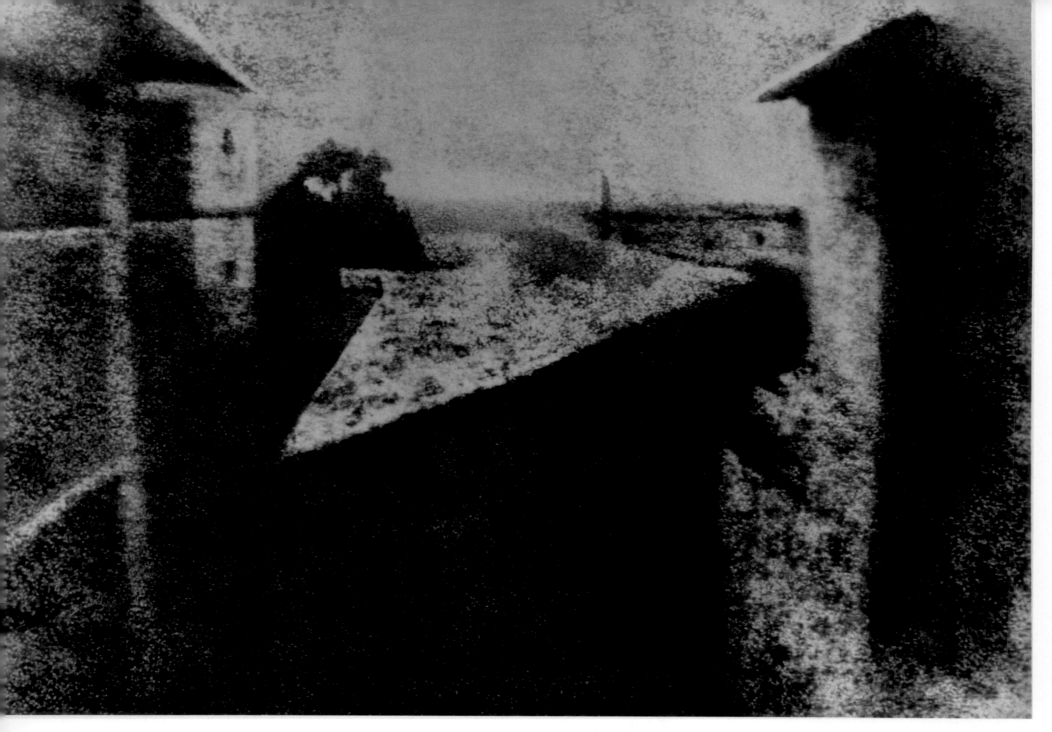

Figure 191 [429]

Figure 192 [429]

Figure 193 [429]

Figure 194 [430]

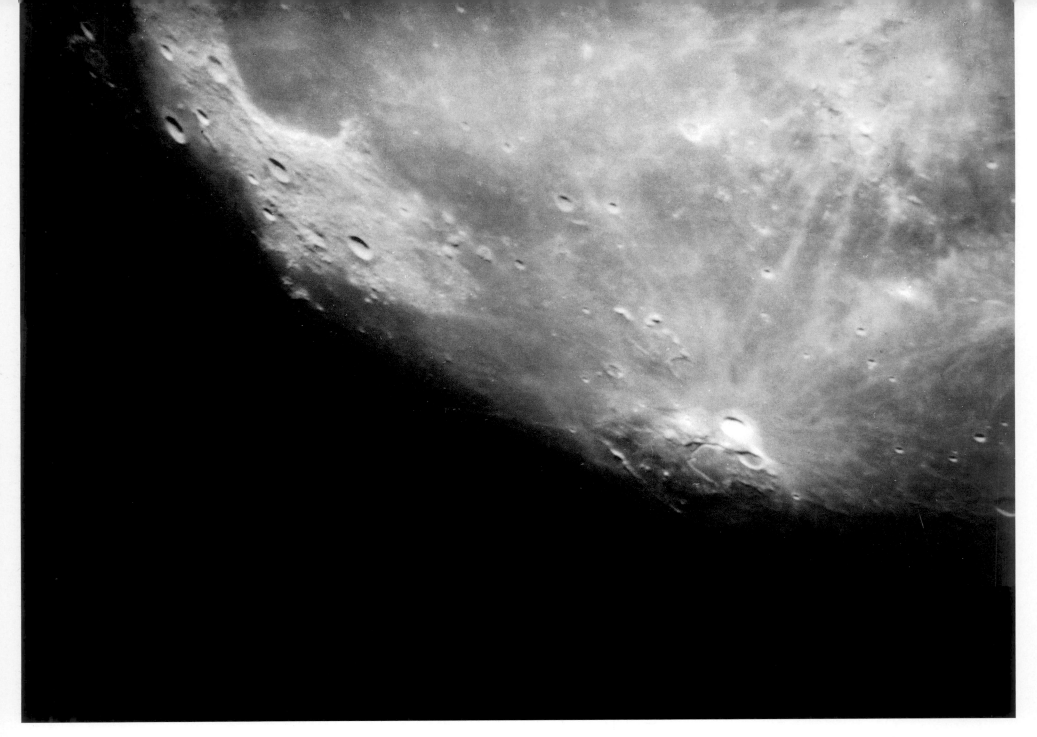

Figure 195 [430]

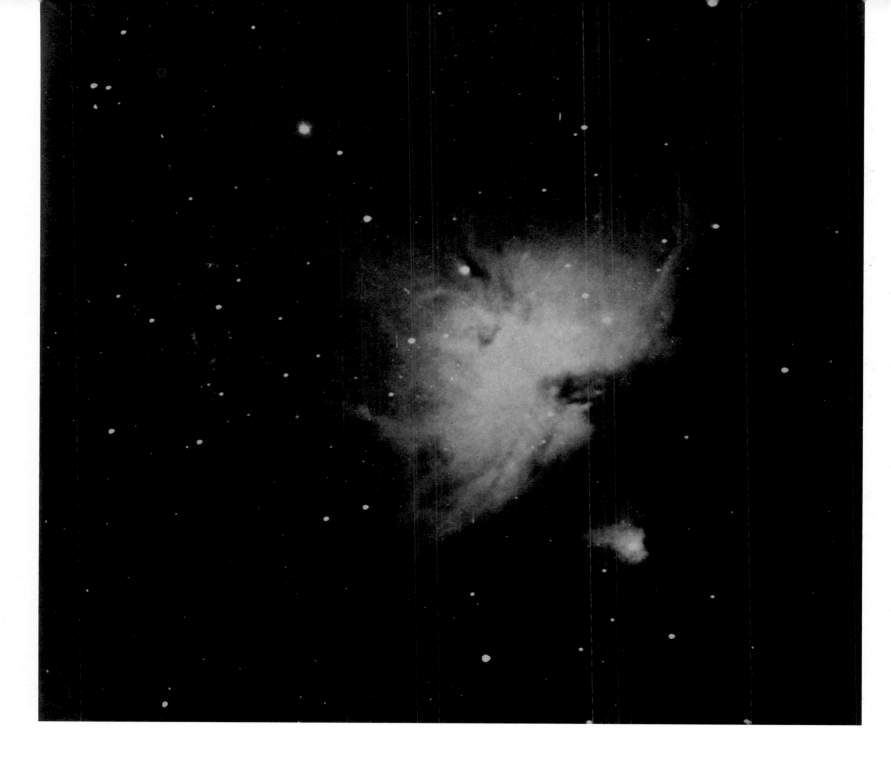

Figure 196 [430]

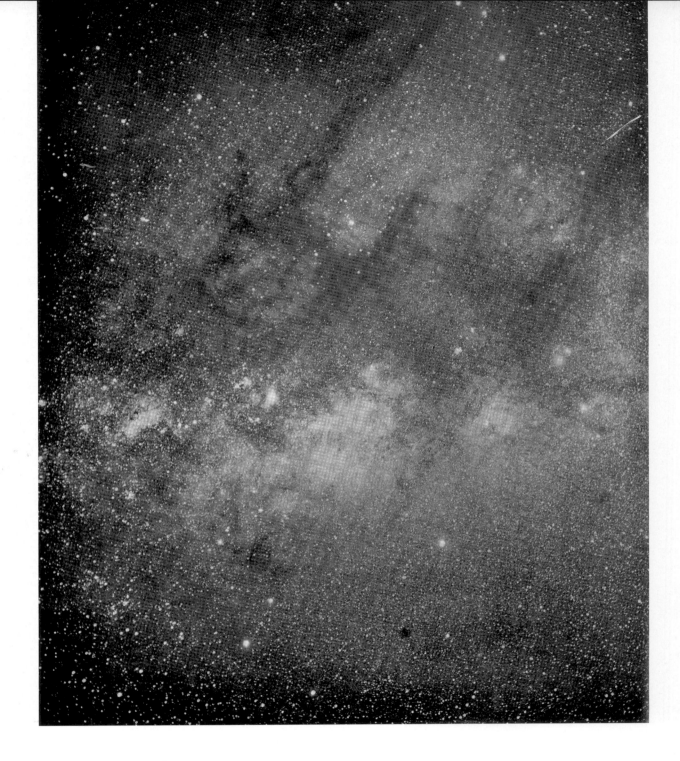

Figure 197 [430]

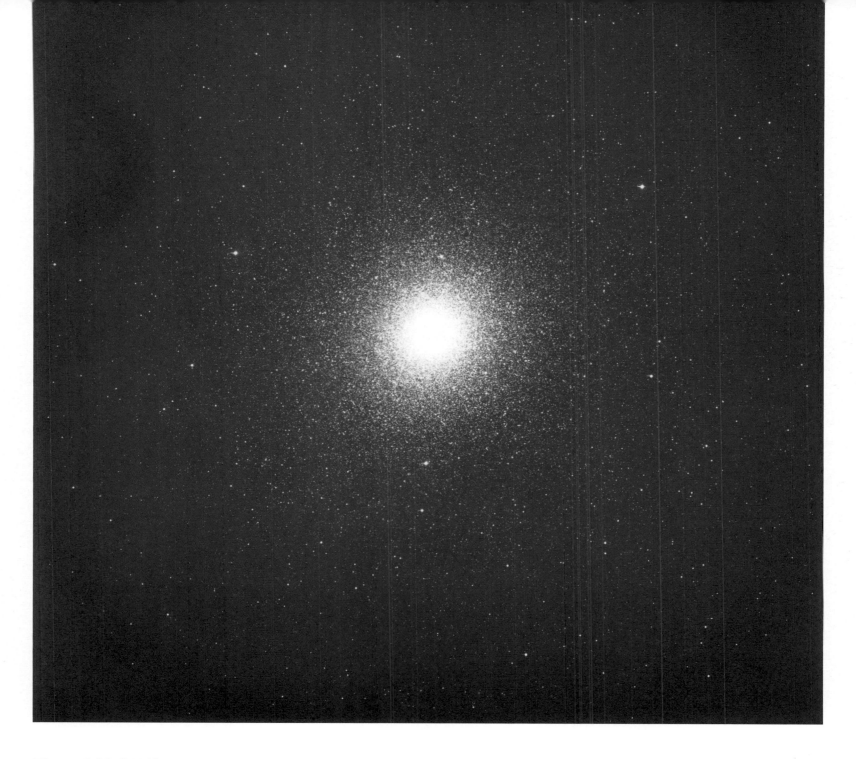

Figure 198 [430]

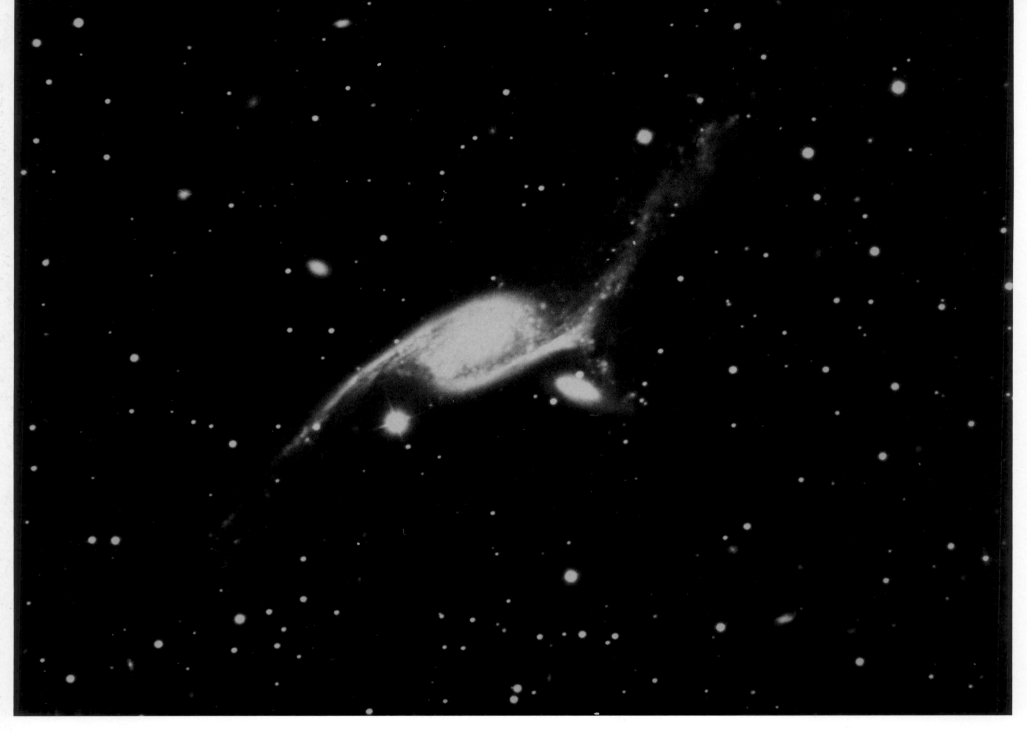

Figure 199 [431]

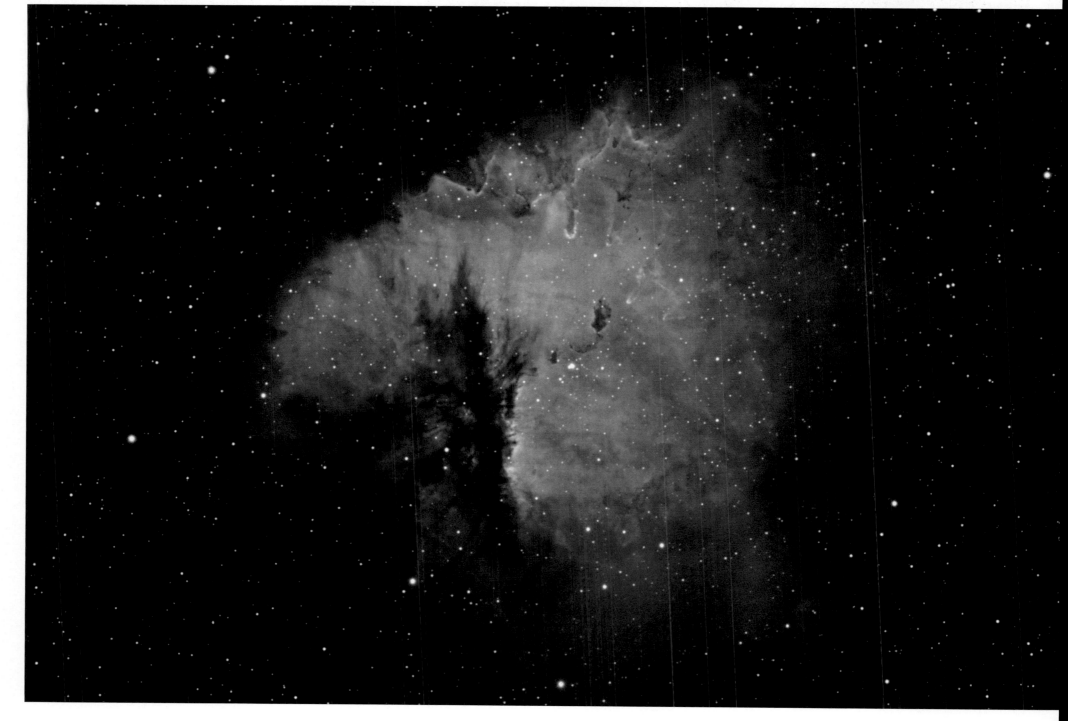

Figure 200 [431]

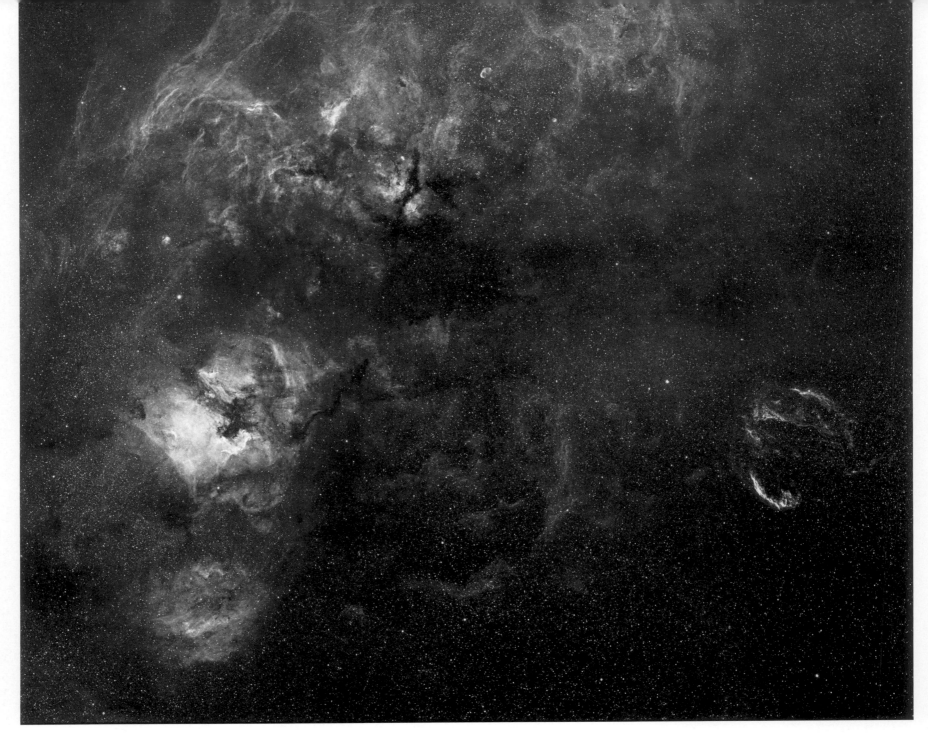

Figure 201 [431]

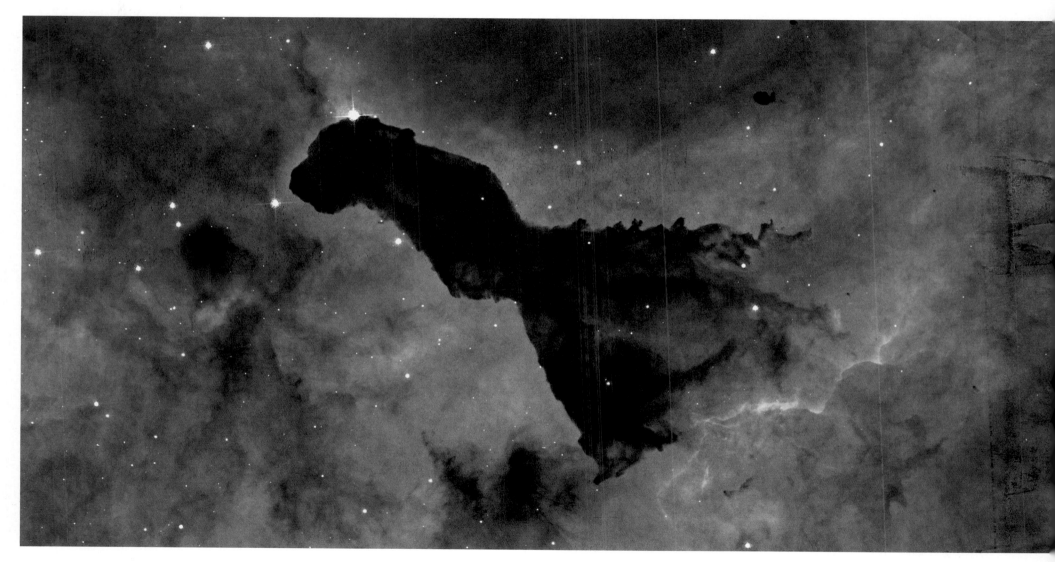

Figure 202 [431]

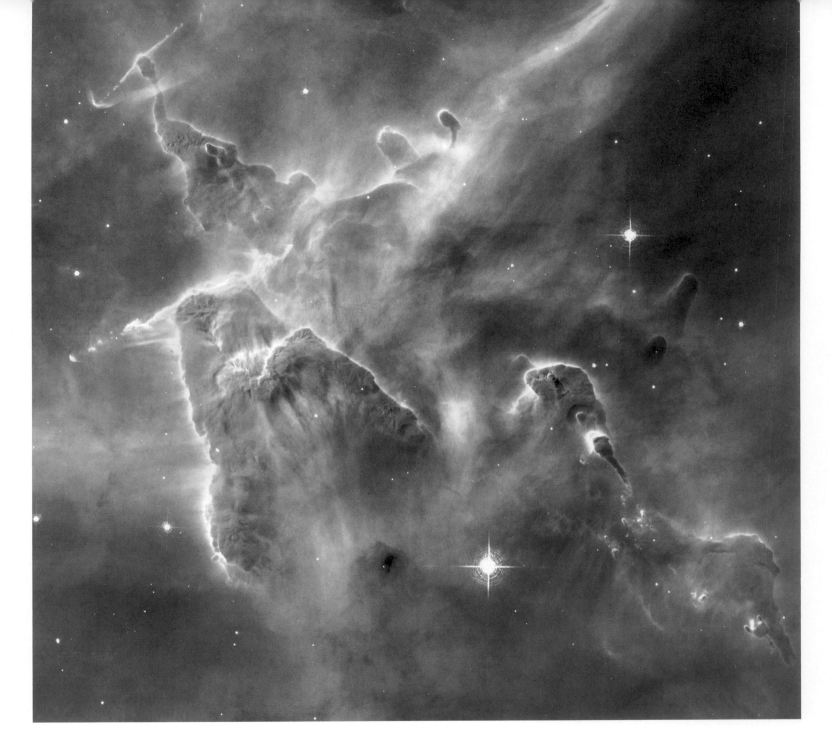

Figure 203 [431]

Figure 204 [431]

n Epilogue – Dr Bruce Elmegreen

There is what seems to be, and there is what is. We look but we cannot see what is. We build instruments that do our looking and still these instruments cannot see everything. There is no limitless gaze. The horizon curves, the fog muffles, the lights and structures get fainter and fuzzier with distance. The redshift dims. Peeling back one layer leads only to another. This is the reality of the Universe in which we live. When we think we have it just right, we see an unimagined new rightness beneath.

David Block and Kenneth Freeman have been looking and measuring, classifying and pondering the Universe for a long time. We are fortunate they shared their story with us. This is a story about the avalanche of insight that follows the discovery of new techniques: of giant telescopes built by hand all around the globe and of the mysteries the builders solved and revealed through their drawings; of the photographic process and the replacement of vision by chemical images; of electronic antennae, cameras, telescopes, and satellites that are sensitive to radio, infrared, ultraviolet, x-ray, and gamma ray light. It is a story of the shrouds of the night that were slowly peeled back, of galaxies viewed both inside and out, like the x-ray fish in Collette Archer's painting below.

The Universe around us is rich with structure in both density and temperature. Some of this structure reveals itself by the light it radiates, the long or the short wavelengths depending on temperature and extinction, the bright or the dim light depending on distance, opacity, and power. Other structures emit no light at all, but show their presence only through gravity. Perhaps still others show their presence only through feeling. This is a very different Universe close to us than the Universe long ago and far away, which had much less structure, much more uniformity in temperature and density, and many fewer types of objects. It had no stars, no carbon or oxygen or other heavy nuclei, no galaxies – just elementary particles and their mutual forces. How that Universe, now mapped and

measured with modern instruments, turned into the Universe around us, is a story being told by countless pixels of digital data, month-long simulations on the largest computers, and atom smashers that probe Big Bang energy densities. How that Universe sprung forth life that ponders and questions as we do is a story that still lies behind the thickest shroud.

Dr Bruce Elmegreen is a senior research scientist at the IBM TJ Watson Research Center in New York. He completed his doctorate at Princeton University; his supervisor was the late Lyman Spitzer Jr, one of the fathers of modern astrophysics after whom the Spitzer Space Telescope is named. Dr Elmegreen then spent three years as a Junior Fellow in the Society of Fellows at Harvard University and joined IBM in 1984, after holding a

faculty position at Columbia University. Dr Elmegreen was awarded the Dannie Heineman Prize in 2001 for theoretical studies of the interstellar medium, starbursts and the dynamics of spiral arms and bars in galaxies. A previous recipient of this prize was coauthor Kenneth Freeman. Dr Elmegreen has served on all three of the international Scientific Organizing Steering Committees for conferences on galaxy morphology and cosmic dust held on South African soil. Dr Elmegreen's winning design for a medal to commemorate the Transit of Venus in 2004 was struck in both gold and silver. A gold medal was awarded to Dr Elmegreen by the Governor of the Reserve Bank of South Africa, Tito Mboweni.

Figure Captions

Figure 1 A view of Galileo's town of birth, Pisa, as depicted in a leaf from the Nuremberg Chronicle published over 500 years ago, in 1493. The Nurmberg Chronicle (*Liber Chronicarum*) was written by the Nuremberg physician Hartmann Schedel and was printed by Anton Koberger.

Figure 2 Papua New Guinea: the land of dancing masks. A photograph of an Asaro Mudman seen wearing his mask, in the Eastern Highlands of Papua New Guinea. Just as masks cover or shroud the human face, so too is our perception of the night sky inextricably intertwined by the presence of cosmic masks. (Photograph: David L. Block.)

Figure 3 Customs in Papua New Guinea have remained unchanged for centuries. Photographed near the town of Goroka is a group of Asaro Mudmen, wearing their haunting masks. In astronomy, cosmic dust grains act as enormously effective masks – much like a fog on Earth. An awesome new view of the cosmos unfolds as these cosmic masks are "penetrated" using state-of-the-art infrared technology. (Photograph: David L. Block.)

Figure 4 From the land of Papua New Guinea where masks still dance, a human face is partially covered in a painted mask. The full moon itself is a mask, for it masks (or hides) myriads of fainter stars. In its brilliant light, only the very brightest of stars are seen. (Photograph: David L. Block.)

Figure 5 What a foreboding sight the dancing Northern Lights, the *Aurora Borealis*, must have been, in an era when no scientific explanation was known. (Reproduced from *Photographic Atlas of Auroral Forms* published by the International Geodetic and Geophysical Union, Oslo, 1930.)

Figure 6 In Middle-Age Europe, the Northern Lights were thought to be reflections of heavenly warriors. According to legend, soldiers who gave their lives for their king and country were allowed to battle on the skies forever, as a posthumous reward. (Reproduced from *Photographic Atlas of Auroral Forms* published by the International Geodetic and Geophysical Union, Oslo, 1930.)

Figure 7 The grandeur of the Milky Way Galaxy celebrated by a group of Aboriginals in Australia during a "walkabout." Writes Aboriginal artist Collette Archer: "Our people always use the stars to find their way on walkabouts during the nights … Our people celebrate the full moon and dance with happiness. They always admire the stars as do myself." (Artwork: Collette Archer, of the tribe Djunban in Far Northern Queensland, Australia.)

Figure 8 A stellar nursery, the Rosette Nebula, in our Milky Way Galaxy. Young stars born toward the central regions of the Rosette Nebula have evacuated a grand cosmic cavity or "hole." Seen silhouetted in the Rosette are numerous dark and imposing "elephant trunk" structures of cosmic dust. (Photograph: David L. Block.)

Figure 9 Another view of the Rosette Nebula, secured at the European Southern Observatory on a mountain in the Atacama desert in northern Chile. The image has been photographically enhanced, to reveal features of exceptionally low surface brightness which are not apparent upon inspection by eye of the original glass negative. The Rosette Nebula presents myriads of globules of cosmic dust. (Photograph: David L. Block.)

Figure 10 The Seagull Nebula. Towering dynamics are at work here; a veritable cosmic sculpture in the making. Bright rims of gas form ridges upon dark clouds of dust. The Seagull's head is located on the border of the constellations of Monoceros and Canis Majoris and it, too, is characterized by a prominent dark ridge of cosmic dust. (Photograph: David L. Block.)

Figure 11 The dark Universe. The dusty Universe. An area of star formation in the constellation of Carina, spawning dark, opaque globules of cosmic dust. Dark globules are often the sites for protostars – stars in the process of being born. Some globules may have grotesque shapes whereas others are almost spherical. The latter may have diameters less than 10 000 times the Earth–Sun distance; others may span diameters of a few light years. (Photograph: David L. Block.)

Figure 12 A spectacular star-forming region in the constellation of Carina, known as NGC 3576 (object number 3576 in the "New General Catalogue"). Gargantuan arcs of glowing hydrogen gas are evident. This object was discovered by Sir John Herschel during his visit to the Cape of Good Hope, South Africa. He recorded it as "Faint; oval." The image has been photographically enhanced to reveal the intricate beauty of the arcs as well as the dark globules of cosmic dust. (Photograph: David L. Block.)

Figure 13 Clouds of dust lie sprawling across this wide-field image of the Milky Way in the direction of Corona Australis, the Southern Crown. Acting as a cosmic smoke, grains of cosmic dust effectively block-out the light from more distant, background stars in our Milky Way Galaxy. (Photograph: David L. Block.)

Figure 14 A close-up of star forming regions in the Corona Australis complex reveals the grandeur of the processes involved in the birth of stars. (Photograph: David L. Block.)

Figure 15 Clouds of dark cosmic dust grains, seen in brilliant silhouette against bright ridges of hydrogen gas. These dark clouds of dust betray the dynamics of the processes at work: a grand celestial interplay between dust grains in interstellar space and photons from young, energetic stars gradually eroding the dark, dusty clouds. (Photograph: David L. Block.)

Figure 16 Resembling a seahorse, the Horsehead Nebula in the constellation of Orion is not a mere hole or chasm in the sky, but rather a *distinct physical entity* of swirling gas and cosmic dust. The Horsehead Nebula (of approximate dimensions 2.7 × 1.8 light years) is gradually being eroded by the intense radiation of an energetic, nearby star; its estimated lifetime is about 5 million years. (Photograph: European Southern Observatory.)

Figure 17 Shrouds of the Night: The enigmatic spiral galaxy known as the "Sleeping Beauty," struts its dark lanes of cosmic dust in a most dramatic fashion. Our challenge was to penetrate these dusty shrouds or masks and unveil cold (minus 210 degrees Centigrade) and very cold (minus 250 degrees Centigrade) cosmic dust grains in galaxies beyond the Milky Way. (Photograph: John Kormendy.)

Figure 18 Shrouds of the Morning: Early morning mists in Canberra, as photographed from the slopes of Mount Stromlo. The obscuring effects of the mist are extremely pronounced – hiding much of the valley below – even though the mist itself may be of negligible mass. (Photograph: David L. Block.)

Figure 19 A bushfire in Australia. Billowing clouds of smoke from the raging bushfire rise into the air, and are seen in dramatic silhouette at higher altitudes above the ground. Cosmic dust pioneer Mayo Greenberg always likened the obscuring effects of dust particles in our Universe to such smoke particles, which in this photograph form terrestrial masks. (Photograph: Gordon Undy.)

Figure 20 An optical photograph of the spiral galaxy NGC 2997, showing a plethora of bright young stars and a magnificent set of dust lanes. In the 1980s, the existence of cold and very cold dust grains in other galaxies was a hotly debated issue – many astronomers believed that galaxies such as this one were dust deficient, compared to our Milky Way Galaxy. Was our Milky Way simply very unusual in being having copious

amounts of cosmic dust? Or could it be that the Infrared Astronomy Satellite had actually missed *ninety percent* of the dust content in spiral galaxies such as NGC 2997, as a result of masking by the hotter dust grains? (Photograph: European Southern Observatory.)

Figure 21 A dust penetrated near-infrared view of the spiral galaxy NGC 2997 shows a most extraordinary galactic backbone. It is almost difficult at first sight to believe that one is looking at the same galaxy as that seen in the preceding figure, when seen in optical light. The dust mask was penetrated using state-of-the-art infrared technology at the European Southern Observatory in the Atacama desert, Chile. (Photograph: David L. Block.)

Figure 22 Shrouds of the Night betray a breathtaking beauty of their own. Dust grains (color coded black on a sepia background) in NGC 2997 do only lie along the spiral arms of the galaxy, but also between spiral arms (this dust is technically known as "inter-arm" dust). We were able to prove that astronomers had underestimated the mass of the Dust Shroud in spiral galaxies such as NGC 2997 by *ninety percent*. This Figure was generated by subtracting our near-infrared image from an optical image. (Photograph: David L. Block.)

Figure 23 The Coalsack Dark Nebula (otherwise known as the Coalsack) is readily visible to the naked eye and is seen silhouetted against the rich starfields of the southern Milky Way, bordering the constellations of Crux and Centaurus. It lies adjacent to the Southern Cross seen here, with its famous four stars, and delineates an oval-shaped dust mask about 8 degrees long and 5 degrees wide (for comparison, our full moon spans one half of a degree in our skies). The bright orange colored star, a member of the Southern Cross, is known as Gamma Crucis or Gacrux, and is estimated to have a diameter over 100 times that of our Sun. The southernmost star of the southern cross (the lowermost member of the cross in this image) is known as Alpha Crucis, and shines with a brilliant blue color. (Photograph: Axel Mellinger.)

Figure 24 Prior to the dawning of the photographic era, astute and careful observers produced some of the most exquisite drawings of objects in our night sky, by eye and by hand. One of our favorite drawings of

the Milky Way Galaxy comes from the work of the French born artist and amateur astronomer Etienne Leopold Trouvelot (1827–1895), who emigrated from France to the United States in 1855. (Digital image: U.S. Naval Observatory.)

Figure 25 The planet Saturn, with its magnificent system of rings, as meticulously recorded by the celestial artist Etienne Trouvelot. The drawing attests to the most astute eye of this observer. Intricate and minute details in the rings are recorded, including a famous gap in the rings, known as the Cassini division. Trouvelot also records less pronounced gaps in the ring system. Saturn has a density less than that of water, with the implication that if it were to be placed in an enormous sea of water, the planet would float. (Digital image: U.S. Naval Observatory.)

Figure 26 Trouvelot's drawing of a cluster of stars in the constellation of Hercules. The cluster (listed as object number 13 in the catalogue of French astronomer Charles Messier) contains several hundred thousand stars, and was discovered by Edmond Halley in 1714, who noted that "it shows itself to the naked eye when the sky is serene and the Moon absent." The diameter of this cluster is approximately 145 light years. (Digital image: U.S. Naval Observatory.)

Figure 27 "The Great Nebula in Orion" as sketched by Trouvelot. Deep within this stellar nursery lies a cluster of young stars, known as the Trapezium. The nebula is roughly 30 light years across. Also vividly recorded in this drawing, based on telescopic observations by Trouvelot spanning two years (1875 and 1876) are dark ridges and dark globules. The birth of stars is inextricably linked to clouds of gas mixed with cosmic dust. (Digital image: U.S. Naval Observatory.)

Figure 28 The glowing zodiacal light, as sketched by Etienne Trouvelot. The zodiacal light is caused by sunlight scattering off interplanetary particles of dust in our solar system. This interplanetary dust, distributed in a volume of space centered on the Sun and extending beyond the orbit of our Earth, lies in the plane of the zodiac, or ecliptic. The zodiacal light betrays the presence of our solar system's dust mask. (Digital image: Emporia State University, Emporia, KS, USA.)

Figure 29 "The November Meteors" as drawn by Trouvelot in November, 1868. Trouvelot vividly captures that extraordinary celestial display: over three thousand meteors were seen during the night of November 13–14. This particular meteor shower, known as the Leonid meteor shower, is linked to the debris of Comet Tempel–Tuttle as it orbits the Sun. Comets have been described as "dirty snowballs" of ice mixed with cosmic dust, and this meteor shower results when the Earth, in its annual orbit about the Sun, encounters debris from Comet Tempel–Tuttle. The debris then burns up in our atmosphere, due to friction. (Digital image: U.S. Naval Observatory.)

Figure 30 A detailed rendition by Lord Rosse of a spiral galaxy listed as object h1744 in the Herschel catalogue; more commonly known as Messier 101. This historic drawing was made using the famous "Leviathan of Parsonstown," a telescope in Ireland boasting a giant mirror of 72 inches diameter. The telescope received its first set of celestial photons (technically known as "first light") in February 1845. The drawing faithfully records bright knots in the spiral arms of this galaxy; these are now known to be knots of ionized hydrogen gas associated with the harsh ultraviolet radiation emanating from clusters of young stars. (Drawing courtesy: The current Lord and Lady Rosse and Mr. A. Stephens.)

Figure 31 An exquisite rendition of the spiral galaxy H. 131 by Lord Rosse, using the giant "Leviathan of Parsonstown." The spiral arms in this galaxy (also known as Messier 33) are correctly depicted as being *broad*, in contrast to the thinner, *filamentary* spiral arms seen in the previous Figure. Galaxy morphologists today make regular use of terms such as *massive* (i.e., broad) versus *filamentary*. It is intriguing to note that Lord Rosse also sketched a multiple set of spiral arms, as attested to by modern optical imaging and photographs. (Drawing courtesy: The current Lord and Lady Rosse and Mr. A. Stephens.)

Figure 32 The Dumbbell Nebula, as sketched by Lord Rosse. The designation "dumbbell" may be traced to a description given by Sir John Herschel, who compared it to a "double-headed shot." This Nebula, number 2060 in the Herschel catalogue, lies in the constellation of Vulpecula and represents the late stages of development of certain low

mass stars which shed their gas. Such may be the fate of our Sun, in some 5 billion years hence. At the heart of the Dumbbell Nebula lies the remnant star, known as a white dwarf. Patterns of bright and dark knots are beautifully recorded in this drawing, produced at Birr Castle in Ireland.

Figure 33 Some of the most exquisite drawings of the Milky Way were rendered by the hand of Otto Boeddicker (1853–1937), who became the astronomical assistant to Lawrence Parsons, the 4th Earl of Rosse at Birr Castle, Ireland. Boeddicker's breathtaking drawings of the Milky Way were made over a period of *six years*, and were published in 1892 as a folio set of four plates, each measuring 18 inches × 23 inches. Boeddicker lay flat on his back, night after night, to produce the drawings reproduced here. He recalls: "This involved for the greater part of the Milky Way the necessity of lying flat on my back (or nearly so) in the open air for hours – a position which, especially on frosty nights, proved somewhat trying, for no amount of clothing was found sufficient to counteract the radiation of heat from the body." (Courtesy: The current Lord and Lady Rosse and Mr. A. Stephens.)

Figure 34 Otto Boeddicker's drawings of the Milky Way received the highest praise. "To appreciate the labour of depicting, in all its intricate details, the majestic arch of accumulated suns … one should examine Dr Boeddicker's splendid drawings of it … There is something of organic regularity in the manner of divergence of innumerable branches from a knotted and gnarled trunk … It is simply amazing that such a work should have been executed in such a climate as Parsonstown" were the thoughts published in the *Saturday Review* of November 30, 1889. In the drawings by Boeddicker, the stars are drawn black on a white background; the numerous masks of cosmic dust appear white.

Figure 35 The Great Nebula in the constellation of Orion, based on almost *twenty years* of careful observation (spanning the years between 1848 and 1867) at Birr Castle. For reproduction purposes, the drawing of the entire nebula was meticulously divided into six sectors, with each sector appearing on a large white card. The six cards were then assembled into a 2 × 3 mosaic to generate the magnificent drawing seen here. Plumes of hydrogen gas abound in the Great Nebula, as do dark ridges

of cosmic dust. All of these details are faithfully recorded in this exquisite mosaic produced at Birr Castle. (Courtesy: The current Lord and Lady Rosse and Mr. A. Stephens.)

Figure 36 How did astronomers at Birr Castle produce their detailed drawings of galaxies and of nebulae, in the dark? What light source did they use when sketching in the dark? This lantern was recently discovered in the attic of a tower at Birr Castle. The rectangular lantern has a brownish-yellow glass in front of it, which would act as a filter to preserve night vision when Lord Rosse made his exquisite drawings with the Giant Leviathan at Parsonstown. The lantern measures 7 inches × 7 inches × 8 inches. The little legs, which are of a different metal and are not rusted, are 4½ inches long. (Photograph: Lady Rosse at Birr Castle.)

Figure 37 Approaching Table Mountain from the sea, the explorer, naturalist and botanist William Burchell wrote upon his arrival in the Cape in 1810: "As we advanced nearer the shore, the mountains displayed an imposing grandeur, which mocked the littleness of human works: buildings were but specks; too small to add a feature to the scene; too insignificant either to adorn or to disturb the magnificence of nature." (Reproduced from a volume by the explorer F. Le Vaillant published by H. J. Jansen, Paris, 1796. Courtesy: The William Cullen Library, University of the Witwatersrand.)

Figure 38 A painting (dated 1843) by the astronomer Charles Piazzi Smyth, showing a moonlight view of Table Bay, as well as depicting the Great Comet of 1843. To the naked eye, the Great Comet appeared to have a double tail, with two streamers flowing in apparent straight lines from the head of the Comet. Table Mountain is visible in the background, at left. In the foreground on the left, the painter shows a small boat with three people on board, all pointing toward the Great Comet. The brilliant intensity of the moonlight is clearly seen reflected in the waters of Table Bay. When Sir John Herschel arrived in the Cape of Good Hope in January 1834, the view of Table Bay with its sailing ships would have been much the same as that seen in this painting by Charles Piazzi Smyth. (Painting: National Maritime Museum, London.)

Figure 39 A photograph secured in the late 1880s of Table Mountain (Photographer unknown.)

Figure 40 Sir John Herschel's telescope erected at Feldhausen. "In point of situation it is a perfect paradise in rich and magnificent mountain scenery, and sheltered from all winds, even the fierce south easter, by thick surrounding woods. I must reserve for my next [letter] all description of the gorgeous flowers … as well as the astonishing brilliancy of the constellations" wrote Sir John of his observing site at Feldhausen. (Courtesy: National Library of South Africa.)

Figure 41 The starry vaults of the southern Milky Way, as drawn from Feldhausen by Sir John Herschel. The top panel includes the appearance of our Galaxy in the constellations of Ophiucus, Centaurus, Sagittarius and Scorpio while the lower panel shows the morphology of the Milky Way spanning, amongst others, the constellations of Crux, Canis Major and Monoceros. The Southern Cross appears as a group of four stars toward the left hand side in the lower panel, adjacent to the Coalsack, drawn as a conspicuous white "hole." Herschel remarked that voyagers and travelers always regarded the Coalsack as "one of the most conspicuous features of the southern sky." (Courtesy: William Cullen Library, University of the Witwatersrand.)

Figure 42 The Great Nebula in Orion, as drawn by Sir John Herschel. It took Sir John over three years to complete this drawing by means of first measuring the positions of coordinate stars, then using these to form a grid on paper, and then drawing in details of the Great Nebula itself. The time consuming process is elucidated by Sir John thus: "By the aid of the measures of December, 1834 … the first skeleton [of coordinate stars] was laid down and filled in on the 4th and 29th January, 1835, and on the 27th December, 1836, and a number of curious and interesting particulars noticed and delineated … but it was not till the end of 1837 that the accumulation of the micrometric measures had enabled me to lay down with some precision a set of skeletons … extending over the whole nebulous area intended to be included in the drawing." From January 1835 to December 1837 the grid was painstakingly laid out and carefully corrected. (Courtesy: William Cullen Library, University of the Witwatersrand.)

Figure 43 Nebulosity and cosmic dust in the constellation of Carina. Of this region, Sir John Herschel wrote: "There is perhaps no other sidereal object which unites more points of interest than this. Its situation is very remarkable, being in the midst of one of those rich and brilliant masses, a succession of which curiously contrasted with dark adjacent spaces (called by the old navigators coal-sacks), constitute the milky way in that portion of its course which lies between the Centaur and the main body of Argo." Modern nomenclature has replaced the constellation Argo with others, the major portion of which is the constellation of Carina: only visible from the Southern Hemisphere. Sir John Herschel remarked that the execution, final revision, and correction of this drawing and engraving over a period of several months "would, I am sure, be no exaggeration." (Courtesy: William Cullen Library, University of the Witwatersrand.)

Figure 44 While at the Cape of Good Hope in South Africa, Sir John Herschel produced a most moving set of drawings using a *camera lucida*. The *camera lucida* superimposes by means of a prism a virtual image of any view onto the plane of a drawing board, so that it can be traced by an artist. Seen here is a view from the "stoep" (verandah) of the home of Sir John Herschel on the property bearing the name Feldhuysen or Feldhausen, situated approximately 10 kilometers from Cape Town on a gentle slope at the base of Table Mountain. Above, in the background, towers a mountainous peak, known as Devil's Peak, while in the foreground a tree, with the minutest of detail in the leaves, is carefully sketched. It is the same incredible attention to detail, whether drawing a window frame or a flower, which is evident in Sir John Herschel's descriptions of his telescopic sweeps of the southern skies. (Courtesy: National Library of South Africa.)

Figure 45 Sir John Herschel was a man of extraordinary wide interests; he made contributions to geology, botany, ornithology, chemistry, mathematics and of course his monumental legacy in matters astronomical. But he was also a family man; their marriage was described as being of "unclouded happiness." Reproduced here is a camera lucida sketch by Sir John Herschel showing three of his young children – Caroline, Isabella and Louisa Herschel – in the north-east avenue of the property "Feldhausen" at the Cape. Sir John Herschel married Margaret Brodie

Stewart on 3rd March, 1829. Their first child. daughter Caroline, was born in March 1830. Next followed Isabella Herschel (born 1831), William James Herschel (born 1833) and Margaret Louisa Herschel (born 1834). Sir John Herschel was father to twelve children – the twelfth child, Constance Ann Herschel, was born in 1855. (Courtesy: National Library of South Africa.)

Figure 46 Sir John Herschel's passion of using the camera lucida to record landscapes extended to both the northern and southern hemispheres. Seen in this drawing, produced soon after the arrival of Sir John in the Cape in 1843, is sunset behind Table Mountain. In the foreground is an ox-wagon (Afrikaans: *Ossewa*) which was a traditional early form of transport in Southern Africa. The ox-wagons were drawn by chains of oxen which were harnessed in pairs. (Courtesy: National Library of South Africa.)

Figure 47 In the handwriting of Sir John Herschel, nebulae were classified according to "magnitude" (great, large, middle, small, minute), "resolvability" (discrete, resolvable, granulated, mottled and milky) as well as "brightness," "roundness" and "condensation." One nebula might be "middle-sized, bright, round, stellate, resolvable" while another might be "small-sized, dim, elongated, discoid, milky." (From the archives of the Royal Astronomical Society, London.)

Figure 48 Classification extends to both the worlds of the microcosm below and the macrocosm above. Photographed here is coral spawning in the Great Barrier Reef, Australia. The annual mass spawning takes place each spring or early summer. During the coral spawning process, corals release eggs and sperm into the water, and the timing is linked to the phases of the Moon. The most common period is 3–5 days after the full moon, in November or December (late spring, early summer). As Majorie Nicholson writes: "... the Divine Artist ... draws in little as exquisitely as in large ... for 'Nature is the Art of God'." (Photograph: Great Barrier Reef Marine Park Authority – GBRMPA, Australia.)

Figure 49 Sir John Herschel as photographed by British master photographer Julia Margaret Cameron. Herschel's role in the history of

photography is forever etched in time: Herschel discovered the "fixing process" of using sodium thiosulfate (or "hypo") in 1819. It is to Sir John Herschel whom we owe the word *photography* (derived from the Greek *photos* – light – and *graphien* – to draw). (Photograph courtesy: Bensusan Museum of Photography, Johannesburg.)

Figure 50 Another, more famous portrait, of Sir John Herschel by Julia Margaret Cameron, dated 1867. The portrait carries the following inscription, written in pen by Sir John Herschel: "The one of the old paterfamilias with his black cap on is I think the climax of photographic art and beats hollow every thing I have ever beheld in photography before." In March of 1839, Sir John read a paper to the Royal Society entitled: "Note on the Art of Photography, or The Application of the Chemical Rays of Light to the Purpose of Pictorial Representation." For some unknown reason, Herschel withdrew his pioneering 1839 Royal Society research paper on photography, from publication. In 1842 Sir John Herschel sent Julia Margaret Cameron early examples of photographic images – the first she had ever seen. (Photograph courtesy: Bensusan Museum of Photography, Johannesburg.)

Figure 51 "Figments number 9": a photographic platinum–palladium print of a fern. The noble metals of platinum and palladium are embedded within the actual fibres of the matte paper – there is no coating of gelatin. It has been written that in all of photography, "there is nothing more beautiful, or more everlastingly permanent, or more completely satisfying to the cultivated eye, than the platinum print" to quote the "Photo–Miniature" of 1911. First steps in the use of platinum in photography may be traced to Ferdinand Gehlen, Johann Dobereiner, Robert Hunt and Sir John Herschel. The patenting of the platinum process occurred in 1873 by William Willis. (From a private collection. Gordon Undy's hand–made book of platinum–palladium prints is entitled "Figments" and "Figments number 9" is reproduced here by permission of Gordon Undy.)

Figure 52 A circular photographic image, on salted paper, by Sir John Herschel. The photograph shows the 4-foot (48-inch) telescope built by his father, Sir William Herschel (1738–1822). This telescope was the world's largest for over fifty years, until Lord Rosse erected the giant 72-inch "Leviathan" at Parsonstown, Ireland. It was on 28th August 1789, on the occasion of "first light" of this telescope, that Sir William Herschel discovered Saturn's sixth known moon, Enceladus, and on 17th September of the same year, its seventh known moon, Mimas. The instrument constructed at Slough, England, is faithfully recorded by means of photography by his son, Sir John Herschel. Not only did Sir John Herschel introduce "hypo" as a photographic fixative to the world, but he also discovered the cyanotype process for blue, monochromatic color photography in 1842. (Photograph courtesy: National Media Museum and the Science & Society Picture Library, London.)

Figure 53 In the handwriting of Sir John Herschel: a document containing his comments on a method devised by Fizeau in 1840. The French physicist Armand Hippolyte Louis Fizeau (1819–1896) had discovered a method of treating daguerreotypes with a solution of gold to contribute to their permanence. Impressions could then be made in printing ink, as in the process of engravings. Herschel begins: "The problem consists in acting from the Dag: [Daguerreotype plate] impressions by an agent which eats into the dark parts without affecting the light parts of the plate …" (Courtesy: Bensusan Museum of Photography, Johannesburg.)

Figure 54 The dream to permanently record images on photographic paper was realized by William Henry Fox Talbot (1800–1877), Fellow of the Royal Society. Talbot's book entitled *The Pencil of Nature*, published in 1844, was the first book to be illustrated with photographs. Seen here is one of William Talbot's early photographs on paper, entitled "The Ladder." (Photograph courtesy: Bensusan Museum of Photography, Johannesburg.)

Figure 55 A photo-engraving of a piece of lace, by William Henry Fox Talbot. The earliest methods of photo-engraving, apart from that of Nicéphore Niépce, included those developed by Alfred Donné in Paris (1839), Joseph Berres in Vienna (1840), and the French physicist Hippolyte Fizeau (1841). Talbot placed a piece of lace on a steel plate sentisized with a coating of gelatin and potassium bichromate. Talbot's technique is a photo-mechanical one; it uses a process in which, by means of the action of photons (light) upon chemical substances, a printing

surface is prepared from which a large number of impressions can be printed on paper using a printing press. This exquisite photo-mechanical impression of lace (an early example of a *photoglyphic engraving*) was produced by Talbot in 1853. Talbot patented one photo-mechanical technique in 1852; his second such patent followed in 1858, wherein the type of plate materials were expanded to include copper – and not only steel plates. (Courtesy: Museum Africa.)

Figure 56 An early photograph of a water pump in South Africa. The photograph, over 100 years old, was secured in the late sector of the 1800s. The long exposure time is betrayed by the water being out of focus, forming a continuous stream. Exposure times up to 1900 were lengthy – of the order of minutes, rather than fractions of a second. The handwritten caption reads: "The airpump – water driven by water obtained from the Disa Gorge." (Photographer: Unknown.)

Figure 57 Following the dawn of the photographic era by Joseph Nicéphore Niépce, Louis Jacques Mandé Daguerre and William Henry Fox Talbot, printed books started to appear with albumen photographs actually pasted in to the book. Seen here is a view of the Furness Abbey from a book dated 1862, entitled *Ruined Abbeys and Castles of Great Britain*, authored by William and Mary Howitt. The publisher took pains to elucidate to the reader the advantages of the use of photography in the book: "The reader is no longer left to suppose himself at the mercy of the imaginations, the caprices, or the deficiencies of artists, but to have before him the genuine presentment of the object under consideration." (Photograph by R. Fenton. Published by A.W. Bennett London, 1862. Digitized image: Beith Laboratories, South Africa.)

Figure 58 Another albumen print from *Ruined Abbeys and Castles of Great Britain* dated 1862. This print is entitled: "Rievaux: Old Gateway." Though the church is "broken up by ruin, it yet presents ... the noble aspect of the whole when it was complete and in use; its windows filled with painted glass ... its lofty groins and traceried [ornamented or decorated with tracery] capitals, and the found of anthems swelling from the choir. The place is worthy of all its fame" commented authors William and Mary Howitt. The tension between the accuracy of the

photographic process and those rendered in earlier engravings by artists gradually reduced with time. (Photograph by W.R. Sedgfield. Published by A.W. Bennett London, 1862. Digitized image: Beith Laboratories, South Africa.)

Figure 59 Using the newly discovered medium of photography as a measure of objective scientific evidence did not take root immediately. Prior to the dawn of the photographic era, seeing was the only source of knowledge available to the Victorian enquirer. As noted by Frances Robertson, it was only in the mid-1870s that photography "as an objective and scientific mode of imaging ... offered a fruitfully expectant moment for Nasmyth." James Nasmyth was a mechanical engineer by profession, but he was passionate about astronomy. In 1874 Nasmyth and his assistant, James Carpenter, coauthored one of the first books which allowed for the placing of photographs to serve as a "reliable" record of Nature. Seen here is a pair of photographs entitled "Back of Hand & Wrinkled Apple" which Nasmyth and Carpenter used to illustrate their belief that the origin of certain mountain ranges on the Moon resulted from a shrinking of its interior. (Reproduced from *The Moon: Considered as a Planet, a World, and a Satellite* by James Nasmyth and James Carpenter, 1874.)

Figure 60 "Full Moon" – a Woodburytype photograph secured by Warren De la Rue and Joseph Beck. (Reproduced from *The Moon: Considered as a Planet, a World, and a Satellite* by James Nasmyth and James Carpenter, 1874.)

Figure 61 A photograph of "The Lunar Apennines" in the aforementioned book by Nasmyth and Carpenter in 1874. The authors were faced with a dilemma of how to bring a flat two-dimensional picture to three-dimensional life, and to this end, plaster models of areas of the Moon were first constructed from drawings derived from detailed telescopic observations. Next, the small plaster models (some of approximate size 60 × 50 × 9 centimeters) were photographed under very carefully controlled lighting, to yield the necessary contrasts between shadow and light. (Reproduced from *The Moon: Considered as a Planet, a World, and a Satellite* by James Nasmyth and James Carpenter, 1874.)

Figure 62 A photograph of the lunar crater "Plato" and its environs. The photograph is actually of a plaster model of this lunar area, but it looks *so real*. The work of Nasmyth and Carpenter received the greatest of acclaim in the scientific journal *Nature*. The astronomer Lockyer endorsed their methods used to present a vivid three-dimensional relief to readers, and noted that their photographs of the Moon were "far more perfect than any enlargement of [direct] photographs could possibly have been." (Reproduced from *The Moon: Considered as a Planet, a World, and a Satellite* by James Nasmyth and James Carpenter, 1874.)

Figure 63 The crater "Copernicus" photographed by Nasmyth and Carpenter, using their methodology of constructing a model of plaster from detailed drawings through a telescope. Nasmyth and Carpenter expressed their ideas thus: "In order to present these illustrations with as near an approach as possible to the absolute integrity of the original objects, the idea occurred to us that by translating the drawings into models which, when placed in the Sun's rays, would faithfully reproduce the lunar effects of light and shadow, and then photographing the models so treated, we should produce most faithful representations of the original." (Reproduced from *The Moon: Considered as a Planet, a World, and a Satellite* by James Nasmyth and James Carpenter, 1874.)

Figure 64 The observatory of Isaac Roberts (1829–1904) on the summit of Crowborough Hill in Sussex, England. Seen in this photograph is Roberts' telescope of twenty inches aperture and ninety-eight inches focal length, as well as a smaller refracting telescope, of seven inches aperture. The reflector telescope was used for photographic work, while the smaller telescope was used for eye observations. (Reproduced from *A Selection of Photographs of Stars, Star-Clusters and Nebulae* by Isaac Roberts, D.Sc., F.R.S. and published by the Universal Press, London, 1893.)

Figure 65 The contribution of Isaac Roberts is one of the most important collections of early photographs of astronomical objects published, and his work represents a great landmark in both astronomical and photographic history. Seen here is the "Great Nebula in Andromeda" now known as the Andromeda Spiral Galaxy. This photograph, secured on 29th December 1888 with an exposure time of four hours, shows the Andromeda Spiral with two of its companion galaxies. One of these, known as Messier 32, was discovered by Le Gentil in 1749; the other discovered by Caroline Herschel in 1783. Roberts commented that "one of the features exhibited [on his photographs of the Great Nebula in Andromeda] was that the dark bands … formed parts of divisions between symmetrical rings of nebulous matter surrounding the large diffuse centre of the nebula." Isaac Roberts had captured those enigmatic Shrouds of the Night in the Andromeda Spiral Galaxy. (Courtesy: The archives of the Royal Astronomical Society, London.)

Figure 66 A magnificent image by Isaac Roberts of the spiral galaxy known as Messier 33, in the constellation of Triangulum, photographed more than 100 years ago. Roberts secured this photograph on the 14th November 1895; the exposure time was 2¼ hours. The image not only reveals the bright pair of inner spiral arms but also records faint detail in the outer disk of Messier 33. (Courtesy: The archives of the Royal Astronomical Society, London.)

Figure 67 The spiral galaxy Messier 51, photographed by Isaac Roberts on 29th April 1889, with an exposure time of 4 hours. Messier 51 remains in history as the very first galaxy in which spiral structure had been detected – this observation had been made earlier, in 1845, by Lord Rosse in Ireland. Roberts of course refers to the galaxy as a "nebula;" the awareness of galaxies external to our own, only came much later. Also seen in this photograph is a companion galaxy, which we now understand has interacted with the larger spiral galaxy Messier 51. (Courtesy: The archives of the Royal Astronomical Society, London.)

Figure 68 One of the most beautiful spiral galaxies in the northern skies is seen here, known as Messier 81. The galaxy was photographed by Isaac Roberts on the 30th March 1889 with an exposure time of 3½ hours. Roberts remarked that his long-exposure photograph reveals this object "to be a spiral, with a nucleus which is not well defined at its boundary, and is surrounded by rings of nebulous matter …" (Courtesy: The archives of the Royal Astronomical Society, London.)

Figure 69 We present two photographs by Isaac Roberts of the Great Nebula in Orion. The image seen here was captured in an exposure time of 205 minutes on the 4ᵗʰ February, 1889. Magnificent filamentary and wispy structure in the outer domains of the Great Orion Nebula is recorded, and ridges of cosmic dust are strikingly evident. (Courtesy: The archives of the Royal Astronomical Society, London.)

Figure 70 A shorter exposure, of duration 81 minutes, by Isaac Roberts of the Great Nebula in Orion reveals delicate inner structure which becomes "washed out" in the longer exposure seen in the preceding photograph. This photograph was secured on Christmas eve, 24ᵗʰ December 1888. (Courtesy: The archives of the Royal Astronomical Society, London.)

Figure 71 The Pleiades star cluster, as photographed by Isaac Roberts on 8ᵗʰ December 1888, in an exposure time of 4 hours. Each particle of dust lurking in interstellar space interacts with any starlight which it may encounter. It does so either by scattering photons off in other directions, or by absorbing them, or by a combination of both. Our sky is blue because of the scattering of short-wavelength blue photons from sunlight by particles of gas in our atmosphere. The Pleiades cluster contains splendid examples of "reflection nebulae," wherein short-wavelength photons of light are scattered by – or reflected off – dust and gas particles surrounding young, hot star members of the cluster. (Courtesy: The archives of the Royal Astronomical Society, London.)

Figure 72 Challenges facing astronomers after the dawn of the photographic era included the recording of intricate details. The German astronomer Johann Krieger was intensely interested in lunar topography, but he realized that low resolution photographs of the Moon failed to reveal intricate structures such as lunar rilles (trenchlike lunar features, some thought to be remnants of ancient lava flows). The reason is that our often turbulent terrestrial atmosphere through which the Moon is observed acts as a *mask of the Moon,* hiding thin sinuous, straight and branching rilles. To address this, Krieger meticulously made telescopic observations of the Moon and then added exquisite details which he saw by eye at the telescope, during moments of atmospheric steadiness. These details were subsequently drawn on low resolution lunar photographs by hand, using charcoal, ink and graphite pencil. The photograph reproduced here of craters Ramsden, Elger and others, completed in 1897, appears in Krieger's classic *Mond-Atlas.* (Photograph: *Mond-Atlas,* Trieste, 1898.)

Figure 73 Krieger's rendition of the Lacus Somniorum region of the Moon, a basaltic plain located in the north-eastern sector of the Moon's near side. Lacus is the Latin for lake: Lacus Somniorum is also known as the Lake of Dreams. With modern astronomical techniques, astronomers today can secure a veritable multitude of images, and with the assistance of a computer, select those images taken in moments wherein our atmosphere is very steady (often referred to as good to excellent seeing) but Krieger added such rille structures by hand. He completed this rendition in 1897. (Photograph: *Mond-Atlas,* Trieste, 1898.)

Figure 74 A photograph of lunar craters Aristarchus and Herodotus, prepared by Johann Krieger; finer rille structures added by the hand of Krieger. (Photograph: *Mond-Atlas,* Trieste, 1898.)

Figure 75 The planet Jupiter, as drawn by the astronomer Edward Emerson Barnard (1857–1923), on the 11ᵗʰ July, 1880. Clearly depicted is one of Jupiter's satellites or moons – seen in silhouette – crossing the Great Red Spot. (From the archives of the Royal Astronomical Society, London.)

Figure 76 Another drawing by the young Barnard, of the planet Jupiter. Barnard was in his early twenties when he produced this drawing on 25ᵗʰ July, 1880. Little could Barnard have imagined that he would be the discoverer of a fifth moon of Jupiter in 1892; up to then, the only known moons of Jupiter were the four discovered by Galileo Galilei. (From the archives of the Royal Astronomical Society, London.)

Figure 77 The Crocker telescope boasted a 6-inch portrait "Willard lens." Here was the telescope used to produce the first photographs showing the detailed structure of our Milky Way Galaxy in the years 1892–1895. The Willard lens allowed photons from a wide-angle field to strike the photographic plate: every inch on the original glass negatives spanned nearly two degrees, the equivalent of almost four full moons.

E. E. Barnard's photographs of the Milky Way with the Willard lens were published by the Lick Observatory in 1913. (Photograph: Lick Observatory, California.)

Figure 78 The astronomer Edward Emerson Barnard. "Barnard is to be reckoned as one of the greatest observers of all time, and his work may be compared with that of Tycho Brahe, J.D. Cassini, and the Herschels" reads the obituary published by the Royal Astronomical Society in London. Barnard's career and struggles prove a very important point: it is never a large telescope alone, which is the seed for great discoveries. Rather, it is the mind of the astronomer. (Photograph courtesy: The Boyden Observatory.)

Figure 79 A section of the Milky Way in the constellation of Taurus. The astronomer E.E. Barnard had this to say about the view seen here: "Very few regions of the sky are so remarkable as this one. Indeed the photograph is one of the most important of the collection, and bears the strongest proof of the existence of obscuring matter in space." This photograph by Barnard was secured on 9th January 1907; the exposure time was 5 hours and 29 minutes and appears in his magnum opus entitled: *A Photographic Atlas of Selected Regions of the Milky Way.* (Photograph courtesy: The Carnegie Institution of Washington.)

Figure 80 Breathtaking beauty – the Milky Way as seen in the constellation of Ophiucus. Barnard comments on this exposure (of duration 4 hours 30 minutes, secured on 5th/6th April 1905): "The region of Rho Ophiuchi is one of the most extraordinary in the sky. The nebula itself is a beautiful object. With its outlying connections in which it is placed and the vacant lanes running to the east from it, it makes a picture almost unequaled in interest in the entire heavens." Barnard used the Bruce telescope, which had been transported to the site of the Mount Wilson Observatory in California. Barnard secured forty of the fifty photographs in his *Atlas* from Mount Wilson, including this one in Ophiuchus. (Photograph courtesy: The Carnegie Institution of Washington.)

Figure 81 Dark lanes or rifts in the Milky Way are strikingly captured in the photograph by E.E. Barnard. The dark lanes photographed here lie in the constellation of Ophiucus. Barnard comments: "The main lane … is continuous for more than 6 degrees [12 full moons] from the nebula … it gradually shatters into fragments … These lanes and spots, though mostly devoid of all stars, are not truly vacant, for there is apparently some sort of obscuring matter in them." A 3 hour exposure secured from the Mount Wilson Observatory site on 3rd/4th June 1905. (Photograph courtesy: The Carnegie Institution of Washington.)

Figure 82 A sector of the Milky Way in Scorpio and Ophiucus. Barnard likens the dark "holes" to "sink-holes" and references the *Century Dictionary*, wherein a sink-hole is defined as … "One of the cavities formed in limestone regions by the removal of the rock through the action of rain or running water, or both. The rock being dissolved away underneath, local sinkings of the surface occur, and these are sometimes wholly or partly filled with water, forming pools." An exposure spanning 3 hours 42 minutes secured on 29th / 30th May 1905. Barnard personally examined 35 700 photographic prints to select only the best to feature in his *Atlas*, of which seven hundred copies were produced. Every photograph in the *Atlas* is pasted in; no photographs were reproduced by means of a mechanical printing press. (Photograph courtesy: The Carnegie Institution of Washington.)

Figure 83 Nebulosity in the Milky Way – a region in Scorpio and Libra. This exposure, approaching *nine* hours (8 hours and 40 minutes to be precise) was secured over two nights on 29th and 30th April 1905. This is the longest exposure of any of the photographs in the *Barnard Atlas*. (Barnard never actually saw his *Atlas* in print, for he died at age 65, in 1923, four years before the *Atlas* saw the light of day. It was published in 1927 by the Carnegie Institute of Washington.) The *Barnard Atlas* was completed by Edwin Frost, Director of the Yerkes Observatory and by Barnard's niece, Mary Calvert. (Photograph courtesy: The Carnegie Institution of Washington.)

Figure 84 "Great Star Clouds in Sagittarius." Barnard recalls: "These great clouds were among the first portions of the Milky Way to be photographed by the writer with the Willard lens at the Lick Observatory, in the year 1889. They are *the most magnificent* of the galactic clouds

visible from this latitude." In his description of these immense starry fields, Barnard notes: "These great *broken* clouds, so beautiful to the eye and on the photograph, rapidly thin out to the south and east [upper right in this orientation], the stars being fewer and fainter. This gives … the impression of greater distance." Barnard identifies a narrow strip or bridge "between two portions of the great cloud" … and he also comments on the crude form of a creature with "round head, nose, mouth, ears, and great staring eyes." Barnard concludes: "The whole star field is *broken up* with many rich structures which it would be difficult to describe." Much like a cosmic fog, dark and dusty Shrouds of the Night are most effective in their obscuration effects. The result is a *"fragmenting"* of the immensely rich starry fields of the Milky Way Galaxy, a portion of which is seen here in the constellation of Sagittarius. Photons from the "Great Star Clouds in Sagittarius" were captured on a photographic plate on 6th / 7th July 1905. The exposure time was a mere 2 minutes short of 4 hours. (Italics: ours. Photograph courtesy: The Carnegie Institution of Washington.)

Figure 85 Shrouds of The Night – dark veils of cosmic dust – lie sprawling everywhere on this breathtaking photograph secured by E.E. Barnard on 28th / 29th June 1905. The exposure time was 4 hours 33 minutes and shows part of the Milky Way in Ophiucus and Scorpio. Barnard speaks of this photograph as portraying "some of the most remarkable features in the sky." He writes further that the "great vacancy" (seen toward lower right in this orientation) "is covered with a *veiling* of what is probably obscure nebulosity, with some detail, hiding the background of stars beyond it." (Italics ours. Photograph courtesy: The Carnegie Institution of Washington.)

Figure 86 Extraordinary Shrouds of the Night photographed by E.E. Barnard on 8th/9th May 1905, from the Mount Wilson site in California. Exposure time: 3 hours 30 minutes. Another region of the Milky Way Galaxy, in the constellation of Ophiucus, north of the star Theta Ophiuchi. Barnard is captivated by the pervasiveness of dark areas and writes: "It is so extremely puzzling that one attempts a description of it with hesitation. That most of these dark markings which, in a word, ornament this portion of the sky are real dark bodies and not open space can scarcely be questioned. There seems to be every evidence of their reality." Barnard uses the terms "black tufts," "black loops" and "curled dark figures" to describe different sectors of the photograph. (Photograph courtesy: The Carnegie Institution of Washington.)

Figure 87 A photograph of our Milky Way Galaxy entitled: "Dark Markings near Theta Ophiuchi." Barnard speaks of "straggling vacancies" and "vacancies within vacancies" in this photograph of exposure time almost 5 hours (4 hours 45 minutes to be precise). Barnard captured this view on 5th / 6th June 1905. In this orientation, the star "Theta Ophiuchi" is the bright star above and to the left of the center of the photograph. The imagery is almost that of mysterious dark creatures lurking as enigmatic Shrouds of the Night. (Photograph courtesy: The Carnegie Institution of Washington.)

Figure 88 A photograph secured by E.E. Barnard, entitled "Region of Theta Ophiuchi and Eastward," spawns myriads upon myriads of grains of cosmic dust in the constellation of Ophiuchus. The view shows breathtaking beauty in those starry vaults of the *Via Lactea* (Milky Way) lying in the vicinity of the star Theta Ophiuchi (seen toward lower left in this orientation). The "great vacancy" which lies toward the center of the photograph is known as Barnard object number 78. In describing a sector of this image, Barnard speaks of the dark "curved horns extending from a black head, as if the head were in the act of charging." Barnard furthermore writes: "It is clearly shown that there is some kind of matter in the great vacancy, which is feebly luminous over its entire area … Whatever the material in the dark spot may be, it is evident that we are not looking out into space through an opening in the Milky Way." Exposure: 4 hours 45 minutes. Date: 30th June/1st July 1905. (Photograph courtesy: The Carnegie Institution of Washington.)

Figure 89 "Region of 58 Ophiuchi" as captured by the astronomer E.E. Barnard on 2nd/3rd August 1905, using the Bruce telescope of the Yerkes Observatory, Chicago, transported to Mount Wilson in California. The duration of the photographic exposure was 4 hours. Upon describing this image, Barnard writes: "The naked-eye star 58 Ophiuchi … close to the middle of the plate, is apparently placed in the midst of a large mass

of small, cloudlike forms ..." Barnard uses "curious curved dark marking," "peculiar matter" and "sharp loops" to describe sectors of this photograph. Barnard also comments on the "beautiful cluster Messier 23" seen toward lower right hand in this orientation. (Photograph courtesy: The Carnegie Institution of Washington.)

Figure 90 "Region in Serpens and Sagittarius" as captured by E.E. Barnard on 25th/26th July 1905 in an exposure time of 4 hours 10 minutes. In describing different regions of this photograph, Barnard notes the presence of "brighter clouds to the east" (to the right of the photograph, in this orientation) and furthermore describes the *extremely fine* distribution of stars in terms of *powder*: "... the darker sky is thinly sprinkled with a *fine powdering* of small stars with some vacant spaces ..." He also remarks on the presence of "several *curved sprays* of small stars [stretching] out from the cluster [Messier 23]" seen above center of the image. (Italics ours. Photograph courtesy: The Carnegie Institution of Washington.)

Figure 91 An area of the Milky Way in the constellations of Aquila and Sagittarius, secured by E.E. Barnard on 24th/25th July 1905. The photograph shows a magnificent nebula in the upper left hand sector; this nebula, technically known as Messier 17, is more commonly referred to as the "Omega Nebula" or the "Swan Nebula." It is not difficult to imagine a graceful Cosmic Swan drifting upon a calm lake of fine powdery stars in our Milky Way Galaxy. Below the Swan Nebula lies Messier 16 – the Eagle Nebula – which Barnard describes as "a mixture of stars and nebulosity which rather closely resembles the great nebula of Orion." Barnard furthermore comments: "One cannot avoid the conclusion, when examining the original negative, that the entire plate is covered with a faint film of nebulosity." (Photograph courtesy: The Carnegie Institution of Washington.) Dark, dusty Shrouds of The Night betray themselves in apparent "holes" or "vacancies" which are seen in striking contrast, in this image of exposure 3 hours 52 minutes.

Figure 92 "Region in Aquila and Sagittarius" as imaged by the astronomer E.E. Barnard on 1st/2nd August 1905. This 5 hour exposure shows brilliant fine sprinklings of stars; veils or shrouds of dark cosmic dust grains lie throughout scattered throughout the region. Barnard is captivated by "chains of small stars." One is reminded of a poem by Chaucer ca. 1380: "See yonder, lo, the Galaxye, Which men clepeth the Milky Wey, for hit is whyt." Chaucer is beckoning his reader to "see yonder the Galaxy, Which men call[eth] the Milky Way, for [because] it is white." The terms "galaxy" and "Milky Way" first appeared in the English literature in this poem written over 600 years ago. (Photograph courtesy: The Carnegie Institution of Washington.)

Figure 93 "This, the gem of the Milky Way, is the finest of the stars clouds" writes E.E. Barnard of the "Great Star Cloud" in Scutum. Barnard photographed this region of the Milky Way from California on 30th/31st July 1905. Barnard writes that: "In looking at this great cloud one cannot imagine that it is anything but a real cloud in form, with a depth comparable to its width ... [its] serrations are possibly due to dark, obscuring matter ... it serves well as a background against which intermediate opaque or non-luminous objects may be seen." Barnard speaks of a "great hammer-like head" [of this star cloud] while noting that the "main body is apparently made up of extremely minute stars." A photograph revealing the most exquisite detail; photons from this star field fell upon the photographic plate of Barnard for a period spanning 5 hours and 30 minutes. (Photograph courtesy: The Carnegie Institution of Washington.)

Figure 94 "Region of the North America Nebula." Barnard comments thus: "This wonderful object, which has so happily been called the 'North America Nebula' by Dr. Max Wolf, is shown here in great perfection. It is a splendid mixture of stars and nebulosity ... The beautiful nebula, with the outlying nebulosities, is in splendid contrast with the blackness of the sky, which is relieved here and there by bright stars – like lighthouses in a great sea – and by a liberal sprinkling of lesser stars." Barnard describes the bright rim (seen above center in this orientation) as "[brushing] out over the dark sky ... almost like electrical or auroral streamers. An exposure of duration 4 hours 20 minutes secured on 4th/5th September 1905 by E.E. Barnard using the photographic Bruce telescope on the Mount Wilson site in California. (Photograph courtesy: The Carnegie Institution of Washington.)

Figure 95 A portion of the Milky Way in the constellation of Cepheus, photographed by E.E. Barnard on 1st/2nd September 1905. The exposure time was 4 hours 47 minutes. Barnard describes this sector as "a very extraordinary region of widespread nebulosity and dark markings." Barnard remarks that the center "is occupied by a large, irregular nebula with a patch of brighter stars than usual." He comments that the central domain is "gritty with small stars which are entirely free of nebulosity." The descriptions given by Barnard continue to be rich and varied; he uses terms such as "sharp, black irregularities," "stratum of stars" and a "straggling zigzag lane." One can almost imagine a wearisome cosmic traveler, after a long sojourn, following a zigzag path to his home, located *somewhere* in the Via Lactea, amidst the starry fields in Cepheus. (Photograph courtesy: The Carnegie Institution of Washington.)

Figure 96 Our journey through the *Barnard Atlas* ends in the same constellation at which we began: the constellation of Taurus. Seen here is a photograph entitled "Region of the Pleiades," showing the pronounced effect of "Rayleigh scattering." Foreground cosmic dust grains not only *obscure* the light from more distant stars, but they are also extremely effective in *scattering* starlight. Our daytime sky is blue as a result of the scattering of sunlight by particles of gas in our atmosphere. The nebulosity seen here is a result of clouds of gas and dust scattering short wavelength, blue photons of light from young blue stars wreathed within these moving cosmic clouds. Barnard himself writes at the beginning of his description: "This plate was intended to illustrate the distribution of some of the exterior masses of nebulosity that surround the Pleiades." Photograph by E.E. Barnard, observing from the Mount Wilson site, on 7th/8th September 1905, in an exposure of duration 3 hours and 48 minutes. (Photograph courtesy: The Carnegie Institution of Washington.)

Figure 97 The Andromeda Spiral Galaxy, as photographed on 7th September 1899 by James Keeler using the Crossley Reflector. The Crossley Reflecting telescope, with a mirror of diameter 36-inches, was made by Dr. A.A. Common of London, in 1879. It was at first sold to Mr. Edward Crossley of Halifax, England and later donated by Mr. Crossley to the Lick Observatory in California. In its day, it was the largest instrument of its kind in the United States. (Photograph: Lick Observatory.)

Figure 98 The spiral galaxy NGC 253, as photographed by James Keeler on 18th–20th December, 1902 in an exposure time of 3 hours. (Photograph: Lick Observatory.)

Figure 99 The spiral galaxy Messier 33, as photographed at the Lick Observatory using the Crossley reflecting telescope. Keeler photographed this galaxy on 12th September 1899 in an exposure of duration 3½ hours. (Photograph: Lick Observatory.)

Figure 100 Dusty and dark Shrouds of the Night are beautifully captured by James Keeler in this very long exposure of the spiral galaxy NGC 891. Keeler imaged this galaxy with the Crossley reflector in a 4 hour exposure on 6th November, 1899. (Photograph: Lick Observatory.)

Figure 101 The Pleiades star cluster as photographed by James Keeler, on 28th December 1899. The exposure time was 4 hours. (Photograph: Lick Observatory.)

Figure 102 Striking contrasts between dark and light: a celestial display of the inextricable link of clouds of gas and surrounding interstellar particles of dust. Seen here is a blue reflection nebula – known as NGC 1977 – in the constellation of Orion. Image secured by James Keeler in an exposure of duration 2 hours 50 minutes on 21st January 1900. (Photograph: Lick Observatory.)

Figure 103 The spiral galaxy Messier 66 (also catalogued as NGC 3627) displays its dark lanes of cosmic dust in a most profound manner. This galaxy was photographed at the Lick Observatory by James Keeler, using the Crossley reflector, on 23rd April 1900; the exposure time was 3½ hours. (Photograph: Lick Observatory.)

Figure 104 James Keeler photographed this spiral galaxy, known as NGC 4565, on 21st April 1901. Exposure time: 3 hours. The galaxy is oriented almost "edge-on," allowing astronomers to clearly view Shrouds of the Night located in the plane of its disk. (Photograph: Lick Observatory.)

Figure 105 The first galaxy in which spiral structure had been identified by Lord Rosse, Messier 51, photographed at the Lick Observatory on 10th May 1899 in a 4 hour exposure. Also seen toward lower center of Messier 51 is the companion galaxy catalogued as NGC 5195, displaying its mask of cosmic dust. (Photograph: Lick Observatory.)

Figure 106 One of the most beautiful spiral galaxies in our skies is Messier 101, with its small central bulge of stars and its filamentary (thin) multiple set of spiral arms. The spiral arms are seen to contain numerous bright "knots," associated with the birth of young stars. James Keeler imaged Messier 101 on 8th June 1899; the plate-holder of the Crossley reflector was kept open for a time interval of 4 hours. (Photograph: Lick Observatory.)

Figure 107 The Trifid Nebula in our Milky Way Galaxy, as photographed at the Lick Observatory by James Keeler. Three dominant lanes of cosmic dust divide the nebula into three lobes, from whence the name "Trifid" is derived. This stellar nursery was photographed on 6th July 1899, in an exposure of duration 3 hours. (Photograph: Lick Observatory.)

Figure 108 The most exquisite filamentary structure is captured by James Keeler in a sector of the "Veil Nebula" in our Galaxy. Glowing filaments of interstellar gas flow out into space, as we behold the remnants of an exploding star. Keeler and others had well demonstrated the enormous power of the photographic method in matters astronomical, both within and beyond the confines of our Milky Way Galaxy. This image of the Veil Nebula was secured on 29th August 1899, sixty years after Talbot presented his paper on photography to the Royal Society. The Crossley reflector was carefully kept on its target, the Veil Nebula, for a period of 4 hours. (Photograph: Lick Observatory.)

Figure 109 Spawning innumerable dark globules of cosmic dust is the stellar nursery, Messier 8, in our Galaxy. Imaged with the Crossley reflector on 7th July 1899, in an exposure time of 4 hours. (Photograph: Lick Observatory.)

Figure 110 "Like delicate cosmic petals, these clouds of interstellar dust and gas have blossomed 1300 light years away in the fertile star fields of the constellation Cepheus. Sometimes called the Iris Nebula and dutifully catalogued as NGC 7023, this is not the only nebula in the sky to evoke the imagery of flowers" is the description provided by Robert Nemiroff and Jerry Bonnell. The Iris Nebula was imaged on 19th/20th August 1903; the exposure time was 3 hours. Keeler never saw this photograph, secured three years after his death which occurred on 12th August 1900. (Photograph: Lick Observatory.)

Figure 111 The Hubble galaxy classification scheme is based on the optical appearance of galaxies. To represent the scheme graphically in his book *The Realm of the Nebulae*, Hubble used a musical "tuning fork" which was rotated by ninety degrees. Following detective work by astronomy historian William Sheehan and the authors, the provenance of the "tuning fork diagram" can be traced back to Sir James Jeans. (From *The Realm of the Nebulæ*, E.P. Hubble.)

Figure 112 The scientific contributions of Mr. John Henry Reynolds (1874–1949) cannot be overemphasized. Without any formal astronomical training, Mr. Reynolds was undoubtedly one of the world's most profound thinkers regarding the classification of galaxies. Edwin Hubble sought the ideas of Mr. John Reynolds. Mr. and Mrs. Reynolds entertained some of the foremost astronomers and cosmologists of the age at their home in Birmingham; these included Sir Arthur Eddington, Sir James Jeans, Sir Frank Dyson, Professor Willem de Sitter – and many others. Mr. Reynolds served as President of the Royal Astronomical Society of London during the period 1935–1937. (Photograph: The Royal Astronomical Society of London.)

Figure 113 The telescope at the private observatory of Mr. John Reynolds at Low Wood, Harborne, England. At the time that this photograph was taken, the telescope contained a mirror of diameter 28-inches. Reynolds was a man with a most generous spirit: he built large reflecting telescopes and then donated them to other observatories. This telescope was later fitted with a 30-inch mirror made by A.A. Common and the instrument was then donated by Reynolds to the Commonwealth Solar Observatory (now known as the Mount Stromlo Observatory) in Canberra, Australia. There was another "Reynolds telescope" in Egypt,

which, under the directorship of Knox-Shaw, did pioneering research in nebular photography. (Photograph from the archives of the Royal Astronomical Society of London.)

Figure 114 The administrative building of the Commonwealth Solar Observatory, Mt. Stromlo, with a Crossley motor car in the foreground. It was relatively close to this building that the 30-inch telescope donated by Mr. John Reynolds was erected in Canberra. (Photography courtesy: National Library of Australia.)

Figure 115 The disassembled Reynolds telescope arrived in Canberra during the years 1928–1929. A steel dome of diameter 26 feet was constructed to house the telescope. Erection of the dome was completed in 1932, and the first photographs through that telescope, from the Canberra site, were secured in 1933. (From the collection of Vince Ford at Mount Stromlo.)

Figure 116 The astronomer Walter Stibbs seen using the 30-inch Reynolds telescope in Australia. Until the 1950s, this telescope was one of the largest operational telescopes in the Southern Hemisphere. The late Gerard de Vaucouleurs secured about 250 one hour exposures of galaxies in our southern skies with this instrument. The generosity of Mr. John Reynolds was thus indirectly crucial to the development of the de Vaucouleurs classification criteria, as is clearly evident in the "Memoirs of the Commonwealth Observatory No. 13" published in July 1956. (Photograph: Historical Archive Collection at the Mount Stromlo Observatory.)

Figure 117 The Reynolds telescope was used by author Ken to secure images of nebulae and galaxies. Seen here, and in the figure following, are two different exposures of the Great Nebula in Orion. In this shorter 45 second exposure, secured on 29th November 1967, intricate inner structure in the nebula is captured. (Photograph: Kenneth Freeman.)

Figure 118 A longer (15 minute) exposure of the Great Nebula in Orion, as imaged on 29th November 1967 using the Reynolds reflecting telescope in Australia. (Photograph: Kenneth Freeman.)

Figure 119 The "Tarantula Nebula" (also known as 30 Doradus) is an area of star formation in one of our nearby galaxies, the Large Magellanic Cloud. This nebula, with its spidery "tarantula" appearance, lies in the southern constellation of Dorado; photographed using the Reynolds telescope in Australia by author Ken. (Photograph: Kenneth Freeman.)

Figure 120 One of the most symmetrcal galaxies in the southern sky is technically catalogued as NGC 1566. This galaxy was photographed in Australia using the telescope donated by Mr. John Reynolds. The prominent "spots" outside of the main circular images are known as "calibrating spots" and are used for intensity – or brightness – determinations. (Photograph: Kenneth Freeman.)

Figure 121 Astronomers Ken Freeman (left) and Ben Gascoigne (right) both used the Reynolds telescope in Australia. Ben Gascoigne was allocated nine months of observing time on the telescope in the early 1950s; his research on "Cepheid variables" with the Reynolds telescope is legendary. (Photograph: David L. Block.)

Figure 122 In this letter from Edwin Hubble to John Reynolds, Hubble seeks for the ideas of Reynolds. The letter commences: "All suggestions on this difficult subject, coming from one of your expertise, are extremely welcomed." At the top of the next page, Hubble requests: *Could you not throw your ideas into the form of a precise classification so we could actually apply it to a large number of nebulae representing the various sizes and degrees of brightness with which we will be dealing?* (Italics ours. From the archives of the Royal Astronomical Society of London.)

Figure 123 Astronomers David Block (left) and Allan Sandage (right) photographed at the *Athenaeum* in Pasadena. Sandage's monumental contributions to the history of our Galaxy and his research papers about globular clusters are no less important than his fundamental contributions to the fields of galaxy morphology and of cosmology. Allan Sandage made galaxy morphology accessible to the general astronomical community, by authoring the photographic *Hubble Atlas of Galaxies*. (Photograph: Robert Groess.)

Figure 124 John Reynolds at a meeting in London of the Club of the Royal Astronomical Society (RAS). Seen in this photograph, dated 12th February 1937, is Mr. John Reynolds, flanked by Sir James Jeans and Sir Frank Dyson. Sir Arthur Eddington is seated at the extreme right of the photograph. (Photographed by Dr G Merton. From the archives of the Royal Astronomical Society Club.)

Figure 125 Another meeting of the Club of the RAS includes John Reynolds seated with, amongst others, the Danish astronomer Ejnar Hertzsprung. Hertzsprung is the co-originator of the famous Hertzsprung–Russell diagram, a fundamental tool in the determination of the distances to stars. The photograph is dated 12th June 1936. (Photographed by Dr G Merton. From the archives of the Royal Astronomical Society Club.)

Figure 126 The American astronomer Edwin Hubble attended a meeting of the RAS Club held in London on 13th November 1936. Hubble is flanked by Frank Dyson and Richard Woolley, both of whom served as Astronomer Royal. Also seen at the extreme right is the legendary cosmologist, Sir William ("Bill") McCrea. (Photographed by Dr G. Merton. From the archives of the Royal Astronomical Society Club.)

Figure 127 The British mathematician and physicist, Sir James Jeans, center, was a prolific author of popular books, such as *The Universe around Us*, *The Mysterious Universe* and *The Growth of Physical Science*. The graphical representation of the Hubble tuning fork must be attributed to Sir James Jeans – a scientist who had a great passion for music, was intimately acquainted with the use of tuning forks and who wrote a famous book entitled *Science and Music*. (Photographed by Dr G Merton. From the archives of the Royal Astronomical Society Club.)

Figure 128 A photograph of Mr. John Reynolds, facing the camera and seated in the Chair as President of the Royal Astronomical Society of London. Sir James Jeans is seen standing at right, addressing a meeting of the Royal Astronomical Society. (Photograph: The Royal Astronomical Society of London.)

Figure 129 "Bridge through a Cavern, Moonlight" as depicted by the English landscape and portrait painter Joseph Wright (1734–1797). A bright full moon acts as a highly effective mask. Light from the full moon masks the light from fainter stars. The view of the captain of a ship approaching a harbor at night may similarly be greatly dominated by the intensely luminous light of a harbor lighthouse. In an analogous way, our view of spiral galaxies in the optical (visible) part of the spectrum may be greatly skewed by the brilliant light from hot young stars. (Reproduced by permission of the Derby Museum and Art Gallery.)

Figure 130 Our Universe presents a rich duality in structure – that of the mask and that behind the mask. The Australian Aborigines capture this profound duality in their x-ray paintings, one of which is seen here. While their paintings of a fish and a turtle have the unmistakable outlines of these creatures, they also unveil their hidden skeletal backbones and organs, as if seen with x-rays. Just as Röntgen opened up a new era to penetrate the skeletal frame encased in a mask – our skin – so too, can infrared images allow us to unveil the actual *backbones* of galaxies. (Artwork: Collette Archer, of the tribe Djunban in Far Northern Queensland, Australia.)

Figure 131 An optical photograph of one of the largest spiral galaxies identified in our Universe, catalogued as NGC 309. Note that spiral galaxies such as Messier 81 – inset in the photograph – can comfortably fit in between the gargantuan spiral arms of NGC 309. When galaxies are imaged photographically in the visual domain of the spectrum, the focus is on the young and brilliant stars delineating the spiral arms; astronomers are preferentially observing the icing or frosting on a cake. Behind the mask lies the older stellar component, where ninety-five percent of the galaxy's total luminous mass is distributed. (Photograph: National Optical Astronomy Observatories.)

Figure 132 A dust penetrated image of NGC 309, secured at the Mauna Kea Observatories in Hawaii. What emerges from behind the Shroud of NGC 309 is a two arm "grand design" spiral galaxy, with a small central elongated feature known as a "bar." Could it be that this image was hinting at a fundamental new and general Hidden Symmetry in Nature? (Photograph: David L. Block, Richard J. Wainscot and *Nature*.)

Figure 133 Seen here is a composite image – a comparison of blue and yellow sensitive images of the Whirlpool Galaxy Messier 51 and its companion NGC 5195. The Whirlpool is seen to display a pair of magnificent "smooth arms" in yellow sensitive light. In 1957, the astronomer Fritz Zwicky elucidated: "We are confronted with the possible case of being a spiral when seen in the light of its blue stars and a barred spiral in the light of the yellow-green stars." That there was a New View of our cosmos was already beginning to surface in the 1950s. The duality of spiral structure is strikingly seen in this composite photograph, produced using images secured with the 200-inch telescope at Mount Palomar, California. (Photograph from the work of Fritz Zwicky in *Morphological Astronomy*.)

Figure 134 An optical image of the Whirlpool Galaxy, Messier 51, and its companion galaxy NGC 5195. Notice the *very irregular* optical appearance of the companion galaxy as a result of its hugely prominent mask of cosmic dust. (Photograph: National Optical Astronomy Observatories.)

Figure 135 An enlargement of the preceding Figure shows, to full advantage, the dusty Shrouds of the Night in the companion to the Whirlpool Galaxy. The presence of grains of cosmic dust are all pervasive in this optical photograph; dark ridges of cosmic dust lie throughout its disk. It is indeed no wonder that astronomers classified this galaxy as "irregular." Sources labeled "A" and "B" assist the eye in comparing this optical image to the dust penetrated view seen in the image following. (Photograph: National Optical Astronomy Observatories.)

Figure 136 Penetrating the Dusty Shroud of the companion galaxy NGC 5195 shows a radically different structure in this near-infrared image secured at the Mauna Kea Observatories in Hawaii. No longer does irregularity or "chaos" reign supreme, but its backbone of old stars is stunningly symmetric. In fact, there is a hint of an incipient two-armed spiral galaxy. Stars "A" and "B" assist the eye in comparing this infrared image with the optical view seen in the preceding figure. Given an infrared image, it is *impossible* to predict what the optical dust mask will look like. (Reproduced from a research paper by David L. Block and collaborators.)

Figure 137 Our closest active radio galaxy, known as Centaurus A, is seen in optical light to proudly adorn its colossal mask of cosmic dust. Dust grains stride across the central regions of this system in a most impressive manner. In 1954, two astronomers, Walter Baade and Rudolph Minkowski, suggested that Centaurus A actually presented two galaxies in collision. What lay behind the Shroud of the Night in Centaurus A? The answer awaited dust penetration of its mask by means of infrared imaging. (Photograph: David Malin.)

Figure 138 Penetrating the Dust Shroud of Centaurus A reveals an extraordinary history: the remnant of a *spiral galaxy* lies at the center of Centaurus A. We have indicated the shape of the remnant spiral, detected using infrared camera arrays, by means of contours. We then overlaid these contours on an optical image of Centaurus A, to show the spatial position of the spiral galaxy observed in the infrared. (Image: David L. Block and M. Sauvage.)

Figure 139 Using specialized computer techniques, Centaurus A is seen to spawn vast arrays of shells in its outer parts. These shells cannot be seen by eye on conventional glass plates, such as that reproduced in the preceding figure – but they become evident upon use of a special method whereby low surface brightness features on fine-grain emulsions are enhanced in the darkroom. They are also clearly evident in this enhanced image produced by means of computer. Arrays of shells and inner ridges of cosmic dust are highly suggestive of the "worlds in collision" scenario painted by Baade and Minkowski. (Image courtesy: E. Peng and collaborators.)

Figure 140 Seen here is an optical image of the spiral galaxy catalogued as NGC 253. Such optical images show a plethora of short, fleece-like spiral arms, with no apparent regularity whatsoever. A grand surprise awaits the investigator seeking to observe the stellar backbone of this galaxy. (Photograph: David Malin.)

Figure 141 In infrared light, the spiral galaxy NGC 253 reveals an exquisite hidden symmetry of two dominant spiral arms. Furthermore, a bar – completely obscured in the optical domain – emerges in the infrared.

The infrared image seen here has been mathematically de-projected using special image processing software on a computer, so that we are viewing the flat disk of the galaxy as if it were precisely "face-on" as opposed to "edge-on." (Much like a flat circular plate can be viewed either "face-on" or "edge-on," in which case one would only see the rim of the plate.) Yet another striking example of the duality of spiral structure: one classification unfolds from optical imaging, and a radically different morphology presents itself in the disk of older stars. (Photograph courtesy: O.K. Park and Kenneth Freeman.)

Figure 142 Giovanni Fazio of the Harvard-Smithsonian Center for Astrophysics, together with a highly dedicated team, devoted over fifteen years from the first conceptual phases of an infrared camera to its final construction – the camera is onboard the Spitzer Space Telescope, launched in 2003. The marvel of the instrument is that instead of tiny molecules and minute grains of dust being viewed as dark dust rifts and patches, one can see *bright* Shrouds of the Night, as these dust grains and molecules glow in the mid-infrared light detected by the Spitzer Space Telescope. (Photograph: Robert Groess.)

Figure 143 The first ever color photograph of our nearest giant spiral galaxy, the Andromeda Spiral Galaxy, or Messier 31. The galaxy measures about 140 000 light years in diameter, and lies at a distance of 2½ million light years from us. Also seen are two of its companion galaxies: Messier 32 (below center) and NGC 205 (right, above center). Astronomer William Miller used the then revolutionary GAF Super Ansco film which had a nominal ASA of 100. He secured the photograph on 11ᵗʰ August 1958, with the Palomar 48-inch Oschin Schmidt Telescope in California. The exposure time was 2 hours. (Photograph: David Malin, Australia and the California Institute of Technology, Pasadena: William Miller.)

Figure 144 Imaging the Andromeda Spiral Galaxy with the Spitzer Space Telescope by Pauline Barmby and her collaborators, secured by pointing the telescope in 700 different positions to cover the entire galaxy. The image reveals two *glowing rings* of dust: the outer ring has a diameter of approximately 65 000 light years, while the second inner ring measures about 4900 light years by 3300 light years. These two rings testify to an almost head-on galaxy collision, as a companion galaxy (most likely Messier 32) plunged almost head-on near the center of the Andromeda Spiral Galaxy. (Adapted from a research paper in *Nature*, with authors: David Block, Frederic Bournaud, Francoise Combes, Robert Groess, Pauline Barmby, Matthew Ashby, Giovanni Fazio, Michael Pahre and Steven Willner.)

Figure 145 Rings of Fire – a close-up mid-infrared view of the inner regions of the Andromeda Galaxy through the eyes of the Spitzer Space Telescope. The square inset (box) dramatically shows the existence of an inner ring, with sectors of the outer ring visible above and below the galaxy center. The inner ring is completely masked, in optical light, by myriads of stars in the luminous bulge of the Andromeda Galaxy. Both rings are expanding; the outer ring expands at about 50 kilometers per second while the expansion velocity of the inner is approximately 20 kilometers per second. The scenario which unfolded before us is that a companion galaxy (probably M32) had collided with the disk of the Andromeda Spiral at a velocity of about 265 kilometers per second, almost 3900 light years from the center of the disk. (Adapted from a research paper in *Nature*, with authors: David Block, Frederic Bournaud, Francoise Combes, Robert Groess, Pauline Barmby, Matthew Ashby, Giovanni Fazio, Michael Pahre and Steven Willner.)

Figure 146 A press release image prepared at the Headquarters of the Spitzer Space Telescope in Pasadena, reveals that the centers of both the outer and inner "glowing rings of fire" do not coincide with the exact center of the Andromeda Spiral Galaxy. The centers of the outer ring, inner ring and of the Andromeda Galaxy are labeled 1, 2 and 3 respectively. The inner ring is offset by forty percent from the center of Messier 31; the outer ring by a smaller factor of about ten percent. Such off-centring of the rings are fully consistent with a near head-on collision in our nearest giant spiral galaxy. (Photograph: Headquarters of the Spitzer Space Telescope in Pasadena. Adapted from a research paper in the journal *Nature*.)

Figure 147 A drawing of the Andromeda Spiral Galaxy by E. Trouvelot in 1874 emphasizes that the galaxy contains very dark lanes of cosmic dust. It is only upon penetrating the luminous bulge of stars in this galaxy as well as

the dusty shrouds in its disk, that both the inner and outer rings are detected. (Drawing reproduced from the Annals of the Astronomical Observatory of Harvard College, Volume VIII, published in Boston, 1877.)

Figure 148 Members of the genus Allosaurus (a multi-ton bipedal predator, equipped with dozens of sharp teeth and averaging 30 feet in length, although some are believed to have reached 40 feet) would have been roaming the Earth as the Andromeda Spiral Galaxy experienced an almost head-on collision with one of its companion galaxies. Of course the collision could not actually be observed on Earth (special infrared detectors onboard a space-borne telescope are required), but the drawing serves to highlight the timescale of when the collision actually took place: a relatively recent event, measured not in billions – but rather millions – of years. The impact is believed to have occurred only 200 million years ago. (Drawing courtesy: Cobus Prinsloo.)

Figure 149 An important physical parameter which we use in our dust penetrated galaxy classification scheme is the angular pull or "torque" provided by a rotating bar of stars. Seven classes of "bar strength" are recognized. In this montage, spiral galaxies have been arranged in rows, in order of increasing bar strength: from NGC 3631 to NGC 1300. The four small black dots in each image are generated by computer to indicate those spatial positions where the gravitational force field of the bar is measured to reach a local "maximum." (Adapted from research by Ronald J. Buta, David L. Block and their collaborators.)

Figure 150 Eyes to the future: quantifying the shapes of spiral galaxies behind their dust masks. Each galaxy seen here is "dust penetrated" in these near-infrared images, secured at several different observatories dotted around the globe. The two classification criteria presented here are the "bar torque" (measuring the gravitational strength or tug of the bar) and the degree of openness of the spiral arm pattern. Three spiral arm "form families" are recognized in the infrared: the classes are designated α, β and γ. Spiral galaxies of class α have tightly wound spiral arms whereas those of type γ have an open spiral arm morphology. These "form families" are *not* at all correlated to the optical classification types of Hubble: note that a "late-type" galaxy (such as NGC 5236 included in this montage) can belong to the tightly wound α bin whereas an "early-type" galaxy (such as NGC 1365) resides in the open γ infrared class. (Adapted from research conducted by David Block in collaboration with astronomers Ronald Buta and Ivânio Puerari.)

Figure 151 The giant loop in the lower section of the image is known as Barnard's Loop. It lies within our Milky Way Galaxy, in the constellation of Orion. Barnard's Loop (named after E.E. Barnard) spans some 20 degrees in the sky – the equivalent of 40 full moons, and measures about 600 light years across. The Loop encompasses the famous Horsehead Nebula seen to striking contrast in this image. Barnard's loop is also visible in ultraviolet light, as dust grains within the loop scatter energetic photons of light from neighboring stars. (Image: Peter Erdman.)

Figure 152 An optical image of the spiral galaxy NGC 2841 reveals the scattering of starlight by dust grains on an extraordinary scale. Arrowed in the inset is an amorphous, linear strip of light. A spectrum of the strip was secured using the Keck telescopes in Hawaii; the spectrum matches that of the bulge stars. What we are seeing is a vast lane of cosmic dust in the disk, scattering photons of light which originate from stars in the bulge of this galaxy. The strip is 6500 light years in extent, by far the largest "reflection nebula" we have yet studied. (Photograph: Peter Kukol, Adam Block, National Optical Astronomy Observatories, AURA and the National Science Foundation. Adapted from a Letter to *Nature* by David L. Block, B.G. Elmegreen and R.J. Wainscoat.)

Figure 153 Inhabitants of Papua New Guinea. A unique environment to explore the mind of Man, without heavy influence of Western culture. *Adam in Arrows, Adam in Plumes* and *Adam with Arrows* are but three of myriads of books written about these regions. (Photograph: David L. Block.)

Figure 154 Looks of wonder and mystery upon seeing a camera lens. These young children reside on the Trobriand Islands, an archipelago of coral atolls located off the eastern coast of Papua New Guinea. Several of their homes are seen in the background. There is almost a sense of *timelessness* in these regions. (Photograph: David L. Block.)

Figure 155 "Tree House, Koiari Village" as photographed by J.W. Lindt. In Papua New Guinea, time is temporal; determined by the wanderings of celestial bodies such as the Sun and the Moon. (Reproduced from *Picturesque New Guinea*, Plate XIV. Longmans, Green, and Co. 1887.)

Figure 156 "Lakatoi, near Elevala Island" as photographed by J.W. Lindt. In a certain sense, space is more fundamental than time in these regions. Can *time* be thought of as a *spatial* concept? Theorists Stephen Hawking and James Hartle actually place time and space on comparable footings. Christopher Isham comments: "From an aesthetic point of view, there is something rather attractive about the completeness as represented [by Hartle and Hawking] … one can almost imagine the Universe being held in the cup of God's hand." (Reproduced as plate VII in *Picturesque New Guinea* by J.W. Lindt. Longmans, Green, and Co. 1887.)

Figure 157 The spiral structure of our Milky Way Galaxy, as drawn by C. Easton in 1912. Easton made use of a selection of photographs from a number of astronomers (including those of Barnard, Wolf, Russell, Pickering and Bailey) to deduce the spiral morphology depicted in his drawing. In the inner parts of a spiral galaxy such as our Milky Way, stars do indeed contribute most of the mass, but as astronomers probe their disks further and further out in radius, another component of the mass dominates. This is the "missing mass" or enigmatic "dark matter." (Photograph: The Royal Astronomical Society of London.)

Figure 158 The galaxy imaged here (NGC 5084) is one of the most massive galaxies known. It is viewed "edge-on," as if viewing a thin plate from one side. All looks so perfectly normal around the environs of NGC 5084 – there is no dimming of background galaxies – its dark matter halo emits no light whatsoever, and remains undetected on optical photographs. (Photograph: Anglo Australian Telescope.)

Figure 159 A wide-angle view of a section of our Milky Way Galaxy as seen "now," billions of years after its birthing process. What happened when the Milky Way was actually being assembled? Astronomers use a novel archaeological approach to probe the primordial history of our Galaxy; an approach known as chemical tagging. (Photograph: *Atlas of the Northern Milky Way* by Frank E. Ross and Mary R. Calvert, 1934. Reproduced by permission of the Yerkes Observatory.)

Figure 160 Another wide angle view, spanning over 400 square degrees, of the starry vaults in our Milky Way Galaxy (1600 full moons would fit into this image). The future lies in chemical tagging of stars, much like human beings may be genetically tagged by their DNA. (Photograph: *Atlas of the Northern Milky Way* by Frank E. Ross and Mary R. Calvert, 1934. Reproduced by permission of the Yerkes Observatory.)

Figure 161 Left Panel: The discovery of arcs of carbon stars in the outer disk of the Triangulum Spiral Galaxy, Messier 33, was published in 2004 by coauthors David and Ken and their collaborators. The left panel shows extensive outer arcs of carbon stars in an infrared image of Messier 33; the ellipse serves to guide the eye through these arcs. North is at the top. A pair of two prominent inner spiral arms is also seen in this "negative" image, wherein stars appear black and the background, white. The presence of carbon stars was identified on account of their very red infrared colors. Right panel: Follow-up spectroscopy of some of the members was conducted in Hawaii, using the Keck I and Keck II telescopes and confirmed their carbon star status. Shown in the panel at right is an optical image of the Triangulum Spiral Galaxy. The area circled is centered on a carbon star in the outer extremities of the optical disk, while other members observed with the Keck telescopes are labeled with plus (+) signs. If these brilliant light beacons of carbon stars are pervasive in the outer disks of spiral galaxies, the implications could be that the disks of spiral galaxies are not fixed, but rather *grow with time* – from the inside, outwards. More recent infrared studies of Messier M33 have been published in 2007 by astronomers M. Cioni and collaborators. (Left panel: From a research paper entitled "Very luminous carbon stars in the outer disk of the Triangulum Spiral Galaxy" by D.L. Block, K.C. Freeman, T.H. Jarrett, I. Puerari, G. Worthey, F. Combes and R. Groess. Right panel adapted from a paper presented in Prague at a meeting of the International Astronomical Union, by David Block, Francoise Combes, Ken Freeman, Ivânio Puerari and collaborators.)

Figure 162 It is often not appreciated just how extensive the disks of spiral galaxies can be, outside of their optical boundaries. Seen here is the extensive outer disk of the spiral galaxy known as Messier 83 (or NGC 5236). Beautiful outer loops or filaments are strikingly captured in this image, which has been photographically "stacked." In the "stacking" process, several long exposures of the galaxy are secured, and each is sequentially projected in a darkroom onto a sheet of photographic paper or film. Prior to projection, registration (alignment) of every photograph is absolutely critical. In this exquisite photograph by David Malin, an optical color image of Messier 83 has been meticulously overlaid. (Photograph: David Malin.)

Figure 163 The outer disk of the spiral galaxy NGC 1566. An optical color photograph of the galaxy is overlaid, for comparative purposes. The reason astronomers cannot routinely capture these amazing outer arms in NGC 1566 is that although their dust content must be low and almost devoid of brilliant young blue stars, they are far too faint to be recorded using traditional infrared detectors. Photographer David Malin would "stack" photographs which had first been "photographically amplified" before following the "multi-image" or "stacking" procedure in the darkroom. (Photograph: David Malin.)

Figure 164 The outer disk of the spiral galaxy NGC 2997, as imaged using the Anglo Australian Telescope, and subjected to specialized photographic techniques. Also overlaid is an optical image of the galaxy, in color. (Photograph: David Malin.)

Figure 165 The outer disk of the spiral galaxy NGC 4321, with an optical image of NGC 4321 overlaid. (Photograph: David Malin.)

Figure 166 An optical color view of a galaxy catalogued as NGC 1313 shows intense star formation; the inner disk is brightly illuminated by young, massive stars. The optical image is seen against a remarkably "deep" set of exposures secured by David Malin in Australia. Extraordinary detail is captured in the outer disk, including faint filaments and plumes. NGC 1313 continues to be an object of much astrophysical interest. (Photograph: David Malin.)

Figure 167 The optical and very faint outer disk of the barred spiral galaxy NGC 1300 are both seen to full advantage. The outer disk is believed to contain the same population of principally old stars which astronomers see when they image galaxies in the near-infrared, through their masks of dust. (Photograph: David Malin.)

Figure 168 The faint outer regions of the Sombrero Galaxy. Overlaid is a color image showing the optical extent of the galaxy. While the distribution of dark matter must be responding to the gravitational field of the stars within the optical limits, the reverse is true in the outer regions: there, the stars must be following the unseen halo of dark matter. Such images serve to highlight the *dynamic interaction* between the structure of spiral galaxies (as seen in the optical) and their mysterious halos of nonluminous dark matter in which they are embedded. Halos of dark matter are dynamically "live" and interactions of stars and dark matter must be continuously taking place. (Photograph: David Malin.)

Figure 169 An optical image of the Sombrero Galaxy shows a dramatic lane of cosmic dust which lies in the disk of this galaxy. When astronomers penetrate the masks of edge-on spiral galaxies, the dust becomes almost transparent. The complete story of the production and of the time development of dust grains in galaxies, however, still requires a great deal of research. (Photograph: David Malin.)

Figure 170 The Large Magellanic Cloud spawns myriads of bubbles of neutral hydrogen gas. Turbulence on a grand scale indeed, with no signature of spiral structure in the hydrogen gas. (Image: S. Kim.)

Figure 171 One of the most famous spiral galaxies in the sky, as imaged in the near-infrared from Hawaii. The galaxy displays exquisite symmetry with a striking pair of spiral arms. The arms are very tightly wound around the bulge, with a winding (pitch) angle of only 10 degrees. To emphasize the duality of spiral structure, we leave it as an exercise to the reader to ponder which famous galaxy is imaged here, and what the optical image of this galaxy might look like. Having identified the spiral, the reader is then referred to Figure 184 to verify their answer. (Near-infrared image courtesy: UKIDSS Consortium, with additional image processing by David L. Block.)

Figure 172 The Large Magellanic Cloud, as seen with the naked eye from "Feldhausen" in the Cape of Good Hope, South Africa. Sketch by Sir John Herschel, published in 1847. It is extraordinary that Sir John Herschel visually detects both stellar spiral structure and the appearance of an elongated feature of stars – a bar – in the Large Magellanic Cloud. The confirmation of stellar spiral structure in the Large Magellanic Cloud by means of photography followed in 1890, forty-three years after the publication of Herschel's observations at the Cape. (Courtesy: William Cullen Library, University of the Witwatersrand.)

Figure 173 This photograph published in 1890, secured by the Australian astronomer H.C. Russell in Sydney, Australia, not only shows the presence of a bar in the Large Magellanic Cloud, but also provides evidence of incipient spiral structure. Russell commented that "the numbers of clustering stars [are] arranged in a way that is very suggestive of spiral structure." The exposure time was 7 hours and 3 minutes and the photograph was secured on 17th / 18th October 1890. (Reproduced as photograph number 13 in "Photographs of the Milky-Way & Nebulae taken at the Sydney Observatory" by H.C. Russell, Sydney.)

Figure 174 "The Hand of God" modeled ca. 1896 by Auguste Rodin (1840–1917). Is humanity to be likened to a mere candle flickering in the corner of a dark medieval cathedral, or are there cosmic fingerprints of design? Does the imagery of men and women being held in the great, life-giving Hand of God ring true in our modern astronomical age? (Photograph by David L. Block.)

Figure 175 A family portrait of the Local Group. Our Milky Way belongs to a group of galaxies, known as the Local Group. Members of the Local Group include the Andromeda Spiral Galaxy M31 seen in the lower left of the montage, the Triangulum Spiral Galaxy M33 (upper left), the Milky Way Galaxy itself (lower right), the Large Magellanic Cloud (designated in the montage as LMC), the Small Magellanic Cloud (SMC), and numerous smaller galaxies. (Montage: Bruno Binggeli.)

Figure 176 The centrality of the observer in our fine-tuned Universe: is the entire cosmic canvas so framed that it might display our name? The original sketch of a man with hat and sack walking along a road in the Cape, South Africa is in pencil, and comes from a collection of unpublished drawings attributed either to Sir Thomas Maclear (1794–1879) or his family. Thomas Maclear was a great friend of both Sir John Herschel and of the explorer David Livingstone. (Photographic reproduction: The Studio. From a Private Collection.)

Figure 177 The discovery by Sir William Herschel of two moons orbiting the planet Uranus. This drawing was presented by Sir William at a meeting of the Royal Society in London; it is dated 1787. The planet Uranus (then known as the Georgian planet) was discovered by Sir William Herschel six years earlier, in 1781. Subsequently, two moons were discovered by Sir William Herschel in 1787; the moons appear as small white dots here. Pertaining to these two moons or satellites, its discoverer expressed his thoughts as follows: "The great distance of the Georgian planet … has rendered it uncommonly difficult to determine whether, like Jupiter and Saturn, it be attended by satellites … The 11th of January, therefore, in the course of my general review of the heavens, I selected a sweep which led to the Georgian planet … I perceived near its disk, and within a few of its diameters, some very faint stars … I do not doubt that I saw them both, for the first time, on the same day, which was January the 11th, 1787." Sir William continued: "…the heavens now displayed the original of my drawing, by showing, in the situation I had delineated them, *The Georgian Planet attended by two Satellites.*" The two moons depicted here, discovered by him on 11th January 1787, are now known as Oberon and Titania. (Reproduced from "An Account of the Discovery of Two Satellites revolving round the Georgian Planet" by William Herschel, read at the Royal Society, 15th February, 1787. From the library of the South African Astronomical Observatory.)

Figure 178 "So vast, without any question, is the Divine Handiwork of the Almighty Creator" wrote Nicolaus Copernicus in his monumental work entitled "De revolutionibus". Photographed at Harvard University are Professors Owen Gingerich (left) and Giovanni Fazio (right) examining a copy of the work of Copernicus (1473–1543). Professor Gingerich writes in one of his William Belden Noble lectures: "I am personally persuaded that a superintelligence exists beyond and within the cosmos,

and that a rich fabric of congeniality toward the existence of self-conscious life shown by our Universe is part of its design and purpose." (Photograph: Robert Groess.)

Figure 179 Some of the earliest woodcut illustrations of shepherds abiding their flock may be found in a manuscript entitled "The Shepheardes Calender" [sic] by Edmund Spenser, originally published over 400 years ago, in 1579. These woodcut illustrations were printed only 60 years after Ferdinand Magellan began his epic voyage to circumnavigate the globe, in 1519. The Psalmist David compared the guidance of his God to a Shepherd, the Great Shepherd, when he wrote "The Lord is my shepherd: I shall not want … thy rod and thy staff they comfort me" in Psalm 23. (Courtesy: The William Cullen Library, University of the Witwatersrand. Reproduced from the original edition of 1579 in Photographic Facsimile with an introduction by H. Oskar Sommer, published by John C. Nimmo, London, 1890.)

Figure 180 According to the New Testament, it was to shepherds abiding their flock that the miracle of God becoming Man was announced. This woodcut illustration comes from E. Spenser's "The Shepheardes Calender" [sic] which first appeared in print in 1579. (Courtesy: The William Cullen Library, University of the Witwatersrand. Reproduced from the original edition of 1579 in Photographic Facsimile with an introduction by H. Oskar Sommer, published by John C. Nimmo, London, 1890.)

Figure 181 "In a small Parisian shop, amid a clutter of presses and parchment, a team of printers works feverishly each day to meet the demand of the era's bestseller. The year is 1514. The bestseller? A compact, illustrated prayer book known as a Book of Hours" writes Sonia Ellis in her article "The Miracle of Print." Reproduced here is a leaf (recto) from a Book of Hours: the term recto–verso describes two sided printing; the recto is the right hand page. Although the actual text is printed, the image of Matthew (at left) writing his gospel is illuminated in color, by hand. The text on the recto is from the second chapter of Matthew, and describes the sighting of the Star of Bethlehem by Magi from the Orient – "stellam eius in oriéte" and "videntes autem stellam

magi – gavisi sunt gaudio magno valde." The latter is translated: "And seeing the star they rejoiced with exceeding great joy." (Printed in France by G. Hardouyn.)

Figure 182 The Universe evokes in many a sense of *wonder*. Joseph Wright captures this wonder in his painting entitled "A Philosopher lecturing on the Orrery," exhibited in 1766. An Orrery depicts the movements of the planets in our solar system, with the light in the center representing our Sun. "Natural Philosopher" was a term used to characterize a scientist. (Reproduced by permission of the Derby Museum and Art Gallery.)

Figure 183 Minute and exquisite detail is captured during this total eclipse of the Sun, which took place on 12th December, 1871. "Engraved from a drawing made from the original negatives taken at Baikul. By Lord Lindsay's assistant Mr Davis." (As published in Memoirs of the Royal Astronomical Society, Volume XLI, 1879. Courtesy: The Royal Astronomical Society of London and the South African Astronomical Observatory.)

Figure 184 The graceful Whirlpool Galaxy, Messier 51 (NGC 5194) and its companion (NGC 5195), was imaged optically in January 2005 with the Advanced Camera for Surveys abroad NASA's orbiting Hubble Space Telescope, to produce the sharpest-ever optical image of this system, seen in the left hand panel. In the right hand panel, we view Messier 51 and its companion galaxy through its dusty Shrouds of the Night by imaging the galaxy in the near-infrared. The view rendered in Figure 171 is produced by carefully cropping away the companion galaxy. (Optical image: NASA, ESA, S. Beckwith and the Hubble Heritage Team at STScI/AURA; near-infrared image courtesy: The UKIDSS Consortium, with additional image processing by David L. Block.)

Figure 185 The pipe of shepherd "Colin cloute" [sic] lies broken "in peeces" (in pieces) on the ground, as depicted in the first Æglogue "Ægloga Prima" of January ("Ianuarye" [sic]) in E. Spenser's masterful work entitled "The Shepheardes Calender" [sic] first published in 1579. (Courtesy: The William Cullen Library, University of the Witwatersrand.

Reproduced from a photographic facsimile of the original edition of 1579, with an introduction by H. Oskar Sommer. Published by John C. Nimmo, London, 1890.)

Figure 186 Comet McNaught – also known as the Great Comet of 2007 – with the majestic Table Mountain in South Africa seen to the east (left) of the Comet. Comets are "dirty snowballs" of ice mixed with grains of cosmic dust; they often show the most magnificent tail(s) as they approach the Sun and the ices begin to melt. Over four hundred years ago, in 1579, the English poet E. Spenser poetically intertwines a Comet with the emotions of his character, Colin – in his famous work entitled "The Shepheardes Calender" [sic]. Colin's manhood was "consumed with greate heate" [sic] (consumed with great heat) and "excessiue drouth" [sic] (excessive drought) writes Spenser, "caused through a Comet or blasinge starre" [sic] – i.e., "caused through a Comet or blazing star." (Comet McNaught photograph: Mary Fanner.)

Figure 187 Comet McNaught as photographed from Hout Bay, South Africa. The comet is seen above the famous Sentinel, with Hout Bay harbor lying in the foreground. (Photograph: Richard Ball.)

Figure 188 An ox-wagon in the Cape, South Africa, is beautifully depicted in this sketch, against a range of mountains in the background. The sketch, in pencil, is believed to have been drawn by either Sir Thomas Maclear (who served as a Director of the Royal Observatory, Cape of Good Hope, in the period 1834–1870) or by one of his family members. Ox-wagons were typically drawn by chains of oxen, harnessed in pairs. The mode of dress of mother and child at right is typical of the 1800s. (Photographic reproduction: The Studio. From a Private Collection.)

Figure 189 An African Farm, with ox-wagon. The wheels of this ox-wagon (used in the 1800s) has wide rims. The axle and wheel appear in silhouette against the slopes of the Helderberg Mountain Range near Stellenbosch, Western Cape, South Africa. Trellised vineyards cling to the granite slopes, from where some of the world's finest wines are produced. (Photograph: David L. Block.)

Figure 190 Arcs of hydrogen gas glow warmly in this color image, photographed from the European Southern Observatory in Chile. Wondrous indeed are these dynamic stellar nurseries, where young stars and dark grains of cosmic dust are both seen to striking contrast. (Photograph: David L. Block.)

Figure 191 A gelatin silver print reproduction – with applied water-color – of Joseph Nicéphore Niépce's "View from the Window at Le Gras" (ca. 1826) produced at the request of Helmut Gernsheim by the Research Laboratory of the Eastman Kodak Company in Harrow, England. Although this famous reproduction produced in 1952 fails to accurately duplicate what the First Photograph actually looks like (see Figure 192 for a faithful rendition), it does allow the eye to identify (from left to right) the upper loft or "pigeon-house" of the family home; a pear tree through which a patch of sky may be seen through the branches; the slanting roof of the barn and, at right, another wing of the family house of Nicéphore Niépce. (Gernsheim Collection, Harry Ransom Center, The University of Texas at Austin.)

Figure 192 A color digital print reproduction of the world's First Photograph (ca. 1826). The reproduction was recently produced in 2003, at the Getty Conservation Institute in California and is "an attempt to reveal more of the unretouched image while still providing a sense of the complex physical state of the photograph." It gives an accurate rendering of what visitors to the Harry Ransom Center at the University of Texas can expect to see upon examining the historic heliograph which Nicéphore Niépce produced using a camera obscura (as discussed in Chapter 6) and a polished pewter plate coated with bitumen of Judea – an asphalt derivative of petroleum. (Gernsheim Collection, Harry Ransom Center, the University of Texas at Austin. Digital photograph by Jack Ross, Ellen Rosenbery and Anthony Peres: The J. Paul Getty Museum. The quotation is from the Harry Ransom Center.)

Figure 193 While the world applauded the birth of photography by Daguerre and Talbot in 1839, the *photographic incunabula* by Nicéphore Niépce lay shrouded in obscurity. Seen here is a heliograph on pewter

entitled "Interior of a Ruined Abbey" produced by Nicéphore Niépce twelve years earlier, in 1827. Niépce sensitized plates of pewter with bitumen of Judea to reproduce images by photochemical means. During a visit to Britain in 1827, Nicéphore Niépce handed this heliograph as a gift to Francis Bauer, a Fellow of the Royal Society. Niépce died of a stroke in 1833; his invention unknown to the world. When news reached England from France in January 1839 that Daguerre had invented photography, Bauer found the report "incomprehensible" stating that "Niépce is the inventor of this interesting art." This heliograph of a print lay in relative obscurity for over 100 years. The correct date associated with the invention of photography is ca. 1826, as attested to by Helmut Gernsheim, Francis Bauer and Victor Fouque. We have digitally increased the contrast in this heliograph to allow the eye to readily identify features such as the rounded pillars in the Abbey, the stairs, as well as a cross between two of the pillars. The higher contrast does reveal myriads of tiny white marks. The inset gives an accurate rendition of the plate of pewter as it currently appears behind its frame. (From the Royal Photographic Society Collection at the National Media Museum and the Science and Society Picture Library.)

Figure 194 Images through a pinhole date back to antiquity: their roots may be traced as far back as 500 BC. Naturally occurring rudimentary examples would be the passage of light rays through the slits of wicker baskets and the crossing of leaves. The tenth century mathematician, physicist and astronomer Ibn al-Haytham discovered that the smaller the "pinhole," the sharper the image. Leonardo da Vinci (1452–1519) discusses pinhole image formation in his *Codex Atlanticus*. A "pinhole camera" with a 0.5 mm diameter pinhole (produced using a needle or sharp drill) with a 50 mm focal length has a "f-stop" of 100, resulting in remarkably sharp images. The still life scene captured here was produced using a pinhole camera and a yellow filter. There is no conventional lens; rather, light entered a minute pinhole which focused the rays onto photographic paper. This image by Rael Wienburg, secured in 1971, has an exposure time of 2 hours. It is believed to be one of the early examples of *color* pinhole photography. In other words, a sheet of color (Cibachrome) paper was placed inside a pinhole camera. (Photograph: Rael Wienburg in London, Ontario.)

Figure 195 "Today mankind is beholding the first real dawn of astronomical science. Yesterday was the preparation for that dawn – how splendid were the pioneers of that time!" An early photograph of the Moon, dated 18th October, 1896. The photograph, secured using the 36-inch telescope at the Lick Observatory in California, shows rich detail and has an impressive scale – the Moon's diameter would span three French feet (38.36 inches or 97.45 cm) in the original enlargements. (Photograph reproduced from an *Observatory Atlas of the Moon*, Lick Observatory, 1896. The quote is from Charles Holmes, 1918.)

Figure 196 One of the most exquisite early photographs of the Great Nebula in Orion, secured in a one hour exposure by A.A. Common on 4th February, 1883. "We," said the stars, "have seen the earth when it was young. We have seen small things creep upon its surface – small things that prayed and loved and cried very loudly, and then crept under it again. But we," said the stars, "are as old as the Unknown." (Photograph: Royal Astronomical Society of London. Text: Olive Schreiner, from her novel *The Story of an African Farm*.)

Figure 197 "The Southern Milky Way" – a view captured by Solon Bailey at the Harvard College Observatory. Bailey used a Cooke lens, about one and a half inches in diameter, of focal length approximately thirteen inches. The glass plates used were 8 by 10 inches in size, and the field covered here is an extraordinary 30 × 40 degrees. The exposure time was 20 hours and the photograph was secured over three nights: 20th, 22nd and 23rd July 1909. Bailey noted that: "The region shown on this plate is in many respects the most remarkable in the sky." Beautifully seen are the rich star fields in Sagittarius upon which this photographic plate is centered. Bailey continued: "Probably no other extended region of the Milky Way equals in brightness the large area [seen here] ..." Bailey commented that "both sides of the Milky Way are broken up by numerous rifts and holes ... their ramifications are extremely intricate." (Courtesy: Boyden Observatory, Bloemfontein, South Africa. From the Annals of the Astronomical Observatory of Harvard College, Volume LXXII, 1913.)

Figure 198 A globular cluster of stars, known as 47 Tucanae, was discovered by Abbe Nicholas Louis de Lacaille on 14th September, 1751.

The name "globular cluster" is derived from the Latin *globulus* – a small sphere of stars, bound together by gravity. The cluster 47 Tucanae contains approximately two million stars. It spans an angle in our southern skies of approximately the full moon and measures about 340 light years in diameter. This vault of stars comprises an ancient Rosetta Stone, whose age is estimated at 11 billion years. The original negative of this image (on glass) was secured by coauthor Ken, observing and "riding" in the prime focus cage of the Anglo–Australian Telescope; the primary mirror of this telescope has a working diameter of just under 4 meters. Reproduced here is a *contact* positive from the original negative taken on 14th/15th December, 1974, with an exposure time of 1 hour and 45 minutes. (Negative: K.C. Freeman and the Anglo–Australian Observatory. Contact positive platinum–palladium print: Gordon Undy, Sydney.)

Figure 199 The spiral galaxy NGC 6872 lies in the southern constellation of Pavo. It was identified by coauthor David as one of the largest known spiral galaxies in our local Universe, spanning a diameter of about seven times that of the Milky Way. The galaxy presents a prominent central bar. NGC 6872 was photographed on a glass plate mounted at the prime focus of the 4-meter Victor M. Blanco telescope at the Cerro Tololo Inter-American Observatory in Chile, South America. (Photograph: Victor Blanco and the Cerro Tololo Inter-American Observatory.)

Figure 200 Spawning a veritable multitude of dark and dusty Shrouds of the Night: the nebula NGC 281, within our Milky Way Galaxy, as imaged recently by Peter Erdman in the United States. "…tomorrow" wrote Charles Holmes in 1918, "we shall be overwhelmed by the vastness of sidereal discoveries and progress …" How far photography of the night sky has advanced since the early work of our pioneers. Modern astrophotography no longer uses a negative, but rather captures photons of light by means of digital detectors. (Photograph: Peter Erdman.)

Figure 201 "None of us today can wholly comprehend … such an infinity of space; but all of us tomorrow will be able to explain why the Cosmos could not be limited …" said Charles Holmes in 1918. This image, recently secured by astrophotographer Peter Erdman, shows a portion of the Milky Way in Cygnus. It represents the longest exposure of any image in our book. An eight-panel mosaic was constructed using state-of-the-art digital equipment: the exposure time per panel is ten hours, so that the total exposure time required to produce this eight-panel swath of the starry vaults in Cygnus, is 80 hours. (Photograph: Peter Erdman.)

Figure 202 "A race in the night – a cheetah in silhouette?" In studying this pillar of cosmic dust in the constellation of Carina, the shape is somewhat reminiscent of a cheetah (*Acinonyx jubatus*), known for its great speed and stealth. The cheetah, a member of the cat family, *Felidae*, can reach speeds of over 100 kilometers per hour; the head of this cosmic monster may remind some readers of a cheetah in silhouette as it hunts in the African savannah. This imposing dark pillar of dust measures over 2 light years in length. (Image secured with the Hubble Space Telescope. Courtesy: NASA, ESA, Nathan Smith at the University of California, Berkeley, and his collaborators, together with the Hubble Heritage Team at the Space Telescope Science Institute, Baltimore.)

Figure 203 Mammoth pillars of cosmic dust and gas within our Milky Way Galaxy, as imaged by the orbiting Hubble Space Telescope, in the southern constellation of Carina. One is truly viewing the genesis of star formation. Blistering ultraviolet radiation from newly born stars will eventually erode these cosmic leviathans of dust on a timescale of approximately 100 000 years. (Image courtesy: NASA, ESA, Nathan Smith at the University of California, Berkeley, and his collaborators, together with the Hubble Heritage Team at the Space Telescope Science Institute, Baltimore.)

Figure 204 "Sunset with her brilliant rays at Golden Gate" – nestled in the rolling foothills of the Maluti mountains lies the Golden Gate Highlands National Park in South Africa. At certain times of the day, these Highlands appear as though painted with brushes of gold, due to reflected sunlight off the imposing cliffs of sandstone. Sunsets as viewed from meandering paths near Phutaditjhaba in Qwa–Qwa, the Free State Province, South Africa are spectacular. A concluding thought from Lucretius (95–55 BC): "This fright, this night of the mind, must be dispelled not by the rays of the sun, nor day's bright spears, but by the face of nature and her laws." (Photograph: David L. Block.)

Index

Printed in the United States of America